# THE CANON REFLEX WAY

# THE
# CANON
# REFLEX
# WAY

LEONARD GAUNT

Focal Press · London

Focal/Hastings House · New York

ISBN (excl. USA) 0 240 50989 7
ISBN (USA only) 0 8038 1228 0

📖 *British Library Cataloguing in Publication
Data*
*Gaunt, Leonard*
*The Canon reflex way.—3rd ed.—(Camera way
books).*
1. *Canon reflex camera*
I. *Title*     II. *Series*
771.3'1        TR263.C3

*First Edition* 1974
*Second Edition* 1975
*Third Edition* 1979

4 6 5 4 7 4 0 5 5

*ALL ENQUIRIES*
*relating to this book or to any photographic problem
are answered by the Focal Press without charge if a
stamped addressed envelope is enclosed for reply*

*Printed and bound in Great Britain
by The Pitman Press, Bath*

# CONTENTS

*Acknowledgements*

The author's thanks are due to J. J. Silber Ltd., Canon's UK distributors, for extended loan of a wide range of Canon equipment while this book was being written and, in particular, to John Oliver, lately of that company for invaluable advice and assistance.

# THE CANON REFLEXES

Canon, one of the most respected names in camera manufacture, entered the 35 mm. SLR field in 1959 and have since produced 15 models, of which the remarkable F-1 system and the A range of electronically-assisted cameras are now current. This comparatively late entry is reflected in the fact that few fundamental modifications have been made in the ensuing years. Improvements and technical advances have certainly been achieved, but the basic mirror and diaphragm action, the method of lens attachment, film transport, flash synchronization, etc., have remained essentially the same and most of the original attachments and accessories can still be used with the later cameras and vice versa.

Naturally, the Canon reflexes incorporated from the beginning all the refinements that had been added to the original 35 mm. SLR design of the 1930's and even the first Canonflex is an eminently usable camera now. It was well in advance of most models in 1959.

## Principle of reflex camera

The modern reflex principle of the first Canonflex is ingenious. The first 35 mm. cameras had no focusing screen. They used separate viewfinder systems placed above the camera lens which gave a considerably reduced approximation of the image projected on to the film. As the angle of view of a lens decreases at close range and as the difference in viewpoint between viewfinder and lens in those conditions also became exaggerated, close-up photography presented problems.

At long range, focusing was sheer guesswork and the subject was difficult to see. Improvements in viewfinder optics and the introduction of coupled rangefinders helped to a limited extent but, generally, the cameras were unusable with lenses of greater focal length than 135 mm. except with a reflex attachment.

The reflex attachment is, however, really a substitute for the reflex camera, which introduced the focusing screen to 35 mm. cameras. Older cameras and some modern technical cameras provide a focusing screen at the back of the camera to present the image formed by the lens. This they can do because the film or plate is held in a darkslide or film holder that is completely detachable. Before the picture is taken the screen is replaced by the film holder.

The 35 mm. camera, however, has unprotected film running across the back and therefore has to remain closed and has to incorporate a shutter to prevent light reaching the film between exposures. The screen cannot be placed in the film plane so it has to be placed in an equivalent focal plane and the image directed to it via a mirror. The logical position is in the top of the camera where it can accept the image reflected by a movable mirror placed at a 45° angle behind the lens. The path through the lens via the mirror to the screen is, of course, the same length as the direct path to the film plane.

Thus, the image on the focusing screen is formed by the lens that takes the picture—whatever its focal length and whatever its distance from the film plane. Even when the lens is moved forward to focus at close range, when attachments are fitted to it, when bellows or tubes are placed behind it, the screen image remains a true representation of the image that will subsequently appear on the film.

That was as far as the early 35 mm. SLRs went. The screen image was small, rather dark in the corners and, because of the mirror, reversed left to right. The camera was very awkward to use. The lens had to be opened up fully to view and focus and closed down as required to take the picture. The mirror, which flipped out of the way before the shutter opened, did not return to the viewing position until the film was wound on for the next exposure.

## Modern improvements

All these drawbacks were eliminated in the first of the Canon reflexes. The uneven illumination of the screen was solved by the addition of a fresnel lens—a special form of condenser lens that spreads the light evenly right into the corners of the screen.

## SLR PRINCIPLES

The essential features of the single-lens reflex camera with through-the-lens metering are:
1. Pentaprism.
2. Magnifying eyepiece.
3. Meter cell.
4. Condenser lens.
5. Focusing screen.
6. Rangefinder.
7. Focal plane shutter blind.
8. Pressure plate.
9. Mirror.

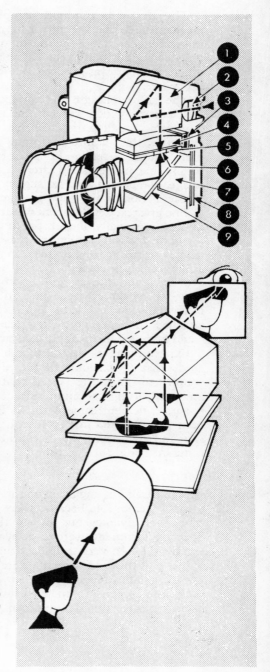

The lens projects an image of the scene in front of it, via the mirror placed at 45° behind it, on to the focusing screen. The user views this image through the magnifying eyepiece via the specially shaped prism which presents a right way up, right way round image. It is important to appreciate that the viewer does not have a direct line of sight through the lens. He views a projected image through a pre-focused eyepiece. There is therefore no question of the eye adapting to a wrongly focused image to make it look sharp.

The mirror action was coupled with the shutter mechanism so that the mirror flipped upward to obscure the screen just before the shutter opened and returned to the viewing position as soon as the shutter closed. Thus, the viewfinder was blacked out only at the instant of exposure.

The lens diaphragm was coupled with the film advance mechanism, which served the additional purpose of tensioning the diaphragm so that, immediately after the exposure, the diaphragm sprang back to full aperture. This automatic action of mirror and lens diaphragm meant that immediately after each exposure a brilliant image reappeared on the screen without any need of further action by the photographer.

The greatest development was, however, the introduction of a specially shaped prism (pentaprism) to fit on top of the focusing screen and present a correctly oriented image to a magnifying eyepiece in the traditional position at the rear of the camera. The SLR thus became usable at eye level and the magnification of the screen image provided by the eyepiece gave an almost life-size image from the standard lens. With very long-focus lenses attached, the camera provided clear images of objects that could not even be distinguished by the naked eye.

Exposure meters were also built into the cameras from 1962, when the Canonflex RM had a selenium type meter coupled to the shutter speed control. Through-the-lens metering, using cadmium sulphide (CdS) as the light-sensitive element came with the Pellix in 1965 and has been incorporated in all subsequent models, except the A-1 and AE-1 and the discontinued EF, which use a faster-reacting silicon sensor.

## Canon reflex features

On early Canons, and again on the Canon F-1, the pentaprism is removable because there can still be occasions when it is advantageous to view the screen from above. Special attachments were made available for this purpose and for the F-1, various finders and screens can be used.

Many of these refinements were made available in the 1959 Canonflex, together with a range of lenses up to 1000 mm., exposure meter providing semi-automatic operation, special flash equipment, camera holder, metal

## SLR OPERATION

All Canon reflex cameras except the Pellix have instant-return mirrors and all except the earliest models can use a range of lenses with automatic diaphragms.

*Top:* The user views the screen image with the lens diaphragm wide open no matter what value is set on the aperture control ring. This provides the brightest image and facilitates focusing owing to the restricted depth of field provided at large apertures.

*Middle:* When the shutter release is depressed, the lens diaphragm closes to the pre-set aperture, the mirror swings upward and the shutter opens to allow the image to be projected on to the film.

*Bottom:* When the shutter closes, the lens diaphragm re-opens to its full extent and the mirror returns to the 45° position for framing and focusing of the next shot.

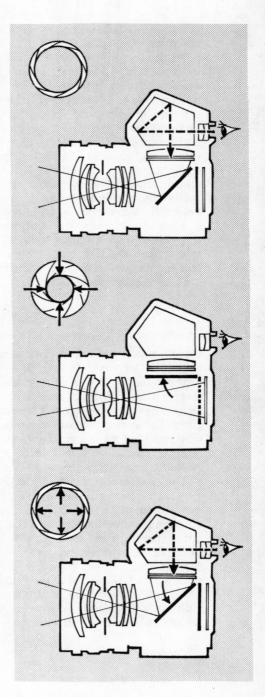

reloadable cassettes, bellows, close-up lenses, copy stand and microphoto unit.

As model followed model, further improvements were incorporated, additional accessories introduced and the range of lenses increased. The accessories for the F-1 now include a variety of interchangeable viewfinder systems and focusing screens, including three exposure meter systems, an automatic flash system, motor drive, a 250-exposure film magazine, remote control units, slide duplicator, photomicrography equipment and numerous other items. Through-the-lens metering is used, of course, and boosters enable the meter to be used in incredibly low light levels. Virtually all the new lenses have fully automatic diaphragm mechanisms.

There have been two exceptional models in the series—the Pellix, with a fixed "pellicle" instead of a movable mirror, and the EX Auto, with automatic exposure control and its own front component convertible lenses. Both are now discontinued.

## The original Canonflex

Canon reflex camera history started with the original Canonflex in 1959. It was, of course, as all the Canon reflexes are, a 35 mm. single-lens reflex. The focusing screen was of ground glass with a fresnel lens. In the centre was a split-image rangefinder surrounded by a ground glass ring free of fresnel lines. Eye-level vieweing was provided by a detachable pentaprism with magnifying eyepiece. A waist-level magnifying finder was available as an accessory.

The shutter was a cloth focal plane type speeded from 1 to 1/1000 second, plus a B-T setting. Time exposures were obtained by setting the shutter dial to B-T and then operating a time lock around the shutter release. A self-timer was built in, set by a fold-up key on the camera front. The shutter was synchronized for electronic flash at 1/60 second, FP-type bulbs at all speeds except 1/30 second, large M-type bulbs at speeds of 1/250 second and slower (except 1/30 second) and small M-class bulbs at 1/30 second and slower. A special flash socket in the side of the camera allowed cable-less attachment of the

Canon Flash Unit V and the Canon Speedlight Unit V. The units could be separated from the camera by using a special Extension Cord Va, which also allowed other units to be attached.

The standard lens was the Super Canomatic R, 50 mm. $f$1.8. The Super Canomatic was an automatic-iris lens, closing down to the preset aperture as the shutter release was depressed and re-opening to full aperture after the shutter closed. Similarly, the mirror flipped upward as the shutter was released and returned to the viewing position when the shutter closed. Other Super Canomatics were the 100 mm. $f$2 and the 135 mm. $f$3.5. The R lens range included 85 mm, 200 mm., 300 mm., 400 mm., 600 mm., 800 mm. and 1000 mm. types. The lenses from 300 mm. upwards had no focusing mechanism and were supplied complete with lens supporter, inter-mediate tube and Bellows R, to provide the extension required for focusing purposes.

The lens mount was a bayonet type with a securing ring, ensuring minimum wear of locking faces. The lens did not rotate during attachment or removal. The same system has continued throughout the range.

Exposure metering facilities were provided by the attachable Canon Meter R, which coupled with the shutter speed ring of the camera via a cogwheel. The meter was a dual range selenium type and an incident light attachment was available.

The camera back was hinged at the take-up spool end and was opened by a key-type lock in the baseplate. The key also opened and closed the special Canon cassettes designed for the camera. An anti-curl roller in the camera back ensured, together with the finely engineered guide rails and pressure plate, that the film remained perfectly flat. The base plate also housed the film transport and shutter tensioning lever which was ratcheted to allow single or multi-stroke operation. The conventional rewind knob had a folding crank. The exposure counter was of the automatic zeroing type.

Accessories included extension bellows, close-up lenses, copying stand, microphoto unit, lens mount converters for use on Canon lenses designed for their rangefinder cameras, camera cradle, filters, Canon cassette and waist level viewer.

## Canonflex R2000 and RP

The 1959 Canonflex had a specification that many current cameras cannot match. Nevertheless, two new models appeared in 1960. These were basically the same camera but the Canonflex R2000 had a top speed of 1/2000 second and the Canonflex RP, designed to sell at a lower price, was similar to the original Canonflex but with a fixed pentaprism and a lever-set self timer. The range of Super Canomatic lenses was extended to include a 35 mm. *f*2.5 and 85 mm. *f*1.8.

## Canonflex RM

In 1962, the Canonflex RM appeared. This, too, had a fixed pentaprism but incorporated an exposure meter coupled to the shutter. Changing the shutter speed moved a needle, visible in a window in the top of the camera, to indicate the aperture to be set on the lens. The large meter window in the camera front made the RM easily distinguishable from previous models. Other differences included a cleaner base plate with the tripod bush centred below the lens. This was made possible by abandoning the trigger-type film transport lever in the base. Film transport on the RM was effected by a rather truncated lever in the camera back behind the shutter speed dial.

## Canon FX

The Canonflex name was dropped with the introduction of the Canon FX in 1964/5. This model adopted the now almost universal film transport lever on the camera top plate. It was ratcheted to allow winding with several short strokes. It had a built-in CdS meter that provided distinctive external features: a small meter window in the front of the camera top plate below the rewind knob and a meter switch in a corresponding position in the back of the camera. The battery for the meter was housed in a compartment with a screw-in cover in the end of the top plate. A safety lock was fitted to the shutter release. A mirror lock allowed the mirror to be fixed in the raised position. A new range of lenses—the FL range—was introduced with this model. The mounting method was the same as with the R lenses used on the previous models but the automatic diaphragm control mechanism was changed. The FL range ran from 19 mm. to 200 mm. plus

a 55-135 mm. zoom. From 300 mm. to 1000 mm. the manual R lenses remained current. The special bayonet flash connector was abandoned and a standard coaxial socket placed on the camera front. All types of flash could be used from the one socket. An accessory shoe was attached to the top of the pentaprism.

## Canon FP

The Canon FP, introduced in mid 1965, was basically similar to the FX but had no built-in meter. An attachable CdS meter, coupling to the shutter speed control, was available. The number of FL lenses was increased and included three zooms. The R lenses remained current for the focal lengths from 300-1000 mm. Among the new accessories was the FL bellows, incorporating a focusing slide and taking a slide duplicator attachment.

## Canon Pellix

Late in 1965 Canon introduced the Pellix to meet the criticism of the SLR design that the mirror blacked out the viewfinder image during the actual exposure. This is barely noticeable in most circumstances but it can be a little disturbing at slow shutter speeds. The mirror in the Pellix therefore took the form of a thin, fixed pellicle—a semi-transparent mirror that acted as a beam splitter to direct part of the light transmitted by the lens to the viewing screen while allowing the major part to pass through. The exposure meter was the TTL type, the CdS cell being placed behind the pellicle.

The meter actuating switch was incorporated in the self-timer lever, which had the distinctive shape used on many later models. An eyepiece shutter was controlled by a ring around the rewind knob that doubled as a battery check. The viewing screen incorporated a microprism type rangefinder. The Pellix took the FL series of automatic diaphragm lenses up to 200 mm. and the manual R lenses from 300 to 1000 mm. Later models incorporated the quick loading system of the FTQL (see below).

## Canon FTQL

The Canon FTQL was introduced in 1966. It, too, had a through-the-lens metering system but, as its mirror was the usual, fully reflecting movable type, the CdS cell was

placed at the back of the camera behind the beam-splitting condenser. The other distinctive feature was the unique Canon quickload system, featuring a subsidiary cover below the back cover of the camera. This clamped the film leader in position as the back was closed and eliminated the process of feeding the film leader into a slot in the take-up spool. An additional exposure meter, known as the Canon Booster, attaches to the accessory shoe and plugs into the battery chamber to provide ultra low-level light metering for the Pellix, the FT and the FTb (see below). Again, FL lenses up to 200 mm. and R lenses from 300-1000 mm. were usable. The Canon FTQL remained the standard bearer of the Canon reflex models until 1972, when it was phased out.

## Canon EX EE and EX Auto

A complete departure from the more-or-less standard design of the other cameras in the range came with the introduction of the Canon EX EE in 1969 and the EX Auto in 1973. These are automatic-exposure models with a built-in TTL exposure meter controlling the aperture setting. Such a design is rather complicated with a fully interchangeable lens camera so the EX cameras have a fixed rear-lens component and interchangeable front components. Manual override is provided. The camera body is similar to the FT but there is no mirror lock.

The flash socket reverts to the side of the top plate on the EX EE but is in the side of the mirror box on the EX Auto, which also has a hot shoe and contacts for the CAT automatic flash system. Both are now discontinued.

## Canon FTb and FTbN

An improved version of the FT was issued in 1971 as the Canon FTb, with full aperture metering. The mirror lock is incorporated in the self-timer control which, as in the FT, also acts as a stop-down lever. The full aperture metering facility is provided by the FD series of lenses designed for the Canon F-1 (see below). FL lenses can be used only for stopped down metering. The camera back is opened by pulling up the rewind lever.

The accessory shoe on the pentaprism incorporates a "hot shoe" flash contact for cordless flash units and

contacts for the CAT automatic flash system. There is also a coaxial flash socket on the camera front.

A later model is distinguished by a shutter speed scale below the viewfinder image area, in addition to minor design modifications. It was discontinued in 1977.

## Canon F-1

The Canon F-1 (first announced at the 1970 Photokina) was designed from the outset as the camera unit of a complete photographic system. The designers studied and analysed in minute detail every feature of the 35 mm. SLR construction and incorporated the most suitable features into what is certainly one of the best thought-out camera bodies of all time. They cut no corners in the engineering either, for this is an expensive camera, intended to withstand rugged use by all types of photographers and with film transport, shutter and mirror mechanisms able to operate with a motor drive at incredible speed or for several hours non-stop.

The technical description of the F-1 is impressive in itself. The viewfinder is the usual pentaprism type, the screen showing 97 per cent of the actual picture area at 77 per cent natural size with the 50 mm. lens. It is interchangeable with the Booster T Finder, Servo EE Finder, Speed Finder and Waist Level Finder. There are many alternative screens. Attachments for the viewfinder eyepiece include the Angle Finder B, a magnifier, dioptric adjustment lenses and an eyecup.

The viewfinder screen shows the meter needle and aperture needle, an indicator of settings that are outside the shutter speed coupling range, battery check mark that doubles as fixed dot for stop-down metering, shutter speed scale and metering limit marks. In the centre of the standard screen is a microprism rangefinder and a rectangular section indicating the area covered by the meter.

The mirror is fitted with a particularly efficient shock-absorbing mechanism and can be locked in the up position.

The lens mount is the bayonet-cum-breech lock type of all Canon reflexes, with automatic diaphragm mechanism coupled to full aperture metering with the FD series of lenses introduced with the F-1. FL lenses can be used

with stopped-down metering and automatic diaphragm control. R lenses can be used with stopped-down metering and manual aperture control.

The shutter is a horizontally moving focal plane type with extremely thin titanium blinds designed to reduce noise. It gives speeds from 1 to 1/2000 second set on a single-shaft dial. It is synchronised for electronic flash at 1/60 second and slower; for flashbulbs at 1/30 second and slower; and, for focal plane bulbs at 1/125 second and faster. An automatic flash exposure system is incorporated for use with special Canon flash units and specified lenses. A self-timer gives about 10 seconds time lag and is operated by the shutter release button.

Naturally, the F-1 uses TTL metering. It is of the semi-spot match needle type operating at full aperture with the FD lenses. The system can be converted to shutter-priority automatic working with the Servo EE Finder, while ultra-low-illumination metering is possible with the Booster T Finder.

The back of the F-1 is fully removable to allow the 250 exposure magazine to be attached. Consequently, the quick-load mechanism is not incorporated. A multi-slit spool, however, makes loading a simple matter. The back cover is opened for loading by pulling up the rewind knob. Opening the back automatically resets the film counter. Film winding is carried out by the usual rapid wind lever, which is ratcheted to give one-stroke or multi-stroke operation.

The bottom cover of the camera is removable to allow the motor drive to be attached.

The size of the Canon F-1 body is 99.5 × 146.7 × 49.5 mm. and it weighs about 845 grams (1.9 lb.).

## Canon TLb

Introduced as the popular version of the 1972 range of Canon reflexes, the Canon TLb is a much simplified version of the FTb. It has a top shutter speed of 1/500 second. It has no self-timer and the accessory shoe has no flash contacts for the CAT flash system. The battery compartment has no sockets for the Canon Booster. In other respects, it is similar in shape and general design to the FTb and takes the FD range of lenses for full-aperture metering and FL lenses for stopped-down

## CANON F-1

The main features of the Canon F-1 are:

1. Shutter release lock lever.
2. Shutter release.
3. Self timer/stop down lever.
4. Film speed setting ring.
5. Lever lock/mirror lock.
6. Carrying strap lug.
7. Back latch lock.
8. Flash socket.
9. Rewind crank.
10. Rewind button.
11. Film transport lever.
12. Shutter speed dial with film speed setting.
13. Finder release button.
14. Tripod socket.
15. Meter scale window.
16. Finder release button.
17. Battery compartment.
18. CAT flash contacts.
19. Exposure counter.
20. Meter switch.
21. Viewfinder eyepiece.
22. Focusing ring.
23. Distance scale.
24. Depth of field scale.
25. Aperture scale.
26. Bayonet locking ring.
27. Servo EE Finder coupling socket.
28. Cassette chamber.
29. Film gate.
30. Exposure metering area.
31. Rangefinder.
32. Focusing screen.
33. Shutter speed indicator.
34. Exposure meter scale.
35. Sprocket wheel.
36. Take-up spool.

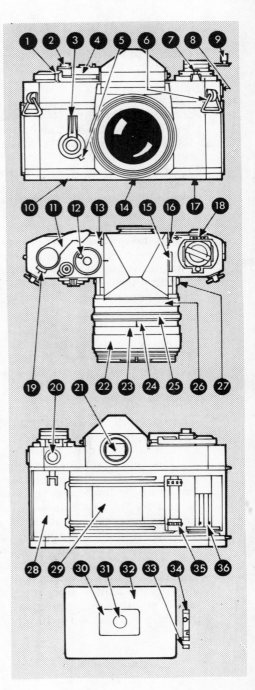

metering. The metering system is a centre-weighted averaging type. The TLb has no shutter release lock or quick-load system. It was replaced by the Canon TX in 1974/5.

## Canon EF

Introduced in 1974, the Canon EF is an automatic exposure model using the shutter priority system. You set the shutter speed and electronic circuitry allied to a through the lens meter with silicon photocell, sets the aperture automatically. The shutter has mechanically controlled speeds from 1/2 to 1/1000 second and electronically controlled speeds from 1-30 seconds. It is a metal bladed, vertically-moving focal plane type synchronising with electronic flash at 1/125 second. The camera takes all accessories except those peculiar to the Canon F-1. The CAT flash system (see page 295) connects with the automatic exposure system of the Canon EF. A multiple exposure facility is provided. The EF was phased out with the introduction of the AE-1.

## Canon TX

Introduced in 1975, the Canon TX is identical with the TLb, which it replaced, but for an additional flash contact in the accessory shoe. It was discontinued in 1977.

## Current Models

The Canon A range of cameras started with the AE-1 in 1976, closely followed by the AT-1 in 1977 and the A-1 in 1978. There is a close family resemblance in body shell and basic operation but there are very great differences in detail. The A-1 pushes the use of electronic circuitry almost to the limits and yet, because it employs digital control for the first time in a camera, it opens up possibilities for even more wizardry in automatic operation. The AE-1, itself quite an advanced camera barely 18 months before, was made to look almost pedestrian.

In brief, the essential difference between the three cameras is in their methods of exposure control. The A-1 incorporates almost every method yet tried, including a rather pointless fully programmed method apparently thrown in as a touch of virtuosity. The AE-1 is a relatively

24

straightforward shutter speed preferred model. The AT-1 is an "old-fashioned" match-needle type. They all have a certain amount of automatic flash control and all take a compact power winder. The A-1 has, additionally, a new motor drive system and an improved automatic flash unit.

The similarities in the three cameras are, of course, in the range of lenses and their attachment method: the established FD lenses are used although the AT-1 cannot use the automatic exposure fitting. They have the same body shell, with front-wall battery compartment incorporating a finger grip, film reminder pocket on the totally removable back (not for the 250 exposure back), motor contacts in the baseplate (slightly different on the A-1), hot shoe with shutter speed setting contacts, stop-down switch, similar self-timers and so on. The shutter is the same horizontally-moving cloth type on all models and is controlled by electro magnets and an electrical switch. Consequently it cannot be used without a battery.

## Canon AE-1

Introduced in 1976, the Canon AE-1 is the first of a new breed of electronic automatic-exposure models using the shutter priority system and a silicon sensor. It has shutter speeds from 2 seconds to 1/1000 second and B, all electronically controlled. There are no mechanically controlled speeds. The cloth-blind shutter moves horizontally and synchronises with electronic flash at 1/60 second. It has a noiseless, electronically timed self-timer. The camera takes all accessories except those specificaily for the F-1 and has an additional range of its own—Data Back, Power Wind, Speedlite 155A automatic flash unit, etc. The viewfinder readout uses light-emitting diodes (LEDs) for underexposure warning and when the lens is set for manual operation. A conventional needle indicates the aperture set but there is no shutter speed display. The Speedlite 155A gives fully automatic control of both shutter speed and aperture.

## Canon AT-1

Introduced in 1977, the Canon AT-1 is an updated, orthodox through the lens exposure metering model with CdS sensor and no automatic-exposure facilities. It has

the same shutter as the AE-1, speeded from 2 seconds to 1/1000 second and B and synchronising with electronic flash at 1/60 second. The shutter cannot be operated without a battery. The viewfinder readout is a meter needle to be matched with an aperture needle with no scales. The camera takes the same accessories as the AE-1 but the auto flash unit sets only the shutter speed automatically.

## Canon A-1

Introduced in 1978, the Canon A-1 incorporates a choice of automatic exposure modes. A switch allows the same control to fix aperture or shutter speed, as preferred, leaving the other to be set by the meter circuit. A further position switches both aperture and shutter speed into a fully programmed mode, leaving the operator with no control over either. The aperture-preferred method can be used with the lens at full aperture or stopped down. There is also fully automatic flash operation with the Speedlite 155A or 199A. The viewfinder readout uses seven-segment LEDs to display shutter speed and/or aperture (depending on the metering method used), M for manual operation, F for flash, 'bulb' for B setting and 'bu F' for B setting with flash. If the system fails or you do something wrong, a row of Es confronts you. The cloth-blind horizontally-moving shutter, with speeds from 30 seconds to 1/1000 second and B, synchronises with electronic flash at 1/60 second and has a variable electronic self-timer. It has an exposure memory switch and a multiple-exposure switch.

The A-1 takes all Canon SLR accessories, except those specifically for the F-1, as well as those for AE-1 and AT-1. It also has a new motor drive with a 5 fps top speed, remote control and time-lapse programmer.

# PREPARING THE CANON F-1
# FOR ACTION

In preparing the Canon F-1 for use, the first operation is to insert a battery in the base of the camera or to check the battery already inserted.

## Inserting and checking battery

The battery is a mercury type (PX625). It is inserted with the + sign facing outward (there is a diagram on the compartment cover) after unscrewing the compartment cover with a coin. This cover also holds the camera base plate in place. It cannot be replaced if the battery is put in wrong way round.

To check the battery, set the film-speed scale on the shutter-speed knob to 100 ASA and the shutter speed to 1/2000 second. Turn the meter switch (on the back of the camera below the rewind knob) to C, and look through the viewfinder eyepiece. The meter needle should rise to the mark toward the bottom end of the panel. If it stays below that mark, the battery has insufficient voltage and should be replaced.

In normal use, the battery should last for about one year. If, however, the camera is likely to be unused for a long period, the battery should be removed and kept in a dry place.

Mercury batteries should not be handled too much and they should be carefully wiped clean with a dry cloth before being inserted in the camera. Greasy finger marks and other contaminants can cause poor contact, corrosion and damage to the relatively delicate contacts in the camera body.

The battery check switch is spring loaded on later models, so that it returns to the off position after use. To use the meter, the switch is turned to the on position. After use, it should be turned off immediately to avoid undue drain on the battery.

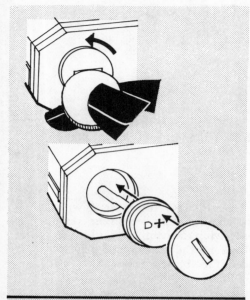

## INSERTING AND CHECKING BATTERY

To insert a battery into the F-1, remove the battery chamber cover by unscrewing anti-clockwise. Insert a PX625 type battery with the plus sign facing outward and replace the cover.

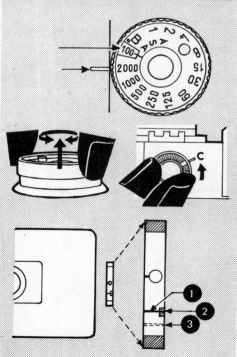

To check the battery power, set the film speed scale at ASA 100 and the shutter speed to 1/2000 second. The film speed is set by lifting up the outer rim of the shutter speed dial and turning it until the appropriate figure appears in the cut out between 2000 and B. Turn the meter switch to C while observing the meter scale in the viewfinder. If the needle (1) swings to the blue index mark (2), the battery has sufficient power. If the needle stops below the mark (3), the battery needs replacing.

## LOADING THE CANON F-1

To load film into the Canon F-1 first pull up the rewind knob while depressing the lock button in front of it. The back springs out and can then be opened fully.

Insert a film cassette into the cassette chamber with the protruding end of the spool pointing downward and push the rewind knob back, twisting it to and fro if necessary to engage the prong with the bar in the spool end. Pass the end of the film across the film gate and push it into one of the slots in the take-up spool.

Advance the film to ensure that it is gripped by the take-up spool and that the sprockets are engaging in the perforations. Close the camera back and press to lock.

Alternately transport the film and release the shutter until the exposure counter indicates 0.

Set the speed of the film you have loaded by pulling up the outer rim of the shutter speed dial and turning it until the required figure appears in the cut out.

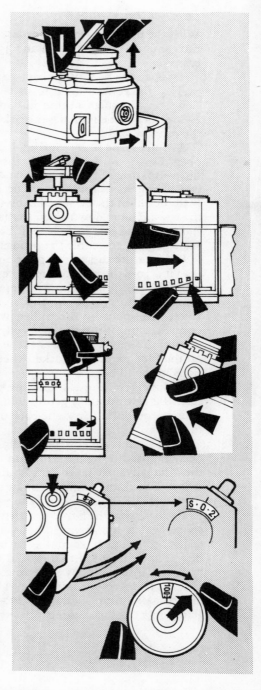

## Loading the camera

With the meter in working order, the next step is to load the camera. The F-1 takes any 35 mm. film in standard cassettes.

To open the back of the camera preparatory to loading, pull up the rewind knob to its click stop while pressing down on the safety button just in front of it. This is an F-1 feature that eliminates the risk of accidentally opening the camera back.

As you pull on the rewind knob the back springs slightly open. Open it fully and insert the loaded film cassette in the compartment below the rewind knob. The protruding end of the spool must be at the bottom of the camera, with the slit in the cassette facing the take-up spool. Push the rewind knob down again so that its prongs engage the bar in the end of the film spool. You may have to turn the knob slightly to enable the prongs to engage.

Holding the cassette in position, pull the film out and lead it across the back of the camera to the take-up spool. Push the end of the film to a depth of two or three perforations into one of the slits in the take-up spool and rotate the spool by the milled wheel at the bottom to ensure that the film passes correctly, emulsion side inward, around the spool. Ensure that the teeth on the spool and on the film advance sprocket wheels engage the perforations in the film.

If, during these operations, the film has bowed upward, turn the rewind knob gently in a clockwise direction to take up the slack. Close the back of the camera and press to lock it.

At this stage, the film protruding from the cassette has been exposed to light and has to be wound on. Operate the film advance lever and shutter release alternately twice. The frame counter shows 0. Then wind on once more and the camera is ready to use.

To check that the film is properly secured to the take-up spool, watch the rewind knob as you operate the film transport lever. It should turn in a counter clockwise direction. It may fail to do so for the first frame or two, however, if there is any slack in the film coils in the cassette. It is, therefore, advisable to take up any such slack immediately after loading by turning the rewind knob gently in a clockwise direction.

## F-1 FINDER AND SCREENS

The features of the Canon F-1 viewfinder are:
1. A fine-ground area with fresnel rings for general framing and focusing and observation of depth of field.
2. A central rectangular area indicating the part of the scene read by the TTL meter.
3. A split-image and micro-prism array for those who prefer rangefinder focussing.

As you turn the focusing ring on the lens, the micro-prism area shows a shimmering, broken image until the position of maximum focus is achieved. At the same time the discontinuous image in the centre lines up.

There are nine types of focusing screen for the F-1. The standard screen described above can be changed by first pressing the studs at the rear of the pentaprism and sliding it out over the back of the camera.

The focusing screen is removed by inserting a finger nail into a notch at the rear of the screen and lifting upward. You can then grasp the edges of the screen and remove it.

The replacement screen is inserted front end first and then pressed down into position. Finally, replace the pentaprism or other finder unit by sliding it forward into the guide rails until it clicks into position.

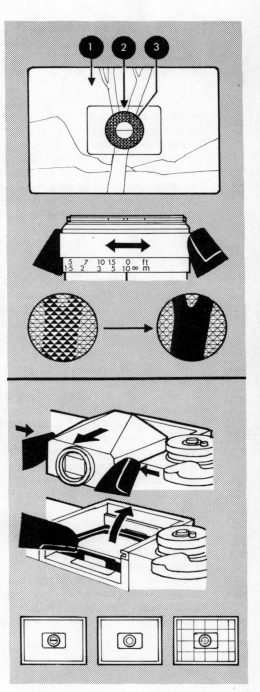

It is best to avoid loading the camera in direct sunlight and to keep the lens cap in place while making the initial blank exposures.

## Setting the film speed

One more operation remains before the camera is ready for use. You have to set the speed of the film you have loaded so that the meter can provide the correct exposure information. The film speed appears in a cut-out on the shutter speed knob and is set by lifting up the rim of the shutter-speed knob and turning it until the required figure appears. The dots between the figures represent the intermediate values shown.

## Viewing and focusing

With the foregoing operations completed, the camera is ready for use. If you remove the lens cap (by pressing the catches at the side) and place your eye to the viewfinder eyepiece, you will see an image of the scene before you at about threequarters life size, assuming that you are using one of the standard 50 mm. lenses. Lenses of longer or shorter focal length give larger or smaller images respectively.

The image may not look completely sharp, however, because the lens has to be focused on the particular part of the scene you wish to photograph. Or, more accurately, the lens position has to be adjusted so that it focuses the image points of the scene sharply on the film. As the focusing screen is the same distance from the lens as the film, you can focus the image on the screen and be sure that the image subsequently produced on the film will be equally sharp.

Focusing is made easier on the Canon F-1 standard screen by a central circular area with a split-image rangefinder surrounded by a microprism collar. When the image is out of focus, the split image shows a broken line, while the microprism area shows a shimmering disjointed image. When the image is correctly focused, the central spot shows a continuous line across the break and the microprism area shows a clear, steady image.

You adjust the focus by turning the large knurled ring on the lens mount to left or right. You will notice that the image appears sharp only in a relatively shallow plane—particularly if the subject on which you are focusing is fairly close to the camera.

This is the effect of the restricted depth of field provided by any lens at a wide aperture. The Canon F-1 lenses have automatic diaphragms, so that the aperture is always at its widest for viewing and focusing. This provides the brightest possible image on the screen and makes focusing swifter and more positive.

Focusing is carried out after you have sighted your picture in the viewfinder, although you may need to set the focus roughly in order to see the picture clearly at all. You select the viewpoint that frames the picture exactly as you want it, focus carefully on the main feature and then use the through-the-lens exposure meter to determine the aperture and shutter speed settings that will expose the film correctly.

Using the exposure meter is a simple enough operation, but to do it properly you have to know how the meter works and how to ensure that it gives aperture and shutter speed settings that are suitable for the subject of your picture.

# FUNCTIONS OF LENS
# APERTURE AND SHUTTER
# SPEED

The aperture of a lens is the opening in an iris diaphragm through which light is allowed to pass to the film. The diaphragm is an arrangement of thin metal leaves that open outward to form a more or less circular opening continuously variable in size. It is situated within the lens at about the optical centre, and is usually controlled by a ring around the lens barrel.

## Aperture as exposure control

The ring usually has click-stop settings marked with some of the figures from the series:

1  1.4  2  2.8  4  5.6  8  11  16  22

which are generally referred to as $f$-numbers or stops.

These figures indicate the light transmission of the lens at each setting and are arrived at by dividing the effective aperture of the lens into its focal length (see page 000). They represent positions of the iris diaphragm at which the amounts of light passed through the lens are mathematically related. At each successively larger $f$-number, the lens passes half the light it lets through at the previous number. Thus at $f4$, it lets through half the light it passed at $f2.8$ and a quarter of that at $f2$. Moreover, as the $f$-number takes account of the focal length of the lens, the same amount of light is passed at any particular $f$-number on any lens, no matter what its focal length—give or take a little according to the relative efficiencies of lenses in transmitting light as opposed to reflecting it from any of the glass surfaces. Such reflections are minimised in modern lenses by coating all glass to air surfaces with microscopically thin films of, usually, magnesium fluoride. All Canon lenses are so coated with either single or multi-coatings as the construction of the lens demands.

This ability to control the size of the lens aperture is of great value in regulating the exposure of the film to light.

A lens with a maximum aperture of $f2$ and a minimum of $f16$, for example, allows continuous variation of light transmission over a range of 1:64.

## Controlling exposure by shutter speed

Exposure cannot be satisfactorily controlled merely by the *amount* of light that is allowed to reach the film. There are occasions when you want only a very brief exposure because the subject is in rapid movement and others when you have to give a much longer exposure because even with the aperture wide open the amount of light reaching the film in a fraction of a second is insufficient to produce a satisfactory image. So you need a control over the time of the exposure as well as its amount, or intensity. The shutter provides this control, in addition to the important function of shielding the film from light when no exposure is being made.

The camera shutter therefore has a number of fixed settings giving a wide range of different speeds for different settings. The Canon F-1, for example, has marked speeds from 1 second to 1/2000 second. It is obviously convenient that the progression from maximum to minimum shutter speed be the same as that used for the aperture control, so shutter speeds also double up—or as near to as is practicable. The standard range is 1, 1/2, 1/4, 1/8, 1/15, 1/30, 1/60, 1/125, 1/250, 1/500, 1/1000 second.

Thus, the exposure time can be varied in the ratio 1000:1 or, on the Canon F-1 and the Canonflex R2000, in the ratio 2000:1. When the F-1 is fitted with the Canon FD 50 mm. $f1.4$ lens (minimum aperture $f16$), therefore, the complete exposure range is 256000:1, represented by 1/2000 second at $f16$ to 1 second at $f1.4$.

## Other functions of shutter speed

The subjects you photograph do not normally vary in brightness by that much, so that is evidently not the real reason for providing such wide-ranging controls. The shutter speed has in fact an additional function. If your subject is in rapid motion, for example, it would be useless to photograph it with the shutter set to, say $\frac{1}{2}$ second. In that time, the subject could move right out of the field of

view of the lens. The image projected by the lens on to the film would also move and the result would be a more or less blurred image according to the speed of the subject. Sometimes you might need such a result, of course, but generally you need a sharp image and that you can obtain only if the time during which the film is exposed is so brief that the subject does not move sufficiently to create a visible blur.

On other occasions, even if the subject is stationary or relatively show moving, you might want to set a fast shutter speed so that you can use a wide aperture to restrict depth of field. Conversely, when you want a small aperture for maximum depth of field, you use a slow shutter speed. The trouble comes when, in these circumstances, the main subject is also moving rapidly. Then you have to compromise or change to a faster film.

## *Interrelationship of aperture and shutter speed*

The doubling up nature of both shutter speed and aperture controls means that various pairs of settings have the same effect as far as the exposure of the film and therefore the density of the image is concerned. Settings of 1/125 second at $f8$ and 1/60 second at $f11$ represent the same degree of exposure of the film and should therefore produce images indistinguishable in density, because the second setting represents double the time at half the intensity of the first setting. Thus 1/250 second at $f5.6$, 1/500 second at $f4$, and 1/30 second at $f16$ all represent the same exposure as the other two settings.

This interrelationship generally holds good at all normal levels of exposure. It obeys what is known as the law of reciprocity. The operation of this law can break down, however, when light levels are very low (calling for exposures in excess of about $\frac{1}{4}$ second) or very high (calling for exposures shorter than about 1/1000 second). This "reciprocity failure", as it is commonly called, requires that longer exposures be given than normal exposure calculations or meter readings would indicate. Its actual effect varies from film to film and if you contemplate shooting many subjects in such conditions, you should consult the film manufacturer's technical literature or conduct experiments for yourself.

# USING THE F-1 EXPOSURE METER

Armed with knowledge of shutter speed and aperture functions, you can turn to the use of the exposure meter to determine the settings you require for a particular subject.

The exposure meter on the Canon F-1 is one of the most sophisticated types. It reads at full aperture through the camera lens and a really efficient meter of this type is no mean achievement. It demands a lens that can transmit to the meter information as to the actual size of its maximum aperture. This information is usually transmitted mechanically but, as most camera lenses are turned as they are mounted on the camera body, the mechanical linkage frequently raises problems. Canon lenses, however, are pushed straight into the body and locked by a separate ring, so the link is comparatively simple. The FD lenses (the only ones that can be used for full-aperture measurement) have a stud protruding at the rear which pushes a lever in the camera body which, in turn, transmits the required information to the meter.

## Cell position and pupillary factor

One of the greatest problems in designing a through-the-lens metering system is the positioning of the light-sensitive cell and/or the location of the area from which the cell takes its reading. The cell has been placed, in various cameras, in the body well, in front of, behind and on top of the pentaprism, behind the mirror, beside the eyepiece and in just about every other conceivable position. The actual location is important because readings can, in certain circumstances, be affected by stray light entering the eyepiece, by flare in against the light shots, by the nature of the viewing screen, by the focal length of the lens and, when telephoto or retrofocus lenses are used, by the pupillary factor of such lenses.

This last phenomenon is a comparatively recently high-lighted factor that can have a considerable effect on

through-the-lens exposure readings. It arises from the unusual structure of telephoto and retrofocus designs which causes the diaphragm opening of a telephoto lens to look smaller when viewed from the rear than it does when viewed from the front (and vice versa with retrofocus designs). As this opening forms the exit pupil of the lens and therefore the source of illumination for the film, it is important when such lenses are used that the exposure meter reading is taken from an "equivalent focal plane".

That means that the light beam must not travel a greater or shorter distance to the measuring area than it does to the film. If it does, the fall-off in illumination varies in a non-linear fashion with the type of lens and meter readings become inconsistent.

In the Canon F-1 these problems are taken care of by using a beam splitter in the condenser to direct part of the light reaching the focusing screen to a CDS element behind the condenser. The area measured is small ($12 \times 8$ mm.) so that the meter acts as a narrow angle type, which means that the user has to have some knowledge of how exposure meters work.

## Basic exposure meter function

He must realise, for example, that the meter is a perfectly straightforward measuring instrument. The light-sensitive element has varying resistance to electrical current according to the amount of light falling on it. Obviously, the varying currents passing through the element can be made to provide a "read-out" or "reading" as we more commonly call it. The reading means nothing by itself. A meaning has to be ascribed to it. In through-the-lens meters, the meaning usually ascribed is "correct exposure". When film speed, aperture and shutter speed are set to a certain combination according to the intensity of the light reflected by the subject, the film will be correctly exposed. But there is a proviso. The meter averages the light reflected from the area it covers. So it treats a collection of various intensities as a single tone. Its job then is to point to camera settings that will reproduce a collection of densities on the film that will average out to the same single tone. The proviso is that the meter can give only one answer, no matter what range of light intensities it reads, and as most scenes consist of a

# F-1 EXPOSURE METER

The Canon F-1 exposure meter scale is visible on the right of the viewfinder. Its features are:
1. Overexposure zone.
2. Aperture pointer.
3. Meter needle.
4. Battery check and stopped down metering index.
5. Underexposure zone.
6. Shutter speed.

The aperture pointer is directly linked with the aperture setting ring.

The position of the meter needle is controlled by the film speed setting, the shutter speed and the light conditions.

Correct exposure is obtained by turning the meter switch to ON and adjusting shutter speed and/or aperture until the meter needle bisects the circle of the aperture pointer. When the shutter speed set is outside the metering range, the scale turns red.

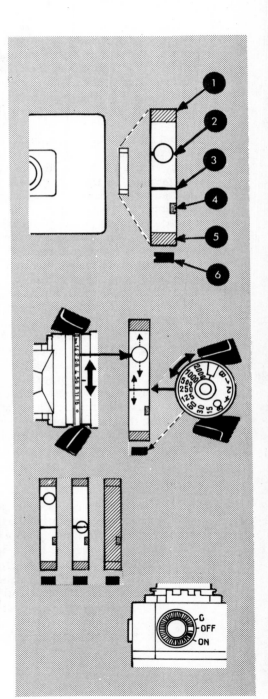

collection of tones averaging to a mid-tone (of about 18 per cent reflectance is the generally accepted standard) that is the situation the meter is calibrated to expect. Unfortunately, in a sense, it means that no matter what intensity of light the meter reads, it always recommends an exposure to produce a result that averages to a mid-tone.

That is rarely of any importance when the meter reads the whole picture area, but it can lead to trouble with narrow angle meters unless its operation is completely understood. On the other hand, when the operation is understood, the narrow angle meter has many advantages. It enables you to choose a small area of suitable tone, instead of leaving you to judge whether the whole scene averages to a mid-tone or whether you should make allowance for a shaded foreground or a large area of sky. It enables you to measure with reasonable accuracy the brightness range of a particular scene so that you can decide whether the film can handle such a range.

The central rectangular area measured by the Canon F-1 meter is clearly shown in the viewfinder because the beam splitter darkens the area of the screen from which the reading is taken. In use, therefore, the camera has to be moved to include the selected subject area in the central rectangle and the appropriate adjustments made to aperture and shutter speed before finally composing the picture in the viewfinder. The straightforward method of composing the picture and then taking a general reading can be used only when the central rectangle happens to encompass a suitable tone or range of tones.

## How the F-1 meter works

The F-1 meter controls are unusual. You set the film speed by raising the outer milled edge of the shutter speed dial and turning it until the appropriate figure shows in the small window between the B and 2000 calibrations.

This operation adjusts the zero point of the galvanometer driving the meter needle. The connection between the aperture control and the meter is entirely mechanical. As the aperture is opened, the circular index moves down the scale in the viewfinder. The needle is then matched to it by varying the shutter speed.

## STOPPED-DOWN METERING

With FD lenses the Canon F-1 should preferably be used with full-aperture metering. When the stopped-down method is necessary, proceed as follows:

Switch on the meter and set an appropriate shutter speed.

Compose and focus the picture and push the stop-down lever toward the lens.

Adjust the lens aperture until the meter needle bisects the index mark also used for battery checking.

Alternatively, you can set the aperture first and adjust the shutter speed to bring the needle to the index mark.

The stop-down lever springs back when you let go of it. It can be locked for continuous metering, however, by moving the small lower lever to the L position.

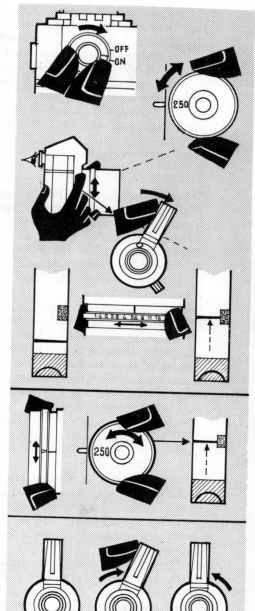

Alternatively, of course, the circular index can be matched to the needle position by altering the aperture setting after the shutter speed has been set.

The film speed settings provided by the meter run from 25 to 3200 ASA (15 to 36 DIN). The progressions are as follows, the italic figures being those represented by the dots on the scale:

ASA 25, *32, 40*, 50, *64, 80*, 100, *125, 160*, 200, *250, 320*, 400, *500, 640*, 800, *1000, 1250*, 1600, *2000, 2500, 3200*

Early models ran to only 2000 ASA.

## Stopped-down readings

When using FD lenses on the Canon F-1, the exposure reading is generally made at full aperture. When any other lenses are used, the reading has to be made with the lens stopped down. The FL lenses use the same automatic diaphragm control as the FD lenses, so stopping down after the required aperture has been set is effected simply by pressing the self timer stop down lever towards the lens. The lever can be held in this position or can be locked by turning the small lever below the stop-down lever to the "L" position. Continuous stop-down metering is then possible but the lock has to be released again if automatic diaphragm operation is required. The earlier Canon SLR lenses have to be stopped down manually when used on the F-1 and all lenses have to be used in the stop-down mode when bellows units, extension tubes, etc., are interposed between camera lens and body. Where automatic diaphragm coupling is provided on these accessories, however, the FD and FL lenses can be stopped down by pushing the stop-down lever.

When the meter is used for stopped-down reading, the operation of the stop-down lever removes the circular index mark from the viewfinder scale. The method then is not to match needle and circle but to bring the needle, by operation of the aperture or shutter speed control, to the centre of the index mark in the lower part of the viewfinder.

There are snags to using the stopped-down metering method. They apply to most full aperture systems—not only the Canon—but are not given too much publicity. They arise from the fact that the CdS element should,

ideally, be fully illuminated. If the lens is stopped down too far, its exit pupil (see page 000) becomes rather small and cannot fully illuminate the CdS element which, in the Canon F-1, is relatively large. It is generally advisable not to stop down below $f8$ for metering purposes. Naturally, a suitable exposure can be calculated from this reading for work at smaller apertures.

Similar considerations apply when measuring at full aperture with lenses not designed for that purpose. Then, especially, with lenses of large maximum aperture ($f2$ and larger) the exit pupil becomes too large for the meter element and it may significantly under-read. The FD lenses take care of this tendency with a carefully machined stud at the rear of the lens. This stud sets the meter to account for their full aperture. With lenses of other types it is preferable to close the diaphragm down to $f2.8$ or smaller.

## Coupling range of F-1 meter

The exposure meter cannot be made to operate at all shutter speeds for all film speeds. In fact it couples with all shutter speeds only at 25 ASA. Then, with each doubling of film speed one slow speed is removed from the range, so that at 200 ASA only speeds from $\frac{1}{8}$ to 1/2000 second are usable and at 1600 ASA, the slowest shutter speed that will give a meter reading is 1/60 second. If you set the shutter to a speed that does not couple with the meter, the scale in the viewfinder turns red.

## Procedure for full-aperture metering

In summary, the meter of the Canon F-1 is used as follows for full aperture metering with FD lenses:

(1) Check battery power. Set the shutter speed dial to 2000 and the film speed to 100 ASA. Turn the battery switch to C. If the needle does not reach the index mark toward the bottom of the view-finder scale, the meter should not be used until the battery has been renewed.

(2) Turn the meter switch to ON.

(3) Set the shutter speed at which you intend to shoot.

(4) Point the camera at the subject so as to include in the metering area in the viewfinder only a mid-tone or an area of tones that appear to average to a

mid-tone. Do not allow the metering area to be filled only with excessively light or dark tones. In colour work, the average flesh tone is a suitable tone to work on. In black and white work a slightly darker tone may be preferable.

(5) Turn the aperture control ring until the circular index is bisected by the meter needle. The camera controls are then set for correct exposure.

(6) Frame the subject correctly in the viewfinder, focus and shoot.

It is common practice to set the shutter speed first in general photography but you can, of course, set the aperture first and then centre the meter needle on the circle by adjusting the shutter speed. The shutter speed set shows below the meter scale in the viewfinder. If the scale goes red, the shutter speed set is not coupled to the meter and, if you need to use that shutter speed you have to calculate the aperture required from a setting within the meter range. It is not uncommon, in any case, to find that the shutter speed you select calls for an aperture that will not provide the depth of field you require. Or a pre-selected small aperture may demand a slow shutter speed that cannot cope with a moving subject. You may even decide to give a little less than the optimum exposure just to squeeze that extra bit of speed out of the shutter or depth of field from the lens. This you can generally manage with black-and-white film but you have to be a little more careful with colour. However, the aperture-linked index marker helps you to set deliberate over or under exposure quickly because the needle travel across the circle is equal to one stop. If you set the needle to the top of the circle you are over exposing by half a stop. If you set it at the bottom you are under exposing by half a stop.

## Procedure for stopped-down metering

When using any lens except the FD type on the Canon F-1 you have to use the stopped-down method. The procedure is as follows:

(1) Check battery power as described on page

(2) Turn the meter switch to ON.

(3) Set the shutter speed at which you intend to shoot.

44

## SHOOTING WITH THE CANON F-1

To operate the Canon F-1, turn on the meter and release the shutter button lock.

Select a shutter speed appropriate to the subject.

Compose and focus the picture.

Adjust the lens aperture until the meter needle bisects the circle of the aperture pointer. The shutter speed set is visible below the meter scale.

Check the composition and focus and release the shutter.

Wind on the film ready for the next shot. If you are putting the camera away, switch off the meter and lock the shutter release button.

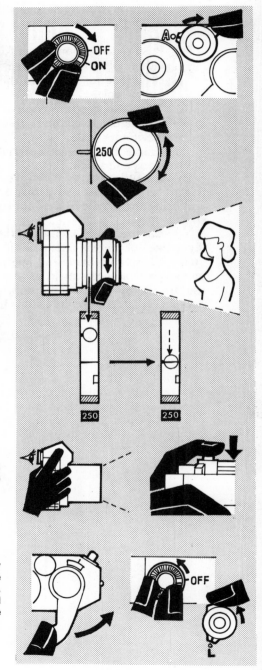

(4) Point the camera at the subject so that the central rectangle in the viewfinder encompasses a suitable tone.

(5) Push the stop-down lever fully toward the lens and either hold it there or move the lever lock to L. The circle pointer moves to the bottom of the viewfinder scale.

(6) Turn the aperture control ring until the needle bisects the index mark toward the bottom of the viewfinder scale.

(7) Frame the subject correctly in the viewfinder, focus and shoot.

As with full-aperture metering, you can, if you prefer it or if circumstances so demand, set the aperture first and bring the needle to the index mark by adjusting the shutter speed.

You can use the FD lenses in the stopped-down mode if you like but there is little point in it. Their full-aperture "teller" permits reliable full-aperture metering and this method is more convenient in general practice. If you do use the stopped-down method, you should, for the reasons explained, use only stops from $f2.8$ to $f8$.

# USING THE BOOSTER T
# EXPOSURE METER

The built-in meter of the Canon F-1 is sensitive down to about $\frac{1}{4}$ second at $f$1.2 with 100 ASA film. When the light reflected from the subject calls for more exposure than that, the Booster T Finder can be used. This is a complex electronic instrument that replaces the pentaprism and eyepiece unit of the F-1. It contains its own metering system that is entirely independent of the camera system (and of a different type) but it does not totally replace it. You can switch immediately from one system to the other as the lighting improves or deteriorates.

The Booster T Finder adds a further six stops of sensitivity to that provided by the camera meter, reading down to 16 seconds at $f$1.2 on 100 ASA film. The shutter speeds provided on the meter run from 1/60 second to 60 seconds and the built in timer actually provides those exposure times on releasing the shutter. Naturally, the coupled range is limited and the 60 second exposure is available only when the film speed set is 25 ASA. At each doubling of film speed a further slow speed is lost, so that at 200 ASA, 8 seconds is the slowest speed that can be set and at the rather theoretical 12800 ASA nothing slower than $\frac{1}{8}$ second is available. Nevertheless, there are ways of overcoming these difficulties (see page 51).

## Failure of reciprocity law

There is an important point to be borne in mind when using the Booster T Finder. It can read very low light levels, and recommend long exposures—but, as with any other meter, it cannot make allowances for the reciprocity effect. This is the breakdown of the generally linear relationship between scene brightness and exposure time when the scene brightness is very high or very low. Thus, when long exposures are given, the reciprocity effect is significant. Most films can cope adequately with brightness calling for exposures between 1/1000 and 1/10

second. If you contemplate doing much work outside that range, you should seek the film manufacturer's advice or conduct experiments on your own account. Whenever possible, it is advisable to make several exposures at varying shutter speeds because results can be rather unpredictable.

## Features of Booster T Finder

The Booster T Finder meter measures the complete image area with a certain amount of centre weighting. Measurements are made at the shooting aperture with all types of lenses.

The shutter speeds available run from 1/60 second to 60 seconds and the finder incorporates a timing device that holds the shutter open on the B setting for exposures from 3 to 60 seconds. The necessity to switch from one range to the other is automatically indicated by the scale illumination in the viewfinder going out when the camera meter becomes unusable and by the Booster indicator light going out and the meter needle zeroing when you have to switch from Booster meter to camera meter. The film speed scale runs from 25 to 12800 ASA in the following progression, the italic figures representing the dots between the marked figures:

25, *32*, *40*, 50, *64*, *80*, 100, *125*, *160*, 200, *250*, *320*, 400, *500*, *640*, 800, *1000*, *1250*, 1600, *2000*, *2500*, 3200, *4000*, *5000*, 6400, *8000*, *10 000*, 12800

The unit is powered by a No. 544 6-volt silver oxide battery that is rather expensive to replace and not very reliable at low temperatures. It is preferable to use the Canon Battery Case whenever possible. It is connected to the camera by Cord 6V 2B.

The viewfinder is the camera viewfinder because the Booster merely replaces the pentaprism and eyepiece, not the focusing screen or condenser. The viewfinder is not available, however, while a reading is being taken because the Booster has an eyepiece shutter that has to be closed to complete the meter circuit.

## Attachment and operating procedure

How you use the Booster T Finder depends very much on the nature of your work and it is likely that in most cases you will use it only when the light is poor and will con-

## BOOSTER T FINDER

The main features of the Booster T Finder are:

1. Eyepiece shutter control.
2. Eyepiece.
3. Attachment lock and release.
4. Shutter speed dial.
5. Film speed scale.
6. Main switch.
7. Meter index.
8. Battery check mark.
9. Lamp window.
10. Camera meter scale window.
11. Battery chamber and power socket.
12. Timer knob.
13. Cable release socket.
14. Shutter release.
15. Lamp indicating camera metering.
16. Lamp to illuminate meter scale.

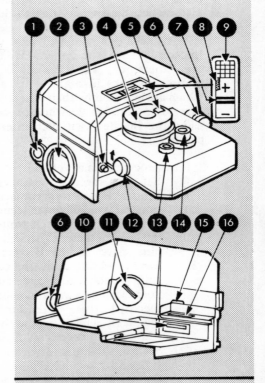

The battery chamber cover is removed by unscrewing. The battery, a silver oxide 6-volt No. 544 type, is inserted with the plus end outward and the cover replaced.

To check the battery condition, turn the main switch to C. The battery has sufficient power if the meter needle then moves to the blue zone of the battery check mark.

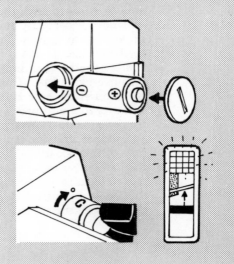

tinue to be so. "Poor" light in this sense can, of course, include occasions when the light level at the film plane is low owing to the use of bellows, extension tubes, etc. It is not likely that you will very often switch from the Booster meter to the camera meter and vice versa. However, there may be occasions when you are shooting interiors, scenes in night spots, theatres, etc., some of which are less gloomy than others. It is convenient, in any case, to run through the whole procedure for attaching and using the Booster as if such interchange were common practice.

The procedure is as follows:

(1) Set film speed on both camera and Booster T Finder. If you forget to set the film speed on the camera, you will get inaccurate exposure information when you switch from the Booster meter to the camera meter. You will find it easier to set the film speed on the Booster unit if you use two hands, holding down the centre of the film speed knob while lifting and turning the outer ring. Some film speeds cannot be set at certain shutter speeds, because of the limited coupling range of the meter. If you set the shutter speed dial to the white 60, however, any film speed can be set.

(2) Set the camera shutter speed anywhere between 1/30 and 1 second. It does not matter where the Booster shutter speed dial is set, but if the camera shutter is set to any other position the two knobs will not be correctly linked and you will find it impossible to turn the Booster shutter speed knob to the orange 3, which is where it links with the camera shutter B setting.

(3) Remove pentaprism from camera by pressing the studs on either side and drawing the pentaprism and eyepiece unit backward.

(4) Remove the dust cover from the Booster T Finder and slide it on to the camera pentaprism. Align the rails of the Booster T Finder with the grooves in the camera so that it can be pushed in from the rear. It locks in position with an audible click. Turn the Booster shutter speed knob until you feel it engage with the camera shutter speed knob.

(5)   Check battery. Turn the main switch of the Booster
      unit to C. If the needle fails to reach the blue
      battery check mark toward the top of the scale, the
      battery needs replacing. When you release the
      main switch, it returns to the off position.

(6)   Point the camera to the subject remembering that
      the Booster meter is a fully integrating type and
      that you are now virtually using the camera as a
      normal separate meter. Set the Booster meter
      switch at ON. The lamp over the scale should then
      light up. If it does not, the eyepiece shutter is
      open or the shutter speed set is too fast for the
      coupling range. If necessary, close the shutter. If
      the shutter speed set is too fast, however, you will
      see that the small window at the side of the
      Booster unit is glowing as the lamp lights to
      illuminate the camera meter scale in the view-
      finder. Turn the shutter speed knob to a slower
      speed and this light will be extinguished as the top
      light comes on.

      The eyepiece shutter must be closed when using
      the Booster meter because light entering the eye-
      piece can significantly affect readings in low-
      light conditions.

      It is also impossible to use the meter unless the
      eyepiece is closed because the eyepiece shutter
      switch forms part of the main switching circuit.
      You close the shutter by moving the wheel next to
      the eyepiece to C.

(8)   Lock the stop-down lever on the camera front to
      give manual aperture control. The Booster meter
      is not a full aperture type.

(8)   Adjust aperture and shutter speed controls as
      required to bring the Booster meter needle to the
      central black bar. The camera controls are then
      set for correct exposure.

## Overriding the coupling range lock

If you need to set exposures longer than 3 seconds, slide
the knob on the rear wall behind the Booster shutter speed
knob upward to disengage the camera shutter speed knob,
which then remains set on B. The Booster shutter speed
knob will then turn freely (without click stops) to a limit

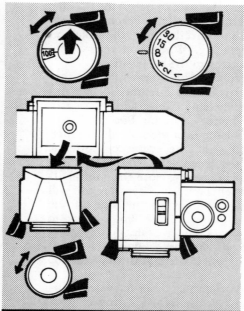

## ATTACHING AND USING THE BOOSTER T FINDER

After removing the pentaprism of the Canon F-1, pull off the dust cover from the bottom of the Booster T Finder and mount it on the camera. First set the speed of the film to be used on both the camera and the Booster T. Set the shutter speed dial of the camera anywhere between 1 and 30. Slide the Booster T into the mounting rails on the camera and push it forward until it clicks into position. Turn the shutter speed dial until you feel it engage the dial on the camera.

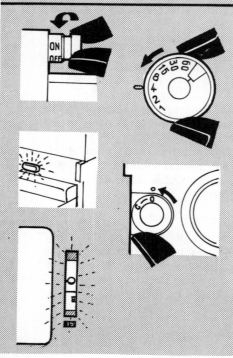

When the Booster T Finder is attached to the camera, metering by the camera meter remains possible at speeds of 1 to 1/60 second. Turn the main switch to ON and set the shutter speed dial to any white figure. The lamp on the side of the Finder then lights up and that on top goes out. Set the eyepiece shutter to O for "open" and use the camera meter in the usual way. The Booster lamp illuminates the camera meter scale.

To use slower speeds with the Booster T Finder, focus and compose the picture at full aperture then lock the stop-down lever on the camera.

The Booster meter is not a full aperture type.

Set the aperture required on the lens and turn the Booster main switch to On.

Turn the shutter speed dial to any orange figure, pushing the timer knob upward to turn past 3.

Close the eyepiece shutter. The lamp in the Booster meter window then lights.

Adjust shutter speed and aperture to bring the meter needle to the index mark.

When you release the shutter, the Booster lamp blinks at each second of exposure.

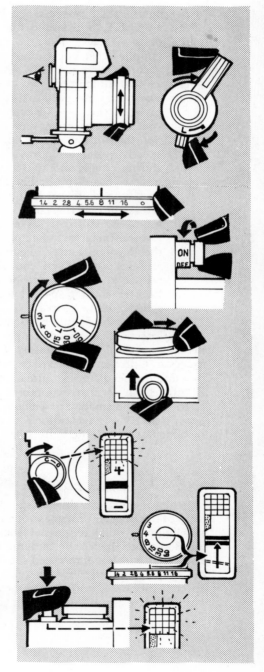

depending on the film speed set. It turns to 60 for a film speed of 25 ASA, for example, but only to 15 for 100 ASA and 4 for 400 ASA.

This implies that you cannot give a longer exposure than 4 seconds for a 400 ASA film but you can, in fact, overcome that difficulty in two ways:

(a) Reset the film speed to 25 ASA; all shutter speeds can now be used. Remember to reset the film speed for subsequent metering.

(b) Set the shutter speed knob to any of the slow speeds (orange figures) available, depress the shutter release and hold it down until the required interval has elapsed. The meter light flashes once each second. This is best done with a locking cable release but, as the camera shutter is, at this stage, set to B, you can make the exposure with the Booster meter switched off. In that case, however, the Booster shutter release locks and the shutter remains open even though you let go of the release knob. It has to be closed by turning the Booster shutter speed knob to one of the faster speeds (white figures).

The freewheeling shutter speed dial of the Booster unit allows intermediate speeds to be set, so that the meter needle can be lined up precisely. In low light conditions, however, CdS meters tend to be rather sluggish in operation and the needle takes quite a time to settle down. The Booster T Finder instruction booklet recommends that a check reading be made 2 or 3 *minutes* later when the light is lower than EV 0 (2 seconds at *f* 1.4 or equivalent) or 10-30 seconds later when the light is brighter than EV 0.

## Meter changeover points

If, when making the shutter speed adjustments, the top lamp of the Booster unit goes out and the small light in the side lights up, you have passed from the metering range of the Booster to that of the camera. This changeover point also varies with the film speed set. You then have to open the eyepiece shutter, switch on the camera meter and observe the meter scale in the viewfinder in the normal way. When using the FD lenses you should also unlock

the stop-down lever and revert to full-aperture metering. With other lenses, you must continue in the stopped-down mode.

## Focusing dimly lit subjects

Unless you are working from a tripod, as you will normally need to be, it is only at this stage that you can actually frame and focus your pictures in the viewfinder because the eyepiece window has to be kept closed while the Booster meter is used. When working from a tripod, however, it is probably more convenient to frame and focus the picture before taking the exposure meter reading.

Focusing very dimly lit subjects can be difficult. It is, of course, carried out at full aperture but even then it may be difficult to see the viewfinder image clearly. If you have no control over the conditions, you can only estimate the distance and set it on the lens distance scale. In arranged set-ups you may be able to light a suitable part of the scene with a pocket lamp, or ask any person in the scene to light a cigarette lighter, or adopt some other such device to give you a point on which to focus.

## Metering at uprated film speeds

Generally, the film speed settings of the Booster T Finder and the camera must be set to the same figure so that correct exposures are obtained when switching from one metering system to the other. If, however, you decide to uprate a film for special processing and therefore set the Booster film speed control to more than 2000 ASA, you cannot set the film speed on the camera to match. Under these conditions, therefore, no changeover point from Booster to camera meter occurs. At the only setting when it would occur (2500 ASA), the Booster meter switches off at 1/60 second but the camera meter illumination does not switch on. You can remove the Booster unit to enable 1/60 second or faster shutter speeds to be used but you must remember to adjust the exposure reading given by the camera meter to the increased film speed unless you intend to cut the film to process the two parts separately.

When you set a film speed in excess of 800 ASA on the Booster, none of the timed (orange) shutter speeds can be

set but you can calculate such an exposure and set the film speed to a figure that allows the required shutter speed to be used. Remember to return the film speed setting to the correct figure for subsequent metering.

## Precautionary notes

The shutter release button on the Booster T Finder is not coupled with the film transport lever. It can therefore be depressed whether the film is transported or not. When the meter is switched on and the shutter speed dial is set to one of the orange figures, pressing the shutter release actuates the timer and the lamp blinks at every second. You could mistake this for an exposure.

When the meter is switched off and the shutter release is pressed while the speed is set to one of the orange figures the release button locks down. To unlock it you have to turn the shutter speed knob to a white figure or switch on the meter and allow the timer to run down.

## Using external batteries

The silver oxide battery that powers the Booster meter is unreliable in cold weather and it is then advisable to use the Canon Battery Case (with Battery Magazine 12V and eight penlight cells) as the power unit. This external power source should also be used for long periods of operation because, at normal temperatures, the life of the silver oxide battery is limited to about 4 hours.

To attach the battery case, unscrew the battery compartment cover of the Booster unit and remove the battery. Screw the single contact end of Cord 6V 2B into the battery compartment. Push the T-shaped end of the cord into the Battery Case and screw down the tightening ring.

# THE SERVO EE FINDER

One of the biggest surprises camera users and, even more, photographic pundits, ever received was the high success rate achieved by automatic exposure systems. The first of these came long before through-the-lens metering and most were based on the shutter speed priority method. This means that the user sets the shutter speed and the metering system automatically selects the aperture according to film speed and light conditions. The success of such a method depends entirely on the fact that most scenes consist of a collection of tones that average out to a mid-tone corresponding to that of a grey card that reflects about 18 per cent of the light falling on it. Naturally it fails with scenes that depart considerably from the norm but the surprise was occasioned by the remarkably few occasions that such scenes were encountered in practice.

When through-the-lens metering was introduced, the EE (for electric eye) systems, as they were commonly called, became even more reliable because they could be used with a variety of lenses and because "weighting" of the readings could be added. The usual method is to use two separate light sensitive units to give rather more emphasis to a small central area of the scene than to the rest of the area photographed. This is the method used in the very sophisticated Canon adaptation of the electric eye principle—the Servo EE Finder.

## Technical description

Like the Booster T Finder, the Servo EE Finder replaces the pentaprism and eyepiece of the Canon F-1. Unlike the Booster, it reads at full aperture and actually sets the apertures its meter recommends. This it does by linking light-sensitive CdS elements on either side of the eyepiece to a small motor which sets a stop to govern the extent to which the lens will stop down

when the shutter release is depressed. The metering range is the same as that of the camera meter—with a 100 ASA film, the equivalent of $\frac{1}{4}$ second at $f$1.2 to 1/2000 second at $f$11. The film speed range is from 25-2000 ASA with the same intermediate values as the camera meter. The shutter speed knob has the same settings as the camera knob. The power source is the Battery Case with 8 or 10 penlight cells connected to the Finder by Cord 12V 2E. The pack can be used simultaneously to operate the motor drive if Battery Connector MD is added.

## Operating principles

The Servo EE Finder can be used only with Canon FD lenses because only those lenses have the extra setting on the lens aperture ring which disconnects the aperture signal lever on the back of the lens from the aperture control ring. The function of this lever—to control the extent to which the diaphragm actually closes down when the shutter release is depressed—is taken over by a prong projecting from a long coupling arm that attaches to the side of the EE Finder. This prong is linked to a further projection from the upper part of the arm that enters a slot in the side of the Finder. This projection is moved up and down in the slot by a small motor actuated by the meter according to the amount of light passing through the lens to the CdS elements. The lower prong is thus similarly raised or lowered to set the diaphragm stop. Operation is extremely rapid. The aperture can move from fully open to fully closed in 2 seconds or less, so that the minor changes normally required are effected almost immediately.

The automatic operation of the Servo EE Finder can be overridden by setting the main switch to M to allow normal use of the aperture control ring. The effect is to move the aperture signal prong to its lowest position and to remove the needle from the meter read-out window. The aperture control ring then resumes its normal function of pre-setting the stop to which the diaphragm closes down when the shutter release is depressed.

## Attaching and detaching sequence

The attaching procedure is similar to that for the Booster T Finder:

## SERVO EE FINDER

The features of the Servo EE Finder are:

1. Lever switch.
2. Shutter speed dial.
3. Film speed dial.
4. Screw socket for EE coupler.
5. Servo operating pin.
6. Scale illuminating window.
7. Lens speed dial.
8. Locating hole for EE coupler pin.
9. Power socket.
10. Battery check button.
11. Battery check indicator.
12. Eyepiece shutter knob.
13. Eyepiece.
14. Attachment lock and release.
15. Shutter speed dial connector.
16. Dust cover.
17. Lever switch.
18. Signal pin coupling lever.
19. Locating pin.
20. Servo coupling lever.
21. Attachment screw.
22. Cord 12V 2E.

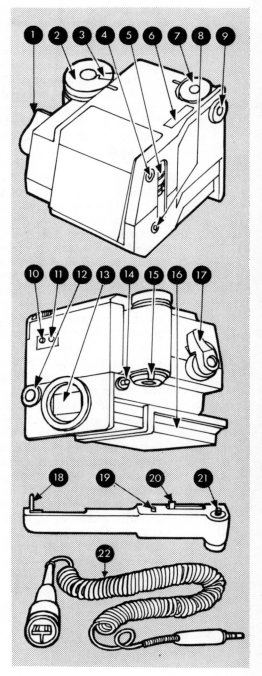

(1) Set the aperture control ring of the lens to the green circle or A beyond the minimum aperture setting. Only FD lenses have this setting.

(2) Remove the pentaprism and eyepiece unit from the camera by pressing on the studs at the sides of the pentaprism and sliding it backward.

(3) Set the shutter speed dial of the camera to any speed between 1 and 1/30 second. The setting on the dial of the Servo EE Finder is immaterial.

(4) Remove the dust cover from the Servo EE Finder and place it on the camera pentaprism unit. Line up the rails of the Servo EE Finder with the grooves of the camera and slide the Finder in from the rear. It clicks into position.

(5) Turn the shutter speed dial in either direction to couple it with that of the camera.

(6) Set the film speed on the Servo EE Finder shutter speed knob by raising the outer rim and turning it until the required figure shows in the cut out. There is no need for the film speed to be set on the camera because it is impossible to use the camera meter with the Servo EE Finder attached. Nevertheless, it is as well to set it in case you decide to revert to the normal pentaprism unit before the whole film is exposed.

(7) Connect the Battery Case to the Finder with Cord 12V 2E. The single plug end is pushed into the socket at the rear of the side wall of the Finder above the rewind knob. The T-connector is is pushed into the socket on the Battery Case and the tightening ring screwed home. Test the battery power by pressing the red button in the rear wall of the Finder. If there is sufficient power in the batteries, the light will glow in the window next to the button.

(8) Turn the ring of the main switch in the side wall by the shutter release to M to bring the servo drive arm (visible in the opening on the other side of the finder) to its lowest position. *This is vital to the correct operation of the Finder*.

(9) Open the cover in the side of the mirror box just behind the lens mount at the rewind end of the camera. It opens back on to the camera body when

## ATTACHING SERVO EE FINDER

To attach the Servo EE Finder to the Canon F-1, first set the lens aperture ring to the green circle or A.

Remove the standard pentaprism and set the shutter speed dial on the camera anywhere between 1 and 30. Slide the EE Finder into the guide rails and push forward until it clicks into position.

Turn the EE Finder shutter speed knob to and fro to engage it with the camera shutter speed knob. Set the film speed on the EE Finder shutter speed dial by lifting up the rim and turning until the appropriate figure appears in the cut out.

Connect the Battery Case to the Finder with the Cord 12V 2E. Connection to the Battery Case is secured by turning the ring around the plug.

Set the main switch at M so that the servo operating pin descends to its lowest position.

Open the cover at the side of the mirror box on the camera and attach the coupler, inserting the signal pin coupling lever into the slot in the camera and the locating pin into the locating hole. Secure by screwing home the attachment screw. Check the battery power by pressing the button on the back of the Finder. If the light glows, power is sufficient.

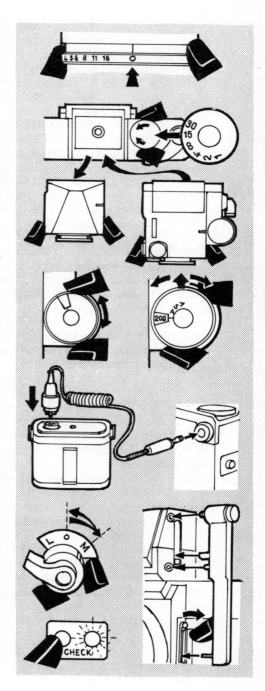

you slide a finger nail beneath it. Attach the coupler arm by lining up the fixing screw with the threaded hole at the top of the side wall and the small fixed screw with the lower hole set diagonally back from it. The lower prong then enters the slit in the mirror box. Tighten the fixing screw. Return the main switch to the red mark (off) position.

(10) Set the maximum aperture of the lens in use on the dial on the top of the Finder. The scale on this dial is as follows, the italic figures representing the dots on the dial:

*1.2*, 1.4, *1.8*, 2, *2.5*, 2.8, *3.5*, 4, *5.6*.

The effect of setting this dial is to move the *f*-number scale in the meter read-out window in the viewfinder up or down so that the maximum aperture of the lens is the first figure visible at the top of the white section of the scale, except for those *f*-numbers represented by the italic figures above. In these cases, there is a small space between the next *f*-number and the upper red area.

When detaching the Servo EE Finder from the camera, the coupler arm must be unscrewed and removed first. The Finder can then be slid backward and off the camera by pressing the stud on the right hand side wall at the rear.

## Operating methods

There are basic differences between the operation of the EE Finder and the standard exposure meter of the Canon F-1. With the camera meter you look through the eyepiece and match up the needle and pointer in the viewfinder readout panel while adjusting shutter speed and aperture controls. With the EE Finder, you observe the viewfinder readout panel merely to find out what aperture the meter is setting or to confirm that shooting is possible at the shutter speed set.

The readout in the EE Finder is therefore different from that seen through the standard finder. It shows *f*-numbers, from maximum aperture at the top to minimum at the bottom. The needle moves to the aperture decided by the meter. You set the shutter speed that seems most suitable to the subject or shooting conditions and point

## USING THE SERVO EE FINDER

Set the lens speed dial to the f-number representing the full aperture of the lens in use. Set a shutter speed appropriate to the subject. Compose and focus the picture.

Set the main switch to the red mark and, holding the lever switch down, observe the meter read-out in the viewfinder. Its features are:
1. Underexposure zone.
2. Meter needle.
3. Auxiliary warning mark, for use with lenses with minimum aperture of f16.
4. Overexposure zone (disappears when maximum aperture is greater than f2).

The needle moves automatically according to the lighting conditions.

When you let go of the lever switch the needle is locked and correct exposure is obtained when you press the shutter release.

When lighting conditions, shooting angle, nature of subject, etc. are constantly varying, lock the lever down by turning the ring switch to L. Continuous metering is then obtained but do not use speeds slower than 1/15 second. To unlock the lever, turn the ring switch back to the red dot.

To detach the Servo EE Finder, first remove the coupler arm or the socket may be badly damaged. Remove the battery cord and detached the Finder by pressing the attachment lock release and sliding the unit backward.

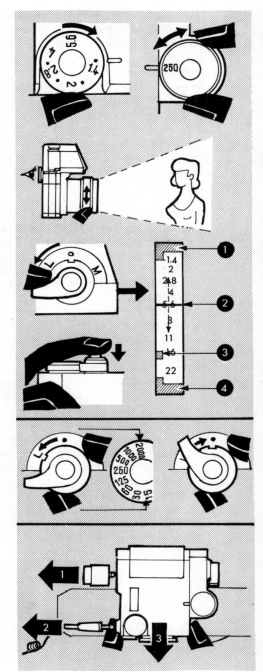

the camera at the subject. You frame the scene and focus and observe the position of the needle in the read-out panel. If it shows an aperture too large or too small for the depth of field you required, you alter the shutter speed until a more suitable aperture is set. If the needle moves into the red over or under exposure zones you also adjust the shutter speed.

The meter switch on the EE Finder is different, too. It is in two parts—a ring forming the main switch with three positions and a lever linking with the ring. The ring switch can be set to M for normal operation of aperture control. You might use that control, for example, if you wished to override the automatic aperture setting, although it is as well to remember that this does not disconnect the circuit, which still consumes battery current. You cannot, however, simply switch off the meter to resume usual control because you cannot then stop the lens down further than the aperture indicated by the meter needle. You have to turn the switch to M until the needle sinks to the bottom of the viewfinder readout and then set the switch to the red dot (OFF) if you intend to cut out the meter operation for any length of time. In other words, the function of the M switch is to nullify the meter's control over the position of the automatic diaphragm stop in the camera body. It causes the operating prong at the bottom of the coupler arm to sink to its lowest position. To set the main switch to M, you have to turn the ring. The lever cannot be set to this position.

The function of the lever is to give a short-duration reading. While your press on the lever, the meter is switched on. When you let go, the meter is switched off and the needle (and therefore the coupler prong) are locked in position. This is the method to use when lighting conditions are stable or when you have taken a reading from a substitute mid-tone or on any other occasion when you do not need continuous metering of every separate shot. You simply take one reading by pressing the lever down, let go of the lever and continue shooting at the aperture set.

If the light is fluctuating, you can set the switch ring to L. The meter is then locked on and the lens diaphragm automatically opens and closes according to the amount of light reflected by the subject. You can hear the servo

motor operating and can also observe the rise and fall of the needle in the viewfinder read out. Remember, however, that this setting gives you an integrated reading of the whole subject area, which is suitable for most subjects but not for heavily backlit shots (unless you want a silhouette effect) or for scenes that are exceptionally light or dark toned. It is, however, the only method that can be used for remote photography using the Motor Drive Unit and, if exceptional conditions prevail, you should set the film speed accordingly.

When you shoot with the main meter switch set to L, you should not use a shutter speed longer than 1/30 second. At slower speeds, the effect of the mirror obscuring the viewing screen is to cut off the light reaching the CdS elements and so cause the diaphragm to reopen slowly during the exposure. This can affect both exposure and depth of field. This does not occur when you leave the ring switch at the red dot and use the lever, because the aperture setting is then locked before you release the shutter. Similarly, the aperture setting is effected between exposures when you use the Servo EE Finder in conjunction with the Motor Drive Unit and any shutter speed compatible with the setting of the Motor Drive Unit can be used.

## EE finder and motor drive

It is rather unlikely that many Canon F-1 users would want to attach the Servo EE Finder to the camera for normal photography. Automatic exposure systems do, indeed, work surprisingly well, but not so well that one would generally surrender the much more flexible system incorporated in the camera itself. The real value of the Servo EE Finder is in remote and unmanned photography, when it is used in conjunction with the Motor Drive Unit and, possibly, the Film Chamber 250. Then, the camera can be left to operate automatically, regardless of any change that may occur in lighting conditions.

When both the Servo EE Finder and the Motor Drive Unit are to be used, the Battery Connector MD is first attached to the Battery Case and its cord plugged into the base of the Motor Drive handle. The screw cover on the other side of the Battery Connector top is removed to

allow the Cord 12V 2E from the EE Finder to be plugged in and screwed home. With this combination, the Servo EE Finder does not function independently. The Battery Connector cord must be connected to the Motor Drive Unit.

It is possible to hand hold this combination and the operation is as described in the previous section but it is difficult to think of any circumstances justifying the extra bulk and weight of the Servo EE Finder. The standard camera finder would be rather more serviceable.

For remote photography, however, the combination is ideal, particularly where long intervals are set between exposures and the light is likely to change. Such photography can be controlled by the Remote Switch MD with 5 m. cable plus a further 15 m. extension cable if required. Exposures can then be made as required or the switch can be locked on to leave the camera to operate at selected intervals. The capacity is greatly increased by adding the Film Chamber 250, which would allow the camera to operate completely unattended for four hours at a rate of one picture a minute.

# MOTOR DRIVE UNIT AND
# FILM CHAMBER 250

The Canon Motor Drive Unit MD is designed to fit any Canon F-1 camera. There is no special motor drive model. The unit is supplied in the Motor Drive Set containing, apart from the Motor Drive Unit itself, a Battery Case, Battery Magazine, Battery Connector MD, Remote Switch MD on a 5-metre cord, Extension Cord MD10 of 10 m. and a Battery Checker. Power drive attachments for other models are described in a separate chapter.

The Motor Drive Unit attaches to the base of the camera and incorporates a timing circuit to allow continuous shooting, as long as the release button is held depressed, at rates from three exposures a second to one exposure every 60 seconds. Single frame shooting is also possible. The unit weighs only 720 g. (1.49 lb.) and is designed for handheld operation, using a special battery case which attaches to the tripod bush.

When the unit is used on a tripod, perhaps with the Servo EE Finder and Film Chamber 250, power is supplied from the Battery Case, with Battery Connector MD attached. The Battery Case is loaded with a Battery Magazine, which holds 10 penlight dry batteries. The capacity is claimed to be eighty 36-exposure cassettes.

The shutter release button of the Motor Drive Unit is threaded for a standard cable release. Thus, a cable release with locking device can be used for continuous unmanned operation. The Remote Switch MD, however, attaches to the Battery Connector and has a lock which also allows the Motor Drive Unit to operate unattended.

The frame counter of the Motor Drive Unit can be set to any number up to 36 and the motor switches off when the counter reaches 0. The frame counter can be disconnected by setting it to FC. This is designed for use with Film Chamber 250. The motor will then run

continuously while the button is depressed, but will switch off when all film in the Film Chamber 250 is exposed.

## Attaching the Motor Drive Unit

The procedure for attaching the Motor Drive Unit to any Canon F-1 camera is as follows:

(1) Unscrew the battery chamber cover in the camera baseplate. Pull the baseplate away from the camera body and release it from the hook at the other end. Stow the baseplate safely away. It is not used while the Motor Drive Unit is attached to the camera. Replace the battery if it falls out during this operation and screw the cover back in. If you fail to do this, the motor drive is not affected but the camera meter cannot operate.

(2) Offer up the Motor Drive Unit to the bottom of the camera with the grip on the right hand side viewed from the back (the transport lever end). Screw the attachment screw into its camera tripod socket.

That is all there is to it. The Motor Drive Unit is ready to operate as soon as you connect its power source.

Whenever possible, it is advisable to attach the Motor Drive Unit to the camera in dustfree, dry conditions; because removal of the baseplate leaves openings through which dust and moisture could enter the camera body. Attachment can, however, be carried out so rapidly that this is not a major drawback.

## Connecting the power source

Power for the Motor Drive Unit is supplied either from the Battery Case, loaded with the Battery Magazine containing ten penlight cells, or from a cordless battery unit attaching to the tripod socket mount of the Motor Drive Unit. This is intended for handheld operation of the Motor Drive Unit and camera alone. It does not power the Booster T Finder or the Servo EE Finder.

The procedure for connecting the Battery Case is as follows:

(1) Load the Battery Magazine with ten penlight batteries (size AA or No. 7). Push the base (minus pole) of each battery against the spring

# F-1 MOTOR DRIVE UNIT

The features of the Motor Drive Unit for the Canon F-1 are:

1. Holding plate.
2. Timer chart.
3. Servo EE Finder contacts.
4. Camera attachment screw.
5. Frame counter setting wheel.
6. Frame counter.
7. Film rewind pin.
8. Film wind coupler.
9. Holding plate.
10. Battery case attachment shoe.
11. Tripod socket.
12. Camera attachment knob.
13. Motor drive button.
14. Rewind lever.
15. Main switch.
16. Timer ring.
17. Timer lock pin.
18. Grip Connector MD.
19. Battery socket.
20. Battery Connector MD plug.
21. Battery checker.
22. Battery case with Battery Connector MD.
23. Battery checker switch.
24. 250 Film Chamber contacts.
25. Holding plate.

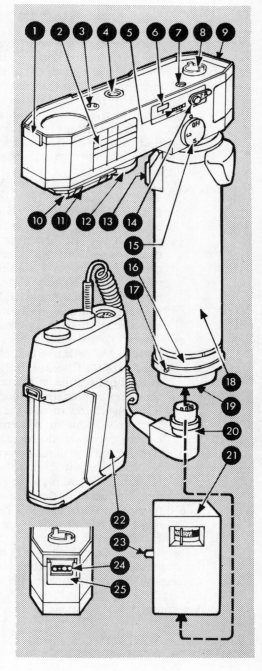

contact and then drop the top into the stud contact.

(2) Slide the bottom cover from the Battery Case and insert the loaded Battery Magazine. The magazine should have a green dot at the end opposite to that carrying the two external contacts and should be inserted into the Battery Case with this dot opposite the green dot in the case.

The magazine therefore goes in connector end first with the connectors under the plain end of the top of the battery case. Replace the Battery Case sliding cover.

(3) If the Battery Connector MD (with coiled cable and DIN plug) is not already attached to the Battery Case, push it on so that the T-shaped plug enters the socket on the top of the case and screw home the fastening screw by the central milled wheel on top. The smaller wheel beside this is a cover for a socket connecting with the socket in the Battery Case, so that other equipment, such as the Servo EE Finder, can be plugged in whether or not the Battery Connector MD is attached to the Battery Case.

(4) Check the batteries. Connect the cord from the Battery Motor Drive Set. Press the red button on the side of the Checker. If the needle does not move to the blue section of the scale, the batteries need changing or recharging, according to type.

If you intend to use the Remote Switch MD, with or without the Extension Cord MD10, the battery check should be carried out only after the switch cord and extension cord are connected.

(5) Set the main switch on the back of the Motor Drive Unit to OFF and plug the Battery Connector cord into the socket in the base of the grip of the Unit.

(6) Assuming that you have just loaded the camera, make the blind exposures with the camera control and transport the film for the first shot.

Despite the long description of the procedure required for attaching the Motor Drive Unit to the camera and connecting the power source, the whole operation can be carried out in 2 minutes without really rushing it. Assuming, as is reasonable, that the power source is

## ATTACHING F-1 MOTOR DRIVE

To attach the Motor Drive Unit to the Canon F-1:

1. Unscrew the battery compartment cover on the camera.
2. Unhook and remove the camera base plate.
3. Replace battery and battery compartment cover.
4. Fit the Motor Drive Unit to the base of the camera with the grip at the lever wind end and screw home the connecting screw.
5. Set the main switch on the Motor Drive Unit to OFF and plug in the cord from the Battery Connector MD.

For use with the Motor Drive Unit, the Battery Case can be loaded with a NiCd 500 FZ pack or with a Battery Magazine containing 10 penlight cells. The NiCd battery is inserted with the slot on the same side as the green dot in the Battery Case. The Battery Magazine has a green dot to line up with the green dot in the case. Attach the Battery Connector MD.

See footnote opposite.

To check battery power after loading the Battery Case, plug the cord from the Battery Connector MD into the Battery Checker and press the Battery Checker Switch. If the needle reaches the blue zone, battery power is sufficient.

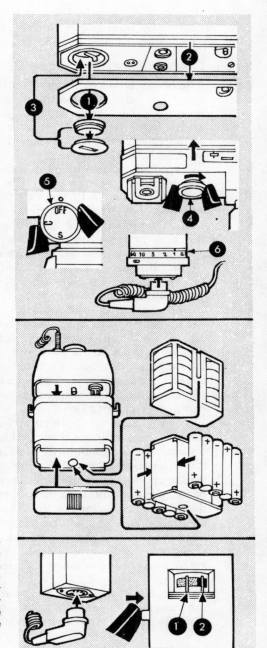

ready for instant connection, this time can be reduced to 45 seconds.

## Operating the Motor Drive Unit

The Motor Drive Unit can be set to take single shots with motorised film transport, for continuous shooting at preset intervals, or for normal camera operation via the release button and transport lever on the top plate. These settings are controlled by the main, circular, three position switch just above the grip.

For manual operation of the camera controls it is sensible to set the switch to OFF, but the camera can in fact be operated with the switch in any position. It is advisable, however, to transport the film before switching over to motor drive because, if the film is not wound on, the first pressure on the motor drive release button operates the shutter release drive and advances the film counter but does not open the shutter until after the film has been wound on. If you are set for single exposures, you could thereby miss a shot.

For single shots with motorised film transport you set the main switch to S and turn the frame counter wheel just above it until the number of exposures you have available shows in the window to the left of the wheel. The motor drive will not function when the exposure counter reaches 0, so if you forget to set it you could lose valuable time before you realise why the motor drive has come to an abrupt halt.

You must also set the timer at the bottom of the grip to T OFF. This indicates that the timing circuit is switched off and that the motor will operate at its basic speed of three frames a second. The significance of this for single-shot operation is that the film is not transported until just before the next frame to be exposed. Thus, if you leave the timer set to 10, for example, the film is not transported until about 9 seconds *after you take your finger off the motor drive button*. Again you could lose a shot (or a lot of shots if the timer were set to 60) before realising why nothing happened when you pressed the shutter release again.

With this setting—S on the main switch and T OFF on the timer—you can use all shutter speeds except B. Actually, the shutter will open at the B setting but it

72

## USING THE F-1 MOTOR DRIVE

To operate the Motor Drive Unit, load the camera as usual and set the frame counter on the back of the unit to the number of exposures loaded.

Set the main switch at S for single frame shooting or to C for continuous shooting.

Set the timer for the interval required (or to T OFF for single-frame shooting) by depressing the lock pin and turning the timer ring. Set an appropriate shutter speed.

Compose and focus the picture and set the correct exposure by adjusting the lens aperture. Press the motor drive button to release the shutter.

When the frame counter on the Motor Drive Unit reaches 0 the unit ceases to function. To rewind the film, push up the rewind lever beside the frame counter setting wheel.

Rewind the film as usual and remove the cassette from the camera.

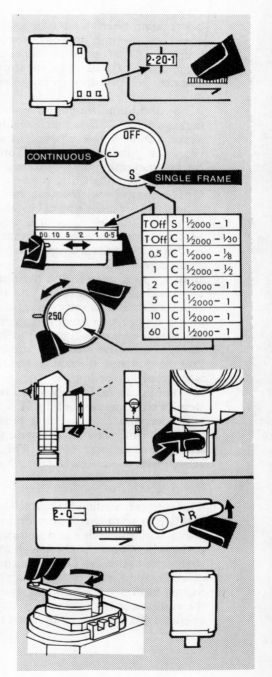

| T Off | S | $\frac{1}{2000} - 1$ |
| T Off | C | $\frac{1}{2000} - \frac{1}{30}$ |
| 0.5 | C | $\frac{1}{2000} - \frac{1}{8}$ |
| 1 | C | $\frac{1}{2000} - \frac{1}{2}$ |
| 2 | C | $\frac{1}{2000} - 1$ |
| 5 | C | $\frac{1}{2000} - 1$ |
| 10 | C | $\frac{1}{2000} - 1$ |
| 60 | C | $\frac{1}{2000} - 1$ |

closes again after about 1/30 second. If you use shutter speeds of $\frac{1}{8}$ second or slower for single shots, you must keep your finger on the shutter release for the duration of the exposure. If you let go, the shutter immediately closes and may give an exposure considerably shorter than that set.

For continuous shooting at preset intervals, you set the main switch to C. You then have the choice of shooting at a rate of three or two exposures a second or one exposure every 1, 2, 5, 10 or 60 seconds. You set the shooting speed on the timer ring at the foot of the grip. Press the small stud and turn the milled ring to the figure required. The T OFF setting gives the basic rate of three exposures a second. At the other settings a delay is introduced to give the slower framing rates. The plate on the back of the Motor Drive Unit shows the shutter speeds that can be used at the various settings. All speeds can be used if the frame rate is one every 2 seconds or slower. If you set a shutter speed outside the permitted range, you do no harm to the mechanism, but the shutter gives less exposure than it is set to give. It can not, for example, give $\frac{1}{2}$ second exposures at three a second (or, in fact, anything longer than 1/30 second, because the mechanism needs time to transport the film between exposures). It fires the shutter at the rate set and the actual shutter speed is shortened accordingly.

You can use the frame counter to provide an automatic stop for continuous shooting. If, for example, you want to take a sequence of six or a dozen shots, you set the counter to 6 or 12 and the motor will stop automatically when the counter reaches 0. The frame counter is then easily reset if you want to take a further sequence.

## Remote control and unmanned photography

The Remote Switch MD consists of 5 metres of cable with a plug to fit the Battery Connector at one end and a switch with single shot and continuous shooting positions at the other. There is also a lock for continuous shooting so that the switch can be used for unmanned photography as well as for remote control. A small light on the Remote Switch flashes at each shutter operation to indicate that the equipment is working correctly. The camera can be operated at a distance of 15 metres by connecting Exten-

## MOTOR DRIVE SYSTEM

The main components of the Canon Motor Drive system are:

1. Film loader 250.
2. Film magazine 250.
3. Film chamber 250.
4. Cord 12V 2E.
5. Speed finder.
6. Eye-level finder.
7. Servo EE finder.
8. Canon F-1 body.
9. Motor drive unit.
10. Battery checker MD.
11. Remote switch MD.
12. Battery connector MD.
13. Battery case.
14. Extension cord MD.
15. Battery magazine 15V.
16. NiCd battery 500FZ.
17. NiCd charger 500FZ.
18. Wireless remote control unit.
19. Ultrasonic remote control unit.
20. AC cord.
21. Timer.

The NiCd battery pack was never marketed but a similar unit for Canon movie cameras was usable.

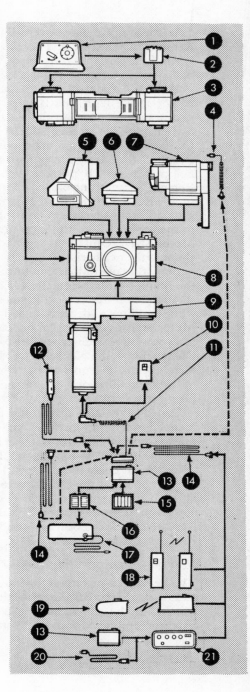

sion Cord MD10 between the Battery Connector and the Remote Switch. It is advisable to check the battery power when these cords are connected. The extra resistance may be too much for batteries nearing the end of their charge.

For remote control or unmanned operation, attach the Motor Drive Unit, the Battery Case and Battery Connector to the camera in the usual way. Plug the Remote Switch into the uncovered DIN socket on the Battery Connector next to the main power cord. Set the main switch of the Motor Drive Unit to either C or S. It does not matter which position you set it to because the Remote Switch controls the operation of the Motor. You set the Remote Switch to C when you want to take several shots in rapid succession or at timed intervals according to the setting of the timer on the base of the grip of the Motor Drive Unit. You set it to S when you intend to shoot as the need arises.

For either operation, shooting is controlled by pressing the round button below the C.L. lettering. These letters stand for continuous lock. If you slide the button forward while holding it depressed, it is locked down and the Motor Drive continues to operate until you release the lock, the frame counter reaches 0 or, when using the Film Chamber 250, the film runs out. This facility allows completely unmanned operation, so that, even with the normal 36-exposure film load, the camera can be left unattended for up to 37 minutes.

You do not have to use the Remote Switch for unmanned operation because an ordinary locking cable release screwed into the motor drive button will serve the same purpose. The advantage of the Remote Switch is that you can delay the start of shooting until you are out of sight and that the little blue indicator light (at the top of the switch) confirms that the equipment is functioning correctly. If necessary the 5 m. cable attached to the Remote Switch can be lengthened by adding an extension cord of a further 10 m.

## Remote operation with Servo EE finder

The versatility of remote operation can be extended by adding the Servo EE Finder to the set-up. The Finder is attached to the camera in the usual way (see page 58) and its cord is plugged into the Battery Connector by un-

screwing the cover next to the attachment screw. This reveals the same T-type socket as that on the Battery Case, to which, in fact, it is connected. The main switch of the Servo EE finder is then set to L to allow continuous metering while the camera is unattended. In these conditions, the eyepiece shutter of the Servo EE Finder should be closed to avoid the possibility of light entering the eyepiece affecting the meter reading. It is also advisable to put a cover over the Finder when the sun's rays are particularly hot. The manufacturers say that a temperature of 45°C (113°F) can lead to over-exposure. It should, however, be normal practice to protect any camera from direct sunlight in much lower temperatures than that.

## Electronic remote control system

The last word (for the present, perhaps) on remote control is provided by the Canon Electronic Remote Control System. This operates on the Canon F-1 camera fitted with either the conventional motor drive unit or the Motor Drive MF, the Servo EE Finder and FD 85-300 mm. ƒ4.5 zoom lens. Other FD lenses can be used if required and the Film Chamber 250 can be attached to the camera.

The operating units consist of a pan and tilt head, a focus and zoom unit and an electronic viewfinder. All these items are controlled by an elaborate control unit containing a 7-inch monitor TV tube and a 100v, 50Hz power source. The switches and controls consist of an on/off power switch, a stand-by switch that allows the heater of the TV tube to remain on, brightness and contrast controls for the monitor screen image, zoom and focusing controls for the lens, pan and tilt controls, shutter release button and frame counter.

The motorised pan-tilt head on which the camera is mounted provides a 340° panning movement at a speed of 6° a second. Tilts of 45° up and down are possible at a speed of 3° a second.

The focusing ring, and zooming ring when used, are belt driven from a separate motor, end-to-end movement in each case being 5 seconds.

77

The electronic viewfinder consists of a $\frac{2}{3}$ in Vidicon tube attached to the eyepiece of the Servo EE Finder and connected to the monitor TV built in to the control unit.

Thus, all photographic operations can be remotely controlled, including shooting direction over a very wide range, framing by means of the zoom lens, focusing, film transport and shutter release. Exposure is automatically taken care of by the Servo EE Finder. The frame counter of the control unit indicates, by means of a light emitting diode, the number of frames exposed and a reset button is provided.

## Features of the Film Chamber 250

The Film Chamber 250 attaches to the camera in place of the normal back and contains two film magazines, one feed and one take-up, to take 10 m. (about 32 feet 9 inches) of film, sufficient for 250 exposures. A small motor is built in, synchronised with the film transport of the Motor Drive Unit to turn the take-up spool as the film is transported. The Film Chamber couples directly to the Motor Drive Unit by three spring contacts, one connecting with the take-up spool motor and the other two with cut-out switches operated by the take-up magazine closing knob and a spring roller held down by the film passing across the Film Chamber back. The switch connected with the take-up magazine knob prevents the Motor Drive operating when the magazine is closed. The switch operated by the film roller cuts out the Motor Drive when the end of the film passes into the take up magazine and the roller springs up. Thus the Motor Drive will not work unless the take-up magazine is open to allow the film to move freely; nor will it operate when there is no film across the Film Chamber back. The cut-out operated by the frame counter of the Motor Drive Unit is generally disconnected by turning it to the FC position when the Film Chamber 250 is attached and the counter of the Film Chamber itself takes over.

This does not, however, operate a cut-out when it reaches o.

The Film Chamber is easily fitted to the camera and it is possible to hand hold the complete equipment with motor drive attached but it is undeniably heavy. The Film

## FILM CHAMBER 250

The features of the Film Chamber 250 are:
1. Supply magazine chamber.
2. Open/close knob.
3. Camera holding lever.
4. Camera holder.
5. White dot.
6. Take-up magazine chamber.
7. Carrying-strap eyelet.
8. Release button.
9. Magazine shell.
10. Film spool.
11. Magazine attachment knob.
12. Film guide roller.
13. Back cover.
14. Back cover lock.
15. Film insertion slit.
16. Outer shell lock.
17. Magazine outer shell.
18. Release lever for connector pins.
19. Connector pins for motor drive.
20. Pressure plate.
21. Frame counter.

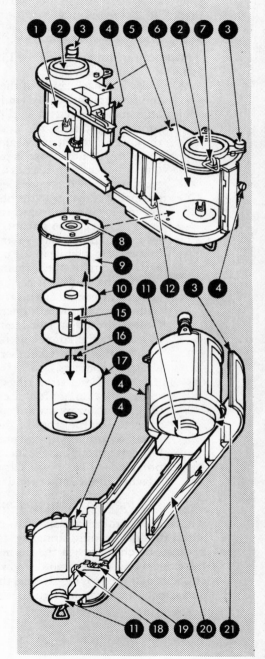

Chamber is very strongly constructed and weighs more than $2\frac{1}{2}$ lb. (1170 grams).

## Attaching the Film Chamber

The procedure for attaching the Film Chamber 250 to the Canon F-1 is as follows:

(1) Open the back cover of the camera by pulling up the rewind knob fully while pressing on the lock stud just in front of it. Press downward on the protruding pin of the cover hinge and remove the cover. Store it away safely. It is not used while the Film Chamber 250 is on the camera.

(2) Open the securing catches of the Film Chamber by turning the two chrome levers on the top of the magazine housings to the outward position. If they are immovable pull upward on the knobs of each lever to release the pin and hole lock.

(3) Lay the Film Chamber on its back and fit the camera into it while lining up the grooves in the top and bottom of the camera back with the corresponding rails of the Film Chamber. It is generally easier to do this without the Motor Drive Unit attached to the camera. If the Motor Drive Unit is already attached, either remove it or press to the left the connector release lever in the left base of the Film Chamber. This withdraws the electrical contacts.

(4) Turn the carrying strap rings of the camera upward so that they do not foul the camera holders. Turn the chrome levers inward so that the camera holders press on the front of the camera and lock the levers by pulling up the knobs at the end of each lever and dropping the locking pins into the holes provided. The Film Chamber is now firmly attached to the camera and is ready to load.

## Extracting the Film Chamber magazines

The Film Chamber contains two interchangeable magazines, the film feeding from one to the other across the back of the chamber via the normal sprocketed drive of the camera and a micromotor, powered through contacts on the Motor Drive Unit, to wind the film into the take-up magazine. This micromotor is necessary to wind the film

## ATTACHING FILM CHAMBER 250

To attach the Film Chamber 250 to the Canon F-1, open the camera back and remove it by pushing downward on the protruding hinge pin and lifting the back clear of the camera. Turn the camera holder levers outward to release the camera holders.

Push the camera body into the Film Chamber with the camera back cover grooves lined up with the rails of the Film Chamber.

When the index lines on the camera line up with the white dots on the Film Chamber, turn the camera holding levers to their click stop positions or to lock in the locking pin holes provided.

## CONNECTING MOTOR DRIVE UNIT TO FILM CHAMBER 250

When using the Film Chamber 250 with the Motor Drive Unit it is easier to attach the Film Chamber 250 first.

Then remove the bottom cover of the camera by unscrewing the battery compartment cover, remembering to reload the battery and replace the compartment cover.

Connect the Motor Drive Unit in the normal way. If you attach the Film Chamber 250 after the Motor Drive Unit has been connected, move the connector pin release lever to the left as you do so to avoid damage to the pins.

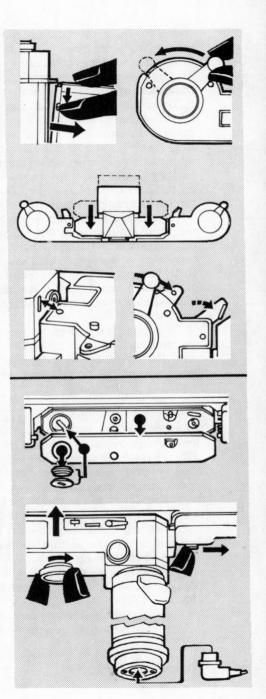

correctly on to the take-up spool. Without it, the film would jam in the magazine and prevent proper operation of the film advance mechanism. Thus, if you advance the film by means of the camera's lever wind, you must turn the magazine end of the chamber to take up the slack film.

To extract the magazines, you must first open the Film Chamber back. This you cannot do unless the take-up magazine is closed. You close the magazine by turning the large knob on top of the chamber to OPEN, which is intended to indicate that you can now open the camera back by pushing upward on the locking lever at the take-up end of the Film Chamber. The back springs away and can be completely removed.

To remove a magazine you pull downward on the magazine attachment knob beneath the chamber and tip the magazine out. The magazine is a three-part type consisting of an outer shell, inner shell and spool. Both shells have openings across their full width so that rotation of the shells enables the openings to coincide or for the inner shell wall to effectively light trap the opening in the outer shell.

To dismantle the magazine, press the spring stud on the top and turn the inner shell by the milled outer edge until the openings coincide. The magazine can then be separated into its three components ready for film to be loaded on to the spool.

## Loading the magazines

Film loading has to be carried out in the dark and the length required for a full load of 250 exposures is 10 m. The normal bulk supply unit is 17 m. so, if you intend to load by hand, you need some method of measuring 10 m. in the dark without scratching or otherwise damaging the film. It is easier to use the Film Loader 250 supplied by Canon. This is a quite simple mechanism consisting of a free-standing upright base with a spindle toward each end and a sprocketed film counter in the middle. You load the bulk film on to the feed spindle at the opposite end of the base to the winding handle. The method of doing so varies according to the type of bulk film supply you use:

(1) If the film roll has no core, push the spool supplied with the loader into the centre of the roll and then

## LOADING FILM CHAMBER 250

To load a film magazine into the Film Chamber 250, first turn both open/close knobs to OPEN, lift up the back latch and remove the back cover.

Pull down the magazine attachment knob below the supply chamber and insert a loaded magazine, guiding the release button and projections through the notch in the top of the chamber. Push the magazine attachment knob back in and pull about 12 inches of film from the magazine. Trim the end to form a short leader.

Dismantle the take-up magazine and fit the film leader into the slit in the spool. Turn the spool two or three times to ensure that the film is firmly held. Slide the inner shell down over the spool and the outer shell up to cover both, allowing the film to pass between the openings. Turn the inner shell anti-clockwise until it locks. Insert the magazine into the take-up chamber in the same manner as for the supply magazine.

Replace the back of the Film Chamber 250, inserting the end opposite the lock first and press to lock. Turn both open/close knobs to CLOSE.

When shooting with the Motor Drive Unit and Film Chamber 250, set the frame counter of the Motor Drive Unit to FC and the counter of the Film Chamber 250 to the number of frames loaded into the magazine. Make six blind exposures by pressing the motor drive release button.

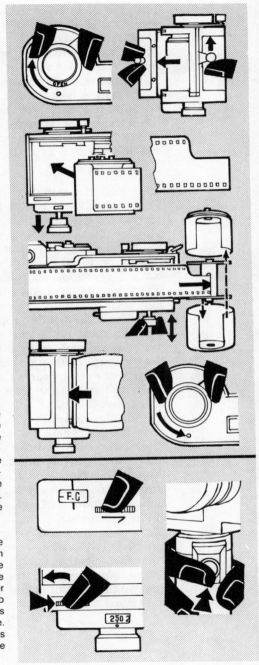

push the spool on to the feed spindle so that the single flange of the spool holds the film in place.

(2) If the film roll is wound on to a core with a central opening into which the spool supplied with the loader can be inserted, fit it to the spindle in the same manner as for uncored film.

(3) If the central hole in the core is too small for the spool, fit the core on to the spindle and push the spool flange first on to the end of the spindle.

(4) Film supplied on spools with flanges at each end can be fitted to the spindle as they are.

The procedure is then as follows (*in total darkness*):

(1) Fold upward the two holding rollers over the sprocketed spindle of the counter.

(2) Pass the film across the counter spindle and insert the trimmed tip into a slot in the magazine spool pushed on to take up spool behind the winding handle. The emulsion must face inward.

(3) Turn the spool by hand a few times to secure the film.

(4) Fold down the holding rollers to clamp the film over the sprockets. Make sure that the film perforations are engaged by the sprockets.

(5) Set the frame counter on the front of the loader to the number of exposures required.

(6) Turn the handle until it stops. It will stop when the counter reaches 0.

(7) Cut the film between the supply and take-up sides and remove the magazine spool from the loader.

(8) Place the spool in the inner shell of the magazine so that, with the shell upside down, the film protrudes through the opening pointing to the right with the emulsion toward you or to the left with the emulsion away from you. Leave about 10 cm. (3 inches) of film protruding.

(9) Align the open sections of inner and outer shell and push the two together. Turn the milled edge of the inner shell clockwise until it locks. The magazine is now loaded and light-trapped.

(10) Remove the remaining film from the Film Loader and return it to its dark store.

## POWER SYSTEMS

The main uses of the various Canon F-1 power units are as indicated in the diagram.

1. Battery magazine.
2. Battery case.
3. Canon F-1 with Servo EE Finder.
4. Cord 12V 2E.
5. Battery magazine 12V.
6. NiCd battery 500FZ.
7. Canon F-1 with Servo EE Finder and Motor Drive Unit.
8. Battery checker MD.
9. Remote switch MD.
10. Battery connector MD.
11. NiCd charger 500FZ.
12. Extension cord MD.
13. Canon F-1 with Booster T Finder.
14. Cord 6V 2B.
15. Speedlite electronic flash.
16. Cord 12V 3S.

The NiCd battery 500FZ was not brought into general production. It is possible, however, to fit the similar pack used in Canon movie cameras.

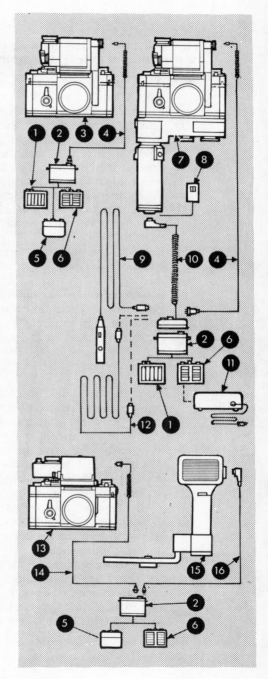

## Loading magazines into Film Chamber

When you have loaded your magazine with film, you load the magazine into the Film Chamber as follows:

(1) Turn the open/close knob at the supply end of the Film Chamber to OPEN.

(2) Pull the magazine attachment knob downward.

(3) Insert the magazine into the chamber, film uppermost and turn the magazine until the white dot below the opening coincides with the dot on the floor of the chamber. The locating lugs at the top will guide it into position.

(4) Push the magazine attachment knob upward.

(5) Pull about 30 cm. (1 foot) of film from the supply chamber and trim its end for insertion into the take-up spool.

(6) Remove the take-up magazine from the Film Chamber and separate it into its three parts as for loading.

(7) Attach the end of the film to the spool and wind it round two or three times before reassembling the magazine as in loading.

(8) Return the magazine to the take-up chamber in the same way as you loaded the supply magazine into its chamber and push in the magazine attachment knob.

(9) Turn the magazine attachment knob below the take-up chamber to take up the slack film across the back of the camera. The instruction book advises you to ensure at this stage that the film is engaged by the drive sprockets but, in fact, the film is too slack without the back in place for you to check this fact satisfactorily.

(10) Replace the back cover by first inserting the edge at the supply chamber end and then snapping the other end shut. It locks automatically. Be careful not to trap the rubber eyepiece in the back if you have it attached.

(11) Set both open/close knobs at CLOSE. The film magazines are then open and the film can pass freely from one to the other. The knob on the take-up end also closes an electrical circuit when it is set to CLOSE. If it is left at OPEN, the shutter

86

will fire once but the film will not wind on until the knob is turned to CLOSE.

(12) Set the frame counter of the Motor Drive Unit to FC to disconnect the automatic stop.

(13) Set the main switch of the Motor Drive Unit to C or S, press the Motor Drive button and make six blank shots to wind off the film fogged during loading.

(14) Set the frame counter of the Film Chamber to the number of shots loaded into the magazine; press the milled wheel above and to the left of the counter window and turn it until the required number appears in the window. The counter is purely a check. It has no effect on the Motor Drive mechanism. The motor drive stops automatically when all the film has passed into the take up magazine.

## Notes on using the Film Chamber 250

The Film Chamber can be loaded either on the camera or off. It is more likely that the general practice will be to load it before attaching the camera because it is necessarily a rather cumbersome procedure. Without the camera attached, however, the Film Chamber is not lightproof and you must be very careful to keep the magazines closed, which means that the open-close knobs must be set to OPEN. There is obvious room for confusion here so the utmost caution is necessary.

The Film Chamber is primarily designed for use with the Motor Drive Unit and if you do use the camera transport lever to wind on the film, you must remember to turn the magazine attachment knob on the take-up side to take up the slack in the magazine.

There are various locking and safety devices on the Film Chamber 250. You cannot, for example, operate the Motor Drive Unit unless the open-close knob over the take-up magazine is set to CLOSE—meaning that the magazine is open. The motor will work, however, with the other open/close knob set to OPEN—meaning that the magazine is closed and you risk scratching the film by dragging it out between inner and outer shell.

Similarly, the back of the Film Chamber remains locked unless the open/close knob over the take-up

magazine is set to OPEN, when the magazine is closed. This is designed for the usual procedure of running all the film through and unloading. You might, however, decide to cut off part of the film for processing. This you can do by running six frames through the camera to wind off the exposed film still outside the take-up magazine. But you must then remember to close *both* magazines (set the knobs to OPEN) before opening the back of the Film Chamber and cutting the film between the two magazines. The knob on the supply side does not control the back lock.

If you have two Film Chambers, you can interchange them as required but, again, you must remember to make six blank exposures and then close both magazines before removing the Film Chamber from the camera.

Although you will normally set the frame counter of the Motor Drive to FC when using the Film Chamber 250, you can use it normally if you wish to make a specific number of timed exposures and do not wish to count them. You could run a sequence of twenty shots automatically, for instance, by setting the Motor Drive frame counter to 20. When it runs down to 0, the Motor Drive Unit will cease to operate.

This facility can be useful for remote operation when you do not want to run off the full load of film on one particular sequence.

# FEATURES AND OPERATION
# OF CANON A-1

The Canon A-1 has taken the use of electronics in cameras to the point where almost anything is possible. The so-called micro-computers now being produced by the million can be programmed to do a vast amount of work in an incredibly short time. In a camera, the time has to be kept short; no perceptible delay between pressing the button and the shutter opening can be tolerated. But for these tiny chips of electronic wizardry, the delay imposed by mechanical shutter release is an age.

These computers, which camera manufacturers call CPUs (central processing units), use digital control circuits that are extremely complicated and rather expensive unless produced in vast numbers. Camera manufacturers have tended to combine them with simpler and less expensive analogue circuits that can do all that has so far been required of them. One difference between the two circuits is that the digital has a far greater handling capacity for a given size. Canon can overcome the expense problem to some extent because they can use the same basic units in a variety of other fields of activity (office machinery, calculators, computers and various other types of control equipment). So they made the A-1 almost totally digitally controlled. This enabled them to add a few automatic features that other cameras do not possess and opened up the rather awesome prospect that they will yet think of a lot more to put into future cameras.

## Technical Specification

The Canon A-1 is a single lens reflex camera with full-aperture through the lens metering. Unlike all the other models, however, its metering system can barely be described in a sentence because it has five different methods—all giving automatic control of the exposure setting or settings not preset.

It has aperture-preferred and shutter-speed-preferred systems, selected at the turn of a switch. The aperture-

preferred system can be used at full aperture or with the lens stopped down (on bellows or extension tubes, etc. or where older lenses are used). It has a fully programmed mode in which the user surrenders all control over both aperture and shutter speed. Finally, with its own special Speedlite flash units, it sets both shutter speed (1/60 second) and aperture automatically for correctly exposed flash shots. In all cases, the viewfinder shows a detailed readout of the necessary information in the now familiar seven-segmented LED characters, even down to spelling out "bulb" when the shutter is set to B. Despite all that, you can simply move the lens off the automatic setting and take all the decisions yourself. You can even switch off the viewfinder display.

The meter uses a silicon sensor above the eyepiece to read the whole screen area with less emphasis on the top of the picture than on other parts—when the camera is held horizontally. The range is wide, with film speed settings from 6 to 12 800 ASA and a coupling range from EV−2 to 18 with a 100 ASA film and $f$ 1.4 lens.

The shutter is a horizontally moving type with cloth blinds and speeds from 30 seconds to 1/1000 second and B—all electronically controlled and operated. The release is an electrical switch and cannot be operated without battery power. The shutter speed range in the AE mode is continuous and stepless but the normal progression of stepped speeds can be set manually when using the shutter-speed-preferred AE mode or when using the camera without the meter. The meter is switched on by light pressure on the shutter release that is overridden by a main switch (doubling as self-timer) in front of the film transport lever. In the L position it switches off all circuits.

The shutter release is a large circular press button with a central cable release socket. It energises a combination magnet to release the shutter. It has a switch on its rear edge to change the display in the window beside it from apertures to shutter speeds. Settings are made with an edge-control with a sliding guard.

The frame counter is at the back edge of the top plate and counts forward, indicating the number of exposures made. It operates in reverse on rewind but does not operate at all when the multiple exposure lever is used. It resets to S when the camera back is opened.

## CANON A-1

The main features of the Canon A-1 are:

1. Action grip screw.
2. Action grip.
3. Shutter release.
4. Shutter speed ring guard.
5. Accessory shoe.
6. Lens locating index.
7. Battery check button.
8. Flash socket.
9. Rewind knob.
10. Battery compartment.
11. Stop-down switch.
12. Exposure preview switch.
13. Exposure memory switch.
14. Self-timer settings.
15. Multiple exposure lever.
16. Aperture/shutter speed selector.
17. Film transport lever.
18. Auto flash contacts.
19. Exposure compensation lock.
20. Rewind crank.
21. Action grip.
22. Battery check/self timer LED.
23. Shutter release.
24. Aperture/shutter speed scales.
25. Flash contact.
26. Viewfinder display switch.
27. Battery check button.
28. Tripod bush.
29. Rewind button.
30. Power wind/motor drive coupling.
31. Power wind/motor drive locating hole.
32. Viewfinder screen.
33. Camera settings read-out.
34. Microprism range-finder.
35. Split-image range-finder.

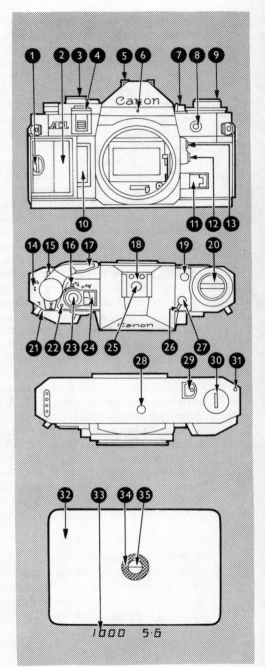

At the other end of the top plate, the film speed scale is around the rewind knob and also has exposure compensation settings with a lock button adjacent. The other button in this position is the battery check button, which also switches off all circuits while held depressed and can thus be used as a momentary cut-off to cancel the self-timer or terminate a long exposure. The switch on the battery check button cuts out the viewfinder display.

The pentaprism housing carries a hot shoe with contacts for the automatic Speedlites. It is a fixed unit with a choice of screens, but screen changing cannot be effected by the user. The standard screen gives a bright image on a fine-ground surface without visible fresnel rings. A central, split-image rangefinder is surrounded by a microprism collar. Magnification is 0.83 with a 50 mm. lens at infinity and coverage is 93.4 per cent vertically and 95.3 per cent horizontally. The eyepiece strength is −1 diopter and a blind is fitted. The meter readout appears in LED characters below the screen area, varying according to the exposure method chosen.

To the right of the lens are three controls in the mirror box wall. The top button is the exposure memory switch, the next the exposure preview switch and the bottom slider is the stop-down switch, which locks in when the hinged end is raised. Above these controls, in the front of the top plate, is a conventional flash socket.

The back of the camera is removable but the 250-exposure back cannot be fitted. A Data Back is available. Although the camera is primarily designed for FD lenses, all other Canon reflex lenses can be used without the automatic exposure facility, full-aperture metering or auto-iris operation as applicable—but automatic exposure in the stopped-down mode is still possible with FL lenses. Lens changing is the same as on all other models.

The Canon A-1 body measures $141 \times 91.5 \times 47.5$ mm. ($5\frac{9}{16} \times 3\frac{5}{8} \times 1\frac{7}{8}$ inches) and weighs 620 g ($21\frac{3}{4}$ oz.).

## Battery check and renewal

The A-1 operates on a single 6-volt silver oxide battery—Mallory PX28 or similar, which should last about one year in normal use. It should be checked frequently, however, especially if long shutter speeds are habitually used. It is advisable to carry a spare because the camera

cannot be used at all without a battery. A battery case is available for attachment to the camera carrying strap.

The battery loads into the compartment in the front of the camera body with the positive end toward the top. The compartment is opened by pushing inward (toward the lens) the minute lug in the cutout at the bottom of the raised rim. The cover springs up and the battery is easily removed by pressing it downward with a finger nail on to the bottom sprung contact and pulling outward. To insert a battery, place the negative end on the sprung contact and push downward and inward.

To check the battery, press the larger button next to the rewind knob (with the main switch set to A). The LED near the shutter release should blink rapidly. If it blinks slowly (twice a second or slower) or does not light at all, the battery should be replaced.

## Loading the camera

The A-1 loads similarly to the F-1 (see page 30) but with the film winding on to the take-up spool emulsion side out. When you make the blank exposures, however, set the camera for manual operation or turn the exposure mode selector to Tv (shutter-speed preferred) and set to a high shutter speed. If you leave it on automatic exposure aperture-preferred, you may find yourself waiting up to 30 seconds for the shutter to close. If that happens, press the battery check switch to cut off the power and so terminate the exposure.

After loading, set the film speed on the ring surrounding the rewind knob. There is a tiny catch in the rim that has to be pressed inward before the ring will turn. It is not an easy operation for those without adequate fingernails. Turn the ring to bring the appropriate figure opposite the small white index line to the left of the dial (viewed from behind the camera). Check that the exposure compensation setting on the other side of the dial is at 1. The film speeds on the dial run from 6 to 12 800 ASA in the following sequence, the italic figures being represented by dots:

6, *8*, *10*, 12, *16*, *20*, 25, *32*, *40*, 50, *64*, *80*, 100, *125*, *160*, 200, *250*, *320*, 400, *500*, *650*, 800, *1000 1250*, 1600, *2000*, *2500*, 3200, *4000*, *5000*, 6400, *8000 10000*, 12800.

## Viewing and focusing

All SLRs use virtually the same system of viewing and focusing the image and the information for the F-1 is equally applicable to the A-1. There are various viewing accessories available, including eyesight correction lenses, angle finders and a magnifier for precision work.

## Unloading the camera

When the frame counter indicates that you reached your last exposure or the film transport lever cannot be operated you have to rewind the film into the cassette before taking it out of the camera. Press the rewind button in the bottom plate, fold out the crank in the rewind knob and turn it in the direction of the arrow. When the frame counter reaches S, you can stop, leaving the film leader still protruding from the cassette, or give another turn or two to wind the film fully in. Pull up the rewind knob to release the back latch, open the back and tip the cassette from the film chamber.

## Using the exposure meter

Instructions for using the exposure meter of the A-1 are apt to be rather long because it can be used in so many different ways. First, you have to decide on the method—or mode, as the jargon has it. In most cases, that means deciding whether you want to set the aperture and let the meter set the shutter speed (aperture-preferred) or vice versa (shutter-speed-preferred).

Having made your choice, make sure that the lens is set to the automatic position. Press in the small lock pin near the A on the lens and turn the aperture ring until the A (or green circle on older lenses) is opposite the aperture index. It locks into position and cannot be moved until the lock pin is again depressed.

Set the lever behind the shutter release to Av for aperture-preferred or Tv for shutter speed preferred. This brings an aperture scale or a shutter speed scale into the window.

Set on this scale the aperture or shutter speed you wish to use by rotating the milled wheel at the front of the camera, first sliding the guard downward if necessary. This action gives priority to the setting you make. If, for example, you set $f8$, the meter circuitry ensures that

the aperture remains at $f8$ and computes and sets the shutter speed required. If you set a shutter speed, it maintains that speed and computes and sets the aperture required.

You can set the shutter speed scale to any position except B and P. The B setting is for exposures that will run longer than the 30 seconds available on the scale and cannot be used with automatic exposure control. The P setting is for programmed operation as described later.

Set the main switch to A and press gently on the shutter release. Then, as you look through the eyepiece, you see the results of your actions in glowing LED figures below the viewfinder screen. If you have set the shutter speed scale to 1/250 second, you will see the figures 250 to the left of the readout. These figures remain steady. Next to them, you see a figure or figures representing the aperture the meter circuit will set when you press the shutter release. The figures may be unfamiliar, like 9.5 or 27, because the meter displays approximate half stops as well as the normal range. These figures change as the light changes. Move the camera around to point at different lighting levels or, if you are indoors, point it at the TV screen. As the light level varies, so the recommended aperture keeps pace with it.

If you have, instead, set $f8$ on the aperture scale (not on the lens: that must be at the A or green circle setting), the reverse happens. The aperture you set appears in the readout and remains steady while the shutter speed display varies. These figures may be unfamiliar, too, because they also indicate various intermediate settings.

There is a difference, however, between the aperture and shutter speed scales. You can set intermediate apertures but not intermediate shutter speeds. If you do set an intermediate shutter speed, the display will show the next faster or slower speed and the meter uses that for its calculations.

The aperture scale is a little more complicated. It runs from 1.2 to 32, but you can set only to 22 on the dial. If you set an aperture larger than that of your lens (you set 1.4 with the 50 mm. $f1.8$ on the camera), the display reads 1.8 and the meter calculates the exposure on that. If on the other hand you set a smaller aperture than the smallest on your lens it is displayed in the readout and used to

calculate the exposure. As your lens can stop down no further than its minimum, you get an overexposed shot. If you want to set an aperture smaller than $f22$, you have to switch to stopped-down automatic exposure.

Apart from the oddness of the intermediate setting readouts, you have the seconds mark (like quotation marks) after a figure representing whole seconds. Thus 4 indicates one quarter of a second but 4″ indicates four seconds. You may also see such oddities as 0.7″, indicating 0.7 seconds or about three-quarters of a second. Despite that, both aperture and shutter speed are calculated and set steplessly. The readout indicates the approximate settings.

If the shutter speed you have set is too fast for the conditions (light and film speed), the readout shows a flashing indication of the maximum aperture of your lens. You must set a slower shutter speed to give a steady aperture reading. Aperture readouts from 19 to 32 always flash when you are set for shutter speed priority. Whether that indicates that you have set too slow a shutter speed depends on the minimum aperture of your lens. If it is equal to or smaller than the readout figure, your shutter speed is suitable. If the readout indicates a smaller aperture than you have on the lens, you must set a faster shutter speed.

At the end of the range, when $f32$ appears in your viewfinder and you have $f32$ on your lens, your shutter speed may or may not be adequate. Check it by setting a faster shutter speed. If the readout changes to 22, your original shutter speed is suitable. If it still shows 32, continue to set faster shutter speeds until 22 appears. You can then use the next slower speed at $f32$.

On the odd occasion when 16 flashes in the viewfinder and your minimum aperture is $f16$, carry out the same checks.

In extremely low light, when the auto exposure system cannot work, both aperture and shutter speed flash. In over-bright light, the aperture reading flashes no matter what shutter speed you set.

When you are in aperture-priority mode, the warnings are more straightforward. If you set too large an aperture, 1000 flashes in the viewfinder. If you set too small an aperture, one of the slow speeds flashes, depending on

## FOCAL LENGTH AND IMAGE SIZE

In these five examples, it is the background building that should be watched. The nun's position changes. From left to right, top to bottom, these pictures were taken with lenses of 7.5, 17, 24, 28 and 35mm focal length, all from the same shooting distance.

On these two pages, the position of the nun remains unchanged. From left to right, top to bottom, the pictures above were taken with lenses of 50, 85, 100, 135 and 200mm focal length. As the shooting distance remains unchanged, the relative sizes of and distances between figure, foreground and background appear the same throughout the series.

On this page, we move into the really long lens class where tripod mounting is generally necessary. The pictures above, from left to right, top to bottom, were taken with lenses of 300, 400, 500, 600 and 800mm focal length. The shooting distance is the same for all 15 pictures in this set, providing an image magnification, on the film, of more than 100X between the 7.5mm and 800mm shots.

## FOCAL LENGTH AND PERSPECTIVE

When the lens is changed to preserve more or less the same subject size from different shooting distances, the size and apparent distance relationship (perspective) between subject and background changes. The pictures above, left to right, top to bottom, were taken with lenses of 17, 35, 50, 100 and 200mm focal length.

## DEPTH OF FIELD

*Opposite.* When shooting from fairly close range, depth of field is limited, especially when a large aperture is used (*bottom*). Stopping down the lens and careful focusing can ensure overall sharpness (*top*). Your stop-down lever allows you to view the picture at the shooting aperture so that you can check the depth of field.

## PERSPECTIVE CONTROL
*Above*. The orthodox 35mm lens had to be tilted (*left*) to include a reasonable amount of the building. As the back of the camera had to be tilted as well, the result was converging verticals. The 35mm TS lens was tilted independently of the camera body (*right*) to keep the vertical lines parallel.

## CLOSE-UP AND CLOSER
A greatly enlarged view of a watch movement is an easy subject for a standard or moderately long-focus lens with extension tubes or bellows.

When you want to study a section of a pumpkin stem or chrysanthemum closely, the Canon cameras are better used on microscopes with the special photomicro adapters.

### LOW-LIGHT METERING
*Above*. In light far too weak for the average exposure meter, this shot was obtained on colour film with accurate exposure assessment by the Canon Booster.

### ASPHERIC LENS
The remarkably flare-free results at full aperture provided by the 55mm AL lens contrasted with a similar shot by the FD 50mm f1.2.

### FLUORITE LENS
*Opposite*. Fine detail and good contrast at long range are specialities of the FLF 300mm lens with fluorite components.

## MOTOR DRIVE
The three-shots-a-second capability of the Canon Motor Drive Unit made this sequence of shots possible. Such a series can allow various sportsmen to study their technique and to pinpoint errors or areas for improvement.

## TIME LAPSE
*Above.* The variety of motor drive, remote control and time lapse equipment available for the Canon F-1 provides unlimited scope for studying plant life, as well as animal behaviour, cloud formation, progress of scientific experiments, etc.

## ZOOM EFFECTS
*Opposite.* Operating the zoom control of any Canon zoom lens changes the focal length and therefore the image size. If this operation is carried out during the exposure, interesting explosive action effects are obtained.

## TWO FISHEYES
Canon supply two types of fisheye lens. The 15mm (*top*) has an angle of view of 180 degrees on the diagonal only, thus allowing the circular image patch to encompass the whole 35mm format. The 7.5mm (*bottom*) has an angle of view of 180 degrees all round, thus placing the circular image patch within the frame.

maximum lens aperture and film speed. Both flash when auto exposure is impossible.

## Stopped-down auto exposure

Generally, you will work with the camera set for shutter-speed or aperture preferred metering and you will read the exposure at full aperture. With an FD lens connected directly to the camera, you must do that. Stopped-down readings can give wrong exposures.

When, however, you use an FL or other lens not fitted for automatic exposure or when you use an FD lens with extension tubes, bellows or other accessory not fitted for full-aperture metering, you must meter with the lens stopped down. But you still get automatic exposure—in the aperture-preferred mode. You set the aperture and the meter sets the shutter speed.

The procedure with FL lenses is simple. Just attach the lens in the normal way and then lift up the end of the stop-down switch and push inward toward the lens. The switch locks there and the lens diaphragm responds to the aperture control ring.

There is a little more to it when you use an FD lens. You must advance the film first and turn the lens aperture ring away from the A mark. Then push in the stop-down switch. The order of operation is important. If you do not advance the film first, the lens can stop down only as far as the aperture setting used for the previous shot.

With these operations completed, you ignore the shutter-speed/aperture dial. It does not matter whether it is set to Tv or Av. You use the lens aperture control only. Set the aperture you require and look through the viewfinder eyepiece. The readout indicates the shutter speed the meter will select. If the figures flash, you have set too small or too large an aperture. If they still flash when you set the smallest or largest aperture, you are outside the meter coupling range and must either change the lighting or switch to manual control. Although this is an aperture-priority mode, you can, of course, control the shutter speed simply by varying the aperture until the shutter speed you require appears in the readout.

Don't forget to disengage the stop-down switch before returning to normal automatic operation. Although you cannot push the switch in when the lens is set to A, you

can set the lens to A with the switch in. Then the meter continues to read in the stopped-down mode but only at the minimum aperture of the lens. Exposure will probably be correct but the practice is not good for the camera's well-being.

The main advantage of stopped-down auto exposure is in close range work with macro and micro accessories. The camera should then be rigidly supported and you can use very small apertures to extend depth of field to the limit. The length of the exposure does not usually matter and the automatic control of the TTL meter and shutter gives you exposures up to 30 seconds. There is the risk, of course, that you could run into reciprocity problems, particularly with colour, if the exposure runs to more than a few seconds. Then you have no option but to switch to manual control. Automatic exposure control has its limits —and very long exposure settings on a camera are of little value in this field.

Another limitation is that you cannot use stopped-down AE metering together with the Power Winder or Motor Drive. If either of these accessories is connected, you must switch it off.

There are other awkward aspects of stopped-down AE work with the A-1. One is the normal mishap of mounting a lens with the stop-down switch pressed in. The aperture ring cannot then couple correctly with the aperture lever in the camera body and exposure meter readings are inaccurate.

You get into trouble if you change your mind, too. If you push in the stop-down switch and then decide not to use it after all, you can release it in the normal way. The camera promptly jams. You cannot release the shutter or move the film transport lever and a row of Es glows in the viewfinder.

The emergency is corrected by pushing the film transport lever to its fully retracted position and pushing the little lever below it (the multiple exposure lever) to the left. Then you can retension the shutter without moving the film and the camera should return to normal operation.

## Disengaging the automatics

Automatic exposure control is suitable for all general

## AE MODES OF THE CANON A-1

With the mode selector at Tv, the camera is set for AE operation with shutter speed priority. The aperture setting varies automatically with changing light conditions.

At Av, the aperture setting takes priority and the shutter speed is changed automatically to maintain correct exposure.

Setting the scale to P with the selector switch at Tv, puts the camera into fully automatic mode. Both aperture and shutter speed change according to the amount of light passing through the lens.

Aperture priority AE can also be carried out with the lens stopped down. Disengage the lens from the A mark and push in the stop-down switch.

When one of the special Canon Speedlites is attached to the camera, both shutter speed (1/60 sec) and aperture are set automatically.

photography. If you have an A-1, there is no point in not using its AE capability for most of your photography. There are occasions, however, when you might prefer to control the exposure yourself. Obvious examples are flash photography without the special Canon units, exposures of more than a second or two (for which AE methods are really totally unsuitable) and any occasion when you do not want the theoretically correct exposure. You can, of course, control the meter to some extent by using the exposure compensation settings or even by setting the "wrong" film speed, but full manual control is often preferable.

Overriding the automatics is reasonably simple. You just disengage the automatic setting of the lens so that you can set the aperture manually and turn the AE mode selector to Tv, so that you can set shutter speeds.

You still get a display in the viewfinder. The letter M shows to indicate that the lens is not on the auto setting. You also see shutter speed and aperture settings. That is useful to the extent that you see the shutter speed you have selected. It is misleading because the aperture indication is not the aperture you have set on the lens: it is the aperture the meter would select if you were in the AE mode. If you find that distracting, you can switch the display off. There is a switch next to the pentaprism at the rewind end of the camera.

You should switch off the display in any case when you use an FL lens or any other lens not fitted for full aperture metering. With these lenses, the readout at full aperture is unreliable.

## Automatic flash exposures

Two special flash units supplied by Canon—the Speed-lites 155A and 199A—give completely automatic exposure control on both the AE-1 and A-1. Both units are fully described in the appropriate chapter. AE flash is available only with an FD lens, because the lens has to be set for automatic working.

If you wish to use either Speedlite with an FL or other non-AE lens, you still have automatic flash control but have to set the lens aperture manually in accordance with the auto setting you have selected on the Speedlite.

116

The viewfinder readout indicates the aperture to which you must set the lens.

## Programmed automatic exposure

The fifth method of automatic exposure on the Canon A-1 is the so-called programmed type. This was first introduced on relatively simple cameras many years ago and died a natural death very shortly afterward. It suffers from one overriding and unavoidable snag—even apparently with the advanced electronic components of the A-1. Without introducing a variety of switches or levers that would defeat the object of simplicity (and one camera did indeed have multiple shutter releases) programmed exposure must mean that the variety of settings possible for a given light level—say 2 seconds at $f$22 and all its equivalents—be reduced to one. The one selected by Canon for this eventuality is, in fact, 1/30 second at $f$2.8 which would not be much use to you if you wanted maximum or even reasonable depth of field. At the other extreme, where the exposure possibilities might be equivalent to 1/500 second at $f$2, the meter would actually give you about 1/90 second at $f$4.5, which would make rather a mess of a fast-moving subject. In average bright conditions, where exposure might be in the region of 1/250 second at $f$8 with a 100 ASA film, that is, in fact, approximately the exposure you would get.

This gives the clue to programmed operation. It works reasonably well at normal light levels, with medium speed films, giving exposures from 1/125 second at $f$5.6 to 1/500 second at $f$11. If you want 1/250 second at $f$4, you can't have it. You have to settle for 1/125 second at $f$5.6. You have no control at all over aperture or shutter speed at any given light level. The only way you could influence them would be by changing the light level or the film.

The system is designed for snapshooting and can be moderately successful in reasonably bright light, when depth of field is relatively unimportant and the subject is not too fast moving. In other conditions it can lead to a lot of failures.

The procedure for programmed AE operation simply consists of setting the mode selector to Tv and turning the shutter speed dial to P. All you have to do is frame and

focus your picture and shoot. The readout shows the approximate aperture and shutter speed that will be used but as the system is designed for the photographic ignoramus, this readout is really a "go" or "no go" indication that the user would not understand.

## Viewfinder readout

Various buttons and switches control the meter readout of the A-1. The normal method of taking a reading, with the main switch on, is to press the shutter release gently. The LEDs then light up, generally showing shutter speed and aperture. In many circumstances of movement or changing light level in the subject area, the meter circuit constantly computes alterations to shutter speed and aperture. This frantic activity, perhaps making very minor changes and taking only milliseconds to complete each operation, is not constantly transmitted to the readout. The LED segments could not light and go out at such a rate and, even if they could, you would not be able to read the fast-moving figures.

The display receives its signal every half a second and you might press the release before a really significant change in light level altered the readout considerably. You still get accurate exposure, however, because it is only the information signal to the readout that is delayed. The camera operation is virtually instantaneous.

The use of LEDs makes the display visible in any conditions, so that it does not have to be illuminated. At low light levels on the screen, however, a brilliant readout could be distracting. Accordingly, the brilliance of the readout is varied with the illumination of the screen. If you still find it distracting, you can switch it off by turning the lever around the battery check button to cover the white dot.

The shutter button is not the only switch for the read-out. You can also obtain it by pressing the exposure pre-view button just above the stop-down switch or the exposure memory button just above that—but the memory button locks the exposure value then set. You generally use the exposure preview button for a reading to make it easier to change shutter speed or aperture at the same time.

## SHOOTING WITH THE CANON A-1

To operate the Canon A-1, set the main switch to A and the lens aperture ring to bring the A opposite the aperture index.

Set film speed and check that the exposure compensation dial is set to 1.

Focus and compose the picture.

Set the AE mode selector to shutter priority *(left)* or aperture priority *(right)*. Take up first pressure on the shutter release.

Look through the viewfinder and check the readout. You can alter either shutter speed or aperture (depending on the mode you have selected) and the other setting will change to maintain correct exposure.

When the settings are satisfactory for the picture, press the shutter release fully down to take the picture.

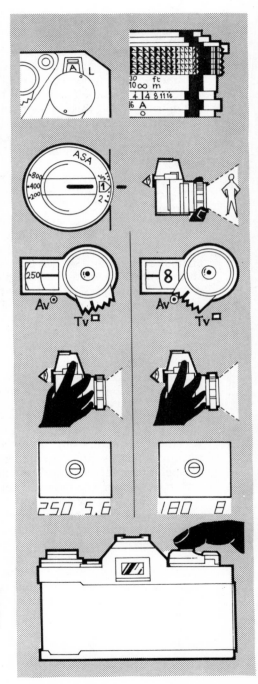

## Exposure memory switch

Some subjects are unsuitable for automatic exposure but need only comparatively minor correction. The usual example is a subject with a very light or very dark background occupying a large part of the picture area. The meter takes too much account of the background tone.

One way round this problem on the A-1 is to approach the main subject closely, excluding as much background as possible, take a reading and press the exposure memory switch. The meter is then told to hold that light value, no matter what it actually sees coming through the lens. Wherever you point the camera, the readout stays the same as long as you keep the exposure memory switch pressed in.

You can, however, change the shutter speed or aperture, depending on the AE mode you have selected. The meter will still hold the light value, compensating for the change by altering the aperture setting to suit the new shutter speed or vice versa. But you must keep the memory switch pressed in throughout the operation and until after you have released the shutter.

Don't use a close-up reading in these circumstances if the subject itself is of extremely light or dark tone. That will simply obtain an exposure to render it as a mid-tone. Take your reading from a substitute mid-tone, such as a grey card or any nearby object of suitable tonal value. Then press the memory switch and proceed as described.

## Exposure compensation dial

When the variation from auto exposure is expected to be within two stops either way, you can use the exposure compensation dial instead of the exposure memory switch or changing to manual operation.

The exposure compensation settings are part of the film speed dial and their effect is, in fact, the same as a change in the film speed. The settings are 1/4, 1/2, 1, 2 and 4. The normal AE setting is 1. The fractions indicate one or two stops less than the meter circuit would normally recommend and the whole numbers one or two stops more. Intermediate settings at 1/3 stop intervals may be made—although the readout shows only half stop changes.

To set the exposure compensation dial, press the lock button behind the battery check button and turn the outer rim of the dial the required amount. When you let go of the lock button the dial is locked in place. Do not forget to reset it when returning to normal operation.

## Multiple exposures

The Canon A-1 has special provision for making more than one exposure on the same frame—against which unintentional mishap you are protected by the interlocking film transport and shutter tensioning controls.

Make the first exposure in the normal way but do not wind on the film. Push the transport lever fully in and turn the small lever underneath it to the left. Now operate the transport lever, which tensions the shutter but does not advance the film. The multiple exposure lever returns to its normal position. If you want a third exposure on the same frame, you must repeat the procedure. Theoretically there is no limit to the number of exposures that can be so made and perfect registration is possible. In practice, apart from possible movement of the film, perfect registration generally depends on perfect arrangement of the subject matter and that is rarely possible on a 35 mm. camera.

When double or multiple exposures are in the nature of superimpositions, i.e. without masking off or otherwise blackening an area in which the second exposure is to be placed, each exposure should be shorter than normal. Experiment is the best tutor but you can start by dividing the exposure by the number of shots. This is most easily done by setting the exposure compensation dial to 1/2 for two shots, between 1/2 and 1/4 for three shots, or to 1/4 for four. Any more would be pushing your luck, but you can obtain the same effect by altering the film speed setting accordingly—setting it to six times its normal value for six shots, etc.

If you change your mind after setting the multiple exposure lever, you still have to make the extra exposure. There is no way of moving the film forward without tensioning the shutter—and that is already tensioned. You can minimise or eliminate the risk of fogging by setting the lens to manual control, stopping it down to the limit and putting the lens cap on. Set the shutter speed to

1/1000 second and release the shutter. If you can do that in darkness or near darkness there should be no harm done. Do not do it with the lens set to automatic. You might get a 30-second exposure and even low light might get past the lens cap in that time.

Neither in this case nor in the normal multiple exposure operation does the frame counter operate. It operates only with the actual movement of the film and is a genuine frame counter rather than an exposure counter.

## Self-timer and shutter release lock

The A-1 self-timer and shutter release lock share the same open lever around the hub of the film transport lever. In the straight ahead position the opening frames the letter A, which is the normal ON position. The lever has to be in that position for all operations because in the L position it switches off the power to the shutter release. The button is not, in fact, physically locked when the lever is in the L position but it is rendered inoperative.

As the lever is moved past the L position, it can be set to the figure 2 or 10. These are the self-timer settings, giving a delay of 2 or 10 seconds between pressing the shutter release and the opening of the shutter. To use the self-timer, first transport the film and set the shutter speed scale to any position except B. Turn the self-timer lever to 2 or 10, depending on the delay you require. The meter continues to compute the required exposure but, if you intend to leave the camera so that your eye is not at the eyepiece, the exposure could be affected by light passing through the eyepiece. Accordingly, close the eye-piece shutter with the small lever to the left of it.

When you press the shutter release the timing circuit is activated. As it is electronic and silent, a small lamp to the left of the lever flashes at half-second intervals. Two seconds before the shutter is due to be released, the flashing rate speeds up to eight times a second.

The lever remains set after the shutter has been re-leased and the self-timer continues to operate for sub-sequent exposures until the lever is returned to its A or L position. Returning the lever to L stops the operation once it has started running. Alternatively, pressing the battery check button has the same effect. Both operations turn off the camera's power supply.

## Accessories

Various accessories have been introduced specifically for the A range of cameras. These include a power winder, motor drive for the A-1 only, automatic electronic flash units, data back and the usual range of eyepiece attachments. Most of the lenses and lens-mount-fitting accessories for other Canon reflexes can also be used with the A-1.

# FEATURES AND OPERATION OF CANON AE-1

The Canon AE-1 is the camera that caused a great deal of comment about its unexpectedly low price when it first appeared on the market in 1976. It is a camera that pushed the use of electronics even farther than it had already reached in both camera operation and construction. The AE-1 is built on modular principles with modules designed and manufactured with considerable assistance from computer technology.

## Technical specification

The Canon AE-1 is a 35 mm. single-lens reflex camera with through-the-lens metering and shutter-priority automatic-exposure facilities. It reads the whole screen area with central emphasis. Superficially, therefore, it is similar to the Canon EF but in both construction and operation it is radically different. The shutter is a horizontally-moving cloth type with speeds from 2 seconds to 1/1000 second and B—all electronically controlled and operated. The speeds can be set manually but the camera cannot operate at all without a battery. As on the EF, the shutter speed dial is around the hub of the film transport lever and has a milled edge for one-finger operation. A guard around the rear of the rim prevents accidental operation. The shutter synchronises with electronic flash at 1/60 second via contacts in the accessory shoe or a coaxial (PC) socket in the front of the top plate. A self-timer gives a delay of 10 seconds.

The shutter release is in the orthodox position but is a large button with a central cable release socket and a large rim turned by lever to provide self-timer and shutter release lock facilities. The release is, in fact, a switch controlling a new form of combination magnet that controls the shutter opening. The frame counter behind the shutter release indicates the number of exposures made and also operates in reverse on rewind.

The base of the camera has the normal tripod socket and rewind button, electrical terminals for power wind at one end and motor coupling gear under a removable cover at the other. To the left of the lens, viewed from the front, is the battery compartment, with a hinged cover that has a raised edge said to form a useful finger grip. A tiny catch has to be pushed with a fingernail to cause the cover to spring up. Alternatively, you can use the edge of the cover in the accessory shoe that also doubles as an eye-piece shutter. The compartment houses a single 6-volt silver oxide battery that powers all the camera functions.

To the right of the lens are three controls in the mirror box wall. The top chrome button is a "backlight" control giving $1\frac{1}{2}$ stops more exposure than the automatic metering would allow. The black button below it is for exposure preview, showing in the viewfinder the aperture selected by the meter circuit. The slider at the bottom is the diaphragm stop-down control for FL lenses or FD lenses used in the stop-down mode on tubes, bellows, etc. In the front of the top plate above these controls is a conventional X-sync flash socket.

The pentaprism housing carries a hot-shoe with contacts for the automatic Speedlite 155A. It is a sealed unit with a particularly bright viewfinder screen. A central split-image rangefinder spot is surrounded by a micro-prism collar on a fine matt field without visible fresnel rings. A blue-tinted mirror and internal silvering help to give a bright even field. Magnification is 0.86 with a 50 mm. lens at infinity and coverage is 93.5 per cent vertically and 96 per cent horizontally of the actual picture area.

An aperture scale appears at the right side of the screen with red over-exposure zones at the top plus a flashing M if the lens is not set for automatic operation and a flashing dot at the bottom as an underexposure warning.

The rewind knob and crank are orthodox and also serve as the back latch release. Next to the rewind knob is the battery check button, which also clears all other electronic functions.

The back of the camera is removable in the same way as that of the F-1 but the 250-exposure back cannot be fitted. A Data Back is available. The camera is primarily designed for use with FD lenses but all other Canon

reflex lenses can be used without the automatic-exposure facility. Lens changing is the same as on all other models.

The Canon AE-1 body measures $141 \times 87 \times 47.5$ mm. ($5\frac{9}{16} \times 3\frac{7}{16} \times 1\frac{7}{8}$ in.) and weighs 590 g. ($20\frac{13}{16}$ oz.).

## Battery check and renewal

The AE-1 operates on a single silver oxide 6-volt battery, Eveready 544, mallory PX 28 or equivalents. The battery should last about one year in normal use. Always carry a spare because the camera cannot work without its battery. A battery case is available for attachment to the camera carrying strap.

The battery loads into the compartment in the front of the camera body with the positive end toward the top. The compartment is opened by pushing inward (toward the lens) the minute lug in the cutout at the bottom of the raised rim. The cover springs up and the battery is easily removed by pressing it downward with a finger nail on to the bottom sprung contact and pulling outward. To insert a battery, place the negative end on the sprung contact and push downward and inward.

To check the battery, press the button next to the rewind knob while looking through the eyepiece. The meter needle should move down to below the mark next to 5.6. If it does not, the battery needs renewing.

There is no on-off power switch. The first pressure on the shutter release switches on the meter circuit and full downward pressure releases the shutter. It is therefore advisable to lock the shutter release when the camera is not in use.

## Loading the camera

The AE-1 has no quick-load facility because the back is removable. Loading procedure is the same as on the F-1 but the film winds on to the take-up spool emulsion out. The frame counter is behind the shutter speed knob. It resets to the S mark when the camera back is opened and, unlike the F-1 counter, also operates in reverse when the film is rewound. It indicates the number of exposures made.

After loading, set the film speed. This is a clumsy operation because you have to pull the film transport lever out to its stand-off position to enable you to get

## CANON AE-1

The main features of the Canon AE-1 are:

1. Carrying strap lug.
2. Battery compartment latch.
3. Shutter release.
4. Accessory shoe.
5. Lens locating index.
6. Battery check button.
7. Backlight control.
8. Flash socket.
9. Rewind knob.
10. Battery compartment.
11. Exposure preview switch.
12. Stop-down switch.
13. Shutter speed dial.
14. Film transport lever.
15. Frame counter.
16. Auto flash contacts.
17. Battery check button.
18. Rewind crank.
19. Film speed setting.
20. Shutter release.
21. Self timer/shutter release lock.
22. Flash contact.
23. Power wind contacts.
24. Tripod bush.
25. Rewind button.
26. Power wind coupling.
27. Power wind locating hole.
28. Viewfinder screen.
29. Microprism rangefinder.
30. Split-image rangefinder.
31. Meter needle.
32. Stopped-down metering/battery check index.

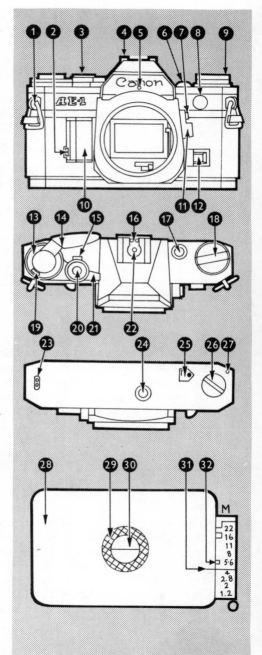

two fingers on to the serrated rim of the shutter speed ring. Pull upward on the rim and turn it to bring the appropriate figure into the cutout. It does not seem to be possible to do this without one finger obscuring the cutout. The speeds run from 25 to 3200 ASA in the following progression, the italic figures representing the dots between marked figures:

25, *32*, *40*, 50, *64*, *80*, 100, *125*, *160*, 200, *250*, *320*, 400, *500*, *650*, 800, *1000*, *1250*, 1600, *2000*, *2500*, 3200.

## Viewing and focusing

All SLRs use virtually the same system of viewing and focusing the image and the information given on page 30 for the F-1 is equally applicable to the AE-1. The viewfinder readout is not unlike that of the F-1. It has a meter needle and aperture scale with over and underexposure warning zones but no aperture pointer—like the F-1 in automatic mode. Additionally, however, the AE-1 has a red letter M above the scale that flashes when the lens is not set for automatic exposure and a flashing light below the scale to indicate underexposure.

## Unloading the camera

When the frame counter indicates that you have reached your last exposure, or the film transport lever cannot be operated, you have to rewind the film into the cassette before taking it out of the camera. Press the rewind button in the bottom plate, fold out the crank in the rewind knob and turn it in the direction of the arrow. When the frame counter reaches S, you can stop, leaving the film leader still protruding from the cassette, or give another turn or two to wind the film fully in. Pull up the rewind knob to release the back latch, open the back and tip the cassette from the film chamber.

## Using the exposure meter

The Canon AE-1 exposure meter is a full-aperture, through-the-lens, automatic exposure, shutter-priority type. This simply means that you set the shutter speed and film speed and the meter circuit both determines and sets the aperture according to the light intensity on the viewfinder screen as read by a silicon sensor. The aperture selected is indicated in the viewfinder by a needle moving

## SHOOTING WITH THE CANON AE-1

To operate the Canon AE-1, set film speed and set lens to A mark.

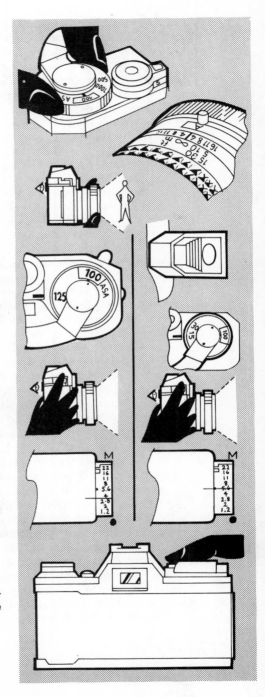

Compose and focus the picture.

For full-aperture metering *(left)* set a suitable shutter speed. Take up the first pressure on the shutter release and check the aperture selected by the meter as shown in the viewfinder. If it is not suitable for the picture, change the shutter speed until the required aperture setting is indicated.

For stopped-down metering *(right)* with non-FD lenses or accessories with no auto-iris facility push in the stop-down switch and set the required shutter speed.

Press shutter release gently and check the meter needle position in the viewfinder. Adjust aperture and/or shutter speed to bring the needle to the stopped-down metering index mark.

Finally, press the shutter release fully down to take the picture.

over a scale after light pressure on the shutter release or somewhat firmer pressure on the exposure preview switch (which can be operated with the shutter release locked).

Automatic exposure control is possible only with Canon FD lenses set to the A or green circle mark on the aperture ring. Lenses produced or redesigned for the AE-1 have a small pin to the right of the A that has to be held down while changing from manual to auto setting or vice versa.

For AE operation of the meter, the procedure is:

(1) Set film speed.

(2) After framing and focusing the image, turn the lens aperture ring to the A or green circle setting.

(3) Set the shutter speed at which you intend to shoot by rotating the dial around the film transport lever shaft until the appropriate figure is opposite the white index line beside the shutter release.

Speeds run from two seconds to 1/1000 sec with the 2 sec setting in orange to distinguish it from the $\frac{1}{2}$ sec setting. The selected shutter speed is not indicated in the viewfinder.

(4) Press the shutter release gently while looking through the viewfinder eyepiece and check the meter needle position. Provided it is not in one of the red zones at the top of the scale and provided the red light at the bottom of the scale does not flash, you can depress the shutter release fully and take the picture.

(5) If the needle is in the red area above the figure 16 you can still shoot if your lens has an aperture of $f$22. If not change the shutter speed to bring the needle lower down the scale. For this operation, you will find it easier to use the exposure preview switch rather than the shutter release. If the needle is in the red area above $f$22, you have to change the shutter speed unless you have a lens with an $f$32 or smaller aperture. In that case, first set a faster shutter speed until the needle indicates $f$22 and then change the shutter speed to one step slower for $f$32, two steps for $f$45, etc.

(6) If the needle is toward the bottom of the scale and the red spot below the scale is flashing, the shutter

speed set is too fast for the light conditions and the maximum aperture of the lens. Set to slower shutter speeds until the light stops flashing.

The underexposure warning light will also flash if the shutter speed set is outside the meter coupling range. The meter couples at all shutter speeds for film speed of 50 ASA and slower. At 100 ASA the two-second setting cannot be used. At 200 ASA, the longest usable speed is 1/2 second; 400 ASA, 1/4 second; 800 ASA 1/8 second; 1600 ASA 1/15 second; 3200 ASA, 1/30 second. The meter does not couple with the B setting of the shutter.

If you forget to set the lens for auto operation, a red M flashes at the top of the aperture scale in the viewfinder.

(7)   With the necessary adjustments to aperture and shutter speed made, depress the shutter release fully to take the picture.

The exposure set by the AE-1 auto exposure facility is based on a reading of the viewfinder screen with central emphasis. This gives perfect exposure for most subjects but strong back or side lighting may put important parts of the subject in shadow. In such cases, you can press the "backlight" switch as well as the shutter release and so obtain 1½ stops extra exposure. The AE-1 does not have a memory lock control.

## Stopped-down readings

Neither full-aperture metering nor the auto exposure system of the AE-1 can be used with lenses other than the Canon FD type or when bellows, extension tubes or other accessories are placed between the lens and the camera body.

The stopped-down metering method with non-FD lenses is virtually the same as with the Canon F-1. The stopped-down index mark on the AE-1 is opposite the 5.6 mark on the aperture scale in the viewfinder. The stop-down lever on the AE-1 can be locked in the stop-down position by pushing it fully inward past the locking chrome button. It is released by pressing the button. Do not mount a lens with the lever locked.

To take a reading with the lens stopped down, press the

shutter release gently or press the exposure preview switch and adjust shutter speed and/or aperture until the meter needle lines up with the metering index.

When using an auto-iris lens for stopped-down readings, be careful to take the reading only after transporting the film. Before that, the lens will not stop down farther than the aperture used for the previous shot.

## Using flash

The Canon AE-1 has a hot shoe contact in the accessory shoe on the pentaprism and a coaxial socket on the front of the camera top plate. A small protective cap plugs into the socket. A plastic cover for the hot shoe can also be used as an eyepiece shutter for long-exposure work on a tripod. Both the hot shoe contact and the socket are X-synchronised for electronic flash at 1/60 second and bulbs at 1/15 second. They can be used simultaneously to fire two units. The shutter is X-synchronised only. It will synchronise with flashbulbs but only at speeds of 1/15 second and slower. It has no provision for synchronising FP bulbs at faster speeds.

The hot shoe has two additional contacts for the Speedlite 155A, a special cordless electronic flash unit described in the chapter on Flash Equipment and Usage.

## Self-timer and shutter release lock

The normal position of the lever on the shutter release is parallel with the camera front. When pulled forward to protrude from the camera front, it delays the shutter release for about 10 seconds. It does not operate unless the shutter is tensioned. If you return the lever to its normal position after pressing the shutter release, the shutter fires. You can cancel the operation of the timer by pressing the battery check button, which switches off the electrics. If, for example, you set a shutter speed of 2 seconds and then press the battery check button, the shutter closes.

The delayed action mechanism works silently, because it is electrical. While it is operating, a light normally concealed by the lever flashes at a rate of two flashes per second.

Do not stand in front of the camera when releasing the shutter with the self-timer in operation. The meter reads

and memorises the exposure immediately the shutter release is pressed.

When pushed inward away from the front of the camera, the lever acts as a shutter release lock. It does not, however, allow the shutter to be locked open.

# FEATURES AND OPERATION
# OF CANON AT-1

The Canon AT-1 is only partly an electronic camera. It has the same electronically-controlled shutter and self-timer as the AE-1 but it remains a straightforward, no-frills, easy-to-operate camera in the traditions of the Canon FT and FTb. It had to replace the FTb because it could be produced less expensively, thanks to Canon's computerised production line and modular design and construction. It is the camera for those who prefer the traditional match-needle approach to exposure control or who see only marginal benefits from the extra cost of automatic exposure facilities.

## Technical specification

The Canon AT-1 is a 35 mm. single-lens reflex camera with through-the-lens metering at full aperture, reading the whole screen area with central emphasis. It uses a CdS sensor coupled to a needle in the viewfinder, and a pointer coupled to aperture, film speed and shutter speed controls. When the needle and pointer are brought together, the camera controls are set for correct exposure.

The shutter is a horizontally-moving cloth type with speeds from 2 seconds to 1/1000 second and B—all electronically controlled and operated. The shutter release is an electrical switch and the camera cannot therefore be used without a battery. The shutter speed dial is around the hub of the film transport lever and has a milled edge for one-finger operation. A guard around the rear of the rim prevents accidental operation. The shutter synchronises with electronic flash at 1/60 second via contacts in the accessory shoe or a coaxial (PC) socket in the front of the top plate. A self-timer gives a delay of 10 seconds.

The shutter release and the rest of the specification are as on the AE-1 with one or two minor exceptions. There is

## CANON AT-1

The main features of the Canon AT-1 are:

1. Carrying strap lug.
2. Battery compartment latch.
3. Battery compartment.
4. Accessory shoe.
5. Lens locating index.
6. Stop-down switch.
7. Flash socket.
8. Shutter speed dial.
9. Film transport lever.
10. Frame counter.
11. Shutter release.
12. Self timer/shutter release lock.
13. Auto flash contact.
14. Flash contact.
15. On/off switch.
16. Rewind crank.
17. Power wind contacts.
18. Tripod bush.
19. Rewind button.
20. Power wind coupling.
21. Power wind locating hole.
22. Viewfinder screen.
23. Split image rangefinder.
24. Microprism rangefinder.
25. Meter needle.
26. Meter pointer.
27. Overexposure warning/battery check index.
28. Underexposure warning.

only one extra contact in the accessory shoe—for automatic shutter speed setting with the Speedlite 155A. The AE-1 has a further contact for aperture setting. The AT-1 has no backlight control or exposure meter preview button in the mirror box wall. It does, however, have the same type of stop-down switch as the AE-1.

## Battery check and renewal

The AT-1 operates on a single 6-volt silver oxide battery —Eveready 544, Mallory PX28 or equivalent. The battery should last about one year in normal use but frequent checks should be made and it is advisable to carry a spare. The camera cannot be used at all without the battery. A battery case is available for attachment to the camera carrying strap.

The battery loads into the compartment in the front of the camera body with the positive end toward the top. The compartment is opened by pushing inward (toward the lens) the minute lug in the cutout at the bottom of the finger grip. The cover springs up and the battery is easily removed by pressing it downward with a fingernail on to the bottom sprung contact and pulling outward. To insert a battery place the negative end on the sprung contact and push downward and inward.

To check the battery, pull back the main switch around the rewind knob to bring the index line to the C position. Look through the viewfinder eyepiece and check the position of the meter needle. It should be above the nick toward the top of the screen. If it is not, replace the battery.

The main switch controls the camera's power circuit to both shutter and meter. It should be in the off position when the camera is not in use. To operate the camera the switch must be turned to ON. The camera cannot function without battery power.

## Loading the camera

The AT-1 loads in the same way as the other current models with the film winding on to the take-up spool emulsion out. As on the AE-1, the frame counter operates in reverse when the film is rewound. In use, it shows the number of exposures made.

Film speed is also set as on the AE-1 by pulling upward

and rotating the serrated rim of the shutter speed ring. The film speeds from 25 to 3200 ASA are as on the AE-1.

## Viewing and focusing

With the camera loaded and film speed set you are almost ready to take pictures, but first you have to sight the picture and focus it correctly. This is virtually the same operation with all SLR cameras and the information given for the F-1 applies equally to the AT-1.

The viewfinder readout is different, however. The AT-1 uses one of the simplest exposure metering methods. All that you see in the viewfinder, apart from the image, are an unobtrusive needle and circular pointer and two small marks at the edge of the screen to indicate over and underexposure positions of the needle. There is no indication of aperture or shutter speed set.

## Using the exposure meter

The AT-1 exposure meter works on simple principles. With the subject properly framed and focused in the viewfinder, the film speed set and the camera main switch on, you adjust aperture and/or shutter speed until the needle bisects the circular pointer. That is all. Aperture and shutter speed are then set for correct exposure.

Naturally you have choices, because, although the meter needle moves only under the influence of light passing through the lens, the pointer moves in either direction as you change aperture or shutter speed. In most circumstances you select a suitable shutter speed and then bring the pointer to the correct position by varying the aperture. If you wish to shoot at a particularly large or small aperture for depth of field reasons, you can, however, reverse the procedure.

You may not always want to set the theoretically correct exposure, or, in low light, you may not be able to make the needle and pointer coincide. The size of the circular pointer gives an indication of the over or underexposure you can risk or deliberately set. The full width of the circle is equal to one lens aperture or stop. With the needle at the top or bottom edge, therefore, you have half a stop departure from the ideal.

The meter uses a CdS sensor to read the whole screen area with more emphasis on the centre and bottom of the

image area than the top. That is logical enough when you take a horizontal picture outdoors and include the sky in your picture. It makes little sense otherwise but is an accepted convention that works well enough in practice.

Exposure meters built into cameras have a limited range of operation—called the coupling range. It is adequate for most subjects in reasonable lighting conditions but on Canon cameras generally allows the slowest shutter speed on the camera to be used only with a film of 25 ASA. As film speed increases in doubling steps, so one slower shutter speed fails to couple with the meter. With a film speed setting of 3200 ASA, therefore, the slowest usable shutter speed is 1/125 second. At a more normal 400 ASA, the slowest usable speed is 1/15 second. You can still shoot at the slower speeds, of course, but you cannot meter the exposure directly.

It is important on the AT-1 to keep your finger off the shutter button while taking a meter reading. The shutter release switch is sensitive and, if the battery is getting low, any extra drain on it can affect the meter reading unpredictably.

## Stopped-down metering

Canon's FD lenses are for full-aperture metering only when directly attached to the camera. When they are used with most behind lens accessories, however, such as bellows, extension tubes, etc, or when FL lenses are used, full-aperture metering is impossible. In such cases, you use the stop-down switch to take the meter reading with the lens diaphragm set to the shooting aperture.

The FD25 and FD50 extension tubes for the FD50 and 100 mm. macro lenses are designed for full-aperture metering, whereas other accessories may have no full-aperture teller or even automatic-iris facility. Then, the lens diaphragm has to be operated manually. If it is an automatic type, you can lock the automatic-iris lever as described on page 252. The lens then acts as a manual type with the aperture opening and closing as you move the aperture ring.

To take a stopped-down reading with the lens on the camera or with an automatic-iris accessory, proceed as usual, framing and focusing the picture and switching on the meter. Then push the stop-down switch inward

## SHOOTING WITH THE CANON AT-1

To operate the Canon AT-1, turn the main switch to ON.

Set the film speed.

Compose and focus the picture.

For full-aperture metering *(left)*, set a suitable shutter speed, look through the viewfinder and check that the needle is between the index marks. If not, set another shutter speed.

Adjust aperture until needle bisects circular pointer. The camera is then set for correct exposure.

For stopped-down metering *(right)*, push in stop-down switch.

Set shutter speed and adjust aperture as for full-aperture metering.

In either case, you can reverse the procedure and set the aperture first if you wish, then adjusting shutter speed to align needle.

Finally, press the shutter release to take the picture.

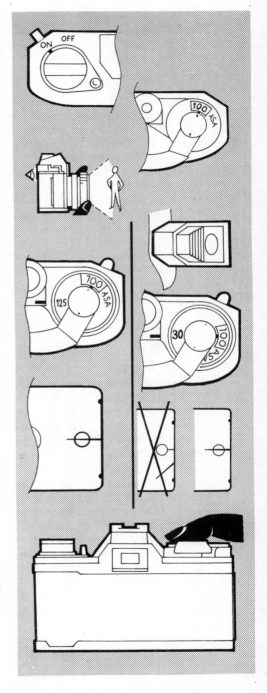

toward the lens before lining up the meter needles. When the switch is pressed fully in, it locks and can be released only by pressing the button then uncovered. Make sure that the switch is unlocked before attaching a lens to the camera.

## Self-timer and shutter release lock

The lever on the shutter speed knob has a dual function. Pulled toward the back of the camera, it locks the shutter release. Pushed forward it switches on the self timer. It cannot lock the shutter open.

To operate the self timer, first tension the shutter and set the shutter speed required. Push the lever fully forward and, with the picture framed and focused, press the shutter release. After a delay of 10 seconds, the shutter is released. While the timer is in operation, a small lamp normally concealed by the lever flashes on and off.

If you change your mind and wish to cancel the self timer, do not return the lever to its normal position. That will immediately release the shutter. First turn the main switch to off and then return the lever. Do not leave it in the forward position or the self timer will operate again next time you press the shutter release.

## Using flash

The Canon AT-1 has a hot shoe contact in the accessory shoe on the pentaprism and a coaxial socket on the front of the camera top plate. A small protective cap plugs into the socket. A plastic cover for the hot shoe can also be used as an eyepiece shutter for long-exposure work on a tripod. Both the hot shoe contact and the socket are X-synchronised for electronic flash at 1/60 second and for bulbs at 1/15 second. They can be used simultaneously to fire two units. There is no provision for synchronising FP bulbs at faster shutter speeds.

The hot shoe has an additional contact for Canon's special Speedlites (155A and 199A). These are automatic exposure models with built-in sensor to control the flash duration. Additionally, however, they have electrical contacts to allow automatic shutter speed and aperture setting on the A-1 and AE-1. The AT-1, with no auto exposure facility, has only the one extra contact that sets the shutter speed to 1/60 second when the Speedlite is

140

attached to the camera accessory shoe, provided the shutter speed dial is not set to B. The aperture you set manually according to the method of operation.

## Unloading the camera

When you come to the end of the film, you have to wind it back into the cassette. This is the same operation as on the A-1.

## Accessories

The AT-1 takes all the accessories of the AE-1, including Power Winder and Data Back, as well as the normal range of accessories for other Canon SLRs. It cannot use the Motor Drive MA for the A-1.

# FEATURES AND OPERATION
# OF CANON EF

After the F-1—practically the last word in system cameras—Canon's next obvious move was into the field of compact, highly sophisticated, automatic exposure cameras. Their first product came early in 1974 with the introduction of the Canon EF—a forerunner of the later-generation A range.

## Technical specification

The Canon EF is a 35 mm. single lens reflex through the lens automatic exposure camera—SLR TTL AE. It bears a strong family resemblance to the other cameras in the then current range but with significant differences, the most noticeable perhaps being the placing of the shutter speed dial and shutter release. The dial is around the shaft of the film transport lever on the camera top plate. Its milled edge projects beyond the front of the camera body rather in the manner of an edge control. The shutter release is in the centre of the dial and carries a standard cable release socket. The release is locked when the camera is switched off. The transport lever is rather longer than that on the F-1 but moves through only a 120 degree arc. It is a single stroke type.

The shutter speed settings run from 30 seconds to 1/1000 second. Mechanical control is used from 1/2 second to 1/1000 second so that these speeds are available if the camera electronics should fail or you should find yourself without batteries. The slow speeds from 1 to 30 seconds are electronically controlled. When these speeds are used a light on the camera top (a light-emitting diode or LED) flashes intermittently to indicate that the shutter is open. Just behind this diode is the automatic exposure (AE) memory lock (see page 148). The pentaprism is not removable and therefore carries an accessory shoe with flash and CAT contacts.

The base of the camera also differs from the other

## CANON EF

The main features of the automatic-exposure Canon EF are:

1. Carrying strap lug.
2. Self-timer and stop-down lever.
3. Self timer lock release.
4. CAT flash stud.
5. Pentaprism.
6. Lens locating index.
7. Lens.
8. Memory lock button.
9. Covered flash socket.
10. Rewind button.
11. Frame counter.
12. Stop-down and mirror lock.
13. Film transport lever.
14. Shutter speed index.
15. Tripod socket.
16. Hot shoe contact.
17. Battery compartments.
18. Battery check button.
19. Shutter speed ring.
20. Focusing ring.
21. Distance scale.
22. Depth of field scale.
23. Green circle or A setting for AE operation.
24. Accessory shoe.
25. Light emitting diode (LED).
26. Rewind crank.
27. Film speed scale.
28. Sprocket drive spindle.
29. Film chamber.
30. CAT switch.
31. Viewfinder eyepiece.
32. Shutter.
33. Viewing and focusing screen.
34. Stop-down index.
35. Multi-exposure button.
36. On/off switch.
37. Take-up spool.
38. Fine focusing collar.
39. Microprism range-finder.
40. Shutter speed indicator.
41. Shutter speed scale.
42. Overexposure zone.
43. Aperture scale.
44. Meter needle.
45. Underexposure zone.

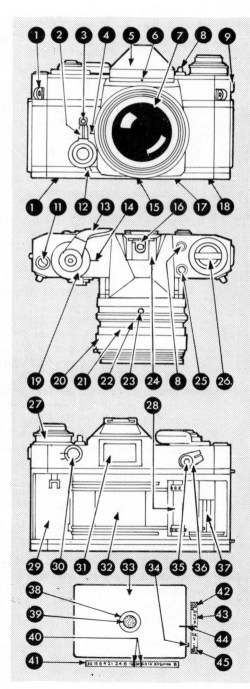

models in that it has two battery compartments and a battery check switch. The back wall has two switches, one for the metering circuit and one for the CAT flash system. A coaxial flash socket is in the side wall of the camera at the rewind end.

The viewfinder screen shows 93 per cent of the actual picture area at 82 per cent natural size with the 50 mm. lens set to infinity. It has a central microprism range-finder in a fine-ground screen with fresnel lens pattern. The rangefinder spot is surrounded by an annular ring free from fresnel lines.

The lens mount is identical to that on all the Canon reflexes with provision for full-aperture automatic exposure control with Canon FD lenses. The FL and R lenses can be fitted but the automatic exposure facility is then disconnected and the meter has to be used in the stopped down mode.

The shutter is a vertically-moving, metal focal plane type synchronising with electronic flash at speeds up to $1/125$ second and with flashbulbs at $1/15$ second and slower.

A self-timer allows the shutter opening to be delayed for up to about 10 seconds after pressing the shutter release. The self-timer lever is similar in appearance to that on the F-1 but has a lock button just above it. This button has to be depressed before the lever can be turned downward away from the lens to set the timer. The lever should be reset to the locked position after use.

The Canon EF does not take the Motor Drive Unit or 250-exposure back so the camera back is not removable. No quick-load mechanism is fitted. An extra feature, however, is the multiple exposure button in the centre of the camera main switch.

The Canon EF body measures $151 \times 96 \times 48$ mm. ($5\frac{15}{16} \times 3\frac{3}{4} \times 1\frac{7}{8}$ inches) and weighs 740 g (1.63 lb.).

*Battery check and renewal*

The EF uses two 625-type batteries to operate the AE system and the electronic control of slower shutter speeds. The batteries are loaded into the base of the camera by unscrewing the two battery compartment covers, insert-ing the batteries with plus signs showing and replacing the covers. Loading the batteries the wrong way round

## SHOOTING WITH THE CANON EF

So that the meter can calculate the correct exposure, you first set the film speed by pulling upward on the ring round the rewind knob and turning it until the appropriate figure appears opposite the index. The ring locks as you drop it back into position.

Turn the main switch to ON. The transport lever springs out to the stand-off position and the shutter release is unlocked.

Press the button behind the green circle or A on the aperture ring and turn the ring until the mark is opposite the aperture index. *This is essential* for automatic exposure control. If you forget it, the meter reads but the lens stops down to the aperture set—not that indicated by the meter.

Make sure CAT flash switch is on normal.

Set an appropriate shutter speed and the meter needle indicates the aperture that will be automatically set.

Focus and compose the picture.

Press the shutter release.

Transport the film for the next exposure.

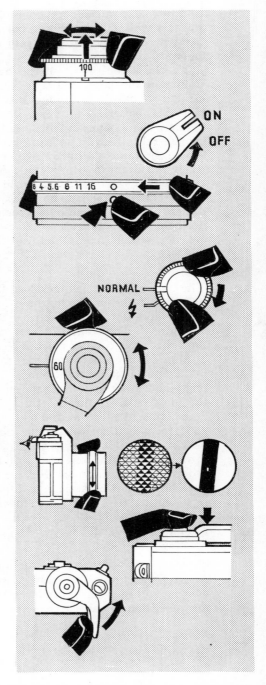

could damage the electronic circuitry. Clean the battery surfaces with a clean dry rag before loading and handle them by the edges only. Greasy contacts are not good electrical conductors.

To check the power of the batteries, press the red button in the baseplate. The LED on the top of the camera should flash rapidly. If it flashes only once, replace *both* batteries.

Carry spare batteries with you at all times because the camera relies heavily on battery power. Make sure you switch the camera off before you put it away or the batteries will drain in a few hours. A small battery case is available and can be attached to the camera carrying strap. If the batteries do fail, however, you can still use the camera manually because the aperture control ring works normally and the shutter speeds from 1/2 to 1/000 second are mechanically controlled, but the main switch must be ON.

## Loading the camera

The Canon EF has no quick-load facility and the loading procedure is the same as for the F-1 except that the shutter release does not have to be pressed between the "blank exposures". The transport lever can be operated freely until the frame counter reaches No. 1.

Although the procedure is the same, there is a difference in the actual take-up of the film. In the F-1, the film winds on to the take-up spool with the emulsion inward (toward the spool face). In the EF, the emulsion faces outward. The film is, in effect, wound on to the spool inside out.

There is a difference in the film speed setting, too, because the scale on the EF is below the rewind knob. Pull upward on the ring and turn until the appropriate figure is opposite the index mark. Release the ring and it locks in position. The ASA scale is as follows, the italic figures representing the dots between marked figures:

12, *16, 20,* 25, *32, 40,* 50, *64, 81,* 100, *125, 160,* 200, *250, 320,* 400, *500, 650,* 800, *1000, 1250,* 1600, *2000, 2500,* 3200.

## Viewing and focusing

All single lens reflex cameras use more or less the same viewing and focusing procedure. The information given for the Canon F-1 applies equally to the Canon EF.

The exposure meter readout in the EF differs from that in the F-1 in that there is no circular index linked to the aperture ring. Apertures selected by the automatic exposure system are indicated by the position of the needle in the right hand side of the screen and shutter speeds are shown on a scale at the bottom. Under- and over-exposure warning zones are coloured red on the aperture scale and the lower red portion varies with the maximum aperture of the lens. With no lens on the camera, the maximum aperture shown is $f$ 5.6. When you attach a lens, its maximum aperture is automatically indicated on the scale and transmitted to the meter circuit.

## Using the exposure meter

The Canon EF meter uses a silicon photocell placed above the viewfinder eyepiece. Its range is much greater than that of conventional CdS cell—from EV18 to EV-2 for a 100 ASA film, representing a low-light limit of 8 seconds at $f$ 1.4.

The increased sensitivity of the EF meter is provided by a special logarithmic amplifier to boost the photocell current. Even at the lowest light level, metering can be carried out in five seconds, but the effect of reciprocity failure has to be borne in mind.

The photocell is placed above the viewfinder and reads the whole screen area with a novel type of centre weighting that puts greater emphasis on the lower centre rather than the upper, to avoid undue influence from bright sky areas when the camera is held horizontally.

Automatic exposure control is possible only with FD lenses. The operating procedure is as follows:
(1) Set film speed.
(2) After framing and focusing the image, turn the aperture control ring on the lens to the green circle or A position. The aperture setting function is then taken over by the electronic system, leaving the diaphragm fully open until the shutter release is pressed.
(3) Turn the camera main switch at the back of the camera below the film transport lever to the ON position. The lever springs out to the stand-off position.
(4) Set the shutter speed at which you intend to shoot

by rotating the dial around the transport lever shaft until the appropriate figure appears opposite the index mark. The yellow figures represent whole seconds. The white figures represent the normal fractions of a second. Intermediate settings cannot be used. The shutter speed set on the dial is indicated at the bottom of the viewfinder screen, so there is no need to take the camera away from the eye while resetting the shutter.

(5) Check the position of the meter needle on the right of the viewfinder screen. It indicates the lens aperture that the AE system will set when you press the shutter release. If the needle is in the white part of the scale, the camera is set for correct exposure. If it is in the red part of the scale at the top, your picture will be overexposed. If it is in the bottom red area, your picture will be underexposed. In either case, or if the aperture indicated is not suitable for depth of field or other reasons, you must select a different shutter speed.

(6) Check framing and focus and release the shutter. The lens stops down to the aperture determined by the meter and indicated in the viewfinder.

On the odd occasions when your subject is wholly or predominantly light or dark toned or is strongly backlit or is otherwise unsuitable for an integrated reading, you can adjust the meter reading.

Between the pentaprism and the rewind knob on the camera top plate, there is a memory lock button. If you press this button, the meter movement is locked and cannot be influenced by changes in light conditions. Thus, you can point the camera at a more even distribution of tones or at a substitute mid-tone and then press the button to lock the exposure while you refocus your picture and release the shutter.

Alternatively, after you have taken your reading from the subject, you can press the memory lock button and alter the shutter speed as experience dictates. When you know that the meter is likely to be misled by a subject with little or no shadow, for example, you can press the lock button and set the shutter one speed slower to give one stop more exposure. If you want a backlit subject to

reproduce in almost total silhouette, you can set the shutter speed two steps faster.

## Stopped-down readings

When you use lenses other than the FD type or interpose bellows, extension tubes etc. between the lens and the camera body, the AE system cannot be used and readings have to be taken by the stopped-down method.

The procedure is similar to that with the Canon F-1. If using an FD lens, free the aperture setting ring by turning it away from the automatic setting. Push the stop-down lever toward the lens and lock it there by turning the small locking lever to the central position, marked with a red L. If you wish, you can simply hold the lever in the stop-down position without locking it. Point the camera to the subject and adjust the aperture or shutter speed to bring the exposure meter needle into the small cut-out toward the bottom of the aperture scale in the viewfinder. Release the stop-down lever to allow the lens to open fully so that you can see your picture clearly and you are ready to shoot.

With non-automatic attachments, such as the Bellows M, you have to keep the lens in the stop-down mode because its aperture must be set manually. With an FD lens, however, you need not use the stop-down lever for this purpose because you can get it to manual diaphragm operation by locking the diaphragm actuating lever in the back of the lens.

## Stop-down multi-purpose lever

The Canon EF has the same type of stop-down lever and self-timer as the Canon F-1 and FTb with locking lever and mirror lock below.

To use the lever on the EF fitted with an FD lens, however, you must first turn the aperture control ring away from the green circle position (to the aperture indicated by the meter if you are merely checking depth of field).

## Lenses for the Canon EF

The Canon EF is primarily designed for use with the Canon FD lenses, which are the only ones that couple with

the AE system. All other Canon lenses can, of course, be fitted but the meter then has to be used in the stopped-down mode.

The lens changing procedure is the same as on all other models.

### Making multiple exposures

Although you can make more than one exposure on the same frame with other Canon cameras, the procedure is greatly simplified on the EF by the inclusion of a multiple exposure button in the centre of the camera main switch. When you press this button inward, the film transport drive and the frame counter are disconnected and operating the film transport lever tensions the shutter without moving the film. You therefore make your first exposure, press in the button, operate the transport lever and make the second exposure. The procedure can be repeated as often as you wish.

### Unloading the camera

To unload the Canon EF, first press in the rewind button in the base of the camera at the film transport end to release the drive mechanism. Fold out the rewind crank in the top of the rewind knob and turn it in a clockwise direction until you feel a sudden easing of the resistance to winding. You will probably also hear the end of the film leave the take-up spool. If you do not wish to wind all the film into the cassette, stop winding at this stage. Otherwise, give two or three more turns to the crank. The camera back can then be opened. Pull the rewind knob upward to release the back catch and open the back fully. With the rewind knob still up, remove the cassette from the camera and put it in a safe place for subsequent processing of the film. The camera back locks automatically when you press it closed.

### Using flash

The vertically moving shutter of the Canon EF is synchronised for the use of electronic flash via the hot shoe or coaxial contacts at speeds up to 1/125 second, as indicated by the flash symbol and orange figures on the shutter speed dial. This is X-type synchronisation and therefore allows flashbulbs to be used at speeds up to 1/15

second only. The two contacts cannot be used simultaneously because the hot shoe contact is disconnected when a cord is plugged into the coaxial socket.

The accessory shoe also contains contacts allowing the CAT system to be used (see page 295). With the Canon EF, however, the focused distance and charge on the flashgun capacitor are transmitted electrically to the automatic exposure circuit and are used instead of light intensity to adjust the lens aperture. Thus even with flash, the camera remains fully automatic.

To use the CAT system on the Canon EF, you attach the Speedlite 133D and the appropriate Auto Ring in the normal manner, but you then have to turn the wheel switch on the camera back to the flash symbol, set the shutter speed to 1/125 second and the lens aperture ring to the green circle position. The camera is then ready to use. The meter needle rises and falls according to the focused distance, reaching the red portions of the aperture scale when you are too close to or far from the subject. When you fire the flash, the needle drops rapidly and rises again as the capacitor recharges. You can, if you wish, shoot again while the needle is still rising. The circuit will still set the correct aperture for the charge on the capacitor and the distance focused.

# FEATURES AND OPERATION OF CANON FTb AND FTbN

The Canon FTb was introduced in 1971 as a second-string camera to the highly-sophisticated Canon F-1. It derives many of its features from the Canon FT, which it eventually superseded, but incorporates the full-aperture metering system, with FD lenses, introduced with the F-1. It was phased out in 1977 with the introduction of the AE-1 and AT-1.

The FTb is a fixed-pentaprism model with a fresnel lens focusing screen and central microprism rangefinder spot surrounded by the darker rectangle of the metering beam splitter which directs a portion of the light reaching the screen to the light-sensitive cell at the back of the viewing screen well. The screen shows 94 per cent of the actual picture area at a magnification of 0.85 with a 50 mm. lens set to infinity.

The meter needle and pointer visible in the viewfinder are similar to those of the F-1 but are within the picture area. Also visible are upper and lower metering limits, a battery check mark that doubles as index mark for stopped-down metering and a red signal that comes into view when the shutter speed set is outside the meter coupling range. Later models, designated FTbN by dealers, have a shutter speed scale below the viewfinder field, indicating the shutter speed set.

The lens mount is the same as that of all other Canon reflex cameras—the bayonet with locking ring introduced in 1959. It takes all the Canon reflex lenses: FD lenses with full aperture metering and automatic diaphragm operation, FL lenses with stopped-down metering and automatic diaphragm operation, and R lenses with stopped-down metering and manual diaphragm operation.

The shutter is a cloth focal plane type with speeds from 1/1000 to 1 second, and a B setting for time exposures. The X synchronisation speed is 1/60 second and the set-

## CANON FTb and FTbN

The main features of the Canon FTb are:

1. Self timer/stop down lever.
2. Shutter release.
3. Shutter speed dial.
4. Lever lock/mirror lock.
5. Meter switch.
6. Rewind knob.
7. Flash socket.
8. Rewind crank.
9. Rewind button.
10. Tripod socket.
11. Film transport lever.
12. Film speed scale.
13. CAT flash contacts.
14. Bayonet tightening ring.
15. Flash contact.
16. Battery compartment.
17. Frame counter.
18. Shutter release lock.
19. Film guide rails.
20. Eyepiece.
21. Film gate.
22. Quick-load mechanism.
23. Green mark or A for AE setting.
24. Focusing ring.
25. Distance scale.
26. Depth of field scale.
27. Aperture setting ring.
28. Rangefinder spot.
29. Metering area.
30. Battery check/stopped-down metering mark.
31. Aperture pointer.
32. Meter limits.
33. Meter needle.

The FTbN has a shutter speed scale below the viewfinder frame indicating the shutter speed set.

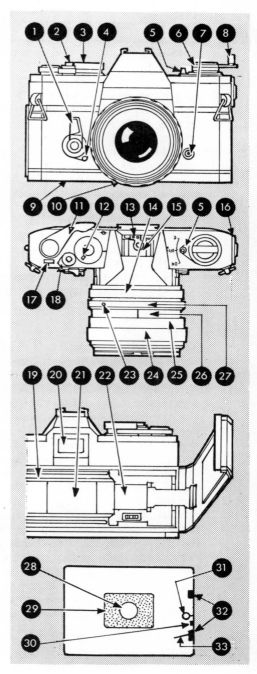

ting is coloured orange on the shutter speed knob. The shutter release can be locked to prevent accidental exposures or, with the B setting, to give long time exposures.

A self timer is built in and the setting lever also acts as stop-down lever for stopped-down metering or observation of depth of field with FD and FL lenses. A small locking lever is placed beneath the self timer lever to enable it to be locked in the stopped-down position. A third position of the small lever both locks the stop-down lever and raises the mirror.

Flash contacts are provided both in the accessory shoe and on the camera front for either bulb or electronic flash. The Canon Auto Tuning (CAT) flash system can also be used with certain lenses.

The film transport lever can be operated by a single stroke or by short-stroke ratchet action. The quick load system is built in.

The Canon FTb body measures $144 \times 93 \times 43$ mm. ($5\frac{5}{8} \times 3\frac{5}{8} \times 1\frac{3}{4}$ inches) and weighs 750 g. (1.46 lb.).

## Battery check and renewal

The battery compartment of the FTb is in the side of the camera just below the rewind knob. You remove the cover by inserting a coin in the groove and turning anti-clockwise. Insert the battery (a 1.3 volt 625 type) with the plus sign outward and replace the cover.

After inserting the battery, you should check its power. Set the film speed scale to 100 ASA by lifting the outer rim of the shutter-speed knob and turning it until the figure appears in the cut-out between 1000 and B. Set the shutter speed to 1/1000 second. Press the meter switch, next to the rewind knob, down to the C position and hold it there. It is spring loaded to return to the OFF position. Look through the eyepiece and check the position of the meter needle in the viewfinder. If the needle swings to or above the small index mark toward the bottom of the screen, the battery has sufficient power. If it stops below that mark, the battery needs changing. The battery has a life of about one year in normal use. If the camera is expected to be out of use for more than a month or two, it is advisable to remove the battery from its compartment

## CANON FTb: LOADING

The procedure for loading the Canon FTb is:

1. Release back cover lock.
2. Open camera back.
3. Insert loaded cassette.
4. Push rewind knob back.
5. Holding the cassette in place, extend the film leader to the red mark below the take-up spool.
6. Partially close the back cover until the quick-load cover clamps the film.
7. Check that the sprockets are engaged in the film perforations and close the back fully.

Make two blind exposures to advance the frame counter from S to O. Lift up outer rim of shutter speed dial and turn until the appropriate figure appears in the film speed cutout.

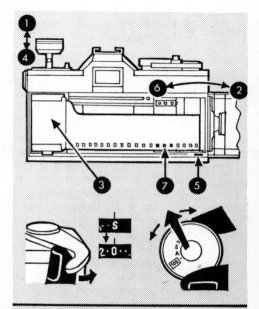

## UNLOADING

To unload the Canon FTb:

1. Press in rewind button.
2. Rewind film.
3. Release back cover lock.
4. Open camera back.
5. Remove cassette.
6. Close camera back.
7. Push back rewind knob.

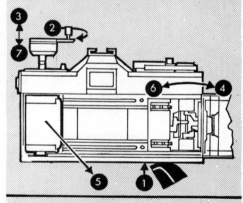

## BATTERY CHECK

To check the battery of the Canon FTb, set the film scale to 100 ASA and the shutter speed to 1/1000 second. Turn the meter switch to C and check the position of the meter needle in the viewfinder. If it rises to the index mark, the battery has sufficient power. If it stays below the mark, the battery must be changed.

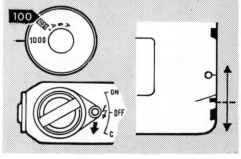

because it can eventually begin to discharge and damage the camera contacts.

## Loading the camera

The Canon FTb takes any normal 35 mm. film cassette. It has a special quick-load system incorporated to avoid the necessity for threading the film into the take-up spool, which is of a special design that works in conjunction with a flap attached to the camera back and opening and closing with it. This flap should never be touched directly.

The loading operation is as follows:

(1) Open the camera back by pulling the rewind knob fully upward against spring pressure. This releases the back latch and the back can be opened fully, pulling the QL flap with it.

(2) Place a loaded film cassette in the chamber below the rewind knob with the projecting end of its spool to the bottom of the camera and the lip through which the film passes pointing to the take-up spool. Push down the rewind knob and rotate it slightly to engage the fork in the bar in the cassette spool.

(3) Hold the cassette down with the left thumb and gently pull the film out of the cassette, across the back of the camera as far as the red mark below the take-up spool.

(4) Close the camera back sufficiently to bring the QL flap down on to the film. Check that the film perforations are engaging with the lower sprocket wheel.

(5) Close the camera back fully and press gently so that the latch engages with an audible click.

(6) Wind off the film exposed during loading by operating the film transport lever and shutter release twice. The frame counter in front of the film transport lever automatically advances to 0 with the third operation of the lever and the camera is ready for use.

The quick-load system is as near foolproof as possible but you should still exercise normal care when loading the camera. When leading the film across the camera back, do not pull too much film out of the cassette. If you do, the cassette will tip up as you close the camera and prevent

## SHOOTING WITH THE CANON FTb

To operate the Canon FTb, advance the film and tension the shutter with the film transport lever. Turn the shutter release lock lever to A.

Compose and focus the picture.

Turn the meter switch to ON and set a shutter speed appropriate to the subject.

When using full-aperture metering, turn the aperture setting ring until the meter needle bisects the aperture pointer.

For stopped-down metering, push the stop-down lever toward the lens and move the lock lever to L. Turn the aperture setting ring until the meter needle cuts the meter index mark.

Check picture framing and focus and press the shutter release gently.

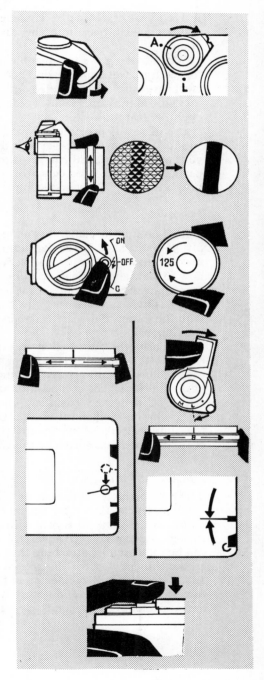

it from locking correctly. If some slack should develop, wind it gently back into the cassette with the rewind crank.

When making the two blank exposures to wind off the fogged film, watch the rewind knob. It should rotate anticlockwise as the film is pulled out of the cassette. If it does not, unload the camera and repeat the whole of the loading operation carefully.

It is generally preferable to load the camera in the most subdued light available—even if that is only the shade of your own body. Light *can* get through the cassete lips— particularly on re-used cassettes—and the loading operation is the most likely occasion for this to happen.

## Preparing to shoot

With a film in the camera, you are almost ready to shoot, but you still have to set the film speed to enable you to make accurate exposure measurements. You have to know how to view and focus the pictures and you should know something of the functions of the lens aperture and shutter speed. These matters are fully dealt with in connection with the Canon F-1 and the details given apply equally to the Canon FTb.

Similarly, the information on exposure metering given on pages 37–46 apply to the meter of the Canon FTb with the obvious exceptions that the maximum shutter speed of the FTb is 1/1000 second and that the shutter speed set is not visible in the viewfinder. The coupling range of the FTb is limited; when the shutter is set to a speed outside the coupling range of the meter, a red signal appears in the bottom right-hand corner of the viewfinder.

## Features of the Canon Booster

The built-in meter of the Canon FTb is sensitive to quite low light levels. It will, for example, measure down to the equivalent of $\frac{1}{4}$ second at $f$1.4 with a 100 ASA film. When the light strength is even lower, the sensitivity of the meter can be increased by attaching the Canon Booster. This is an attachment that fits the accessory shoe of the camera and is electronically connected to the CdS element of the camera meter. It then allows readings to be made down to the equivalent of 15 seconds at $f$1.2 with a 100 ASA film.

## CANON BOOSTER

The features of the Canon Booster are:

1. Connecting cord plug.
2. Camera type indicator.
3. Meter index mark.
4. Meter needle.
5. Battery check mark.
6. Film speed scale.
7. Exposure time dial.
8. Main switch.
9. Camera attachment marks.
10. Camera attachment lever.
11. Viewfinder cap.
12. Scale illuminator. switch.
13. Battery compartment (scale illuminator).
14. Battery compartment (meter power).

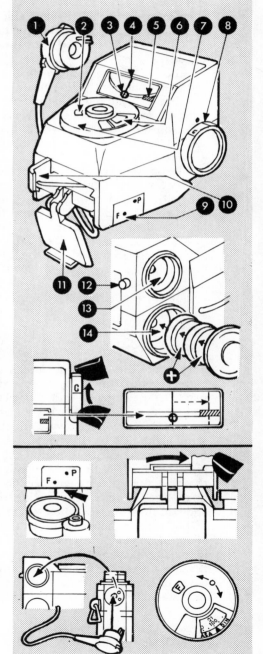

Battery power is tested by turning the main switch to C and checking the position of the meter needle. If it is completely within the blue zone, power is sufficient. If it remains at the edge, change both meter batteries.

To fit the Canon Booster, align the appropriate camera attachment mark with the shutter speed dial index on the camera. Place the Booster on the accessory shoe and tighten with the attachment lever.

Set camera type in the camera type indicator and set film speed on the film scale.

The Booster uses three 625 batteries, two in the lower compartment on the left-hand side and one in the upper compartment to provide illumination of the meter scale. All batteries are inserted with the plus signs facing upward.

An ON/OFF and battery check switch is located on the right-hand side of the Booster. The meter window on the top shows a fixed red index mark and a needle that moves with the adjustment of the lens aperture and the meter's own shutter speed dial, which gives readings from 1/60 second to 30 seconds in the normal doubling-up progression.

The shutter speed dial incorporates adjustments for the type of camera used (the Booster can also be used with the Pellix) and for film speed setting. The film speed scale is as follows, the italic figures representing the dots between the marked figures:

ASA  *20*, 25, *32*, *40*, 50, *64*, *80*, 100, *125*, *160*, 200, *250*, *320*, 400, *500*, *640*, 800, *1000*, *1250*, 1600, *2000*, *2500*, 3200, *4000*, *5000*, 6400, *8000*, *10000*, 12800.

The corresponding DIN figures run numerically from 14 to 42.

## Attaching the Booster to the camera

To prepare the Booster for use, you first open the lower battery compartment by unscrewing the cover. Insert two 625 type batteries with their plus signs facing upward and screw the cover fully home. Check that the batteries have sufficient voltage by turning the wheel switch on the right-hand side of the Booster to the C position. The needle should swing to within the blue marking on the right-hand side of the meter window. If it does not reach that area, the batteries have insufficient voltage and should be replaced. The switch is spring loaded at the C position and will turn to OFF when you release it.

The camera meter cannot be used while the Booster is attached, so the camera battery can be removed and placed in the upper compartment of the Booster. Similarly, as the Booster plugs into the camera battery compartment, the cover of that compartment is used on the Booster. This upper battery provides illumination for the meter scale via

## USING THE CANON BOOSTER

To use the Canon Booster, first close the camera viewfinder eyepiece, either with its own shutter as on the Pellix or with the flap cover of the Booster.

Lock the stop-down lever on the camera and set an appropriate aperture on the lens. Switch on the Booster.

Compose and focus the picture and allow the meter needle 5 seconds to settle down.

Turn the exposure time dial until the needle cuts the meter index mark. Read the shutter speed indicated opposite the index mark. Set the camera shutter to that speed or to B for exposures longer than 1 second.

When using the Pellix unlock the stop-down lever before releasing the shutter.

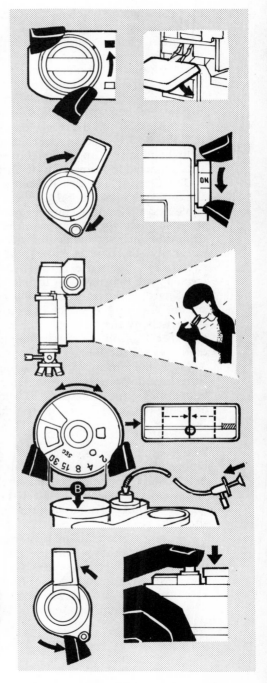

the push-button switch next to the name plate on the front of the Booster.

With the batteries in place (after pulling the plug out of the upper compartment where it is usually parked) fold the black plastic eyepiece cover out from underneath the Booster and pull the metal lever above it backward. This rotates the accessory shoe clamp in the bottom of the Booster so that the whole unit can be placed on the accessory shoe and the lever pushed home again to lock it in position. The dots marked F and P on the plate on the right-hand side of the Booster are for lining up with the shutter speed index mark to facilitate attachment.

The Booster is electrically connected to the CdS cell of the camera by inserting the plug at the end of the Booster cable into the battery compartment of the camera where there are two sockets to take the plug pins. The plug cannot be incorrectly inserted.

Finally, the shutter speed dial has to be set to the camera and film in use. If the small cut-out shows the red letter P, the Booster is set for use with the Canon Pellix. Press hard on the transparent dial covering the film speed setting and pull the dial clockwise by the small stud projection by the 4 second mark. The letter F (on later models FTb) will then click into place to indicate that the dial is set for the FTb.

To set the film speed, hold the outer rim of the dial and turn the inner wheel by the same projecting stud until the figure indicating the speed of the film in use appears opposite the black triangular mark.

## Operating the Canon Booster

The Booster is designed for use in extreme low light conditions with the camera on a tripod or other solid support. After composing and focusing the picture you fold the black plastic flap down to cover the eyepiece, because in such conditions light passing through the eyepiece might affect the reading.

Light measurements are made at the shooting aperture. The Booster cannot use the full aperture reading ability of the FD lenses. The procedure, therefore, is as follows:

(1) Set the stop-down lever lock to the L position and press the stop-down lever towards the lens. This converts the lens to manual operation.

(2)   Set the lens to the required shooting aperture.

(3)   Switch on the Booster. The needle in the Booster window will start to move very slowly. *Wait at least 5 seconds* for the needle to settle down.

(4)   Turn the shutter speed dial of the Booster to bring the needle to the red circle zero mark in the window.

(5)   Note the shutter speed aligned with the zero mark and set it on the shutter speed dial of the camera.

When the shutter speed indicated by the Booster exceeds 1 second, set the shutter speed dial to B and operate the shutter with a cable release. For long time exposures, a locking cable release can be used or you can depress the shutter button and, while holding it down, push the locking ring surrounding the shutter button toward the lens until the black line aligns with the red dot marked L. At the end of the exposure time release the lock by turning the ring until the black line points to the black dot marked A.

When you find that adjustment of the shutter speed dial of the Booster does not bring the needle to the zero position, the aperture set is too large or too small. It is too large if the needle stays to the right of the zero mark and too small if it stays to the left. Adjust the aperture accordingly but remember to wait at least 5 seconds for the meter needle to settle down.

The shutter speed dial of the Booster cannot be set to all the marked positions. When the film speed is set to 100 ASA, for example, the limit of movement is from $\frac{1}{4}$ to 15 seconds. At 400 ASA, it is from 1/15 to 4 seconds. Naturally, you can calculate other exposures and set the camera controls accordingly. If, for example, the Booster indicates that $\frac{1}{2}$ second at $f4$ is a correct setting, you can set 8 seconds at $f16$ if you want the maximum depth of field.

The Booster is not a separate meter. It simply augments the camera meter and, when used with the FTb therefore gives a semi-spot type reading. It reads the area indicated by the darker rectangle in the focusing screen. When lining up the camera for a reading, therefore, you have to ensure that the area metered is not uncharacteristically light or dark. This may mean that you have to recompose the picture in the viewfinder after taking the exposure reading.

The Booster is essentially slow in operation and is not ideally suited to situations demanding rapid shooting. Where, however, the light is reasonably consistent, it can be used once to take a reading and then switched off or removed from the camera until it is felt that another reading is advisable.

## Self-timer and shutter release lock

The self-timer lever of the FTb, to the left of the lens mount, has a dual function. It serves both to set the self-timer mechanism and to stop down the lens to its pre-set aperture.

To set the self-timer, push the lever downward away from the lens as far as it will go. The shutter will then open about 10 seconds after you press the shutter release. The shutter can be tensioned before or after the self-timer is set; but the fact that the shutter is not tensioned does not prevent the self-timer from operating.

Should you require to use the self-timer with the mirror in the up position, you have to set the mirror lock (the small lever below the self-timer) to the M position after setting the self-timer, because at the end of its travel the self-timer lever pushes the locking lever to the normal automatic-iris position.

Once you have set the self-timer, the lever runs free so that it can still be used for its stop-down purpose by pushing it inward toward the lens. This operation is necessary when you use the stop-down metering method (with the Booster unit, FL and R lenses, extension tubes, etc.). It can also be used to observe the depth of field obtained at the shooting aperture.

The lever can be locked in the stop-down position by turning the small lever below it to the L position. The M position of this lever, as already mentioned, is used to raise the mirror. It can only be used with the main lever in the stop-down position. The mirror lock is used in photo-micrography and in other cases where it is imperative to eliminate any vibration the mirror may cause. It has to be used, too, with the FL 19 mm. $f3.5$ lens, which would otherwise impede the mirror operation because of its projection into the lens body.

The mirror must be locked up before the lens is attached to the camera. Naturally, the reflex viewing

facility is lost when the mirror is in the up position and the built-in meter is similarly put out of operation. The FL 19 mm. is supplied with a separate direct vision viewfinder. On other occasions, framing, focusing and metering must be carried out before the mirror is raised.

## Unloading the camera

When all exposures have been made, the film has to re re-wound into its original cassette before the camera back can be opened. The procedure is as follows:

(1) Press in the small button in the camera base. It will remain depressed until the film transport lever is next operated.

(2) Lift up the crank in the rewind knob and turn it in the direction of the arrow engraved on its underside. Keep turning until you feel the film leave the take-up spool and there is less resistance to turning the crank.

(3) Pull the rewind knob fully upward to open the camera back.

(4) Remove the cassette.

# FEATURES AND OPERATION
# OF CANON TX AND TLb

The Canon TX and TLb were virtually the same camera, the only difference being that the TX had an extra flash contact in the accessory shoe. It replaced the TLb in 1975 and was discontinued in 1977. The TLb was introduced in 1972.

The general specification is the same for both models— a fixed pentaprism with a fresnel lens focusing screen and central microprism rangefinder spot surrounded by a narrow ring free from fresnel lines. As in the FTb, the viewfinder shows 94 per cent of the actual picture area at a magnification of 0.85 with the 50 mm. lens set to infinity.

The viewfinder screen differs from that of the FTb in that the darker rectangle caused by the beam splitter is not present. The exposure meter cell is located above the eyepiece and reads the entire screen area with a certain amount of centre weighting. The other features are, however, the same, in that the meter needle and pointer are visible in the picture area, together with marks indicating the upper and lower metering limits, an index for stopped-down metering (there is no battery check facility) and a red signal that comes into view when a slow shutter speed is set outside the meter coupling range.

The lens mount is the standard Canon reflex type, taking all Canon reflex lenses: FD lenses with full-aperture metering and automatic diaphragm operation, FL lenses with stopped-down metering and automatic diaphragm operation and R lenses with stopped-down metering and manual diaphragm operation.

The shutter is of the same general type as that of the FTb but has speeds from 1/500 to 1 second and B. The 1/60 second setting is coloured orange to indicate that it is the X-synchronisation setting for electronic flash. The shutter release has no lock.

The lever in the usual self-timer position has, in fact, no self-timer function. It acts solely as a stop-down lever

## CANON TX and TLb

The features of the Canon TX and TLb are:

1. Stop-down lever.
2. Shutter release.
3. Shutter speed dial.
4. Fixed pentaprism.
5. Accessory shoe.
6. Flash socket.
7. Rewind crank.
8. Rewind button.
9. Tripod socket.
10. Film transport lever.
11. Bayonet tightening ring.
12. Battery compartment.
13. Frame counter.
14. Cassette chamber.
15. Rewind knob.
16. Film gate.
17. Eyepiece.
18. Film guide rails.
19. Focusing ring.
20. Distance scale.
21. Depth of field scale.
22. Aperture setting ring.
23. Sprocket wheel.
24. Take-up spool.
25. Perforation pin.
26. Fresnel screen.
27. Rangefinder.
28. Coupling range signal.
29. Meter needle.
30. Aperture pointer.
31. Stop-down metering index.

The Canon TX has, additionally, a flash contact in the accessory shoe.

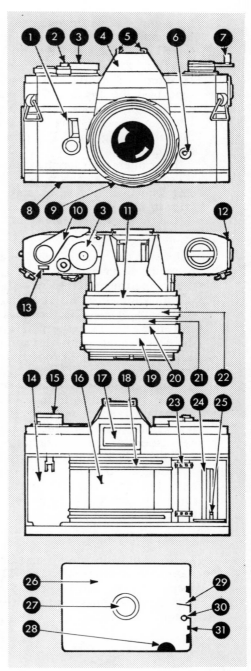

for stopped-down metering or observation of depth of field with FD and FL lenses. The reflex mirror cannot be locked up. Flash contacts consist of a coaxial type on the lens front and a cableless type in the accessory shoe with an internal synchronisation for electronic flash and all types of flashbulbs. The CAT system cannot be used.

The film transport lever can be operated by a single stroke or repeated short strokes. The exposure counter is the self-zeroing type. The cameras have no quick-load system.

The camera body has the same dimensions as that of the FTb—$144 \times 93 \times 43$ mm. ($5\frac{5}{8} \times 3\frac{5}{8} \times 1\frac{3}{4}$ inches). The missing refinements, however, make it 70 g. lighter at 680 g. (1.32 lb.).

## Inserting the battery

Before the through-the-lens meter of the TX or TLb can be used, you have to insert a 625 type 1.3 volt battery into the compartment in the side wall of the camera below the rewind knob. First insert a coin into the groove of the compartment cover (or turn the cover by its milled edge) and unscrew it. Place the battery in the compartment with the plus sign facing upward and screw the cover back in. The cover cannot be properly replaced if the battery is incorrectly inserted. There is no battery check facility but it should normally be evident whether or not the meter needle is responding to light. The life of the battery in normal use is about one year and it is advisable to change it after that period whether or not it seems to be nearing exhaustion. As the camera has no meter switch, the lens cap should be kept in place between exposures.

A discharged mercury battery can corrode, so the battery should be removed from its compartment if the camera is expected to be out of use for more than a few weeks.

## Loading the camera

To load a film into the TX or TLb first pull up the rewind knob against spring pressure. The back springs slightly open and may then be opened fully on its hinge. The camera has no quick-load facility and loading is as on the Canon F-1.

## CANON TX and TLb: LOADING

To load the Canon TLb or TX:

1. Pull up the rewind knob and release the back cover lock.
2. Open the back cover completely.
3. Insert a loaded cassette in the cassette chamber.
4. Push down the rewind knob and twist to left or right to engage the cassette spindle.
5. Insert the film leader into a slit in the take-up spool.
6. Check that the film perforations are engaged by the pins on the take-up spool and the sprockets of the sprocket wheel.
7. Close the camera back and press to lock.

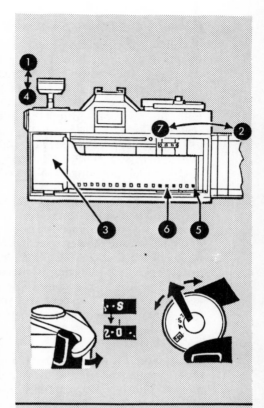

Make two blind exposures to advance the frame counter from S to O. Lift up the rim of the shutter speed dial and turn until the appropriate figure appears in the film speed cutout.

## CANON TX and TLb: UNLOADING

To unload the Canon TX or TLb:

1. Press in the rewind button.
2. Rewind the film.
3. Pull up the rewind knob to release the back cover lock.
4. Open the camera back fully.
5. Remove the cassette.
6. Push back the rewind knob.
7. Close the camera back and press to lock.

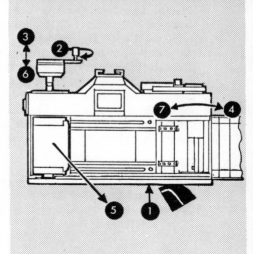

## Film speed setting and exposure meter range

To allow the meter to provide correct exposure settings you have to set the film speed on the camera. Pull up on the rim of the shutter speed knob and turn it until the figure representing the speed of the film in the camera appears in the cut out. The ASA range is as follows, the italic figures representing the intermediate dots on the scale:

25, *32*, *40*, 50, *64*, *80*, 100, *125*, *160*, 200, *250*, *320*, 400, *500*, *640*, 800, *1000*, *1250*, 1600, *2000*.

On models showing DIN speeds, the range runs consecutively from 15 to 34.

The range of the exposure meter is more restricted as the speed of the film increases. With a 25 ASA film, for example, all shutter speeds can be used. As the film speed doubles, so one slower speed is lost from the coupling range. With a 100 ASA film, for example, the slowest usable speed for metering is $\frac{1}{4}$ second, while with an 800 ASA film, it is 1/30 second. The meter couples with all apertures, however, except at 1/500 second on a 25 ASA film, when the minimum aperture for metering is $f$16.

## Stop-down lever

The Canon TX and TLb have what appears to be a self-timer lever on the front of the camera body beside the lens mount. This is, however, the stop-down lever and can be pressed only toward the lens against a spring. When released, it springs back to the upright position. The function of this lever is to allow stopped-down metering to be used with FL lenses, which have no signal pin to allow full-aperture metering to be carried out. As you press the lever inward, the lens diaphragm closes down to the aperture preset on the lens aperture control ring. You can also use this lever with FD or FL lenses to obtain some idea of the depth of field that a given aperture will provide. The lever has no lock and must be held against the spring while metering is carried out.

## Using the exposure meter

The exposure meter of the TX and TLb is not the semi-spot type of the F-1, FTb and FT. Its CdS light-sensitive element is located at the rear of the pentaprism above the

## SHOOTING WITH THE CANON TLb and TX:

To operate the Canon TLb or TX, compose and focus the picture after ensuring that the film is wound on and shutter tensioned.

For full aperture metering, set a shutter speed appropriate to the subject, view the subject through the viewfinder and turn the aperture setting ring until the meter needle bisects the circle of the aperture pointer.

Alternatively, first set an appropriate aperture and coincide needle and pointer by adjusting the shutter speed.

For stopped-down metering, set an appropriate shutter speed. Push the stop down lever toward the lens and adjust the aperture setting until the meter needle cuts the meter index mark.

Release the shutter gently.

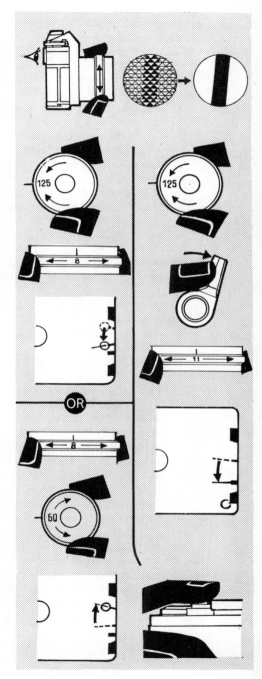

eyepiece and reads the whole screen area with slight weighting to the central area.

With FD lenses, metering is performed at full aperture. With FL or R lenses only stopped-down metering can be used. The procedure for full-aperture metering is as follows:

(1) Set the shutter speed dial to an appropriate speed for the subject.

(2) Look through the eyepiece to focus and compose your picture. The exposure meter needle moves according to the amount of light reflected from the subject and according to the shutter speed and film speed set.

(3) Turn the lens aperture until the circular pointer is bisected by the meter needle. Shutter speed and aperture are then set for correct exposure.

Alternatively, you can set the aperture first, if you wish to shoot at a particular aperture for depth of field reasons. Then turn the shutter speed dial to align needle and pointer.

The procedure for stopped-down metering with FL or R lenses is as follows:

(1) Set the shutter speed dial to an appropriate speed for the subject.

(2) Look through the eyepiece and focus and compose your picture.

(3) Press the stop-down lever when using an FL lens. This stops the lens down to the aperture set and moves the circular pointer to the bottom of the viewfinder. The R lenses do not couple with the automatic iris mechanism, so the pointer does not move from its lowest position at any time.

(4) While holding the stop-down lever, turn the lens aperture control ring until the needle cuts the small index mark toward the bottom of the screen. Shutter speed and aperture are then set for correct exposure.

As with full aperture metering, if required, the aperture can be set first and the needle then brought to the index mark by adjusting the shutter speed.

If, by either metering method, you cannot align the needle and pointer correctly, the conditions do not allow you to shoot at the particular aperture or shutter speed

you have set. You must choose another preliminary setting or await more suitable conditions.

The metering range is limited necessarily and when you turn the shutter speed dial to a slow speed that is outside the coupling range, a red signal appears at the base of the viewfinder. These are low-light conditions and the meter needle does, in fact, continue to respond reasonably linearly to light changes and to stopping down, although the instruction book says that it will swing all the way up. It would be unwise to rely on such metering results, however, without conducting tests on your particular camera.

For 90 per cent of your photography, these metering methods will prove satisfactory but you must bear in mind that you are measuring the light reflected by the whole picture area. Provided that area contains a reasonable distribution of dark, medium and light tones, your exposure should be accurate. If it contains an undue proportion of dark tones, you may need to give rather less exposure than the meter indicates. If it contains a lot of light tones, rather more exposure may be necessary. Similarly, if you are shooting against the light and wish to obtain detail in the shadow areas you may need to counter the effect of the direct light on the meter by increasing the exposure beyond that indicated.

## Viewing and focusing

There is little difference between the TX or TLb and the other Canon reflex models in the viewing and focusing operations and these subjects are adequately covered in the description of the Canon F-1. But these models do have a slightly different screen. As the darker rectangle caused by the beam splitter in the F-1 and FTb does not appear in the TX or TLb viewfinder, there is room for an additional focusing aid. This takes the form of a fine-ground "collar" free of fresnel rings around the micro-prism rangefinder spot. This can be useful in close-up work with the camera on a tripod for really critical focusing of very fine detail. As the Canon screen is quite bright, however, the fresnel rings are barely visible and, additionally, as the fine ground area is so narrow, this refinement is a little superfluous for normal work.

173

## Unloading the camera

The Canon TX and TLb are unloaded by pressing the rewind button and turning the rewind crank as on all the later Canon reflex models.

## Flash synchronisation

The single flash socket on the Canon TLb is synchronised with the shutter in such a way that electronic flash can be used at speeds of 1/60 second and slower, while ordinary flashbulbs can be used at 1/30 second and slower. FP class flashbulbs can be used at any speed except 1/60 second which is synchronised for the instantaneous operation of electronic flash only.

The Canon TX has an additional flash contact in the accessory shoe for use with cableless flashguns.

Neither the TX nor the TLb can use the CAT automatic flash system because they do not have the direct flash contacts of the F-1 and FTb that are needed to operate this system.

# FEATURES AND OPERATION
## OF CANON FT

The Canon FT was the workhorse of the Canon range of reflex cameras from 1966 to 1972—during the period, in fact, that Canon were devoting their research facilities to the design of the F-1 and its range of lenses and accessories. The FTb and the TLb followed rapidly on the F-1 and the FT was honourably retired.

The major difference between the FT and the later models is that its meter takes readings at the shooting aperture. It is not fitted with the internal connections that enable the FD lenses to transmit maximum and pre-set aperture information to the meter circuit. Consequently, even when fitted with FD lenses, it still has to take readings with the lens stopped down to the shooting aperture.

Externally the camera is similar in appearance to the FTb but the self-timer lever performs only two functions —self-timer and stop-down lever. The mirror lock is placed on the other side of the lens mount, above the flash socket. The accessory shoe does not contain the centre flash socket or the contacts for the automatic flash units. The meter switch has no ON/OFF positions—the meter is permanently ON. The meter check is as on the FTb. The meter on early models was switched on by the operation of the stop-down lever. The rewind knob has the familiar built-in crank but it does not pull up to unlock the back. The FT has a key-type lock in the baseplate.

The Canon FT is a fixed-pentaprism model with the same type of fresnel lens focusing screen as the FTb with central microprism rangefinder spot surrounded by the darker rectangular field indicating the area read by the meter. The screen is, however, clear of any other features except the fixed metering index (a small circle) and the meter needle, which is affected by both shutter speed and lens aperture settings.

The lens mount is the standard Canon type and all

Canon reflex lenses can be used—although the camera cannot, of course, take advantage of the full-aperture metering facilities of the FD lenses. The R range of lenses can be used only with manual diaphragm operation.

The shutter is the normal cloth focal plane type with speeds from 1/1000 to 1 second and a B setting for time exposures. A separate setting, marked X in orange, is provided for use with electronic flash. The shutter release button can be locked either down or up.

The film transport lever can be operated by a single stroke or by short-stroke ratchet action. The quick-load system is built in.

The Canon FT body measures $144 \times 93 \times 43$ mm. ($5\frac{5}{8} \times 3\frac{5}{8} \times 1\frac{3}{4}$ inches)—exactly the same as the FTb, but weighing a fraction less at 740 g. (1 lb. 10 oz.).

### Battery check and renewal

Like the FTb, the Canon FT has a battery compartment in the side wall of the camera below the rewind knob. Remove the cover from the compartment by inserting a coin in the groove and turning anti-clockwise. Insert a 625-type mercury battery into the compartment with the plus sign facing upward and screw the cover back into place. Avoid touching the faces of the battery and wipe them clean if they have been touched.

The battery check switch is around the rewind knob. Set the film speed at 100 ASA by pulling up the outer rim of the shutter speed knob and turning it until the figure 100 appears in the cut-out between 60 and 30.

The FT has two film speed windows. The other, between the X and B markings, gives the DIN figures.

Set the shutter speed dial at X and turn the battery check switch against spring pressure to the C mark. The meter needle visible in the viewfinder should swing up at least to the zero index. If it stays below that mark the battery has insufficient voltage to operate the meter correctly.

### Loading the camera

The Canon FT has the same QL loading method as the FTb and the instructions given apply equally to the FT model except for the back-opening procedure. Whereas

176

## CANON FTQL

The features of the Canon FTQL are:

1. Stop-down and self-timer lever.
2. Shutter release.
3. Shutter speed dial.
4. Lever lock.
5. Mirror lock.
6. Rewind knob.
7. Flash socket.
8. Rewind crank.
9. Rewind button.
10. Tripod socket.
11. Film transport lever.
12. Film speed scale.
13. Film plane mark.
14. Bayonet tightening ring.
15. Accessory shoe.
16. Battery check switch.
17. Battery compartment.
18. Frame counter.
19. Shutter release lock.
20. Film guide rails.
21. Eyepiece.
22. Film gate.
23. Quick-load mechanism.
24. Aperture setting ring.
25. Focusing ring.
26. Distance scale.
27. Depth of field scale.
28. Auto-manual ring.
29. Rangefinder.
30. Metering area.
31. Meter index mark.
32. Meter needle.

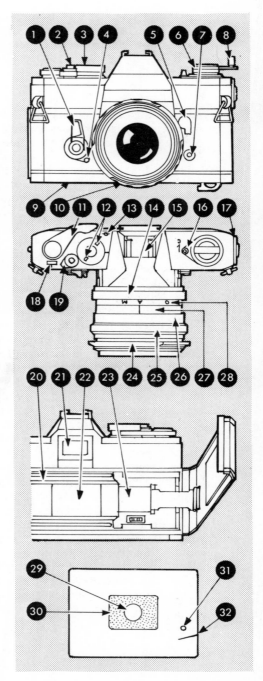

the FTb back is opened by pulling up the rewind knob, the FT has a fold-out key in the base which has to be turned anti-clockwise to release the lock. The rewind knob has to be pulled up to allow the cassette to be inserted.

## Preparing to shoot

As with the other coupled meter models, the last step in preparing the camera for shooting is to set the film speed on the shutter knob. The method is the same as for the FTb but the FT has two film speed windows. The film speed scale is the same as on the F-1 and FTb.

With the camera loaded and the film speed set, you are ready to compose and focus your picture in the view-finder. Then you can use the built-in meter to decide which aperture and shutter speed to set. The basic exposure meter information given for the FTb also applies to the FT but the metering procedure is different in that the FT meter can be used only with the lens set to the shooting aperture.

## Using the built-in exposure meter

The darker rectangular area visible in the centre of the viewfinder indicates the part of your subject that the Canon FT meter measures. You cannot, therefore, simply take a reading with the subject correctly framed and focused in the viewfinder as you would with a meter measuring the whole field. You have to be sure that the rectangle encompasses a range of tones that average to a mid-tone. If it should, in fact, be practically filled with a shadow or highlight, the meter will recommend over- or under-exposure respectively.

Once you have chosen the area to meter, set either the lens aperture or the shutter speed you intend to shoot at. Conditions may demand that you give priority to the shutter speed—as in the case of a fast-moving subject requiring a relatively fast shutter speed to avoid blur. If you set the shutter speed first, you determine the aperture required for correct exposure as follows:

(1) View the subject in the viewfinder with the chosen area encompassed in the rectangle.

(2) Press the meter lever (self-timer) inward toward the lens and either hold it there or move the small

## CANON FTQL:
## LOADING

To load the Canon FTQL:
1. Unlock the back cover.
2. Open camera back.
3. Pull up rewind knob.
4. Insert loaded cassette.
5. Push back rewind knob.
6. Lay tip of film leader to the red mark below the take-up spool.
7. Partly close camera back to bring quick-load mechanism down on to the film and check that the film perforations are engaged.
8. Close the camera back.
9. Turn baseplate key.

Make two blind exposures to bring frame counter from S to O.

Lift up the rim of the shutter speed dial and turn until the appropriate figure appears in the cut-out.

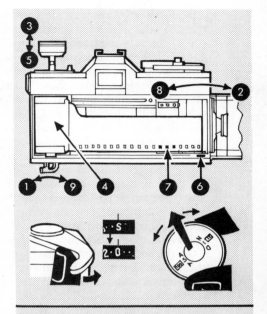

## UNLOADING

To unload the Canon FTQL:
1. Push in rewind button.
2. Rewind film.
3. Unlock back cover.
4. Open the camera back.
5. Pull up rewind knob.
6. Remove cassette.
7. Push back rewind knob.
8. Close the camera back.
9. Turn baseplate key to lock camera back.

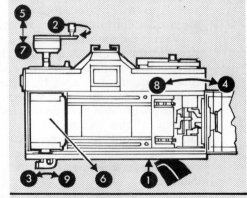

To check the battery of the Canon FTQL, set the film speed to 100 ASA and the shutter speed to X. Turn the battery check switch to C and observe the position of the meter needle in the viewfinder. If the needle swings to or past the meter index, the battery has sufficient power. If not, it must be changed.

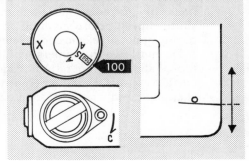

lever below it to the L position.

(3)   Adjust the lens aperture until the meter needle bisects the fixed circular index mark.

If you accomplish that successfully, the aperture and shutter speed are set for correct exposure. Frame the subject correctly in the viewfinder, check your focus and shoot. You may, in fact, find that you cannot line up needle and index, for one of two reasons:

(1)   The shutter speed set is too fast for the light conditions, even with the lens set to full aperture.

(2)   The shutter speed set is outside the coupling range of the meter.

In the first case, you have to set a slower shutter speed and try again. If the shutter speed becomes too slow for the action, the picture is not technically possible. You can, of course, shoot at the shutter speed you consider necessary and risk the results of underexposure.

In the second case, the meter needle stays at the top of the viewfinder when the shutter speed is too slow and at the bottom when it is too fast. It does not move when the aperture is adjusted. The remedy in this case is to set a different shutter speed for metering purposes and then to revert to the required shutter speed and adjust the aperture accordingly before shooting.

When you wish to shoot at a particular aperture—to provide the required depth of field, or lack of it, for differential focusing you follow the same procedure but line up needle and index by adjusting the shutter speed. Again, you may find that you cannot line up the needle and index because the needle suddenly jerks to the top or bottom of the viewfinder (indicating that the shutter speed set is outside the meter coupling range) or because the aperture set is too large or too small for the light conditions at the range of shutter speeds available on the camera.

The remedies are as before. You alter the aperture for metering purposes and then reset both aperture and shutter speed before shooting or, where the shot is technically impossible, you compromise and hope for the best.

Do not leave the camera with the meter needle at the top of the viewfinder (indicating a slow shutter speed outside the meter range) because the battery is then discharging rapidly and will soon become exhausted.

## SHOOTING WITH THE CANON FTQL

To operate the Canon FTQL, first wind on the film and tension the shutter with the film transport lever. Turn the shutter release lock to A.

Compose and focus the picture.

Set a shutter speed appropriate to the subject. Press the stop-down lever toward the lens and hold it there. Adjust the lens aperture until the meter needle bisects the index mark.

Alternatively, set the aperture dictated by the conditions, press the stop-down lever and hold it, and adjust the shutter speed to coincide the meter needle and index.

Release the stop-down lever and press the shutter release gently.

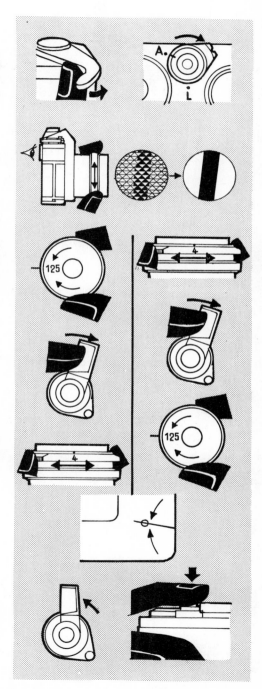

One some early models of the Canon FT, the meter cannot be operated until the meter lever is pressed. On later models it is always in circuit and it is advisable to keep the lens cap in place when the camera is not being used. When light levels are too low for the built-in meter of the Canon FT, the Canon Booster can be used in the same way as on the Canon FTb.

## Using the mirror lock and self-timer

The mirror of the Canon FT can be locked in the up position by turning the small lever to the right of the lens mount upward. This is necessary when the FL19 mm. *f*3.5 lens is used.

The self-timer works in the same manner as on the Canon FTb.

## Unloading the camera

To unload the Canon FT:

(1) Press in the small button in the camera base. It will remain depressed until the film transport lever is next operated.

(2) Fold out the crank in the rewind knob and turn it in the direction of the arrow engraved on it. Keep turning until you feel the film leave the take up spool and there is less resistance to turning the crank.

(3) Fold out the key in the base of the camera and turn it anti-clockwise to release back lock.

(4) Open back fully, pull up the rewind knob and remove the cassette.

# FEATURES AND OPERATION OF CANON EX EE AND EX AUTO

Despite a family resemblance in general design and the many features they have in common with the other Canon reflexes, the Canon EX EE and EX Auto are totally different types of camera.

They are 35 mm. single-lens reflexes, with cloth focal plane shutter and the Canon quick-load system. They are similar in shape to the other Canons and have many minor features that also appear on the other models. The difference is immediately apparent, however, when you you look at the lens. It is firmly attached to the camera and cannot be taken off. It has no aperture control ring. This, together with the clue given by the EE or Auto in the name, conveys the information that these are, in fact, models providing automatic exposure control.

The lens is a front-component convertible type, alternative focal lengths being provided by unscrewing the front component and replacing it by a different type.

The viewfinder screen is a non-focusing type with a central microprism rangefinding spot, giving a 90 per cent life-size image with the 50 mm. lens. Aperture numbers, warning marks and meter needle are visible at the right-hand edge within the picture area.

The shutter is speeded from 1/500 to 1/8 second, with a B setting and an electronic flash synchronisation speed of 1/60 second printed in orange on the shutter speed dial. The flash socket of the EX EE is in the side of the top plate at the rewind end of the camera. On the EX Auto it is in the side of the mirror box. The EX Auto also has a hot-shoe contact in the accessory shoe on top of the penta-prism with an additional contact for the CAT flash system.

The built-in exposure meter is powered by a 625-type battery housed in the camera baseplate. The meter reads through the camera lens and the lens closes down to the appropriate aperture when the shutter release is depres-

sed. The meter measures the whole screen area with slight centre weighting.

The film transport lever can be operated with a single stroke or by several strokes with a ratchet action.

A self-timer is provided but there is no stop-down lever or any other provision for manually stopping the lens down. Even when overriding the EE system, the lens remains at full aperture until the shutter is released.

Both models, with the standard lens, measure $143 \times 92 \times 84$ mm. ($5\frac{5}{8} \times 3\frac{5}{8} \times 3\frac{1}{4}$ inches) and weigh 900 g. (a fraction under 2 lb.).

## Battery check and renewal

The battery compartment is in the base of the camera. Remove the cover by inserting a coin in the slot and turning anti-clockwise. Insert a 625-type battery with the plus sign upward and replace the cover. Avoid touching the faces of the battery because moisture from the fingers can lead to corrosion and damage to the camera contacts.

To check the battery, you need daylight or extremely bright artificial light. There is no battery check mark or switch as on other models. You set the film speed to 100 ASA (see below) and the shutter speed to 1/30 second. Turn the meter/aperture ring to EE and look through the eyepiece, with the camera pointed to the sky or a bright light. The meter needle should swing to 16 or above. If it does not, the battery needs replacing.

In normal use the battery has a life of about one year and it is advisable to replace it at that time. It is in circuit only when the meter/aperture ring is set to EE.

## Loading the camera

The Canon EX EE and EX Auto are fitted with the Canon quick load system and the rewind-knob-operated back latch like the Canon FTb. The loading method is therefore the same as for the FTb.

## Preparing to shoot

After loading the film, the next step is to set the film speed. This is effected in the same manner as on the other models by lifting up the rim around the shutter speed knob and turning it until the required figure appears in the cut-out. On the EX EE, however, there are two index

## CANON EX EE AND EX AUTO

The features of the Canon EX EE and EX Auto are:

1. Self timer.
2. Shutter release.
3. Shutter speed dial.
4. CAT system switch (on EX Auto).
5. Flash socket (on EX Auto).
6. Carrying strap lug.
7. Flash socket (on EX EE).
8. Rewind crank.
9. Frame counter.
10. Film transport lever.
11. Rewind button.
12. Film speed scale.
13. Tripod socket.
14. Accessory shoe (with direct and auto flash contacts on EX Auto).
15. EE switch and manual aperture setting.
16. Battery compartment.
17. Rewind knob.
18. Film guide rails.
19. Eyepiece.
20. Film gate.
21. Quick-load mechanism.
22. White index for lens changing.
23. Interchangeable front component.
24. Focusing ring.
25. Distance scale (for 50 mm lens).
26. Depth of field scale (for 50 mm lens).
27. Meter needle.
28. Rangefinder.
29. Aperture scale.
30. Meter limits for f3.5 lenses.
31. Lower limit for 50 mm lens.

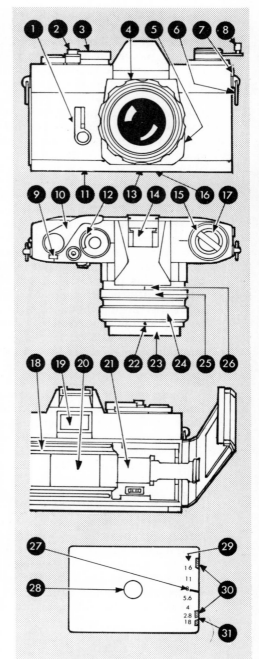

dots for the film speed—one in blue marked 1.8 and one in red marked 3.5. With the standard lens attached, you set the required film speed to the blue dot. With any one of the alternative lenses, you set the film speed to the red dot, because the maximum aperture of those lenses is *f*3.5. The effect is to reposition the meter needle. The meter circuitry has been improved on the EX Auto and this procedure is not necessary. Whichever lens is fitted, the film speed is set in the normal way.

The film speeds available—the italic figures representing the dots between the engraved figures—are:

25, *32*, *40*, 50, *64*, *80*, 100, *125*, *160*, 200, *250*, *320*, 400, *500*, *640*, 800.

Composing the picture in the viewfinder is the same as with any other SLR but focusing the EX models is rather different because the finder presents only an aerial image. There is no ground glass screen to show a focusing image. Focusing has to be carried out solely by means of the microprism rangefinder spot in the centre of the viewfinder. This presents a shimmering, broken-up image while the lens is incorrectly focused. As it is brought into focus, by turning the knurled focusing ring around the lens barrel, the image becomes steady and clear. The very fine fresnel lines of the viewing screen do give a slight in and out of focus effect but correct focus cannot be obtained on the screen image. You must use the rangefinder.

These matters apart, the general focusing and viewfinding information for the Canon F-1 apply equally to the use of the Canon EX cameras, as does the information on apertures, shutter speeds and exposure meters. The practical use of the EX meter is, however, rather different from that of the other models.

### Using the built-in exposure meter

The meter of the Canon EX cameras reads the whole screen area, but attaches rather more importance to the central area, where the most important part of the subject is likely to be located. Nevertheless, if that central portion should happen to be over-bright or extra-dark, suitable compensation should be made.

Generally, the full area reading gives an accurate

## CANON EX EE AND EX AUTO- LOADING

To load the Canon EX EE or EX Auto:
1. Pull up rewind knob.
2. Open back cover fully.
3. Insert loaded cassette.
4. Push back rewind knob.
5. Lay tip of film leader to index mark. up spool.
6. Partly close camera back to bring quick-load mechanism down on to film and check that sprocket wheel is engaging film perforations.
7. Close camera back and press to lock.

Make two blind exposures.

On the EX EE, the film speed figure has to be set to the 1.8 index when the standard lens is used or to the 3.5 index for other lenses.

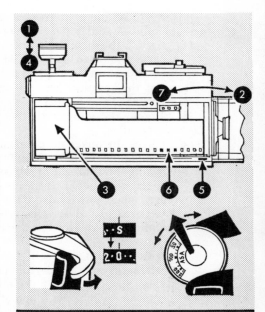

### UNLOADING

To unload the Canon EX EE or EX Auto:
1. Press rewind button.
2. Rewind film.
3. Pull up rewind knob to release back cover lock.
4. Open back cover fully.
5. Remove cassette.
6. Push back rewind knob.
7. Close camera back and press to lock.

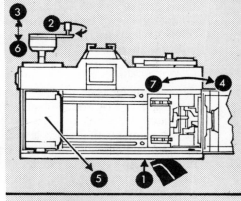

### CHECKING BATTERY

To check the battery of the Canon EX EE or EX Auto, set the film speed scale to 100 ASA and the shutter speed to 1/30 second. Turn the EE/manual switch to EE and point the camera toward bright light. If the needle swings up to 16 or higher, the battery has sufficient power. Otherwise, it must be replaced.

exposure recommendation because most subjects do average out to a mid-tone. So the procedure is:

(1) Switch the meter on by turning the ring round the rewind knob to bring the EE marking opposite the black line on the camera top plate.

(2) Set the required shutter speed according to the nature of the subject.

(3) Frame the subject in the viewfinder and focus accurately.

(4) Check the meter needle position. If it is in the red zone at the top of the viewfinder, the shutter speed is too slow for the light conditions and a faster speed must be set. If the needle is in the lowest red area when you are using the 50 mm. lens or in the red area just above that with any other lens, the shutter speed is too fast and a slower speed must be set.

(5) If the meter needle is in the clear area between the red marks and the aperture indicated is suitable for your purposes, press the shutter release and the exposure will be made at that aperture.

The coupling range of the meter is limited. With a film speed of 100 ASA, for example, all shutter speeds and all apertures can be used with the standard lens but with other lenses only the 1/30 to 1/500 shutter speeds couple with the meter.

## Overriding the auto-exposure control

There will be occasions when you need to modify the reading given by the exposure meter. A backlit subject, for example, tends to give too high a reading with an exposure meter that reads a wide angle. When you point your camera at the subject you may find that the aperture indicated is *f* 11 or *f* 16 when experience tells you that, at the shutter speed you have set, such an exposure cannot give any shadow detail. In that case you turn the meter/ aperture ring back past the off position to the area marked 1.8-16 and continue turning until the meter needle in the viewfinder points to the aperture setting you consider correct.

This action switches off the exposure meter and enables you to preset any aperture you like. The lens diaphragm does not close down, however. It remains at

## SHOOTING WITH THE CANON EX EE AND EX AUTO

To operate the Canon EX EE or EX Auto compose and focus the picture after ensuring that the film is wound on and the shutter tensioned.

For automatic operation, turn the EE/manual switch to EE. Set a suitable shutter speed and observe the position of the meter needle in the window. It indicates the aperture that the meter will set when you release the shutter. If the aperture indicated is unsuitable or the needle moves to the over or under-exposure zones, select a different shutter speed.

For manual operation, set the shutter speed in the normal manner and set the appropriate aperture by turning the EE/manual switch clockwise until the needle points to the figure required.

Press the shutter release gently.

full aperture until the shutter release is depressed. The camera is, in other words, an automatic-diaphragm type but the automatic exposure facility is by-passed and manual pre-setting of aperture irrespective of shutter speed becomes available.

You override the automatic exposure facility in this way when you wish to use combinations of aperture and shutter speed that are not within the meter coupling range. If, for example, with 400 ASA film, the meter should indicate an exposure of 1/60 second at $f$ 5.6 but, for depth of field reasons perhaps, you want to give the equivalent exposure of 1/15 second at $f$ 11, you will find that when you turn the shutter speed dial to 1/15 second, the needle flips to the bottom of the scale, indicating that the shutter speed set is outside the meter coupling range. If you shoot at that setting with the meter switched on, the lens will remain at full aperture. You can, however, switch off the meter and turn the meter/aperture ring to its limit to bring the needle up to the $f$ 16 mark. The lens will then stop down fully when you fire the shutter. You also need manual control of the aperture when using flash equipment.

## Changing lenses

The lenses of the Canon EX cameras are entirely different from those for all the other Canon reflexes. The other cameras use lenses that are totally removable from the camera. The Canon EX lenses have a common rear component that remains fixed to the camera body. The front component, however, can be unscrewed and replaced by another. The alternative front components provide focal lengths of 35, 95 and 125 mm.

The general information on lenses applies to the Canon EX lenses. They act in exactly the same manner as other lenses of equivalent focal length but they cannot be used with any of the behind-the-lens accessories such as bellows extension tubes, macro coupler, etc. With the 50 mm. lens, however, you can use the 48 mm. close-up lenses 240 and 450.

The procedure for replacing the 50 mm. lens by one of the alternatives is as follows:

(1)   Remove the front compartment of the lens by grasping it just in front of the focusing ring and

## CANON EX EE AND EX AUTO LENSES

The Canon EX EE and EX Auto lenses are of the interchangeable front component type. The rear component is permanently mounted on the camera and the focal length is changed by unscrewing the front component and screwing one of the alternative components in its place. Apart from the 50 mm standard lens, there are 35, 95 and 125 mm lenses available.

When attaching one of the alternative components set the distance scale of the rear component. Screw in the alternative component and turn its distance scale until its infinity mark is opposite the white dot on the focusing ring. This operation is not essential but if it is not carried out, the distance scale gives incorrect readings. The focus of the lens is not affected.

When using the EX EE with one of the alternative lenses, remember to set the film speed to the 3.5 index on the shutter speed dial.

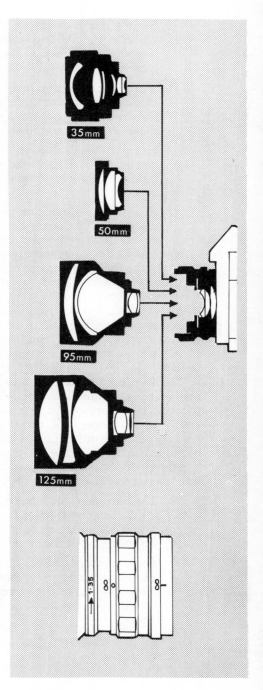

turning it anti-clockwise about $2\frac{1}{2}$ turns.

(2) Unscrew the rear cap from the lens to be attached and screw the lens into the rear component on the camera.

(3) Turn the focusing ring on the rear element clockwise to its limit, when the infinity symbol on the distance scale comes opposite the orange index mark on the depth of field scale.

(4) Using the finger grips on the chrome ring, turn the distance scale of the front component to centre the infinity symbol over the white dot on the focusing ring.

(5) Reset the film speed on the EX EE shutter speed dial to the red dot marked 3.5. This is not necessary on the later EX Auto model.

When using the 35, 95 and 125 mm. lenses, you focus by means of the focusing ring on the rear component. As the focusing movement is fixed, this allows the 35 mm. lens to focus much closer than the 50 mm. lens—down to about 0.26 m. ($10\frac{1}{4}$ inches) compared with 0.43 m. ($16\frac{3}{4}$ inches). The measurements are taken from the film plane. The 95 mm. lens, on the other hand, focuses only a little closer than 1.3 m. (4 feet 4 inches) and the 125 mm. to 2.1 m. (6 feet 10 inches).

The focused distance when using these lenses can be read off their distance scales opposite the white dot on the focusing ring—provided the distance scales are properly set. The adjustment of these scales is for distance-reading purposes only. It has no effect on the actual focus of the lens.

The vitally important points to remember about the interchange and use of Canon EX lenses are:

(1) The film speed must be reset on the Canon EX EE when changing from or back to the standard lens, which has a maximum aperture of $f$1.8 compared with the $f$3.5 of the other lenses.

(2) Focusing is carried out by means of the rear component focusing ring using the central range-finder portion of the screen only. The rest of the screen does not provide an accurately focusing image.

## Using the self-timer

The self-timer works on the same principle as on the other Canon reflex models. On the EX cameras, however, the self-timer lever serves no other purpose. There is no stop-down lever and no mirror lock.

## Flash with the EX cameras

The Canon EX EE and EX Auto are fitted with the usual 3 mm. coaxial sockets for bulb and electronic flashguns. To use such units, you have only to plug in, set the shutter speed dial to the appropriate synchronising speed, set the lens aperture and fire.

Flashbulbs can be used only at shutter speeds of 1/15 second and slower while electronic flash can be used at 1/60 second and slower. The EX cameras are not suitable for focal plane flashbulbs at faster shutter speeds.

Exposure with orthodox flash units is determined by the guide number system, and the required aperture is set by turning the ring switch around the rewind knob until the needle visible in the viewfinder point to the appropriate $f$-number.

When using flash units manually in this way with the Canon EX Auto, particularly electronic flash, ensure that the accessory shoe contacts are covered with the cap provided. These contacts are "live" when the flash is fired.

The Canon EX Auto hot shoe contact allows cableless flash units to be used and, additionally, has contacts to allow the Canolite D flash unit to be used for automatic flash exposure determination by the CAT system.

On the EX Auto this system can be used only with the standard 50 mm. $f$1.8 lens and the Canolite D. It uses no coupling ring because the circuitry is built into the camera body. The operating procedure is as follows:

(1) Push the CAT switch on the mirror box downward toward the lens so that it couples with the lens distance ring just beyond the infinity mark.

(2) Set the shutter speed dial at 60 and the meter switch ring around the rewind knob at OFF.

(3) Set the film speed.

(4) Remove the cover from the accessory shoe, attach the Canolite D and set its main switch to ON.

(5) Compose and focus the picture in the viewfinder.

(6) Check the exposure meter needle position in the viewfinder. It should, when the flash is ready to fire, point to one of the $f$-numbers visible in the viewfinder. That is the aperture at which the exposure will be made and you can press the shutter release button to take the picture. Be careful not to press the shutter release button before the needle stops rising because slight pressure on the button locks the needle and its indication is then inaccurate.

If the exposure meter needle remains at the bottom of the scale, the camera to subject distance is too great for the power of the flash. If it rises to the overexposure warning zone, the camera-subject distance is too short.

The principle of the CAT system is that the exposure meter needle is activated by the charge on the capacitor in the flash gun. The higher the capacitor charge, the smaller the aperture indicated. You can, therefore, release the shutter at any time during the recycling period of the flash unit. Even if the capacitor is not fully charged, your film will still be adequately exposed as long as the exposure meter needle points to one of the $f$-numbers.

The Canolite flashgun can be used as an ordinary unit by setting the meter switch ring of the camera to the aperture required, as indicated in the viewfinder. The guide number of the Canolite D is about 52 (feet) or 16 (m.) with a 100-125 ASA film.

# THE OLDER CANON
# REFLEXES

The Canon FT was phased out in 1972 after six or seven years as the standard-bearer of the Canon reflex range. The Pellix became available just before the FT, and six predecessors date back to 1959—the Canon FX, Canon FP, Canonflex RM, Canonflex RP, Canonflex R2000 and the original Canonflex of 1959.

## Original Canonflex

*Loading.* To open the camera, turn the key in the baseplate anti-clockwise. The back then hinges open. Pull upward on the rewind crank and insert a loaded film cassette into the chamber below it, with the protruding end of the spool at the bottom of the camera and the cassette lips facing toward the take-up spool. Push the rewind crank back and rotate it back or forth to engage the claw with the bar in the spool end. Pull sufficient film out of the cassette to reach the take-up spool. Rotate the take-up spool by the milled wheel at the bottom until you can slide the end of the film into the slot. The emulsion (non-shiny) side of the film should now be facing inward— toward the lens. Engage the second perforation from the end of the film in the hook in the take-up spool slot. Rotate the take-up spool further anti-clockwise to take up the slack film across the camera back and ensure that the film perforations engage the bottom sprockets of the drive spindle next to the take-up spool. The film winds on to the take-up spool with the emulsion side outward.

Close the camera back and press to lock it. Turn the key in the camera back clockwise. This key also serves to open and close the special Canon Film Magazine V, which was available for this camera.

Advance the film and tension the shutter by folding up the end of the lever in the camera baseplate and pulling the lever toward the rewind end of the camera. Press the shutter release. Repeat these operations and the two

frames exposed to light in the loading operation are wound off. When you operate the lever again, the frame counter next to the shutter release advances to No. 1 and you are ready to take your first shot.

To remind you what film you have in the camera, pull up the knob surrounding the rewind crank and rotate the notched levers to show the appropriate film speed figure and film type symbol. The sun symbol means daylight colour film, the black-and-white triangles indicate black-and-white film and the lamp means artificial light colour film. If you use colour negative film, you have to compromise. These symbols and the film speed setting are reminders only. They are not connected to any of the camera controls.

*Viewing and focusing.* When you look through the Canonflex eyepiece you see a magnified version of the image formed by the camera lens on the viewing screen. Thus, you see the image that will appear on the film, no matter what lens you use or what accessory you attach in front of or behind the lens. There is no problem of parallax as with cameras using a separate optical system for viewfinding.

You focus the image by means of the split-image rangefinder in the centre of the screen. Turn the focusing ring on the lens until a continuous image appears across the two halves of the rangefinder spot. It is best to direct the rangefinder spot to a straight line or edge in the scene. The ground glass area around the rangefinder spot can be used for focusing when the subject has no suitable continuous lines.

You should always focus with the lens set to full aperture, because the image is then at its brightest and focusing is more positive, owing to the restricted depth of field at large apertures. When using the Super Canomatic lenses on this model, therefore, you must ensure that the visual aperture ring is set to full aperture while focusing.

You can view and focus the image from above on the Canonflex because the pentaprism unit can be removed and replaced by a waist-level viewer. To remove the pentaprism, press the lever on the front of the camera near the rewind knob and slide the pentaprism unit backward. The waist level viewer slides into position and locks automatically.

## CANONFLEX AND CANONFLEX R2000

The features of the Canonflex and Canonflex R2000 are:

1. Shutter speed dial.
2. Meter mounting shoe.
3. Shutter release.
4. Self timer.
5. Removable pentaprism.
6. Pentaprism lock.
7. Rewind crank.
8. Flash connector.
9. Tripod socket.
10. Rewind button.
11. Trigger-action winding lever.
12. Shutter release lock.
13. Frame counter.
14. Fim type reminder.
15. Film speed reminders.
16. Back cover lock.
17. Bayonet tightening ring.
18. Depth of field scale.
19. Distance scale.
20. Focusing ring.
21. Manual aperture ring.
22. Preset aperture ring.
23. Eyepiece.
24. Film gate.
25. Sprocket wheel.
26. Film slit.
27. Focusing screen with fresnel lens.
28. Area clear of fresnel lines for fine focusing.

Early models had a non-focusing screen with split-image rangefinder and ground glass collar.

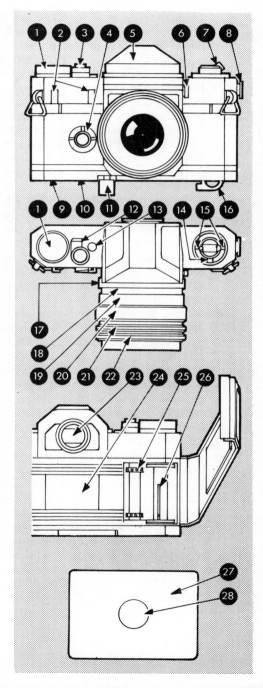

*Using the Canon-Meter R.* An attachment exposure meter was supplied for the Canonflex. It consists of a more or less conventional selenium meter with a large dial on top with film speed settings, shutter speed and aperture markings. Meshed with this dial is a cog-wheel that engages with cogs on the shutter speed dial of the camera.

To attach the Canon-Meter R, set the same shutter speed on both meter and camera. Press the hook on the side of the meter inward and slide the meter down on to the mounting shoe on the front of the camera below the shutter speed knob. Release the hook and the cogs should be properly meshed. To detach the meter, press the hook and pull the meter off.

To use the meter, first set in the small cut-outs on the dial, the speed of the film in the camera. Point the camera to the subject. Light entering the meter window causes the needle to move to one of the black or white segments indicating an aperture number on the meter dial. That is the aperture to which you must set the lens at the shutter speed set on the camera. If either shutter speed or aperture is unsuitable, you can select an alternative simply by turning the shutter speed dial on the meter. Operation of the meter automatically sets the shutter speed, but you have to set the aperture on the lens separately.

The meter has a dual sensitivity control. If the light is so bright that the meter needle moves directly across the scale no matter what shutter speed is set, turn the knob on the side of the meter so that either of the white marks points to the index mark above it. You then read the aperture from the white scale on the meter dial. If the light is so low that the needle does not move, turn the knob so that one of the orange marks is opposite the index and read the aperture from the orange scale.

There was also an incident light attachment for the Canon-Meter R—a flat diffuser that slides over the meter window. The principle of incident light is that when the meter is pointed from the subject position toward the camera it averages the light falling on the subject (instead of the light reflected by the subject) and thus provides exposure recommendations that take no account of subject tone or the nature of the lighting. Even back-lighting is dealt with adequately. The incident light meter, in fact, should provide the same result as a reflected-

light reading from a mid-tone and is particularly recommended for colour work.

*Interchangeable lenses.* The lenses originally made available with the Canonflex were two Super Canomatics, 50 mm. $f1.8$ and 100 mm. $f2$, with other lenses in the R series in the focal lengths 85 mm. $f1.9$, 135 mm. $f3.5$, 200 mm. $f3.5$, 300 mm. $f4$, 400 mm. $f4.5$, 600 mm. $f5.6$, 800 mm. $f8$ and 1000 mm. $f11$.

The Super Canomatic lenses are of the fully automatic diaphragm type. There are two aperture setting rings. That at the front of the lens is the preset aperture ring. You set it to the required shooting aperture but the lens diaphragm remains fully open for viewing and focusing. When you press the shutter release, the iris closes down automatically to the preset aperture and reopens after the exposure is completed.

The second ring is the visual aperture ring and acts like a normal manually operated control so that you can preview the depth of field at the stop selected. The lens must, however, be opened up to full aperture before the shutter is released.

These lenses have an aperture preset charge lever in the back of the mount. This lever must be pushed from left to right (as you view the lens from the back) before the lens is fitted to charge the preset mechanism. If this is not done, no damage will be caused but the automatic iris feature will not work for the first exposure after fitting the lens.

The other lenses in the R range have no automatic iris feature and are used manually for aperture control.

The lens changing operation on this original Canonflex was the same as that still used on the current models—a bayonet plus tightening ring that involves no turning of the lens as it is attached or detached.

*Flash synchronisation.* The flash connector of the Canonflex is a special type located in the side of the top plate at the rewind end of the camera. It was designed for direct attachment of the Canon Flash Unit V for bulbs and the Canon Speedlight (electronic flash) Unit Model V. To use flash units of other makes Canon Extension Cords Va were available in 3 and 15 feet lengths.

The synchronisation shutter speeds are all speeds except 1/30 second for focal plane bulbs, 1/30 second and

slower for normal bulbs and 1/60 second (the X setting on the shutter speed dial) for electronic flash.

*Unloading*. When all exposures have been made, the film has to be wound back into the cassette. Push the rewind button in the camera base (next to the tripod socket). Raise the rewind crank and turn it clockwise until you feel the film pull out of the take-up spool. Turn the opening key in the base of the camera to the left and open the camera back. Pull the rewind knob upward to disengage the prong drive and remove the cassette.

The rewind button does not need to be held down. Once pressed, it will stay down until the winding lever is operated.

*Other features*. The Canonflex has a self-timer or delayed action mechanism built in. The control is a lift-up key in the front of the camera below the shutter release. When the key is turned as far as it will go in the direction of the arrow, a timing device is set to delay the operation of the shutter release. The self-timer can be set before or after the shutter is tensioned but, once set, it cannot be by-passed and the next exposure has to be made with a delay. The shutter opens about 10 seconds after you press the shutter release.

The shutter release is threaded for a standard cable release and has a lever lock for use with time exposures (locking the button down) or as a safeguard (locking the button up against accidental release).

The shutter speed knob carries the standard speed markings from 1-1000, plus a B-T setting for time exposures and X ( = 1/60 second) for electronic flash. At the B-T setting, the shutter remains open as long as the button remains depressed.

*Accessories*. A wide range of accessories was issued with the Canonflex. Apart from the waist-level viewer already mentioned, there was a Bellows R; Lens Mount Convertors to allow lenses designed for Canon rangefinder cameras to be used on the Canonflex and vice versa; a focusing adaptor to allow lens heads of certain Canon rangefinder camera lenses to be used on the Canonflex; close-up lenses 450 and 240; Copy Stand R; a Photo-micrographic Unit; filters; Camera Holder R; and a special reloadable metal Film Magazine or cassette.

The Bellows R is fully described later. With the Canon-

flex and its successors for many years it served as the focusing unit of the longer focal length lenses (from 300 mm. upward), which were supplied with the Bellows R, lens supporter and intermediate tube.

The Camera Holder R was particularly useful for copying and similar work because the tripod socket of the Canonflex is at one end of the baseplate. The Camera Holder was screwed into this socket and mounted on the tripod horizontally via a socket in the base or vertically by a socket in the side of the holder.

The Film Magazine is of the type that is dismantled into three parts and requires no velvet light trapping. Slits in the inner and outer shells are brought into coincidence to allow the film to pass through when the locking key in the camera baseplate is turned to the locked position. When the key is turned to unlock the baseplate it also closes the cassette.

## Canonflex RP and R2000

These two models, introduced in 1960, differ very little from the 1959 Canonflex. They do, however, have one notable difference each. The RP has a fixed pentaprism and was produced at a lower price. The R2000 added the then revolutionary 1/2000 second to the shutter speed range. To accommodate this setting on the shutter speed dial the X setting was moved to share the 1/60 position.

The range of Super Canomatic lenses was extended to include a 35 mm. *f*2.5, 50 mm. *f*1.8, 85 mm. *f*1.8, 100 mm. *f*2 and 135 mm. *f*2.5.

The R range of lenses was, in fact, becoming rather complicated, because, apart from the Super Canomatics, there were Canomatics, which were semi-automatic, as well as manually preset and manually operated types with no preset ring. These last-mentioned were the 300 mm. upward lenses used with the Bellows R.

The Canomatic lenses had a preset aperture ring and a charge ring. The charge ring performed the function of the charge lever on the Super Canomatics, which is operated by the shutter tensioning mechanism. When the charge ring is operated, the lens is locked at full aperture, regardless of the position of the preset ring. There is, however, a release button at the rear of the lens mount just in front of the bayonet locking ring which closes the aperture to

the preset value. On the Canomatic lenses, the diaphragm closes down to the preset aperture when the shutter is released but has to be reopened by manual operation of the charge ring.

The Canon R manually preset lenses have a preset aperture ring and an aperture set ring. You set the shooting aperture on the preset ring, which leaves the diaphragm fully open. Just before shooting, you turn the aperture set ring to its full extent and the diaphragm closes down to the preset stop.

The Canon R manually operated lenses have no preset ring and are simply opened and closed by the single aperture ring.

Among the additional accessories introduced with the RP and R2000 was a Flash Unit Coupler which fitted over the flash connector to provide an accessory shoe fitting for clip-on type flashguns.

Both models had built-in self-timers, but the RP had the lever tye, as opposed to the fold-up key of the R2000 and 1959 model.

## Canonflex RM

With the introduction of the RM model in 1962, the removable pentaprism was abandoned, not to be introduced again until the Canon F-1. There were many other differences, of which the most notable was the built-in selenium exposure meter with needle linked to shutter speed and film speed setting. Styling differences included the absence of the shutter release lock, and removing the film winder from the base plate, making room for the tripod socket to be placed at the point of balance. A film transport lever was placed in the back of the top plate, behind the shutter speed knob. In other respects, the RM is virtually identical to the original Canonflex described in detail in the previous pages. Loading, unloading, operation of the self-timer (the RM has a lever that is pulled downward), flash synchronisation, lens changing and automatic diaphragm operation, viewing and focusing, etc., are all the same. The difference is in the operation of the built-in-meter, which takes the place of the attachable Canon Meter R.

*Using the built-in-meter.* The shutter speed dial of the Canonflex RM differs slightly from those of the previous

## CANONFLEX RP

The features of the Canonflex RP are:

1. Shutter speed dial.
2. Meter mounting shoe.
3. Shutter release.
4. Self timer.
5. Fixed pentaprism.
6. Carrying strap eyelet.
7. Rewind crank.
8. Flash connector.
9. Tripod socket.
10. Rewind button.
11. Trigger-action winding lever.
12. Frame counter.
13. Bayonet tightening ring.
14. Film type reminder.
15. Film speed reminders.
16. Back cover lock.
17. Cassette chamber.
18. Film gate.
19. Eyepiece.
20. Sprocket drive.
21. Pre-set aperture ring.
22. Manual aperture ring.
23. Focusing ring.
24. Distance scale.
25. Depth of field scale.
26. Focusing screen with fresnel lens.
27. Area clear of fresnel lines.
28. Film slit.

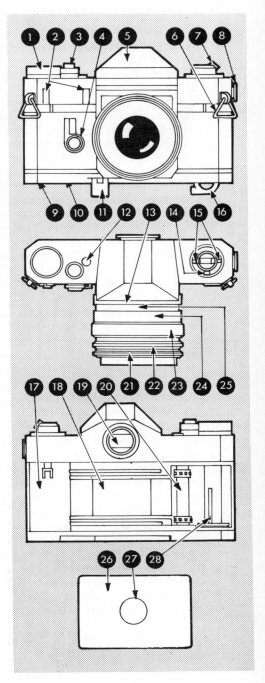

models. There is no X marking—the 1/60 second position being used for electronic flash. Similarly, the T marking was dropped with this model, leaving just the B to indicate the setting for exposures longer than 1 second. The dial does not rotate continuously. It cannot be turned between B and 1000.

The most important difference, however, is that the shutter speed knob carries two small cut-outs, marked DIN and ASA. If you pull upward on the outer rim of the shutter speed dial and turn it, the figures in the cut-outs change. This enables you to set the speed of the film in the camera so that the built-in exposure meter is calibrated to recommend the correct exposure. The ASA scale runs from 10 to 800, the DIN scale from 11 to 30. On the DIN scale, the dots between certain figures represent the *two* missing figures, i.e., the dot between 15 and 18 is used for settings of 16 and 17. The ASA scale runs as follows, the italic figures representing the dots between marked figures:

  10, 16, *25*, 32, *40*, 50, *64*, *80*, 100, *125*, *160*, 200, *250*, *320*, 400, *500*, *640*, 800.

The meter can be used either to determine the shutter speed after setting the aperture required; or to determine the aperture after setting the required shutter speed. The method is similar to that used with the clip-on meter of the previous models, but on the RM the needle is coupled directly to the shutter speed dial.

If you wish to shoot at a certain aperture, for depth of field reasons perhaps, set that aperture on the lens, point the camera toward the subject and turn the shutter speed dial until the segment in which the needle lies lines up with the aperture figure set.

If, on the other hand, you have to use a certain shutter speed, perhaps because of movement in the subject, set that speed on the shutter speed dial and point the camera to the subject. Read the aperture indicated by the position of the exposure meter needle and set that reading on the lens.

Generally, it is best to set the shutter speed and use the meter to read the aperture, because intermediate positions can be set on the lens aperture ring but not on the shutter speed dial.

There is a zero adjustment screw for the meter in the

## CANONFLEX RM

The features of the Canonflex RM are:

1. Shutter speed dial.
2. Shutter release.
3. Exposure meter window.
4. Self timer.
5. Fixed pentaprism.
6. Carrying strap eyelet.
7. Flash connector.
8. Rewind crank.
9. Rewind button.
10. Tripod socket.
11. Film transport lever.
12. Film speed scale.
**7**3. Frame counter.
14. Exposure meter scale.
15. Meter zero adjustment.
16. Back cover lock.
17. Cassette chamber.
18. Eyepiece.
19. Pre-set aperture ring.
20. Manual aperture ring.
21. Focusing ring.
22. Distance scale.
23. Depth of field scale.
24. Bayonet tightening ring.
25. Focusing screen.
26. Fine focusing zone.
27. Rangefinder.
28. Film gate.
29. Sprocket wheel.
30. Perforation hook.
31. Take-up spool.

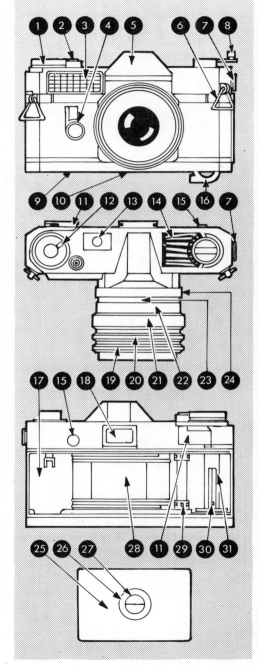

back of the camera top plate. It has a cover that first has to be removed by turning anti-clockwise. You then use a fine screwdriver to turn the screw to left or right to bring the needle into line with the zero mark. During this operation, the meter window must be completely covered.

All accessories designed for the previous models can be used except, of course, the clip-on meter and waist level finder replacing the pentaprism. A Waist-Level Viewer 2RM was available, however, for attachment to the eyepiece. It provided a laterally reversed image.

## Canon FX

The Canonflex name was dropped in 1964, when the Canon FX was introduced, with the styling that can still be seen in all the later models. The main stylistic alterations included the movement of the shutter speed dial away from the end of the camera to make room for the redesigned rapid wind lever. There was a lock on the shutter release. An accessory shoe was built on to the top of the pentaprism. A mirror lock lever was placed in the camera front to allow the mirror to be locked in the up position. The focal plane mark, indicating the actual position of the film, made its first appearance on the top plate. The flash synchronisation socket moved to the front of the camera and the flash unit direct attachment socket was abandoned.

The main innovation in this model, however, was the built-in CdS meter. The Canon FX is, therefore easily distinguished by the small meter window in the front of the top plate below the rewind knob, by the meter indicator window in the top plate, and by the battery compartment in the rewind end of the top plate.

The lock on the shutter release was reintroduced allowing the shutter to be locked open or closed. The back cover lock was the fold-up key type used on earlier models. The camera body measured $141 \times 90 \times 43$ mm. and weighed 670 g.

*Battery loading and checking.* As the meter of the Canon FX is built in, the first step on taking the camera into service is to insert a battery or check the battery already inserted. The cover of the battery compartment unscrews by turning anti-clockwise. Insert a No. 625 battery with the plus marking facing outward and screw the cover

## CANON FX

The features of the Canon FX are:

1. Self timer.
2. Shutter release.
3. Shutter speed dial.
4. Pentaprism.
5. Accessory shoe.
6. Mirror lock.
7. Flash socket.
8. Meter window.
9. Rewind crank.
10. Rewind button.
11. Tripod socket.
12. Film transport lever.
13. Bayonet tightening ring.
14. Meter scale.
15. Meter sensitivity switch.
16. Back cover lock.
17. Battery compartment.
18. Frame counter.
19. Shutter release lock.
20. Cassette chamber.
21. Meter switch.
22. Film gate.
23. Eyepiece.
24. Aperture ring.
25. Focusing ring.
26. Distance scale.
27. Depth of field scale.
28. Auto/manual ring.
29. Sprocket wheel.
30. Take-up spool.
31. Perforation hook.
32. Focusing screen.
33. Fine focusing area.
34. Rangefinder.
35. Meter needle.
36. Aperture scale.
37. Guide lines.

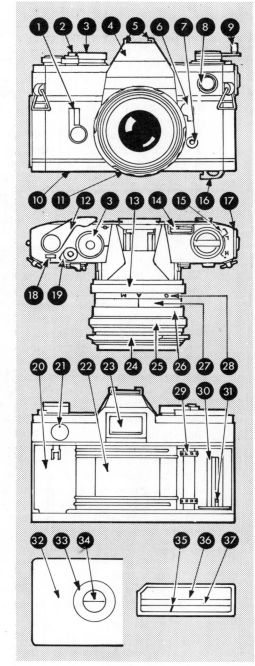

back into place. The battery is the popular type now used in a great number of cameras and the usual warnings as to cleanliness, finger marks, etc. should be heeded.

To check the battery, turn the circular switch on the back of the camera top plate to the "Check" position. The meter needle should then swing into the blue section on the scale in the meter indicator window. If it remains in the white section, the battery has insufficient power and should be changed.

*Shutter operation and film speed setting.* The shutter speed dial of the Canon FX has the now common cut-outs for film speed setting. To set the film speed, pull upward on the rim of the shutter speed knob and turn until the appropriate figures appear in the cutouts. The film speed scale runs from 10-800 ASA and 11-30 DIN, with the same markings as on the attachable meter of the FP model.

The shutter release is similar to that of the previous models but it has a lock lever around the release button. When the lever is turned so that the line on the rim of the shutter release lines up with the dot on the top plate marked L, the shutter release is locked and the shutter cannot be accidentally opened. When the mark is turned to the dot marked A, the shutter can be released. The lock can also be used to lock the shutter open when you wish to make lengthy time exposures.

*Flash synchronisation.* The Canon FX shutter is synchronised for all types of flash but the recommended shutter speeds for flashbulbs are 1/15 second and slower.

*Camera operation.* The normal loading, unloading, viewing and focusing, use of self-timer, etc., are carried out in the same way as with the earlier models.

*Lenses.* A major difference between the Canon FX and the previous models was the introduction of the FL range of lenses from 19 to 200 mm. plus a 55-135 mm. *f*3.5 zoom. The R lenses were still used for focal lengths from 300 mm. upward. The method of attachment to the camera remained the same but in other respects the FL lenses are considerably different from the previous Super Canomatic and Canomatic lenses. They are all (except the ultra wide angle 19 mm.) fully automatic diaphragm types, but the mechanism is different. A single pin lever protrudes from the back of the lens and there is no charge

Sunset. In this type of shot, the apparent size of the sun depends on the focal length of the lens. – *Tom Sheppard*.

*Page 209*. Japanese girl. A single light source and a plain background for the classic profile. – *David Waterman*.

*Page 210*. Silhouette. A short exposure from a low viewpoint makes an impressive late evening shot. – *Tom Hustler*.

Aerial. An industrial shot with a difference. A floodlit satellite communications aerial at sunset. – *Tom Sheppard.*

*Page 211.* London's Big Ben. A remarkably flare-free against-the-light picture. – *David Waterman.*

*Page 212.* Background. Raising the viewpoint creates a background without distracting lines. – *Ruan O'Lochlainn.*

*Page 213.* Foreground. Added interest and colour, together with an impression of depth, were provided by shooting close to the foreground blooms. – *Tom Hustler.*

Star. James Mason in a scene from the film of Chekhov's *The Seagull* – *Ruan O'Lochlainn*.

*Opposite*. Desert symbol. A striking example of manufacturing a picture, even on a desert plain. – *Tom Sheppard*.

Through the clouds. A long-range shot from peak to peak at above cloud level. – *Leo Dickinson*.

*Opposite top*. Frame. Mountain peaks shot through a small ice tunnel to provide an interesting and appropriate frame. – *Leo Dickinson*.

*Opposite bottom*. Fisheye in a cave. Note the lack of curvature in the figure. – *Leo Dickinson*.

Coins. Sidelighting with frontal fill-in provides all the detail required. Close-range work like this can be undertaken with close-up lenses, bellows or extension tubes from the Canon range. – *Tom Sheppard*.

Spider. An example of the close-up capability of the Canon lenses. A strongly glancing light with plenty of fill-in brought out the shape and texture. – *Tom Sheppard*.

Roses. A short extension tube can make flower photography in close-up a practical proposition. – *Tom Hustler*.

Parachutist. From a series using the Motor Drive Unit and Servo EE Finder. – *David Waterman*.

Pattern. Rotating the camera on its axis while the shutter was open created this interesting pattern of light. – Canon Inc.

lever or charge ring. There are two aperture rings—the preset and manual aperture rings—but they work in the manner of the previous preset lenses rather than the Super Canomatics. The manual aperture ring, for example, cannot be turned beyond the limit set by the position of the preset aperture ring. If you wish to use the lens manually, you have to turn the preset ring to the smallest aperture setting. Although they have the same connotation, these lenses are not, of course, the same FL lenses as those that immediately preceded the introduction of the FD range, which are fully automatic diaphragm types without the extra aperture ring.

Because the mounting method is the same, all the previous lenses can be used on the Canon FX, but none of them connect with the automatic diaphragm mechanism and all, therefore, have to be operated manually. The same applies to the use of the new FL lenses on the Canonflex models.

*Mirror lock.* The super wide angle, 19 mm. *f*3.5 lens introduced with the Canon FX has too short a back focus to allow the mirror to carry out its normal movement. So the Canon FX has a small lever on the camera front above the flash socket. When this lever is swung to the right and upward, the mirror is raised to a horizontal position beneath the viewing screen and remains there until the lever is returned to its normal position. Only after the mirror has been raised in this way can you use the 19 mm. lens.

Naturally, the raised mirror prevents the lens from projecting an image on to the viewing screen and the camera ceases to be a reflex type. A separate viewfinder is therefore supplied with the lens. It attaches to the camera accessory shoe and shows the field of view of the 19 mm. lens at infinity.

As the viewfinder is separated from the lens, the coincidence between the images shown by the viewfinder and the lens lessens as the shooting distance decreases. This is parallax error—a difficulty that does not normally bother the reflex user. You must be careful, therefore, to allow more room at the top of your picture than you would normally when shooting at 3-4 m. (10-13 feet) or less. At very close range, the parallax error is considerable and you would do better to line up the lens with the centre

of the subject by measurement or observation whenever possible.

The FL range of lenses was increased for later models of the Canon FX and included three zooms—55-135, 100-200 and 85-300 mm. The R type lenses were still used for focal lengths from 300 mm. upward. Some of the FL lenses were redesigned to introduce a manual/automatic switching ring with A and M positions instead of the manual ring of the previous models. When the A-M ring is turned to A, the aperture closes to the preset value only when the shutter release is depressed. When it is set to M, the preset ring acts as a manual ring.

*Using the Canon FX Meter.* To use the built in meter of the Canon FX, you first set on the shutter speed dial the speed of the film in use. As the meter is battery powered, it has to be switched on. Turn the switch on the back of the camera top plate to the ON position.

The meter has a dual sensitivity range. A lever switch around the rewind crank has L and H positions. These operate in the same way as the dual ranges of the Canon FP meter. The L setting is for normal outdoor lighting or very bright (photoflood, studio lamps, etc.) lighting indoors. The H setting is used when the light is weak and high sensitivity is required. Again, as with the FP meter, you read the orange aperture figures when using the H setting and the white figures when using the L setting.

Operation of the meter is the same as that of the Canon FP meter. Similarly, when the meter is not in use, the switch must be turned to the OFF position to avoid draining the battery. If the meter is not to be used for a long period the battery should be removed from the camera. If it is allowed to drain completely it might discharge and corrode the camera contacts.

*Accessories.* The eyesight adjustment lenses introduced with the Canon FP also fit the FX. The Waist-Level Viewer Model 2 can also be fitted. Among the new accessories for the Canon FX were the Macrophoto Couplers FL48 and FL58, the Photomicro Unit F, Bellows FL and Slide Duplicator, and the Extension Tubes FL15 and FL25.

## Canon FP

The Canon FP is virtually the same camera as the Canon FX but for the fact that it has an attachable CdS meter in place of the built-in model of the FX.

A film type indicator was incorporated in the rewind knob. The back lock consisted of a safety sliding button and opening press button. A coupling CdS exposure meter was supplied. Four adjustment lenses for attachment to the eyepiece were introduced. The camera body measures 141 × 90 × 43 mm. and weighs 650 g.

*Loading*. The back of the Canon FP is opened by sliding the safety lock (the button nearer the back of the camera) while pressing the other button—the opening button. The rest of the loading procedure is the same as for the previous models. The back is closed simply by pressing it downward. The lock engages automatically.

After loading, set the film speed and type indicator as a reminder of the film loaded into the camera. Hold the dial surrounding the rewind crank by the rim and turn the projecting pin until the film type shows in the cut-out. The marking are B + W, Color plus a lamp symbol indicating artificial light colour film, Color plus a sun symbol indicating daylight type colour film, and Color N indicating colour negative film. To indicate the film speed, turn the dial by the rim until the appropriate figure is opposite the triangular index mark on the camera top plate. Both DIN and ASA figures are marked: 11-30 DIN and the equivalent 10-800 ASA. These settings are reminders only and have no functional purpose.

*Unloading*. After all exposures have been made, unloading is performed in the same way as with the earlier Canonflex models, except for the slightly different method of opening the back.

*Flash synchronisation*. The Canon FP shutter is synchronised for electronic flash at the X-setting. Focal plane bulbs can be used at all shutter speeds except 1/30 second—including B but excluding the X setting. Ordinary flashbulbs can be used at shutter speeds of 1/30 second and slower, including B. The flash unit can be attached to the camera by sliding it into the accessory shoe on top of the pentaprism and plugging the cable into the socket on the front of the camera. The previous direct contact Canon flash units cannot be used.

*Using the Canon FP Meter*. A special CdS type meter was supplied to fit into the accessory shoe of the Canon FP and to couple with the shutter speed knob. This was a very sensitive meter reading light levels for a 100 ASA film corresponding to 1 second at $f$1.4 to 1/1000 second at $f$16. The film speed scale ran from 10-800 ASA, 11-30 DIN. It was a dual range type powered by a type 625 mercury battery. Measuring overall $70 \times 65 \times 31$ mm., the Canon FP Meter weighed 160 g.

As this meter uses a cadmium sulphide photo-resistor instead of the selenium cell of the Canonflex meters, it needs battery power. The first operation, therefore, is to load a battery into the compartment on the left-hand side of the case. You remove the compartment cover by pushing it inward with a finger and turning it anti-clockwise. The battery used is the now well-known mercury 625 type. It is inserted in the usual manner, with the plus sign showing, and the cover is screwed back in. It is advisable to wipe the faces of the battery with a clean, dry cloth or tissue before placing it in the compartment. Grease or perspiration transferred to the central camera contact could damage it and entail a rather expensive repair.

Once the battery is inserted, and whenever it is used after an interval, its power should be checked. This you do by turning the circular switch on the other side of the meter case to the C position. If the needle swings to the blue coloured section the battery has sufficient power. If it stops in the white section, the battery must be replaced. In normal use, the battery has a life of about one year.

The procedure for attaching the meter to the Canon FP camera is as follows:

(1) Turn the locking lever at the back of the meter to the right (toward the shutter speed dial).

(2) Place the meter on the camera top with the shutter speed dial directly over the shutter speed dial of the camera and the locking piece placed centrally in the accessory shoe.

(3) Turn the locking lever to the left so that the locking piece turns and slides into the accessory shoe grooves. The meter must be accurately positioned to ensure that the lock operates correctly.

(4) Turn the shutter speed dial of the meter to left or right until you feel additional resistance when the

## CANON FP

The features of the Canon FP are:
1. Self timer.
2. Shutter release.
3. Shutter speed dial.
4. Pentaprism.
5. Accessory shoe.
6. Mirror lock.
7. Film speed and type indicators.
8. Flash socket.
9. Rewind crank.
10. Rewind button.
11. Tripod socket.
12. Film transport lever.
13. Focal plane mark.
14. Bayonet tightening ring.
15. Back cover lock.
16. Frame counter.
17. Pre-set aperture ring.
18. Eyepiece.
19. Film gate.
20. Sprocket wheel.
21. Take-up spool.
22. Focusing ring.
23. Distance scale.
24. Manual aperture ring.
25. Depth of field scale.
26. Fine focusing zone.
27. Rangefinder.

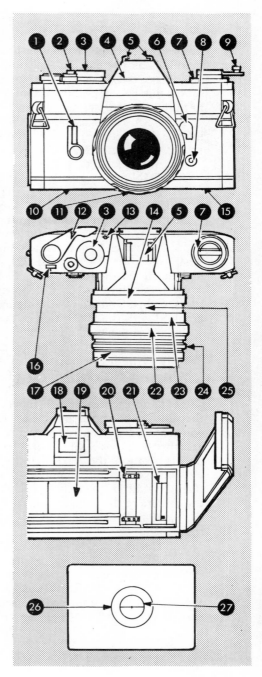

coupling groove links with the pin on the camera shutter speed dial.

The shutter speed dial of the meter bears the same markings as the camera dial but, additionally, has cut-outs marked DIN and ASA for film speed setting. To set the film speed, pull the rim of the dial upward and turn until the appropriate figure appears in the cut-out.

The ASA scale is as follows, the italic figures representing the dots between marked figures:

10, *12*, 16, *20*, 25, *32*, *40*, 50, *64*, *80*, 100, *125*, *160*, 200, *250*, *320*, 400, *500*, *640*, 800.

The DIN figures run consecutively from 11 to 30.

When the meter is not in use, the switch should be set to the OFF position to conserve the battery. Apart from the C position for battery checking, the switch also has L and H positions. These represent low and high *sensitivity*— not low and high light levels as on many later CdS meters. The L position is used when the light level is relatively high, as in most outdoor work. The H position is used for work in low light levels. When using the L position read the aperture from the white figures. The orange figures are used with the H position of the switch.

There are two methods of using the meter to determine the exposure, depending on whether you wish to give priority to the shutter speed or to the aperture.

When you wish to shoot at a particular aperture, first set that aperture on the lens. Point the camera at the subject and the needle will move across the scale. Turn the shutter speed dial and the aperture scale on the meter will also move. When the figure corresponding to the aperture you have set on the lens comes opposite the needle position, the correct shutter speed has been set.

When you wish to shoot at a particular shutter speed, turn the shutter speed dial to set the speed selected, point the camera to the subject, and read the aperture figure on the meter to which the needle points. Set that aperture on the lens.

You can use settings between the marked position on the aperture ring, but not on the shutter speed dial.

You cannot use the B or X positions on the shutter speed dial for metering purposes.

In low-light conditions, the movement of the needle may become rather sluggish. It is then advisable to

## CANON FP METER

The features of the Canon FP attachable meter are:
1. Film speed scale.
2. Shutter speed dial.
3. Attachment lock lever.
4. Main switch.
5. Aperture scale.
6. Battery check zone.
7. Meter needle.
8. Meter window.
9. Battery compartment.

To attach the meter, pull the attachment lock lever to the right and place the meter on the accessory shoe so that the locking plate sits centrally. Align the coupling part of the shutter speed dial with the shutter speed dial of the camera. Push the lock lever back to the left to lock the meter in the accessory shoe. Turn the shutter speed dial to left or right to couple with the dial on the camera. Set the film speed by lifting the rim of the shutter speed dial and turning it until the appropriate figure appears in the cut-out.

The meter switch has L and H positions. Use the L position when the light is bright and the H position for low lighting. Read the white figures on the scale when using the L setting and the orange figures for the H setting.

To use the meter, set an appropriate aperture on the lens, point the camera to the subject and turn the shutter speed dial until the scale figure representing the aperture set is opposite the needle position. Alternatively, set an appropriate shutter speed, point the camera to the subject, read the aperture opposite the needle and set that aperture on the lens.

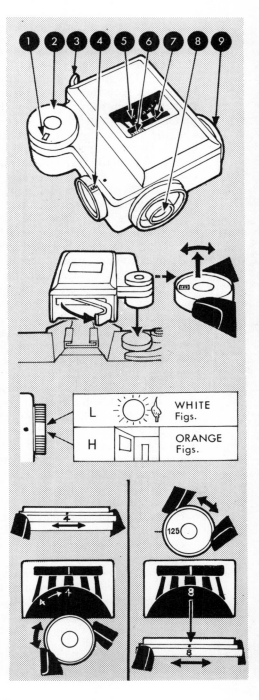

L — WHITE Figs.
H — ORANGE Figs.

wait until the needle settles to a fixed position. This is a characteristic of all CdS meters which is more marked as the light level becomes lower.

When detaching the meter from the camera, move the locking lever to the left and lift the meter off. Make sure that the switch is in the OFF position before putting the meter away.

*Viewing and focusing.* The viewfinder of the Canon FP is similar to those of the previous models. The screen is a fresnel type with split-image rangefinder in the centre surrounded by a fine ground area free of fresnel rings. An innovation with this model, however, was the availability of four correction lenses for the viewfinder eyepiece. These enable some spectacle wearers to dispense with their spectacles for viewing and focusing purposes. The correction lenses are supplied in rectangular frames that slide over the eyepiece frame. They are marked (a little confusingly) in dioptre strengths of $+1.5$, $0$, $-2.5$ and $-4$. These are, in fact, the dioptre strengths of the eyepiece lens as corrected, because it has always been customary for Canon to fit a $-1.2$ dioptre lens in the viewfinder eyepiece, on the principle that this is the most suitable lens for the greatest number of people.

A Waist-Level Viewer Model 2 can also be fitted to the eyepiece. This is in the form now more commonly known as an angle finder but it presents a laterally reversed image.

*Self-timer.* The self-timer on the Canon FP is set by a lever on the camera front below the shutter release button. To set the timer you pull the lever to the left and downward as far as it will go. Then with the film advanced and the shutter tensioned (either before or after setting the lever), you press the shutter release button to actuate the timer. The shutter is released after a 10-second delay. You can shorten the delay slightly by pulling the lever only part way down but it must cover at least two-thirds of the full travel.

Once the self-timer is set, you cannot release it without releasing the shutter.

*Accessories.* Most of the accessories for previous models can be used with the Canon FP but there are a few notable exceptions. The direct-coupling flashguns cannot be used, for example, but new Canon flash equipment—notably the Quint, firing five flashbulbs consecutively—

was made available. The camera holder designed for the Canonflexes had an off-centre attachment screw because of the positioning of the tripod socket, so a remodelled Camera Holder R4 was supplied.

## Canon Pellix and Pellix QL

If the single lens reflex camera has a fault, it is the momentary black-out of the viewfinder when the mirror flips out of the way while the exposure is made. Some photographers find this disconcerting in action shots and in portraiture because they fear that, because they cannot see the subject at the actual moment of exposure, they cannot be sure that they caught the right expression or movement.

Canon sought to overcome this difficulty by substituting for the movable glass mirror a fixed, extremely thin, partially reflecting membrane known as a pellicle. While passing most of the light transmitted by the lens, this pellicle acts as a beam splitter to peel off part of the light and redirect it to the viewing screen. Thus, the image remains visible through the eyepiece even while the exposure is being made.

*Special features.* The fixed pellicle was by no means the only new feature of the Pellix. It also introduced through-the-lens metering to the Canon reflexes. In the Pellix this is a semi-spot type meter reading the small area around the rangefinder spot via a light-sensitive CdS element placed behind the pellicle. The meter is powered by the same type 625 mercury battery as the CdS meter of the Canon FX, housed in the same type of compartment in the end of the camera top plate.

A further new feature is the microprism rangefinder spot as used in the current models in place of the previous split-image type.

The pellicle had a slight drawback in that it could in some circumstances allow light to pass through the eyepiece and the pellicle to the film and cause ghost images. The Pellix therefore has an eyepiece shutter for use on occasions when photographs are taken without the eye at the eyepiece.

Later models of the Pellix are known as the Pellix QL because they introduced Canon's quick-load system to facilitate film loading.

The QL models also have a modified battery compartment with contact sockets for the Canon Booster.

The general design and operation of the Pellix follow on the same lines as the previous models. The dimensions are the same as those of the FP and FX—141 × 90 × 34 mm.—but the weight is up at 700 g. There are, however, minor noticeable differences. The self-timer lever was restyled, and was given the extra function, when pressed toward the lens, of switching on the meter and stopping down the lens to its preset aperture.

The shutter speed dial is in the chrome finish of the top plate instead of the previous black.

Despite the built-in meter, there are no external meter scales, because settings are automatic when lining up the needle visible in the viewfinder.

The shutter speed safety and time lock are the same as on the Canon FX but the mirror lock lever is, of course, removed. Similarly, the meter switch on the back of the FX and the meter sensitivity switch around the rewind knob do not appear on the Pellix. Instead, a collar around the rewind knob acts as a switch for the eyepiece shutter.

*Battery insertion and check.* As with the Canon FX, the battery for the exposure meter is inserted in a compartment in the side of the camera top plate. The battery check procedure, however, is slightly different. To check the battery, you first set the film speed on the shutter speed dial to 100 ASA and the shutter speed to X. Then turn the ring around the rewind knob, which also acts as the eyepiece shutter control, to the C position, and look through the eyepiece to check the position of the meter needle. If the needle stops below the edge of the circular index mark, the battery has insufficient power and must be changed.

*Loading and unloading.* The earlier Pellixes load in the same way as the previous models. The QL models have the special take-up spool and QL cover introduced with the Canon FT and continued in later models.

Unloading is by the now well-established method of pressing the rewind button in the camera base plate and turning the rewind crank in a clockwise direction until the film is felt to leave the take-up spool.

*Viewing and focusing.* The Pellix abandoned the split image rangefinder spot used in previous models and

## CANON PELLIX AND PELLIX QL

The features of the Canon Pellix and Pellix QL are:

1. Meter switch and self timer.
2. Shutter speed dial.
4. Lever lock.
5. Eyepiece shutter and battery check switch.
6. Rewind knob.
7. Flash socket.
8. Rewind crank.
9. Rewind button.
10. Tripod socket.
11. Film transport lever.
12. Film speed scale.
13. Film plane mark.
14. Bayonet tightening ring.
15. Accessory shoe.
16. Back cover lock.
17. Battery compartment.
18. Frame counter.
19. Shutter release lock.
20. Film guide rails.
21. Eyepiece.
22. Film gate.
23. Quick load mechanism (only on later models designated Pellix QL).
24. Aperture ring.
25. Auto-manual ring.
26. Focusing ring.
27. Distance scale.
28. Depth of field scale.
29. Rangefinder.
30. Metering area.
31. Meter index.
32. Meter needle.

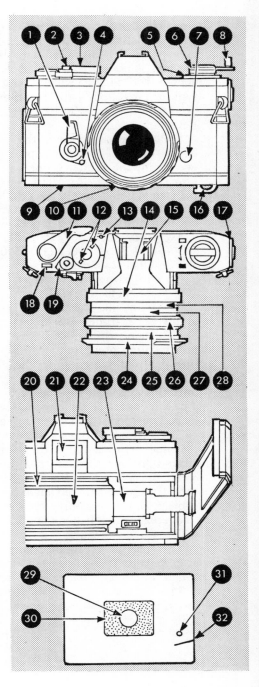

substituted a microprism type more suitable for subjects without distinct lines on which to focus. The microprism area presents a disintegrated, shimmering image when the lens is not correctly focused. When correct focus is achieved, the image steadies and looks sharp. With this type of rangefinder, the additional clear-ground area is not really necessary and it is accordingly omitted on the Pellix.

Viewing is carried out in the normal way but the Pellix has the unique advantage of providing a continuous image even while the shutter is open.

*Using the Canon Pellix Meter.* To use the built-in meter of the Canon Pellix, you first set the film speed on the shutter speed dial. The ASA scale runs as follows, the italic figures representing the dots between marked figures:

25, *32*, *40*, 50, *64*, *80*, 100, *125*, *160*, 200, *250*, *320*, 400, *500*, *640*, 800, *1000*, *1250*, 1600, *2000*.

The DIN scale runs consecutively from 15 to 34.

On earlier models, however, the scale ran only from 10-800 ASA (11 to 30 DIN).

To switch the meter on, you push the meter-switch lever (the self-timer lever) toward the lens. You can either hold it there while metering and then allow it to return under spring pressure or you can (on later models only) turn the small switch under the lever to the lock position. Then the meter lever stays at the switched-on position until the lock lever is returned to the white-dot position. The lever has to be unlocked while shooting because in the locked position it also locks the shutter against release.

The Pellix meter is a semi-spot type. It measures only the small area marked in the viewfinder by the rectangle around the rangefinder spot. So, when you point the meter toward the subject to take a reading you must be careful to place this rectangle over a suitable part of the subject. If it covers only a dark area, the reading will lead to overexposure. If it covers only a light area, the result will be underexposure.

This narrow acceptance angle has advantages, however, because it enables you to meter various parts of the subject and so calculate the subject contrast.

The Pellix meter reads through the camera lens. This, too, is quite an advantage over the normal separate meter with its acceptance angle generally in the region of 40

degrees. When a long-focus lens is used, for example, the ordinary meter necessarily reads an area much greater than that covered by the lens, frequently including dark foreground objects. The through-the-lens meter can read only the area covered by the lens or, as in the case of the Pellix, an area a great deal less than that covered by the lens.

As with the attachable meters of the previous models and the built-in meter of the Canon FX, there are two methods of using the Pellix meter, according to whether you wish to give priority to the shutter speed or the aperture.

If you wish to shoot at a particular shutter speed, you set that speed on the shutter-speed dial of the camera. Then, while looking at the subject through the viewfinder (remembering to aim the rectangle at a suitably-toned area), press the lever switch and turn the aperture ring of the lens until the meter needle visible in the viewfinder bisects the circular index mark.

Because the meter reads through the lens and both aperture and shutter speed are directly linked to the meter, the mere lining up of needle and index mark sets the camera controls for correct exposure. The further step of transferring the measured aperture to the lens is no longer required.

If you wish to shoot at a particular aperture, you set that aperture on the lens, switch on the meter and, again, line up the meter needle and index mark looking through the viewfinder and turning the shutter-speed dial. Aperture and shutter speed are then set for correct exposure.

The Pellix meter reads at the shooting aperture because the meter switch also acts as a manual switch for the lens so that the aperture closes as the aperture preset ring is turned. You must, however, remember to return the lever to the OFF position before shooting.

When giving priority to the aperture, you cannot always line the meter needle up accurately because you can use only the marked settings of the shutter. Intermediate positions cannot be used. The aperture ring can, however, be set to positions between $f$-numbers.

*Lenses and accessories.* All the previous lenses except the FL 19 mm. $f$3.5 and most of the accessories fit the Pellix—the exceptions being only those depending on the re-

movable prism unit of the Canonflex and the clip-on meters. An extra lens was introduced for the Pellix only—the FLP 38 mm. $f$2.8, which has a back focus too short for the movable mirror of the other models. Conversely, the FL19 mm. $f$3.5 lens cannot be used on the Pellix because its even shorter back focus requires the mirror to be raised—and the Pellix has a fixed pellicle.

# CANON INTERCHANGEABLE LENSES

With the exception of the Canon EX EE and EX Auto all the Canon reflex cameras take a full range of inter-changeable lenses. This means that the lens on the camera can be removed and replaced by another at will. The object of that operation is to obtain a wider or narrower view of the subject. At the extremes, the wide view enables you to cram a large object (say a tall building) into your small film area from relatively close range, while the narrow view allows you to fill that same film area with a small detail (say a window in that building) from a relatively long range.

## Focal length

The size of the image of any given object on the film from a given shooting distance is strictly proportional to the focal length of the lens. This is the main characteristic by which lenses are described and is, in normal lenses, the distance from the focal plane (the film surface) to the optical centre of the lens when it is focused on infinity. We need not go further into that subject at this stage. Full details can be obtained from more specialised books such as *The Focalguide to Lenses*. It is evident, however, that this characteristic governs the physical length of the lens. A lens of 1000 mm. focal length must be more than 1000 mm. (3 feet 3 inches) long. A lens of 28 mm. focal length must have its rear element within that distance from the film, which can raise difficulties with reflex viewing because it allows little room for the mirror. So there are exceptional lenses that have their optical centres outside the physical limits of the lens. These are the retrofocus and telephoto types.

## Angle of view and image size

These differences in construction do not affect handling or performance. A lens of a given focal length has a certain

angle of view and therefore a certain ratio of reproduction (image size:object size) at a given shooting distance. Change the lens without moving camera or subject and the image size changes in direct proportion, so that a 100 mm. lens gives an image twice the size of that from the standard 50 mm. lens. Naturally, if the film remains the same size, the picture includes less of the surroundings; whereas a 28 mm. wide angle lens reproduces more of the scene in front of it, but with details at only about half the size given by the 50 mm. lens.

The angle of view of any lens is easily calculated, as shown in the diagram opposite. When comparing angles of view of various lenses, however, it is important to check that the same angle is given for each lens. The angle can be expressed on the horizontal, the vertical or the diagonal of the image area and published figures do not always make the necessary distinction.

## Aperture and f-numbers

The focal length of a lens has some effect on its maximum aperture, sometimes referred to as its speed or power. The aperture is the opening in the adjustable diaphragm within the lens, sometimes known as the limiting aperture. The maximum size of the opening is governed by the size of the front element of the lens and that, in turn, is governed by practical considerations.

The prime function of the aperture is to control the amount of light passing through the lens. Any point within the field of view of the lens sends a diverging beam of light towards the front surface of the lens. That light beam is then bent or refracted by the lens so that when it emerges from the back of the lens it can converge to a point again. When the aperture is wide open, all of that beam of light passes through the lens to help form the image. When the aperture is made smaller, it cuts off some of the light rays striking the outer edges of the lens because they cannot be bent back sharply enough to get through the aperture. Thus, only a part of the beam striking a certain area of the front surface is used and the smaller the aperture the smaller the area of the front surface of the lens that actually contributes to forming the image.

That area, the circular patch on the front of the lens

## LENS ANGLES

The shorter the focal length of a lens, the wider its angle of acceptance or angle of view. The Canon lenses range from a 180° angle to 2.1° and less. The focal length and angles of view of some of the lenses are shown in the top part of the diagram.

| focal length (mm) | angle of view |
|---|---|
| 1200 | 2.1° |
| 1000 | 2.5° |
| 800 | 3.1° |
| 600 | 4.1° |
| 500 | 5° |
| 400 | 6.2° |
| 300 | 8.3° |
| 200 | 12° |
| 135 | 18° |
| 100 | 24° |
| 55 | 43° |
| 50 | 46° |
| 35 | 64° |
| 28 | 75° |
| 24 | 83° |
| 17 | 104° |
| 7.5 | 180° |

mm

The angle of view of any lens can be calculated by drawing a line AB, of the diagonal of the image area, and erecting from its centre a perpendicular CD of the focal length of the lens. The angle ADB is then the angle of view of the lens when it is focused at infinity. When the lens is focused closer, the lens-camera extension is greater than the focal length, and the angle of view, AEB, is narrower.

through which pass all the rays that actually pass right through the lens, forms what we call the effective aperture. It is, in fact, the diameter of that circle that is used to designate the effective aperture and to calculate therefrom the $f$-number or relative aperture. We calculate the $f$-number simply by dividing the effective aperture into the focal length of the lens. Thus, if the effective aperture is 25 mm. and the focal length of the lens is 50 mm., the relative aperture or $f$-number is 2, commonly written $f2$.

It is evident that, if the focal length of the lens were 100 mm., the relative aperture for the same size effective aperture would be $f4$. For a 200 mm. lens it would be $f8$. On the other hand, to provide a relative aperture of $f2$ on a 200 mm. lens, you would need an effective aperture of 100 mm., calling for a front element of at least that diameter. That would be a very large and heavy lens with glasses of a size not easy to cut, grind and polish to the accuracy required. That is why generally speaking very long focus lenses have restricted maximum apertures.

The relative aperture, or $f$-number, is the one with which we are most concerned in practical photography because we are primarily interested in setting the lens to pass a certain amount of light through to the film. As we generally use exposure meters, tables or experience of light conditions as our guide for the amount of light required, we want a setting of the diaphragm that has the same effect whatever lens we put on the camera. The $f$-number enables us to do this because as focal length, and therefore lens-to-film distance increases, so, for the same $f$-number, the effective aperture increases to compensate for the fall-off in light intensity with increased distance. Thus, when we set a 50 mm. lens to $f8$, we know that we are transmitting the same amount of light as when we set a lens of any other focal length to $f8$.

## Effect of aperture on depth of field

The lens aperture does not only control exposure. It also has a marked effect on how much of the picture is reproduced sharply. If you imagine the reproduction of a single subject point by a lens system you can appreciate that light radiates from that point to fill the lens aperture, forming a cone with its apex on the subject point and its

## APERTURE AND FOCAL LENGTH

The effective aperture is the diameter of the light beam entering the lens and passing through the diaphragm opening. As the front element of a lens is usually a positive (converging) lens, the effective aperture is generally larger than the actual diaphragm opening.

The diameter of the effective aperture is divided into the focal length of the lens to obtain the $f$-number. Thus, the same $f$-number denotes a different-sized aperture according to the focal length of the lens, so that, where the light has to travel a greater distance to the film, more is admitted to allow for losses. Thus, the $f4$ diaphragm opening is considerably greater in a 200 mm lens than in a 50 mm lens.

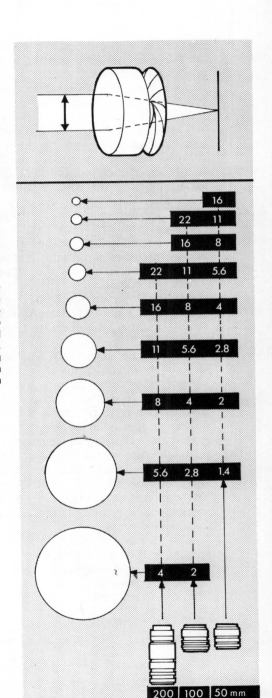

base on the lens surface. Now it is evident that these cones are fatter or thinner according to the lens aperture used and that the thinner the cone, the farther you can travel along it from the apex before a section through it will produce a disc appreciably greater in size than the apex point.

Thus, at small apertures, points quite considerably separated in space can be reproduced almost equally sharply, while at larger apertures the permissible separation between such points is less. On the other hand, at a given aperture, the cone in front of the lens becomes fatter when the subject is closer to the camera and, again, the permissible separation in depth between points to be sharply reproduced is less.

This permissible separation is known as depth of field and we have now seen that it is greater when the aperture is smaller and less when the shooting distance is short. There is a related factor that is obvious when you think about it. Other things being equal, depth of field is greater with a lens of shorter focal length, because, at the same $f$-number, the aperture is smaller when the focal length is shorter.

Despite the apparently immutable nature of these features, however, depth of field has to be regarded as a subject full of complications. In theory, it can be calculated exactly. In practice, it depends on so many variables that, as with most photographic problems, the only true guide is experiment or experience. In 35 mm. photography, for example, we are never concerned with contact prints. Pictures are always enlarged as prints or projected at quite considerable enlargement as transparencies. How sharp or otherwise the various parts of the picture then look depends on the viewing distance. The tendency to render points as discs is less noticeable as the viewing distance increases.

All Canon reflex cameras allow the depth of field to be studied on the camera's viewing screen, but even then the texture of the screen sharpens the image to some extent and some experience is needed to forecast the final effect from the screen image.

## Lens classifications

The technical description of a lens always includes its

## DEPTH OF FIELD

The camera is assumed to be focused on the tree in this diagram and therefore each point of light reflected by the tree is imaged as a point in the film plane. The image is consequently sharp.

Points of light reflected from the more distant church are brought to a focus in front of the film plane. Points from the nearer figure are brought to a focus behind the film plane. All these points therefore are reproduced in the film plane as discs, as is easily appreciated if you regard the triangular shapes in these diagrams as solid cones.

Provided these discs are of such a size that at the normal viewing distance of the final image they are indistinguishable from points, the image still looks sharp. When the objects are too far from or too close to the lens relative to the focused distance, their images in the film plane are unsharp.

It is the distance between the nearest and farthest object that can be simultaneously reproduced as sharp images that we call the depth of field.

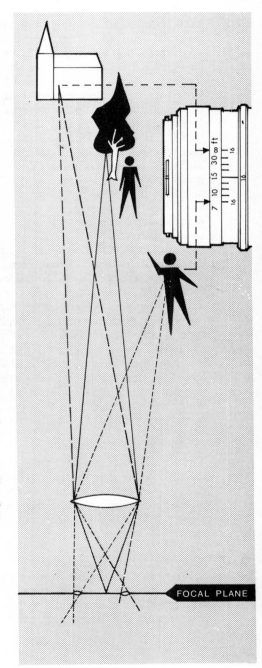

FOCAL PLANE

focal length and its maximum aperture. These are the practical features. When you are told that a lens is a 50 mm. $f2$, you know that it is a relatively fast, standard lens giving an angle of view of about 45° that can be used for most day-to-day photography, but is not ideally suited to use in very cramped surroundings or to work that needs large images of comparatively distant objects. If you are told that a lens is a 300 mm. $f5.6$, you know that it is designed to be used at long range and that it will give you an image size $6 \times$ that of the standard lens shooting from the same distance. You know also that its maximum aperture of $f5.6$ means that you need to use fairly fast film if the light is none too bright—especially for hand held photography or if the subject is moving, because in those circumstances you need fairly high shutter speeds.

It is, however, the focal length that we generally consider first when choosing a lens and we therefore tend to group lenses into wide-angle, standard and long-focus types. It is general practice to call all long-focus lenses telephoto or tele lenses these days although the purist must point out that the telephoto lens is a particular type of long-focus lens. Lenses of variable length are also available. These are normally of the zoom type, which maintain their focus as their focal length is altered. Zoom lenses are designated by their extreme focal lengths, thus you know that an 85-300 mm. $f5$ lens has a focal length which can be varied from 85 to 300 mm., and a maximum relative aperture of $f5$ throughout the range.

## Lenses and perspective

The standard lens of about 50-58 mm. focal length is so called because it is the lens generally supplied with the camera—others being optional extras. It is considered to produce the type of picture that looks right to the average viewer. This is a highly debatable point set about with a variety of misconceptions but it is not really very important. The misconceptions that it engenders, on the other hand, can be important.

First, this argument implies that lenses of different focal lengths produce different types of image. They do and they don't, according to how you look at it. No matter what the focal length of the lens, if it is put on a

## FACTORS AFFECTING DEPTH OF FIELD

The size of the effective lens aperture and the focused distance have a considerable effect on the depth of field, because they affect the shape of the cones illustrated in the previous diagram.

At *f*11 and a focused distance of 15 feet, for example, your depth of field might stretch from 10 to 30 feet. If the focus is moved to 8 feet, depth of field may cover only 6 to 11 feet.

With the focused distance unchanged, say at 12 feet, depth of field at *f*4 might be from 10½ feet to about 14 feet. At *f*16, it increases to, perhaps, 6 to 40 feet or more.

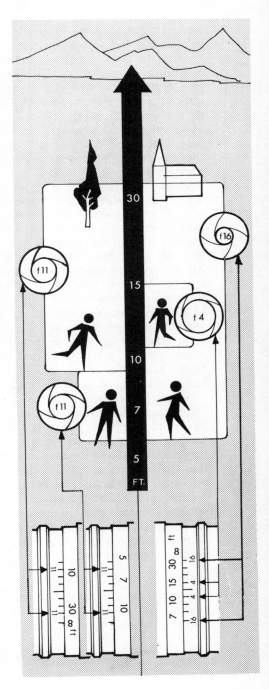

camera that remains stationary, and shoots a static subject at a fixed position from the camera, it produces exactly the same image as any other lens except for a magnification or reduction which is strictly proportional in every respect. The long-focus lens produces a larger image than the short focus lens. Enlarge the relevant part of the image from the short-focus lens and you have exactly the same image as that produced by the long-focus lens. Naturally, differences in quality may emerge but there is no difference in relative sizes of objects, i.e. perspective.

Nevertheless, what does happen is that the enlarged portion of the shot by the short-focus lens no longer looks as if it were taken from a distance. It looks as if the camera were much nearer the subject (part of the subject actually) than it really was. The shot with the long-focus lens has given this impression all the time, of course. Moreover, both shots do now probably show what the average observer considers unnatural perspective. If there were two similar-size objects in the scene, separated by perhaps many feet, the images of them probably show very little difference in size. But, if the shot were taken from where it appears to have been taken, the nearer object would look much larger than the more distant. So we have false perspective—created, not by the lens, but by the long shooting distance.

This is the classic refutation of the statement that the focal length of the lens affects the perspective presented by the picture. It is perfectly true, but we must always temper our enthusiasm for the truth with a little compromise that allows for the facts of life. The real point is that the long-focus lens is generally used at long range, while the wide angle lens encourages us to go in close. Neither is suited to the other's job so their use becomes compartmented and wide-angle shots do, in practice, tend to show exaggerated perspective effects while long-focus shots have a flattening effect. It is as well to bear this in mind while not totally ignoring the academic truth.

## True wide-angle distortion

There is a type of distortion that is entirely due to the attempt to present a very wide angle view of three-dimensional objects on the flat film. Any lens of much less

than 35 mm. focal length takes a very oblique view of objects right out on the edges of its angle of view and consequently projects the image at an acute angle from the back of the lens. When the object is three-dimensional, its image is therefore spread sideways and objects such as pillars, human figures, spheres, etc. are reproduced with a rather stretched horizontal dimension. This is true wide-angle distortion—something that the eye does not see but that the camera lens creates. The rather similar distortion of flat objects in a plane more or less at right angles to the film plane, such as the exaggerated narrowing of parallel lines or the pulling of discs into ovals, is not a character-istic of the lens because the eye can also see this effect. It is commonly exaggerated by the wide-angle lens, how-ever, because of the close viewpoint the cameraman often takes up when using such a lens.

## Other forms of distortion

If the camera is so held that the film plane (the back of the camera, in effect) is parallel with the most important vertical lines in a scene, there is rarely any apparent distortion in the image. Naturally, parts of the subject farther away from the camera are reproduced on a smaller-scale than those nearby, so that a shot lined-up on a corner of a box, building, etc., shows converging hori-zontal lines, but that we accept as normal perspective. What we do not accept is the convergence of vertical lines (or, indeed, the divergence) caused by tilting the camera so that its back is no longer in the same plane as the vertical lines. Even in a tall building, we cannot accept anything more than the slightest convergence of vertical lines as natural. It may make an effective picture but we regard it in just that way—as an effect deliberately created. We are even less able to accept the diverging verticals caused by tilting the camera downward to photograph a box or similar object.

If you want your verticals to be vertical your camera back must be vertical.

## Deliberate distortion

Another form of wide-angle distortion is the extreme effect produced by the so-called fish-eye lens. This type of lens has an angle of view approaching 180°. The

Canon Fish-Eye 7.5 mm. does in fact cover that angle. The effect here is almost of a simultaneous tilt in all directions so that only horizontal and vertical lines cutting the lens axis can be reproduced as straight lines. All other lines must follow the curvature of the naturally circular image produced by the lens. Normally, only the centre part of the image patch is used and the lens is specially designed to present a faithful record in that area. Where an angle of view of 180° all round is required, that obviously cannot be done and the whole circular image has to be presented. The effect is unique and the extreme depth of field and close-focusing ability of such a short focus lens allows quite startling results to be produced. There are various scientific and industrial uses for such a lens, as in photographing cavities, pipe interiors, etc., but the normal photographic uses are limited to those where special dreamlike, nightmarish or fantasy-based effects are required.

## The Canon range of lenses

The range of lenses for the Canon reflex cameras is extensive. Those generally available number more than thirty, but there have been many more than that for earlier Canon cameras, including the screw mounting range-finder models, and nearly all of them can be used on all the Canon reflex cameras except the Canon EX EE and EX Auto. The method of attaching lenses to the reflex models has not changed since the first Canonflex camera appeared in 1959, but there have been refinements of the automatic aperture control mechanism and the later introduction of full-aperture TTL metering and automatic exposure control with the FD range.

The focal lengths available in the FD range run from 7·5 to 800 mm. plus six zoom lenses. The range includes specially corrected super-wide-angle types of 17, 20, 24 and 28 mm., a tilt and shift 35 mm. perspective-control type and a 50 mm. macro lens. All except the fixed-focus 7.5 mm. fish-eye lens have straight-drive, double-helicoid focusing systems. The longer focal lengths were previously provided by the FL 600, 800 and 1200 mm. lenses which have a separate focusing adaptor containing a two element lens component.

Before the FD range became available the FL series of

## FD AND FL LENSES

The main features of the Canon FD lenses are:

1. CAT coupling pin.
2. Focusing ring.
3. Distance scale.
4. Depth of field scale.
5. Bayonet catches for lens hood and cap.
6. Red alignment dot.
7. Aperture control ring.
8. Green mark or A for AE setting.
9. Bayonet tightening ring.
10. Hole for AE switch pin.
11. Aperture signal levers.
12. Full aperture signal pin and lever.
13. Automatic/manual aperture levers.

The FD 50 mm *f*1.8 lens has an additional manual lock lever for converting the automatic aperture lever to manual use.

Later FD lenses incorporate a safety mechanism to prevent movement of the diaphragm blades or locking ring while the lens is off the camera. To bypass this mechanism press the lock pin in the top bayonet recess while turning the locking ring.

The main features of the Canon FL lenses are:

14. Bayonet tightening ring.
15. Auto/manual ring.
16. Depth of field scale.
17. Distance scale.
18. Aperture index.
19. Focusing ring.
20. Pre-set aperture ring.
21. Red alignment dot.
22. Finger grip.

Attachment procedure is the same for all Canon lenses. The red dot should be in line with the guide pin on the lens. Then line up red dots on lens and camera, push the lens in and tighten the bayonet by turning the locking ring clockwise.

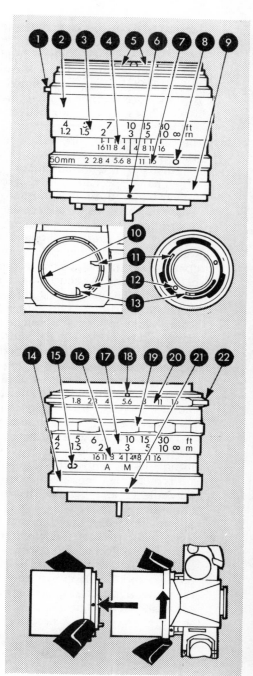

lenses ran from 19 to 200 mm. plus three zooms. Longer focal lengths were supplied by the R300, 400, 600, 800 and 1000 mm. lenses which used the Bellows R as the focusing mechanism. These lenses were designed for the Canon FTQL and previous models, which did not use full aperture metering. They are suitable for the later models but only with stopped-down metering.

There are still older lenses in the R range designed for the early Canonflex models. These included automatic-iris Super Canomatics in 35, 50, 85, 100 and 135 mm. focal lengths and a semi-automatic Canomatic R200 mm. which had a special charge ring to hold the diaphragm at full aperture until the shutter release was depressed. These mechanisms do not couple with the automatic-iris mechanisms of the later cameras so, although they can be used, they must be stopped down manually. There were also pre-set R100 and 135 mm. lenses which had an aperture set ring which was turned to a pre-set stop just before releasing the shutter to close the diaphragm down to the limit set on a separate pre-set aperture ring.

To summarise the range, therefore, the early R lenses from 35 mm. to 1000 mm. can be used on all Canon reflex cameras, except the EX EE and EX Auto, but only with manual operation of the diaphragm on models other than the early Canonflexes.

The FL lenses can also be used on all these models but do not couple with the full aperture metering systems of the later models. Nor do they couple with the automatic-iris mechanism of the Canonflex models.

The FD lenses give full aperture metering and auto-matic-iris control on the F-1, FTb and later models, automatic-iris control and stopped-down metering (where TTL metering is possible) on all other models except the Canonflexes and manual diaphragm operation on the Canonflexes.

The FD lenses have an automatic/manual aperture lever in the back of the lens mount. When this lever is moved anti-clockwise (viewing the lens from the back) against a strong resistance, it is locked in the manual position and the diaphragm can be operated manually on the Canonflex cameras, or wherever an accessory without automatic-diaphragm coupling is used, or if, indeed, it should be considered necessary to observe the screen

image with the lens stopped down on the Canon FP or FX. These models have no stop-down lever. On the FD 50 mm. *f*1.8 and FD 28 mm. *f*2.8 lenses an additional locking lever has to be swivelled to lock the automatic/ manual aperture lever. The lock position is marked with a red L. These lenses cannot be used on the Canonflex models.

## Features of Canon FD lenses

With the introduction of the F-1 camera, Canon brought out a new range of lenses—the FD range. These lenses have many unique qualities, not the least important being their durability. Both the camera mount and the lens mount are made of brass with hard chrome plating over nickel plating. The mounting system is the same as that introduced with the Canonflex in 1959. A locating pin on the back of the lens fits into a groove in the camera body flange. Then, instead of turning the lens, as is usual with most bayonet-fixing lenses, the Canon lens is simply pushed straight in and its locking collar rotated only a few degrees clockwise to clamp the lens in place. None of the mating surfaces rub over one another to cause abrasion and wear. Moreover, the straight-in attachment method allows the various signal pins, levers and contacts to be aligned with complete accuracy. Lenses produced from mid-1974 onward have a spring-loaded automatic lock. As you push the lens into the camera body, the locking collar rotates automatically to lock the lens in place.

Moving anti-clockwise (looking from the back of the lens) from the locating pin, there are four other active mechanisms in the back of the lens. First, there is the aperture signal lever which moves through an arc on the left-hand side of the lens. As the lens is pushed into the camera, this lever locates above an arm in the camera body. With the rotation of the aperture control ring the arm is moved downward and drives the needle for full aperture metering. When the Servo EE Finder is used, the arm in the camera body is driven by the coupling arm of the Finder.

Just below the aperture signal lever in the back of the lens, at about the 7 o'clock position, is the full-aperture signal pin. This is a precision-machined immovable pin that pushes against a teller arm in the camera body to calibrate the camera meter to the maximum aperture of

the lens in use. The pin varies in height from lens to lens, according to the maximum aperture of the lens and according to the additional calibration adjustment required to compensate for the so-called "full aperture effect". This refers to the tendency for the TTL meters to under-read the light level when the lens exit pupil is significantly larger than the light-sensitive element of the meter.

The existence of the full aperture effect is one of the arguments advanced in favour of stopped-down metering as a more reliable method. In the Canon lenses, however, the full-aperture signal pin can make very accurate compensation for this effect and the extremely low wear rate of the lens-mounting system ensures that the accuracy will be maintained.

At the bottom of the lens mount, in a slot running to about the 4 o'clock position, is the automatic/manual aperture lever. This is actuated by the trigger in the camera body which is connected to the shutter release action and so causes the diaphragm to close down to the pre-set aperture just before the shutter opens. On all Canon reflex cameras since the Pellix, this trigger is also operated by the exposure meter switch or by the stop-down lever, according to model. The automatic/manual aperture lever can be locked to give manual operation of the diaphragm as described on page 252.

It is important when attaching lenses to the auto-iris models to ensure that the stop-down lever is not locked in the stop-down position. If it is, the trigger in the camera body remains in the central position in the camera body and the aperture lever on the lens passes behind it as the lens is inserted and so cannot be operated by the trigger even though the stop-down lever is subsequently unlocked. The result is that all pictures are taken at full aperture, regardless of the setting of the aperture control ring. The user does not become aware of this until he attempts to use the stop-down lever. The red spot in the camera body that is uncovered when the trigger is in the central position is intended as a warning of this state of affairs.

There is a very small pin just to the right of the aperture lever slot, within the bayonet lug recess, that emerges only when the lens aperture control ring is set to the green circle or A for use with the Servo EE Finder or automatic-

exposure camera. This pin fits into a hole in the corresponding bayonet lug on the body flange of the automatic-exposure cameras and the aperture control ring cannot be turned to the automatic position unless there is room for the pin to emerge. Consequently the lens cannot be fitted to other models if the aperture control ring is set to the automatic position.

Later FD lenses have an additional safety feature in the form of a mount lock which locks the bayonet tightening ring in the unmounted position, so preventing the automatic/manual pin from being set to manual and thus keeping the diaphragm blades in the fully open position. To override this safety lock, press the lock pin (near the locating pin in the bayonet recess) with a pin while turning the bayonet tightening ring to the mounted position.

The other stud (two on the shorter focus lenses) at about the 3 o'clock position is reserved for a use not yet announced.

A feature of the FD lenses is the substantial focusing ring with a patterned grip of considerable width even on the short-focus lenses. The focusing scale, depth-of-field scale and aperture control ring are prominently marked with easily read figures and there are half-stop settings throughout the aperture scale. The focal length of each lens is marked to the left of the maximum aperture figure on the aperture control ring as well as in the traditional position on the front of the lens mount.

## Full-range aberration-free system

A feature of some of the Canon FD lenses is a special system for the correction of curvature of field. A common problem in lens design, particularly with lenses of large maximum aperture, is to maintain flatness of field at all focused distances.

In the past, designers tended to work on the assumption that as lenses were generally used to photograph relatively distant subjects and, as it was possible to correct lenses fully only at one focused distance, it was reasonable to provide optimum performance at or near the infinity setting. With lenses of normal construction, it was possible to maintain a performance near to the optimum down to the closest focusing distance, which was rarely less than 1 m. (39 inches). With the emergence of larger

aperture lenses and of retrofocus designs that could focus down to 20 cm. (about 8 inches) or less, this performance could not easily be maintained.

Consequently, Canon designed their "full-range aberration-free" or "floating" system in which the front part of the lens moves forward from the rear part as the whole lens is moved forward to focus closer. This enabled a startling improvement to be made in lens performance over the whole image area at very close range. Canon have introduced this system in their 17 mm. $f4$, 20 mm. $f2.8$, 24 mm. $f2.8$, 35 mm. $f2.8$ Tilt and Shift, 35 mm. $f2$ and 55 mm. $f1.2$ AL lenses in the FD range.

## Special Canon lenses

Even before the introduction of the FD range of lenses, Canon had many lenses designed for special purposes. There is, for example, the FLP 38 mm. $f2.8$—a lens designed specifically for use on the Canon Pellix which has no moving mirror to foul the back of the lens. Consequently, this is an extraordinarily compact lens with an overall length of only 21 mm.

A lens designed to cope with both close-range and normal photography out to infinity is the FD 50 mm. $f3.5$ macro lens. This focuses down from infinity to 23 cm. (9.2 inches) and is supplied with a "life size adaptor" accessory to extend the focusing range down to about 20 cm. (8 inches) from the film plane for 1:1 photography. A 100 mm $f4$ macro lens is also available.

The fish-eye type of lens has already been mentioned. The Canon 7.5 mm. $f5.6$ fish-eye is a lens of retrofocus design. It is a fixed-focus lens covering an angle of 180°. It is an 8-component, 11-element construction and has six built-in filters—skylight, yellow, orange, red, daylight to artificial light and artificial light to daylight—brought into position by rotating a ring behind the aperture control ring. Viewing is possible through the reflex mirror. Depth of field is considerable even at maximum aperture, but where a sharp image is required from extreme close range to far distance, the lens may be stopped down. The minimum aperture is $f22$. The lens provides remarkable contrast despite its bulging front element (a lens hood cannot, of course, be used), which is a tribute to the Canon multi-layer coating system (Super Spectra) now used on

most FD lenses. At 67.8 mm. in length, the fish-eye lens is rather longer than the average standard lens but weighs only about 380 g. (about $13\frac{1}{2}$ oz.). The 15 mm. $f2.8$ fish-eye has a 180° view on the diagonal, giving a full-frame image.

The TS35 mm. $f2.8$ is a special lens for perspective and depth of field control. It allows simultaneous tilting and shifting of the lens on the optical axis.

Aspherical surfaces are the special feature of the FD55 mm. $f1.2$ AL standard lens, the wide-angle 24 mm. $f1.4$ AL and the moderate telephoto 85 mm. $f1.2$. The most outstanding effect of the aspheric construction is claimed to be the remarkable flare elimination. Impressive results have been shown of full-aperture night-time photographs with light sources in the picture area.

Almost complete correction of spherical aberration is possible with aspheric surfaces, and with fewer elements than in the normal lens. This provides an overall improvement in sharpness and constrast that can, moreover, be maintained throughout the focusing range with the "full-range aberration free" focusing system (see page 255).

## Features of Canon FL lenses

The FL lenses are comparatively simple. They have none of the elaborate signal mechanisms of the FD range. The sole feature of the rear lens mounting is a substantial pin linked to the iris and driven by the stop-down trigger in the camera body. The automatic/manual control is provided by a ring just in front of the locking collar with A and M markings that can be moved opposite to the focusing index mark.

The lenses vary in design over the range, but most of them have the aperture control ring in bright satin-finish metal with protruding milled grips at either side. The focusing ring is considerably less prominent than on the FD lenses and the focal length is marked only on the front of the lens.

The FL lenses were introduced with the Canon FX camera and the range was increased over the years to include many special types including a macro lens, three zooms and fluorite long-focus versions (see below). The limit of their focal length was originally 200 mm.,

the longer focal lengths being provided by the older R lenses. With the introduction of the FD range, newer FL lenses were introduced in the longer focal lengths to obviate the need for the bellows focusing mechanism previously used.

A common Focusing Unit is now used instead of the bellows. This unit contains the two rear elements common to the 400, 600, 800 and 1200 mm. lenses. It also embodies the automatic aperture control mechanism and focus control. The combination of Focusing Unit and front component is remarkably compact. At 50.8 cm., for example, the FL 800 mm. $f$8 was the world's shortest all-glass lens of this focal length.

A feature of the FL series is the set of moderate speed lenses known as the "compact lens series". These are the 28 mm. $f$3.5, 135 mm. $f$3.5, 200 mm. $f$4.5 and 100-200 mm. $f$5.6. The extra speed available from large aperture lenses is frequently wasted because the owner of the lens rarely, if ever, uses it at full aperture. It was for this reason that Canon designed the compact series, which could be made comparatively small, lightweight and inexpensive.

As the FD series of lenses is extended and the cameras become more automated the need for FL lenses is, however, declining. FD lenses are now available in the longer focal lengths.

## Fluorite lenses

Fluorite (calcium fluoride) has long been known for its outstanding optical characteristics but in the natural state large crystals are rare. Canon research engineers, however, have discovered a method of making artificial fluorite crystals large enough for the manufacture of lenses, while keeping the costs within reasonable limits.

Fluorite has many advantages. It enables telephoto lenses to be made considerably smaller and lighter than those made from normal optical glasses. The Canon fluorite lenses are, in fact, about 20 per cent shorter and 30 per cent lighter than conventional telephoto lenses of the same focal length. The three in the Canon range are the FD 300 mm. $f$2.8, FL300 mm. $f$5.6 and the FL500 mm. $f$5.6. Even the 500 mm. can be hand-held. The 300 mm. $f$2.8 is supplied with a 2 × tele extender to convert it to a

compact 600 mm. $f$5.6. It uses special insertion-type filters in a holder.

Fluorite lens elements have practically no chromatic aberrations. The use of this material, in combination with normal optical glasses, facilitates the production of a lens that gives extremely high resolution and contrast.

## Zoom lenses

There are six zoom lenses in the FD range and three were available in the FL range. All these lenses are of remarkably compact construction. Even the 85-300 mm. can be held, if necessary, without a tripod.

Operation of the zoom control on a zoom lens increases or decreases the separation between some of its elements, which has the effect of varying the focal length. Thus, with the 85-300 mm. you have a choice of all focal lengths from moderate to long telephoto and can adjust your image size and framing anywhere between those limits, without moving the camera. The advantage of that is self-evident, particularly when you use colour transparency film. The advantage of carrying only one lens instead of two or three is also obvious. Nevertheless, the zoom lens is not yet ready to take over completely from single focal length types. The main reason is that very large aperture zooms are not yet available, because the maximum relative aperture is limited by the maximum practicable for the longest focal length. The 85-300 mm. $f$4.5, for example, is an impressively large aperture 300 mm. lens, but $f$4.5 is rather slow for, say, 85, 135 or even 200 mm. focal lengths.

The traditional failings of zoom lenses—shift in focus wich change of focal length, vignetting, lack of critical sharpness, etc.—have been very largely corrected in the Canon zooms, but for the highest quality, the single focal length lens still has the edge.

The zoom lens comes into its own when the shooting position is relatively fixed, as in some sports photography, coverage of ceremonial and other public events, theatre photography and so on. Then, particularly with such a large zoom ratio as the 85-300 mm., a wide choice of framing from general scene-setting shots to long close-ups can be made, with the camera firmly anchored to a tripod if necessary.

## Choosing alternative lenses

The range of lenses for the Canon reflex cameras is now extensive and the camera owner may have some difficulty in deciding which lenses to buy. The choice must, of course, depend on the type of photography to be carried out and those already experienced in their field should have no difficulty in deciding which focal lengths are most likely to be of use to them.

A camera is most usually bought together with a standard lens. There is a choice of Canon standard lenses with 50 and 55 mm. focal lengths, and various maximum apertures. A lens of this type is most satisfactory for general photography of people and places, events and scenics, etc. It provides, when all or most of the image is used and viewed from a reasonable distance, a picture that corresponds most closely to our ideas of what the eye sees. It is a lens of reasonable size and weight, easily handled and capable of giving results of first-class quality. It gives good depth of field in most circumstances and the large maximum apertures available provide a bright, clear image on the focusing screen.

Standard lenses focus down to 60 cm. (2 feet) or less, and are well suited to even closer-range work with extension tubes, bellows and/or Macrophoto Coupler, which allows the lens to be reversed for better edge definition.

## Applications of wide-angle lenses

Although a standard lens can cope with most day-to-day photography, there are many occasions when its angle of view is too restricted. Pictures of the guests at a crowded wedding reception, of an interesting shop front in a narrow street, of simultaneous interiors and exteriors in cars and coaches, etc., call for lenses with a wider angle of view. Apart from the exceptional fish-eye lenses mentioned, Canon offer wide-angle lenses in 17, 20, 24, 28 and 35 mm. focal lengths. All of these lenses are available in the full-aperture metering FD range.

If you already have the usual standard lens of 50 or 55 mm. focal length, you may find that the 35 mm. does not give you as great an increase in angle as you would like. This is a moderately wide angle lens that is, in fact,

extremely useful to photographers who habitually shoot at close range. But they usually regard it as their standard lens and do not use the 50 or 55 mm. You might consider this possibility when you first buy your Canon or when you decide that it is time to buy additional lenses. If you have found that you like to get in close and the standard lens angle is a little too narrow, you might well decide to trade in your standard lens for a 35 mm. and use, perhaps, an 85 or 100 mm. as your second string.

If, however, you find that the standard lens copes nicely with most of your photography, you are likely to prefer as your wide-angle lens a 28 or 24 mm. These cover about twice the field of the standard lens and are able to cope well with most cramped-area shooting. They also focus down to 30 or 40 cm. (12-16 inches) from the film plane.

The very wide-angle 15, 17 and 20 mm. lenses are for specialist work and are not easy to use satisfactorily unless you know exactly what you are doing. More often than not, they are likely to be used to introduce deliberately striking and unnatural looking effects. Do not be deluded into thinking that such lenses, or even the 24 and 28 mm. types, are, by virtue of their wide angle, especially suited to taking wide, sweeping views. This, indeed, they can do if you want to place a tiny feature in a wide expanse of virtual nothingness or if you want to show wide ranging patterned fields or other flat outlooks. The wide-angle lens, cannot, however, give you an impressive panorama of distant mountains and other undulating features. It reproduces distant objects on such a small scale that mountains can look like hillocks. It is the long-focus lens that you need to set the mountains as a soaring backdrop to less impressive foreground objects that are, in fact, much farther from the camera than they look in the photograph.

In practice, the wide angle lens is generally used at fairly close range. You might use it from a moderate distance to bring in all of a tall or wide building when you cannot retreat from it to the extent that the standard lens would require. Then, however, you might have a great deal of unwanted foreground below the tall building and have to enlarge part of the negative to an unnecessary extent. The special TS35 mm. *f*2.8 is a much better

proposition if you do a great deal of this sort of work. It enables you to shift the lens upwards from its axis, to bring in the top of the building and cut out some of the excess foreground, while still keeping the camera back upright.

The wide-angle lens comes into its own in crowds, small rooms, to get very close to reasonably flat subjects of small dimensions and so on. When used at a range of 3-4 m. (10-13 feet), moreover, it can be used as a fixed focus lens. This is especially true with the 17 and 20 mm. lenses which are, in any case, not easy to focus on the screen because of their exceptional depth of field. It is much quicker and often more realistic to use the distance scale and take advantage of the extreme depth of field that those lenses provide.

## Applications of long-focus lenses

Just as some photographers prefer to be close to their subjects, others like to (or have to, because of the nature of their subject) stand back and take the longer view. If you do a lot of more or less traditional portraiture, for example, a lens of rather longer focal length than the standard lens makes life a lot easier. In the FD range, Canon have two lenses that are ideal for this purpose—the 85 mm. $f$1.8 and the 100 mm. $f$2.8.

With the standard lens you have to get uncomfortably close to your subject, who is likely to become over conscious of the camera as a result. Moreover, you might get in the way of your own lights and you are somewhat restricted in the poses you can ask your subject to adopt. At close range, the distance between the shoulder and the head in a "one-shoulder-forward pose" becomes significant and a certain amount of perspective distortion is inevitable. The longer focal length lenses enable you to shoot from a comfortable distance.

Many photographers find the 85 or 100 mm. lens and the 35 mm. an admirable "standard pair" instead of the compromise all-purpose 50 mm. The 35 mm. is a very easy lens to use and is suitable for a wide range of subjects within, say, 1-6 m. (3-20 feet) from the camera. Those are not its absolute limits, of course, but most of its work is probably done at that sort of range. At longer range, the angle is likely to be a little wasteful and the 85 or 100 mm.

lens can be rapidly brought into action to provide a larger image and a more restricted view.

For the photographer who sticks to the normal standard lens, however, and possibly uses a 24 or 28 mm. lens as his wide angle, a better choice for a long focus lens is the 135 mm. This is one of the most popular long-focus lenses. Giving an image 2.7 times larger than that from the 50 mm. lens it is very useful for a variety of subjects from sports photography to ground-to-air shots near airfields and at air shows. It can be used to pick out not-too-distant architectural detail, for "candid" shots in public places, theatre photography from the closer view-points and so on.

Above 135 mm., we begin to get into the really long range area and, as in the case of the super wide angle, these lenses are really for the specialist. The average photographer may occasionally find a use for the 200 mm. lens. If he often shoots birds, small animals, distant architectural features, etc., he may even find frequent opportunities—but he is then beginning to specialise. Once he does start specialising in one of more of these fields, there are many lenses he can choose from to give him just the shooting distance he habitually requires, right up to the FL 1200 mm. $f$11.

Even that is not the limit for the real specialist. The Canon Company has always been known for the exceptionally long focal length lenses it makes available. The FL range includes a 5200 mm. $f$14 lens that can be supplied to special order. This provides a staggering 100 × increased on standard-lens image size.

Canon call these longer-focus lenses their super-telephotos. The 400 mm. $f$4.5, 600 mm. $f$4.5, and 800 mm. $f$5.6 use rear-group focusing, only the rear group of lens elements moving as the lens is focused. The overall length of the lens remains the same throughout the focusing range.

## Canon lens coating techniques

It is self-evident that glass reflects light. The greater the angle at which a light beam strikes the glass surface, the greater the reflection. With camera lenses, the greater the light reflection, the less the light transmission, so that some of the image-forming light that should be reaching

the film is lost. Moreover, where a lens has several components and different forms of optical glass are used in some of them, reflections from interfaces are sometimes reflected back again on to the film, causing ghost images and flare.

These problems are substantially solved by coating glass-air surfaces with a specially produced film which acts as an anti-reflection layer. Canon first used this process in the late 1940s on the Serener lens used with Canon rangefinder type of cameras. It was soon realised, however, that the thickness of the coating, relatively unimportant for black-and-white photography, was critical for colour photography because changes in coating thickness affect the colour balance of the lens. The new coating technique that Canon introduced in the 1950s is based on this fact plus the necessity to maintain transmission factors for interchangeable lenses. All Canon lenses were coated by the new method, known as Spectra coating, from the mid 1950s and the user could be certain that colour rendering and light transmission remained virtually constant throughout the range of lenses.

This was a single-layer technique and it is perfectly adequate for most photographic applications. In the early 1970s, however, there was a move by other manufacturers toward multi-layering techniques. There is doubt in many people's minds as to whether this is really necessary for all lenses but the trend has been established. Multilayering is necessary, however, in certain circumstances and Canon researched the problem in connection with zoom lenses in the 1960s. With ten or more glasses in a zoom lens, the risk of reflections and ghost images is obviously greatly increased and Canon decided that multilayer coating might be the best answer to the problem. They first applied multilayer coatings to their 45-300 mm. TV zoom lens in April 1967.

Multilayer coating needs considerable technical skill and expertise as well as specially designed precision equipment. Canon engineers acquired the necessary experience and skill in the following four years to be able to mass produce with complete confidence the multilayer thin films required for this technique. Consequently, in March 1971, they started applying the same treatment to specialised lenses in the FD range—the 55 mm. *f*1.2,

55 mm. $f$1.2 AL and 7.5 mm. $f$5.6 fish eye. The process continued until, by early 1973, all newly manufactured FD lenses had Canon's own Super Spectra multilayer coatings.

Naturally, Canon do not reveal full details of their Super Spectra Coating methods. The coating is a number of very thin films of unspecified elements which are vapour-deposited on the lens surface under vacuum conditions. Several types of film are being used to suit the varying properties of the 200 different kinds of optical glass used in lens construction and it is claimed that when glass and anti-reflection film are perfectly matched, the maximum surface transmission factor is very close to 100 per cent. No lens can, however, be made to transmit all light incident upon it. Even apart from surface reflections, all glass occludes or absorbs a certain amount of light, varying with the wavelength, and optical glass is no exception. Coating can reduce reflection almost to zero but it cannot eliminate absorption, which must amount to several per cent in any photographic lens.

In practical terms the functions of Canon's lens coatings are to reduce reflections, which both improves transmission and helps to reduce ghost images and flare, and to level up colour balance from lens to lens so that similar performances can be expected from any lens in the range. The importance of the coating for colour balancing purposes cannot be overemphasised because recent lens designs have tended to use glasses with high refractive indexes. These are very useful in the manufacture of high-performance lenses, but have rather low blue light transmission, so that the transmitted light is rather yellow.

Canon's Super Spectra coating does not use the extraordinary number of layers attributed to some other techniques. It makes use of special non-metallic elements and a vapour-depositing technique claimed to be superior to the conventional coating of multiple layers of film containing metallic elements. The Super Spectra coating is claimed to be equal or superior to conventional single layer coating and superior to other multi-layer coating in hardness and durability, and to give superior efficiency. It has the advantage over the multiple coating of seven or more layers that there is less difficulty in controlling the thickness of the film in the manufacturing process and that

it is less subject to excessive wear and loss of performance over a period of time.

## Handling and care of lenses

The Canon lenses are easily mounted on and dismounted from the camera (see page 253). They also have smoothly moving, easily-operated controls—a feature that has been brought to near perfection in the FD range. These aspects of handling should therefore present no difficulty.

There is a difference, however, in the way the camera is held according to the type of lens fitted. Generally, when ordinary wide angle or standard lenses are fitted, the camera can be held in the "traditional" way with one hand at each end of the body. This gives a firm, balanced grip and, if you keep your elbows pressed well into your sides and operate the shutter release smoothly, there is little danger that you will shake the camera as you press the release. If you grip the camera awkwardly or too tightly or spread your elbows outward in an unsupported position, there is every chance that your pictures will show signs of camera shake. You may not see these signs. You may just be rather disappointed that your rather expensive lens does not provide the really crisp results you expected. The effect of camera shake is often very subtle indeed, just taking the edge off the all-over definition.

It is a very real danger when you use any lens of greater focal length than the standard lens because the greater the focal length, the greater the magnification of the image— and of any blur brought about by camera shake. When you shoot at extremely long range, even from a tripod, it needs only the slightest tremor to move the subject right out of the image area.

For these reasons a modified camera hold is essential with virtually all long-focus lenses and, indeed, with any lens that exerts a noticeable downward pull on the front of the camera. Basically, this hold consists of taking the whole weight of the camera in the left hand by gripping the lens barrel. The right hand then simply fulfils a steadying purpose, holding the wind-on end of the camera with forefinger poised on the release button. It takes the weight only while you operate focusing and aperture setting controls.

Additonal support should be obtained when physically

## HOLDING THE CAMERA

It is important that you hold your camera rock steady while you release the shutter. The slightest shake can have a considerable effect on image sharpness. Gripping only the ends of the camera is rarely advisable, especially with long-focus lenses. It is better to take most of the weight of the camera, whether held vertically or horizontally, with the left hand grasping the lens barrel. When actually shooting with the long lens, after setting the aperture and focusing, you will find that you can steady the camera by sliding the left hand forward to the front of the barrel. Always take advantage of any support that is available and when shooting from a standing position, keep the elbows well tucked in and the legs slightly apart.

The safest carrying position is with the shortened strap passing over one shoulder and across the chest so that the camera cannot either slip off the shoulder or swing out from the body.

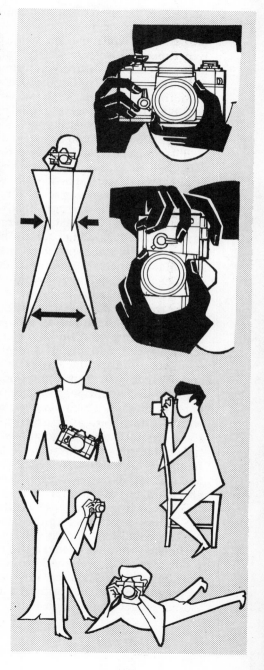

long lenses are used. The front end of the lens can, perhaps, be rested on a chair back, a wall, even the crook of the left arm while the left hand grips the right wrist. Experiment with various holds and make-shift supports for those occasions when you cannot use a tripod.

The tripod is, of course, the ideal support and should be used, in conjunction with a cable release, whenever possible. It must, however, be a sturdy tripod of reasonable weight with a firm anchoring platform for the camera. When a tripod is claimed to be lightweight its rigidity must be suspect, unless it is the small table top version. This type of tripod can be useful for a great deal of close-range work, particularly outdoors when photographing wild flowers, insects, etc.

Care of lenses is a subject that is sometimes given too much attention. Canon lenses are rugged, durable and capable of withstanding constant handling by ham-fisted users. They are also precision-made, relatively delicate optical instruments. Above all, they are practical items of equipment intended to be used for taking pictures. These facts can be looked at in various ways—especially if just one of them is taken in isolation.

There is, for example, an unfortunate tendency to lay too much emphasis on the fact that optical glass is relatively soft and easily damaged. This leads to the temptation to treat the lens as a valuable glass ornament and, if not to wrap it in cotton wool, at least to lavish on it the care and attention normally reserved for collectors' items. Certainly a photographic lens should be treated with as much care as is practicable. It should become second nature to a photographer to avoid placing his fingers on the glass surfaces, to ensure that the surfaces he places the lens on are reasonably clean, to keep front and rear caps on when the lens is not immediately needed and so on, but care is often carried to absurd lengths.

There is little to recommend the practice of keeping a UV filter permanently on the front of the lens—even in adverse conditions of dust and spray. The professional is more likely to stuff a handkerchief up the lens hood or push a polythene bag over the lens between shots. Similarly, he cannot carry his alternative lenses capped, wrapped in polythene bags and buttoned into a lens case inside a closed gadget bag. Canon lenses can be detached from

## CAMERA SUPPORTS

The pan-tilt head gener-
ally has a sizeable platform
and tilts up and down as
well as turning through a
complete circle with the
camera horizontal. It can-
not tilt horizontally, but
the camera can be turned
on the platform to give the
same effect.

Where absolute sharp-
ness is essential, in copying
and when using long focus
lenses, a rigid support for
the camera is essential.

Tripods vary from the
substantial types with
large, pan-tilt heads and
often an adjustable centre
column to small table-top
versions with ball and
socket heads. A cable
release, preferably with a
locking screw, should al-
ways be used with a tripod-
mounted camera.

The ball and socket head
has a smaller platform to
allow the camera to be
tilted and turned in almost
any direction.

Other supports include
pistol grips with built-in
cable release operated by a
trigger and various types of
clamp with ball and socket
head.

and attached to the camera very quickly indeed—but not if they are to be returned to and extracted from elaborate wrappings every time. Rapid lens changes demand that the lens is easily accessible and has, at most, no more than front and rear caps protecting it.

Lens cleaning can become even more of a fetish and is potentially more dangerous than no cleaning at all. In present day conditions it is virtually impossible to keep *anything* spotlessly clean and a camera lens is no exception. A few specks of dust on a lens—perhaps even a few dozen —are unlikely to make the slightest difference to its performance. But careless rubbing of the lens just once with a handkerchief can raise a pattern of tiny scratches that would be considerably more harmful. Similarly, the over-zealous application of lens tissues can do more harm than good. If a lens does appear to be excessively dusty, brush it carefully with a lens brush or a handkerchief or tissue used as a brush (i.e. with no direct pressure). If you do get finger marks, a very soft handkerchief mositened with ordinary tap water will probably remove them. If more extensive dirt is apparent, particularly inside the lens, the services of a skilled repair technician should be obtained. It just does not make sense to tinker about with an expensive piece of equipment in the hope of saving a relatively small amount of money. It makes even less sense, however, to send the lens away for regular "servicing" in case the odd speck of dust has turned up.

Naturally, the opposite side of the coin must be considered, too. Canon lenses are well made, rugged and durable. That does not mean that you should throw them around regardless. They *can* be damaged by impact with unyielding surfaces, by corrosive salt spray, by sand entering the focusing mechanism, etc., and all normal precautions should be taken. If rapid lens changing is not important, it *does* make sense to keep the spare lenses in polythene bags if you are shooting in dusty or wet conditions. If you store a lens for any length of time, it is wise to pack it carefully with front and rear caps in position and keep it in a case or even in its original box. If you have the misfortune to drop it into the sea or have it buried in sand, make all haste to the repair-man. If you cannot get there immediately it even makes sense to wash it thoroughly under the tap or drop it into a bucket of clean

water. The cleaning bill will be a large one but it would be a lot larger if you left salt water to corrode the lens for several days.

The camera lens does need to be handled with care but its prime function is to be used and that should always take precedence.

# LENSES FOR CANON REFLEX CAMERAS

The list of lenses given here is subject to constant alteration. Canon Inc. change the specifications frequently in their endeavours to provide the best possible performance. New lenses are introduced and old ones are dropped. The number of lens components, the weight and the type of coating has changed in many of the FD lenses since the range was introduced. Most of these lenses are now multi-coated by Canon's Super Spectra process. These models carry the SSC designation on their barrels.

## FD Series (For Full-Aperture Metering or AE Operation)

| Lens | Construction Elements Groups | | Angle of View (°) | Minimum Aperture | Closest Focusing Distance (m) | Distance (ft) | Filter Size (mm) | Hood | Length (mm) | Weight (g) | (lb-oz) | |
|---|---|---|---|---|---|---|---|---|---|---|---|---|
| Fish-Eye FD 15mm f/2.8 SSC | 10 | 9 | 180 | f16 | .3 | 1 | Built-in | Built-in | 60.5 | 485 | 1 | 1 |
| FD 17mm f/4 SSC | 11 | 9 | 104 | f22 | .25 | .9 | 72 | — | 56 | 450 | 1 | 0 |
| FD 20mm f/2.8 SSC | 10 | 9 | 94 | f22 | .25 | .9 | 72 | — | 58 | 345 | | 12 |
| FD 24mm f/2.8 SSC | 9 | 8 | 84 | f16 | .3 | 1 | 55 | †BW-55B | 52.5 | 330 | | 12 |
| FD 28mm f/2 SSC | 9 | 8 | 75 | f22 | .3 | 1 | 55 | †BW-55B | 61 | 343 | | 12 |
| FD 28mm f/2.8 SSC | 7 | 7 | 75 | f22 | .3 | 1 | 55 | †BW-55B | 49 | 280 | | 10 |
| *FD 35mm f/2 SSC | 9 | 8 | 63 | f22 | .3 | 1 | 55 | †BW-55A | 60 | 345 | | 12 |
| *FD 35mm f/3.5 SC | 5 | 5 | 63 | f22 | .4 | 1.5 | 55 | †BW-55A | 49 | 236 | | 8 |
| *FD 50mm f/1.4 SSC | 7 | 6 | 46 | f16 | .45 | 1.5 | 55 | †BS-55 | 49 | 305 | | 11 |
| *FD 50mm f/1.8 SC | 6 | 4 | 46 | f16 | .6 | 2 | 55 | †BS-55 | 38.5 | 200 | | 7 |
| *FD 55mm f/1.2 SSC | 7 | 5 | 43 | f16 | .6 | 2 | 58 | †BS-58 | 52.5 | 510 | 1 | 2 |
| FD 85mm f/1.8 SSC | 6 | 4 | 28 | f16 | .9 | 3 | 55 | †BT-55 | 57 | 425 | | 15 |

| Lens | | | | | | | | | | | |
|---|---|---|---|---|---|---|---|---|---|---|---|
| FD 300mm f5.6 SSC | 6 | 5 | 8 | f22 | 3 | 10 | 55 | Built-in | 198.3 | 685 | 1 | 8 |
| FD 400mm f4.5 SSC | 6 | 5 | 6 | f22 | 4 | 13 | ††Exclusive | Built-in | 282 | 1,300 | 2 | 14 |
| FD 600mm f4.5 SSC | 6 | 5 | 4 | f22 | 8 | 27 | 48 | Built-in | 435 | 4,300 | 9 | 8 |
| FD 800mm f5.6 SSC | 6 | 5 | 3 | f22 | 14 | 45 | 48 | Built-in | 567 | 4,300 | 9 | 8 |
| FD 50mm f3.5 SSC Macro with Extension Tube FD 25 | 6 | 4 | 46 | f22 | 20.5 (cm) | 8.1 (in) | 55 | None Necessary | 59.5 | 310 | | 11 |
| FD 100mm f4 SC Macro with Extension Tube FD 50 | 5 | 3 | 24 | f32 | .4 | 1.31 | 55 | None Necessary | 112 | 530 | 1 | 3 |
| †††FD 24–35mm f3.5 SSC ASPHERICAL | 12 | 9 | 84–63 | f22 | .4 | 1.31 | 72 | W-75 | 86.3 | 515 | 1 | 2 |
| FD 28–50mm f3.5 SSC | 10 | 9 | 75–46 | f22 | †††1 | 3.5 | 58 | W-69B | 105 | 470 | 1 | 1 |
| FD 35–70mm f2.8-3.5 SSC | 10 | 10 | 63–34 | f22 | ·†††1 | 3.5 | 58 | W-69 | 120 | 575 | 1 | 4 |
| FD 100–200mm f5.6 SC | 8 | 5 | 24–12 | f22 | 2.5 | 8 | 55 | Built-in | 173 | 765 | 1 | 11 |
| FD 80–200mm f4 SSC | 15 | 11 | 30–12 | f22 | 1 | 3.5 | 55 | Built-in | 161 | 750 | 1 | 10 |
| FD 85–300mm f4.5 SSC | 15 | 11 | 28–8 | f22 | 2.5 | 8 | Series IX | Built-in | 243.5 | 1,695 | 3 | 12 |
| FD 24mm f1.4 SSC ASPHERICAL | 10 | 8 | 84 | f16 | .3 | 1 | 72 | — | 68 | 500 | 1 | 2 |
| FD 55mm f1.2 SSC ASPHERICAL | 8 | 6 | 43 | f16 | .6 | 2 | 58 | †BS-58 | 55 | 575 | 1 | 4 |
| FD 85mm f1.2 SSC ASPHERICAL | 8 | 6 | 28 | f16 | 1 | 3.5 | 72 | — | 71 | 756 | 1 | 11 |
| FD 300mm f2.8 SSC FLUORITE with Extender FD 2X | 6 | 5 | 8 | f22 | 3.5 | 12 | ††Exclusive | Built-in | 230 | 1,900 | 4 | 3 |

# FL and Manual Series (For Stopped-Down Metering and Stopped-Down AE)

| Lens | Construction Elements | Groups | Angle of View (°) | Minimum Aperture | Closest Focusing Distance (m) | (ft) | Filter Size (mm) | Hood | Length (mm) | Weight (g) | (lb-oz) |
|---|---|---|---|---|---|---|---|---|---|---|---|
| Fish-Eye 7.5mm f5.6 SSC | 11 | 8 | 180 | f22 | Fixed Focus | | Built-in | — | 62 | 380 | 13 |
| TS 35mm f2.8 SSC | 9 | 8 | 63/79 | f22 | .3 | 1 | 58 | †BW-58B | 74.5 | 545 | 1 3 |
| **FL 400mm f5.6 | 7 | 5 | 6 | f32 | 4.5 | 15 | ††48 | Exclusive | 338 | 3,890 | 8 9 |
| **FL 600mm f5.6 | 6 | 5 | 4 | f32 | 10 | 35 | ††48 | Built-in | 448 | 5,000 | 11 0 |
| **FL 800mm f8 | 7 | 5 | 3 | f32 | 18 | 60 | ††48 | Built-in | 508 | 5,360 | 11 13 |
| **FL 1200mm f11 SSC | 7 | 5 | 2 | f64 | 40 | 130 | ††48 | Built-in | 853 | 6,200 | 13 11 |
| FL 300mm f5.6 FLUORITE | 7 | 6 | 8 | f22 | 4 | 13 | 58 | Built-in | 168 | 850 | 1 14 |
| FL 500mm f5.6 FLUORITE | 6 | 5 | 5 | f22 | 10 | 33 | 95 | Built-in | 300 | 2,700 | 5 15 |

SSC = Super Spectra Coating    SC = Spectra Coating
*Equipped with a coupling pin for Canon Auto Tuning System
**Front component interchangeable type. Focusing Unit (2 elements, 1 group, FL automatic diaphragm, with A-M ring)

†FD lens hoods are of bayonet mount.
††Filter is of insertion type with holder.
†††Macro focusing capability.

# CANON POWER DRIVE ATTACHMENTS

The conventional motor-drive unit for the Canon F-1 is a one-piece unit but the power pack is a separate item. The later design of the Motor Drive MF separates the hand grip from the drive unit and incorporates the power pack into the grip. It also incorporates other contacts to allow more sophisticated and even custom-made items to be attached.

## Features of Motor Drive MF

Like the conventional motor drive, the Motor Drive MF is interchangeable with the bottom plate of the F-1 camera. It uses a two-motor system for film drive and shutter release respectively. Operation of the motors is controlled by a relay, which allows a variety of accessory controls to be plugged into the remote control jack on the side of the body. The manufacturers can consider requests for special items of this nature.

The motor drive unit can operate continuously at a rate of 3.5 frames a second or single frame as desired. All shutter speeds except B can be used for single-frame shooting. On continuous operation, shutter speeds of 1/60 to 1/2000 second can be used. The frame counter is as on the conventional unit, stopping automatically at 0 but with an override when set at F.C. for use with the Film Chamber 250.

Power is provided by ten penlight cells loaded into the grip and the shooting capacity with fresh batteries is more than eighty rolls of thirty-six exposures. A battery test button and lamp indicator are built into the grip.

The body measures 153 × 51 × 23 mm. (6 × 2 × 1 in.) and weighs 650 g. (1 lb. 7 oz.). Body and grip together measure 179 × 120 × 63 mm. (7 × $4\frac{3}{4}$ × $2\frac{1}{4}$ inches) and weigh 1.07 kg. (2 lb. 3 oz.) with batteries. The grip attaches directly to the right-hand side of the motor-drive unit, where it protrudes in front of the camera to simplify

275

holding for either horizontal or vertical shots. When the Film Chamber 250 is attached to the camera, however, the grip has to be detached and connected via a special connecting cord. This cord is limited in length owing to the excessive voltage drop over a long cord. A special long extension cord is provided for remote control.

The Servo EE Finder can be used with the Motor Drive MF in the same way as with the conventional motor drive but the power connection is to a special socket on the front of the MF unit.

### Interval timers

Whereas the conventional motor drive can conceivably be hand-held with the Film Chamber 250, the Motor Drive MF system does not allow this because the shutter release is on the separate grip. The Motor Drive MF is really designed for a different and wider range of operations.

The conventional motor drive, for example, provides a range of sequence shooting rates from three shots a second to one shot every 60 seconds. The Motor Drive MF has a sequence rate of 3.5 shots a second but this rate can be extended, by attaching the Interval Timer L, to allow two shots a second, one shot a second, or one shot every 2, 5, 10, 30, 60, 120 or 180 seconds. The timer is remarkably small and plugs into the side of the Motor Drive MF behind the grip. It takes its power from the grip and incorporates its own lockable switch that over-rides the shutter release on the grip. It is then more feasible to hand hold the equipment.

The timer is set by turning a large milled wheel on the back of the unit. At T-OFF, meaning "timer off", so that the motor drive operates at $3\frac{1}{2}$ frames a second, shutter speeds of 1/60 second and faster can be used. At the 0.5 setting (two frames a second) speeds of $\frac{1}{8}$ second and faster are available and at the 1 setting (one frame a second), the usable speeds are $\frac{1}{2}$ second and faster. At all the remaining settings, all speeds except B are usable.

With its button locked and the motor drive unit set for continuous operation, the timer allows the camera to run unattended for up to $1\frac{3}{4}$ hours with a 36-exposure roll of film. With both Servo EE Finder and Film Chamber 250 attached, the period of automatic operation can be con-

## MOTOR DRIVE MF

Features of the Motor Drive MF system are:
1. Frame counter.
2. Frame counter setting wheel.
3. Shutter speed selection chart.
4. Film rewind lever.
5. Alignment hole.
6. Direct connector for attachment.
7. Film chamber direct connector.
8. Thumb rest.
9. Grip.
10. Selection switch.
11. Camera attachment knob.
12. Tripod socket.
13. Connecting screw to motor drive.
14. Battery chamber cover.
15. Battery chamber cover lock.
16. Remote switch 60 MF.
17. Interval Timer L.
18. Interval Timer E.
19. Battery check button.
20. Motor drive button.
21. Battery check lamp.
22. Self timer E.
23. Grip mounting rail.
24. Winding coupler.
25. Motor drive mounting shoe.
26. Direct contacts.
27. Connecting screw to motor drive.
28. Film rewind operating pin.
29. Camera attachment screw.
30. Socket for Servo EE Finder.
31. Contacts for controlling motor drive.
32. Supporting plate for Film Chamber 250.

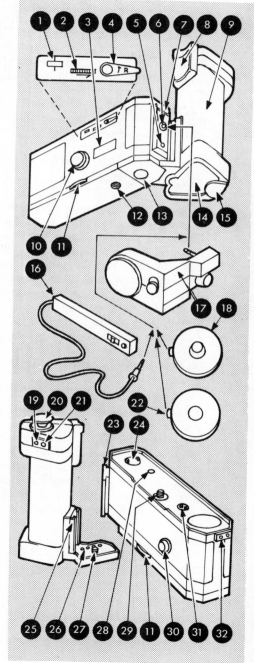

siderably extended and the camera can also automatically adjust for changing light conditions.

A simpler Interval Timer E, originally designed for 8 mm. work, is available in two models: one adjustable from 1 to 10 seconds at one-second intervals, the other from 10 to 60 seconds at 10-second intervals. It is attached to the MF via an extension cord.

Operation of the Self Timer E, also originally designed for 8 mm. work is similar but allows only 10 second shots with a delay of 10 seconds.

## Remote switch and extension cord

The Remote Switch 60 MF is similar to the Remote Switch MD for the conventional motor-drive unit. It is 60 cm. long and plugs into the jack on the side of the Motor Drive MF also used for the Extension Cord E1000 (see below) and the interval timers. As in the Remote Switch MD, it has a sliding switch which overrides the switch on the motor drive unit and can be locked for continuous, unmanned operation. A light emitting diode flashes with each operation of the shutter. The range of remote control can be extended by connecting any number of the Extension Cords E1000. This cord is 10 m. long and plugs into the jack on the side of the Motor Drive MF. At the other end it has a similar jack socket to take the Remote Switch 60MF and the interval timers.

## Time lapse programmer

The most sophisticated of all the programming units for attachment to the Canon F-1 is the Canon Time Lapse Programmer. This, too, is connected with Canon's interest in high-grade cine equipment and is used to perform single-frame photographic analysis of movement stages and for work sampling, indented and otherwise. It provides a great variety of combinations of length of continuous shooting time and intervals. Its time regulation facility runs from $\frac{1}{2}$ second to 24 hours.

## High-speed sequence photography

The Canon F-1 system is in a constant state of development and users who have special requirements and are planning the setting up of facilities and purchase of equip-

ment should contact the manufacturers for news of the latest developments.

The company have paid particular attention, for example, to sequential photography at rapid filming rates and the equipment they designed for use with the Canon F-1 and either the conventional motor drive unit or the Motor Drive MF aroused considerable interest at the Sapporo Olympic Games. The basis was the Tandem Control Unit.

*Tandem Control Unit.* This is a control system that can operate up to six motor drive units simultaneously in two separate methods that provide at least three distinct usages.

The motor drive units are plugged into six separate sockets on the Control Unit, which has a system of switches and dials to allow simultaneous high-speed photography in series, sequential high-speed photography in series, and multiple angle parallel photography.

*Simultaneous high-speed photography in series.* With six cameras, this mode of operation provides a filming rate of a single continuous action of 18 frames a second. This is achieved by firing each camera shutter in series so that each camera shoots one frame before camera No. 1 fires its second frame and so on.

*Sequential high-speed photography in series.* When the subject is moving, the cameras can be placed along the line of the travel and set to operate sequentially to analyse, for example, the motion of a runner, steeplechaser, etc.

*Multiple angle parallel photography.* Sometimes the requirement is for analysis of a movement from several directions simultaneously. This, too, can be achieved with the Tandem Control Unit and cameras set up at various angles to be subject.

The motor drive units use their own power sources for these various operations. The settings are made by the manipulation of switches and dials. The control unit has switches for series or parallel photography, and for single frame or continuous photography, and an interval timer dial with a range of intervals up to 1 minute. Indicator lights confirm that each camera is working correctly.

## High-speed motor drive camera

Designed specifically for shooting rapidly moving subjects, the Canon High-speed Motor Drive Camera, based on the Canon F-1 body, was originally developed for use at the Sapporo Olympic Games in 1972.

Operation of the camera is very similar to that of the F-1 but there are many differences of detail. Perhaps the most important difference is the reintroduction of the fixed pellicle in place of the rapid return mirror. Apart from obviating the need for a more or less continuously moving mirror, the pellicle allows the image to be seen continuously, even while the shutter is open.

The shutter is a focal plane type with titanium blades. The speeds are 1/60, 1/125, 1/250, 1/500 and 1/1000 second. The release is the normal button on the camera top plate with thread for cable release.

The film transport is power driven by twenty penlight batteries in a large separate battery case connected to the camera by a cable. The motor drive mechanism and housing is built on to the camera. It provides shooting rates from 4-9 frames a second. Usable shutter speeds are 1/60-1/1000 second at 4 frames a second; 1/125-1/1000 second up to 7 frames a second; and 1/1000 second only up to 9 frames a second. The camera does not incorporate the quickload system, but has the normal multi-slit film spool of the Canon F-1. The shooting capacity of the batteries is said to be thirty rolls of thirty-six exposures at normal temperatures.

The pentaprism is removable, as in the F-1, and the standard focusing screen is the split-image rangefinder type. As the camera has no meter, however, there is no beam-splitting mirror in the condenser lens. The field of view is 97 per cent or more of the actual picture area. The standard eyepiece ring has a − 1.2 dioptre lens. Adjustment lenses can be fitted. Other eyepiece attachments are the eyecup, Angle Finder B and Magnifier R.

The camera is specifically designed for use with automatic diaphragm lenses, so that a bright, clear image is visible at all times. It takes the normal FD range but can use FL lenses with no disadvantage. Lenses can be stopped down manually with the stop-down lever, which has a lock position. The lever does not operate either the

mirror lock (because a pellicle is used) or the self-timer, for which there is no requirement.

The overall measurements of the High-speed Motor Drive Camera are 146.7 × 136.8 × 43 mm. ($5\frac{3}{4} \times 5\frac{3}{8} \times 11\frac{11}{16}$ inches). It weighs 1,100 g. (2 lb. 3 oz.) without lens.

## Motor Drive MA

A special motor drive unit was introduced with the Canon A-1, which cannot take the unit designed for the F-1. It is a three-speed type usable with the Canon A-1 only and carries the designation Motor Drive MA.

The drive unit itself is very small, consisting of a grip housing the mechanical parts only and a flat plate to connect the grip to the camera baseplate via the tripod socket. The power source and electrical circuitry are in a separate power pack available in two versions—Battery Pack MA, taking 12 AA size batteries, or Ni-Cd Pack MA, with built-in rechargeable nickel cadmium batteries. Either type will normally expose about 60 rolls of film. The power pack is attached to the baseplate by lining up locating pins and operating a simple lock. With the NiCd Pack the complete unit weighs about 400 g.; with the Battery Pack, about 600 g.

The drive system consists of a motor with a slipping clutch, so that the motor does not have to restart for each cycle. It gives a choice of three speeds on the main switch at the bottom of the grip—5 frames a second at the H setting, 3.5 frames a second at L and single frame shooting at S. There is an overriding switch on the power pack providing instant conversion to the H setting while shooting on S or L.

There are three release buttons—the camera shutter release, a button on top of the grip and another on the end of the power pack, particularly useful when the camera is held vertically.

To attach the motor drive to the Canon A-1 (it cannot be used with other models), first remove the palm grip if fitted. Push the strap ring in front of the film transport lever upward out of the way. Remove the cover from the coupling gear in the camera baseplate: there is a storage clip for it in the motor drive baseplate. Offer up the grip and baseplate, locating the pin beside the four electrical contacts into the hole in the camera base. Fold up the key

in the motor drive base plate and turn it to tighten the screw in the camera tripod socket. Fold the key down. Press the small button in the back edge of the baseplate and move the slider away from the lock position, disclosing a red dot. Make sure that the main switch is set to OFF and offer up the power pack so that the three locating pins enter the holes in the baseplate. Press the lock button and the slider automatically engages to lock the power pack in position.

The Ni-Cd Pack has built-in batteries but the Battery Pack has to be loaded with batteries. It has a separate magazine that is extracted by pushing the switch in the bottom of the pack in the direction of the arrow. The magazine slides out easily. Load with 12 AA size alkaline or nickel cadmium batteries and push the magazine back into place. Set the main switch to the required framing rate. If the shutter is untensioned you will hear the motor operate.

From then on, you use the camera in the normal way but you can use any of the three release buttons as convenient. All shutter speed settings, including B, can be used with either automatic or manual exposure control. The self-timer can be used, too, and, with a locking cable release, the shutter is released and the film wound on at 2 or 10 second intervals.

When you reach the end of the film, the motor cuts out and a red light on the back of the power pack flashes. The film has to be rewound manually. Press the hub of the lever marked R and push the lever upward to operate the camera rewind button. Rewind the film in the normal way.

## Wireless Controller LC-1

The back of the power pack for the Motor Drive MA carries a jack plug socket below the end-of-film warning light. This is for a remote control unit using infra-red radiation pulses at about 900 mm.

The Wireless Controller LC-1 is a two piece unit, consisting of a receiver 35 × 62 × 84.5 mm. weighing 153 g. and a transmitter 49 × 120 × 37 mm. weighing 172 g., both weights including batteries. The receiver uses a 9-volt transistor-radio type battery and the transmitter two AA size alkali-manganese type.

## POWER WINDER A

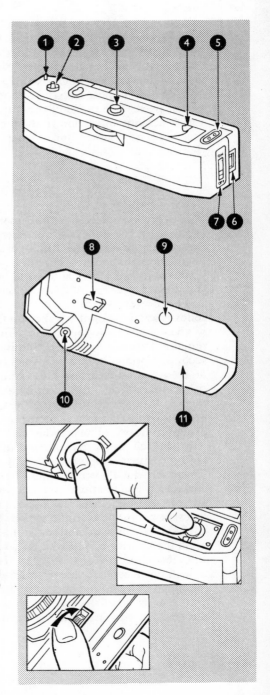

The main features of the Power Winder A are:
1. Guide pin.
2. Coupling gear.
3. Fixing screw.
4. Holder for coupling gear cover.
5. Electrical contacts.
6. Battery pack latch.
7. Main switch.
8. Rewind button.
9. Tripod socket.
10. Warning lamp.
11. Battery pack.

To attach the Power Winder, unscrew the coupling gear cover from the camera baseplate. Store it under the clip provided on the Power Winder. Locate the guide pin in the hole in the camera baseplate and screw the fixing screw into the tripod socket.

The controller can be set for continuous or single-frame shooting and the receiver is fitted with an indicator lamp that lights when the camera operates.

The receiver can be attached to the camera accessory shoe or to a bracket when used together with a flash unit. It has a cord to plug into the remote control socket on the power pack. The range of the transmitter is about 60 m. for direct-line operation, reducing as the angle between receiver and transmitter is increased to 15 m. at 45 degrees.

## Power Winder A

Not everybody needs the full motor drive capability of rapid-sequence shooting but many people, particularly those who are left-eyed, find operation of the film transport lever a distraction. For those, the power winder, the prime object of which is to wind on the film and tension the shutter after each exposure, is a possible answer.

The Power Winder A fits all the A range of Canon reflexes and is a slight advance on the normal type in that it gives continuous operation while the shutter button remains depressed, with a framing rate of about two a second. Canon literature advises shutter speed settings of 1/60 second and faster for continuous operation but the winder works quite happily at all speeds. Naturally, there is little point in keeping the unit working at speeds much slower than 1/30 second and the battery drain is probably heavy. The winder also works in conjunction with the self-timer giving fixed interval shooting if you hold the shutter release down with a locking cable release. To attach the Power Winder, remove the cover in the camera baseplate and slip it into the clip on the Winder for safe keeping. Offer the Winder up to the camera base and screw it into the tripod socket. Slide the switch at the left hand end upward and the unit is ready for use. Simply press the shutter release and let go and the shutter opens and closes and is retensioned by the motor as the film is wound on. Keep the shutter release depressed instead of letting go of it and the operation is repeated continuously until you let go of the shutter release or reach the end of the film. As the last frame is exposed, the motor ceases

working and the red light on the right hand end of the Winder flashes. To rewind, press the rewind button in the base of the Winder and rewind the film in the normal manner.

# FLASH EQUIPMENT AND USAGE

All Canon reflex cameras are flash synchronised, which simply means that, when you attach a flashgun to the appropriate electrical contacts on the camera and set the correct shutter speed, the firing of the flash and the opening of the shutter are synchronised to ensure that the film is evenly exposed.

The focal plane shutter used on all Canon reflexes (and most others, too) has one unfortunate disadvantage in connection with flash work. This derives from the fact that the focal plane shutter consists, in essence, of a variable-width slit moving across the film plane so that various parts of the film are exposed at fractionally different times. Thus, an electronic flash, with a duration of, at most, 1/300 second, and virtually no build-up time, exposes only the part of the film that happens to be behind the slit at the time that the flash fires. The result is that electronic flash can be used with focal plane shutters only at the speeds when the separation between the two blinds is such that the whole image area is simultaneously uncovered. With the Canon reflexes, these speeds are generally 1/60 second and slower (but see the specific instructions for each model).

The position is a little more complicated when you use expendable flashbulbs. The duration of their usable intensity is about 1/100 second (longer for the larger bulbs) and they need time to ignite and build up to that intensity. Thus, for electronic flash the flash contacts can be closed as soon as the first blind of the focal plane shutter reaches the end of its travel, but for flashbulbs the contacts must be closed rather earlier to ensure that the flashbulb has reached a usable intensity before the film is uncovered. Moreover, with flashbulbs, the shutter must remain open long enough to allow the maximum amount of usable light to reach the film. When the normal type of small flashbulb (PF1, AG3, etc.) is used with the Canon

## FLASH SYSTEMS

The flash equipment produced for the Canon F-1 and Canon FTb include:

1. Flash Unit J3.
2. Flash Quint.
3. Flash V-3.
4. Cube Flash, Cube Flash D.
5. Speedlite 102.
6. Speedlite 133D (for CAT system).
7. Flash Coupler D.
8. Flash Coupler L.
9. Flash Auto Ring (for CAT system).
10. Speedlite 500A.
11. AC Pack.
12. Cord 12V 3S.
13. NiCd Battery 500 FZ.
14. Battery Magazine 12V.
15. Battery Case.
16. Battery Case 500.

Items suitable for the Canon FTb (the camera on the left of the diagram) can also be used with the other Canon reflex cameras, excepting only those items forming part of the CAT system.

reflexes, the fastest usable shutter speed is generally 1/30 second. The 1/60 second speed is reserved for electronic flash.

There are, however, special flashbulbs that have a long-peaking characteristic. That is, they take the usual time to build-up to a usable intensity but then maintain that intensity for up to 1/40 second or longer. Thus, these special focal plane bulbs can be used at all the faster shutter speeds—generally 1/125 second and faster. The bulbs are, however, rather expensive and are not so freely available as the normal types. The later Canon reflexes are not designed to use FP bulbs and are not even very well suited to the use of ordinary flashbulbs.

The unfortunate aspect of the slow shutter speeds that have to be used with electronic flash and the normal flashbulbs is that the existing lighting may be sufficient to form a shadowy image on the film. Any movement in the subject is then registered as an extra, dark, perhaps blurred image, alongside the sharp image formed by the flash. Fill-in flash in daylight with fast-moving subjects is impossible.

## Characteristics of flashbulb equipment

Modern flashguns are extremely small, mainly because the size of flashbulbs has been steadily decreased over the years. The popular small bulb is now the AG3 type—a glass envelope filled with highly inflammable metal foil or wire in an atmosphere of oxygen. It has simple bent-wire contact passing through the envelope to a primer paste that ignites when a suitable voltage is applied to the contacts.

A flashbulb can be fired with as little as 3 volts direct from a small battery. Such a system is unreliable, however, because the on-load voltage of the battery falls with each flash and, as the battery nears exhaustion the bulb may be slow to fire or may fail to fire at all. Uncertain firing delays cannot be tolerated because they would make synchronisation with the shutter opening unreliable.

Modern flashguns overcome this problem by including a capacitor in the circuit to store an electrical charge from the battery and to release it through the bulb when the flash contacts are closed. The capacitor can charge relatively slowly, compared with the immediate high current

required to fire the bulb, but the rate of charge is still rapid enough to enable bulbs to be fired in quick succession.

Apart from the battery—usually 15 volts—and the capacitor there is only a resistor in the flashgun circuit, so all the components can be packed into a very small space. The modern small flashbulb needs only a small reflector and even that is often made in a collapsible fan form. The result is that a flashgun and two or three dozen bulbs need make no more than a slight bulge in a jacket pocket.

Nevertheless, larger units and larger bulbs are also available. The smallest bulbs are quite powerful, generally far more so than the popular small electronic flash units, but quite moderately-sized bulbs have twice their power, while the largest bulbs have an output some 10-12 times as great as that of the smallest bulbs.

The larger bulbs take rather longer to build up to a usable intensity than do the smaller bulbs and considerably longer to build up to peak intensity. They maintain their usable intensity about twice as long as the smaller bulbs—in the region of 22 milli-seconds, for example, for the PF100, against 8-12 milli-seconds for the AG3, PF1, PF5, etc. When films were slower (and bulbs were a little less powerful) Canon tended to recommend that the smaller bulbs should be used only with shutter speeds of 1/15 second and slower to ensure that all the light from the bulb was used. On the other hand, they indicated that the larger bulbs could be used at shutter speeds of 1/250 second and slower because they burnt rather longer. With the current cameras, their general recommendation is that there is a risk of uneven illumination at shutter speeds faster than 1/15 second.

These various recommendations might seem to indicate that all things are possible and, indeed, there have been claims by some users that they have achieved perfect synchronisation with flashbulbs at faster speeds than those recommended. In certain circumstances, that is not impossible, and any regular user of flashbulbs would do well to expend a roll of film on experimental exposures at various shutter speeds, noting not only whether the whole frame is illuminated, but whether it is illuminated evenly and how the density of the image compares with that obtained at the recommended shutter speed. It is advisable to conduct separate experiments for black-and-white and

for colour because what might be accepted as even illumination in black-and-white might not be so in colour, where unevenness frequently shows up as a more noticeable change in colour. In even-toned areas, for example, the edges of the frame may, through under-exposure, show as a deeper colour than the centre.

## Characteristics of electronic flash equipment

Electronic flash has the great advantage of not using expendable bulbs. Its flash is provided by an electrical arc across two electrodes extended by a gas filling in a sealed tube. The tube actually has a life of only a few seconds but, as the average electronic flash has a duration of only 1/800 to 1/1000 second, you can generally get quite a few thousand flashes out of a tube before it ceases to function.

Another advantage is that the electronic flash has no build-up time. It is virtually instantaneous and therefore raises no synchronisation problems. It does, however, make it impossible for the focal plane shutter to be used at high speeds. The shutter has to be fully open when the flash fires and, with the Canon reflexes, the fastest speed at which that happens is 1/60 second. That is undoubtedly a disadvantage but it is the fault of the shutter, not the flash.

A disadvantage inherent in electronic flash itself is that its circuitry is relatively complicated. It needs rather high voltages to operate at all and those high voltages have to be obtained from low voltage supplies in order to keep the size of the unit down to manageable proportions. Hence the complications which inevitably lead to greater bulk and expense than in the bulb flashgun.

Both the bulk and the expense have been greatly re-duced over the years but only by sacrificing power. The small, inexpensive pocketable electronic flash unit is generally much less powerful than the flashgun using the smallest bulbs. Consequently, its use is limited to fairly close-range work and it gives little opportunity for indirect flash work. More powerful units are available but the greater the power, the greater the bulk and the higher the cost.

As the electronic flash unit gets larger and the greater bulk and cost is accepted, the advantages begin to emerge again. For serious studio work, really high power units are

available and a variety of accessories and built-in ancillary services can be obtained. Extension flash heads can be plugged in to permit multiple lighting set-ups. Flash spotlights can be used. Modelling lights can be built in to the flashtube holders to enable the effect of the lights to be judged in advance. The lights can be powerful enough to allow totally indirect, shadowless lighting to be used. The additional power also enables small lens apertures to be used so that the ambient lighting can have no effect when rapid-sequence photography is undertaken. With power in reserve, variable power switches can be built-in and lamps can be positioned at long range to cover wide areas or minimise the effect of light fall-off in a deep subject.

Between the extremes of the really bulky studio equipment and the very small electronic flash units, there are various models that remain portable if not pocketable and provide a reasonably powerful source of light. These outfits are not inexpensive but they are fairly versatile and allow the photographer to undertake a wide variety of flash work.

Some of these more powerful units, and most of the smaller variety, offer various forms of automatic operation. The common principle is a built-in sensor that measures the light reflected from the subject and a high-speed switching circuit that halts the capacitor discharge when the film has received sufficient light for correct exposure. The result may be a flash of extremely short duration when the unit is used at close range with a relatively fast film. Automatic operation may be limited to the use of a single lens aperture or, in the more sophisticated types, to two or three stated apertures. Manual override is usually provided so that the unit can be used in the normal way—assessing exposure by means of guide numbers.

## Flash guide numbers

The guide number system relies on the fact that a particular type of flashbulb or tube emits a constant amount of light at each firing. Thus, if all the available light is used, the amount reaching the film is governed by the distance of the flash source from the subject and the aperture of the lens. The distance from the subject is important because, with any source of light emitting a

diverging beam, the light is spread over a greater area as the distance increases. Therefore, the illumination at any given point in the plane of the subject is less as the light is taken farther away.

There is a law (the inverse square law) governing the relationship between the rate of illumination fall-off and the distance of the light source. Strictly speaking, it relates only to point sources of light, i.e. an infinitely small source radiating light in all direction, but in most circumstances the flash source can be regarded as approximating closely enough to this condition for practical purposes. The law states, in effect, that the fall-off in illumination of a given plane is inversely proportional to the ratio between the squares of the distances of the light source. Thus, when the light source is moved from 3 to 6 feet from the subject the ratio between the squares of those distances is 9:36 or 1:4. Inversely, the relative strengths of illumination with the light source at those distances is 4:1. At 3 feet, the subject is four times as brightly illuminated as at 6 feet.

Conveniently, the $f$-numbers denoting lens apertures work in the same way. At $f4$, for example, the lens passes through to the film four times as much light as it does at $f8$. Thus, at $f4$ and 6 feet flash distance, the same amount of light reaches the film as at $f8$ and 3 feet flash distance. In each case, these figures multiplied together give 24. The same would apply at $f2$ and 12 feet, $f16$ and $1\frac{1}{2}$ feet and so on. So each flash tube or bulb can be given a number denoting its power, the number derived from multiplying together any combination of lens aperture and flash distance that gives correct exposure. The correct aperture for a given flash distance, or vice versa, can then be calculated simply by dividing the known factor into the guide number.

The obvious snag is that the guide number, being an indication of power, becomes a sales factor and could be overstated by the manufacturer. This does not generally happen with flashbulbs but it is by no means unknown with electronic flash units. Additionally, the guide number depends on various other matters for accuracy. It depends, for example, on the efficiency of the reflector placed behind the bulb or tube to throw the light forward. It depends on the proximity and tone of suitable surfaces

## FLASH EXPOSURE

Every flash unit and flashbulb has a guide number quoted by its manufacturer. When the guide number is divided by the distance (there are different guide numbers for feet and metres) from the flash to the subject, the resulting figure is the *f*-number to set on the lens. Some rounding off may be necessary. The diagram shows the apertures required at various distances with a guide number of 64. It also shows the rapid fall-off in illumination with increasing distance. This follows the inverse square law, so that, if *f*11 were used at 24 feet, the subject would receive only 1/16th of the light required for correct exposures.

to reflect some of the diverging light back on to the subject. It depends on the flash being correctly aimed at the subject and on its not being so close to the subject that the reflector ceases to be efficient.

There are further complications regarding guide numbers for flashbulbs that do not apply to electronic flash. First, many flashguns can use various types of bulb and, naturally, the guide number is larger for the more powerful bulbs. Secondly, as the flashbulb continues to emit light for 1/100 second or longer, its guide number is lower at faster shutter speeds, because only part of the flash is used. This does not generally affect the Canon reflex cameras, because they all have focal plane shutters which, ideally, should be used with flash only at speeds that expose the whole image area simultaneously. If you do find it possible to use faster speeds, the constant speed of movement of the shutter blinds across the film plane ensures that the same amount of light reaches each part of the film. Usually, the lack of perfect synchronisation causes you to cut into the build-up or tailing-off time of the flash. Then you have under-illumination at either end or both ends of the image area.

The only notice you need take of the various guide numbers printed on flashbulb packets for different shutter speeds is to ensure that you use the 1/30 second or "open flash" guide number.

## Guide numbers and film speed

We have stated the fundamental principle that flash exposure depends solely on lens aperture and distance from flash to subject—the principle that allows us to allot a single figure as a guide number for any flash bulb or tube. Naturally, however, as with any question of exposure, the sensitivity of the film must also be taken into account. The guide number is greater for a faster than for a slower film. So each flashbulb or tube has a different guide number for each film speed. That is obvious enough, but the trap to avoid is that ASA film speeds work on a doubling-up principle; twice the speed equals twice the sensitivity. This does not apply to guide numbers because doubling the flash distance does not call for double the exposure but for four times the exposure. Similarly, halving the flash distance means that

you need give only one quarter of the exposure. That is the operation of the inverse square law and it means that, as film speed doubles, the guide number is multiplied by the square root of 2, just as successive $f$-numbers are (with some rounding off). So, if the guide number for a 50 ASA film is 45, the guide number for a 100 ASA film is about $45 \times 1.4$ or 63. With more awkward numbers you multiply the guide number by the square root of the relationship between the film speeds. Thus if the guide number is, again, 45 for a 50 ASA film, for a 64 ASA film it is $45 \times \sqrt{64/50}$, which is near enough $45 \times 8/7$ or 51.

## Canon Auto Tuning System

Electronic flash is virtually instantaneous, so it does not have different guide numbers according to shutter speed—as the flashbulb does. It does, however, have a problem of its own, in that the accuracy of the guide number depends on the state of charge of the high-voltage capacitors. The flashbulb works off a low voltage and its capacitor charges very rapidly. Moreover, it either fires or misfires; it cannot emit more or less light according to the voltage applied. The capacitors in electronic flashguns take considerably longer to build up the high voltages required to fire the flash tube. As battery power decreases, this "recycling time" becomes longer and can extend to 30 seconds or more. Even with fresh batteries it may be as long as 10 seconds. If you fire the flash before the capacitor is fully charged, the intensity of the light emitted is less than the guide number indicates. Most electronic flashguns have visual and audible signals indicating when the voltage is sufficient to fire the tube. The visual signal is generally a neon lamp set to strike when the voltage on the capacitor reaches a certain level. This voltage can be set at any level within the striking capability of the neon and it is, in fact, common practice to set it at 80 per cent of the full capacitor charge. This is sufficient to fire the tube but not sufficient to allow it to emit the full output of which it is capable. If you delay the firing for a further time equivalent to that taken for the neon to strike, the light output may be nearly doubled.

Canon have overcome the uncertainty engendered by the guide number system in relation to the charge on the

capacitors by their CAT (Canon Auto Tuning) system. This uses a specially designed electronic flash unit and electrical contacts on the Canon F-1, FTb and EF to transmit the actual voltage level on the capacitors in the form of a signal that actuates the needle of the camera exposure meter. The needle moves upward as the voltage increases, just as it would if the light level increased to the same extent as the potential flash power has increased. Moreover, a coupling ring attached to the front of the lens and electrically connected via a cable to the flash unit links the focusing movement of the lens via an electrical resistance to movement of the meter needle so that, as the focused distance is increased or decreased, the needle moves down or up respectively.

As a result of these electrical signals and the needle movement, the meter pointer linked to the lens aperture control can be used in the normal way to set the aperture for correct exposure *according to the charge on the capacitor*, regardless of whether or not the capacitor is fully charged. The meter needle moves only when the charge on the capacitor is sufficient to fire the flash tube.

One great advantage of this system is that all information is visible in the viewfinder. The meter needle acts as a recycling indicator and repeated shooting can be undertaken without taking the camera away from the eye even when the focused distance is altered. One great disadvantage is that the flash distance is transmitted to the meter as the focused distance and the flash unit must, therefore, be on the camera—even apart from the fact that it has to be there to make the necessary electrical contacts.

The flash unit used for the CAT system is the Canon Speedlite 133D. It can be used only with four FD lenses—the 50 mm. $f1.8$, 50 mm. $f1.4$, 35 mm. $f2$ and 35 mm. $f3.5$. Four types of flash-auto ring are available to couple these lenses to the focusing ring and Speedlite 133D—the A, B, A2 and B2. The A2 can be used with all the lenses except the 50 mm. $f1.4$. The B2 can be used with all except the 50 mm. $f1.8$. The A ring is for the 50 mm. $f1.8$ and 35 mm. $f2$ only and the B ring for the 50 mm. $f1.4$ and 35 mm. $f2$ only. The distance coupling range is not complete. With the 50 mm. $f1.8$, 50 mm. $f1.4$ and 35 mm. $f1.2$ it is approximately 1-10 m. (3-33 feet). With the 35 mm. $f3.5$, it is about 0.9-5 m. (3-16 feet).

The Canon FTb and EF have the necessary electrical contacts built into the accessory shoe, but the removable pentaprism of the F-1 makes this impracticable and the flash contacts are adjacent to the rewind knob. A special Flash Coupler L has to be attached over the rewind knob.

## Operation of CAT system

The Canon Speedlite 133D is supplied complete with the A or B Flash-Auto Ring according to the lens to be used. Note that the FD35 mm. $f3.5$ lens can use only the A2 or B2 ring. The original A and B rings cannot be used with this lens. For use with the Canon F-1, the Flash Coupler L is also required. The procedure is as follows:

(1) When using the Canon F-1, load the Flash Coupler L with a 1.3 volt HD mercury battery to power the signals of the CAT system and a 1.3 volt MD mercury battery to illuminate the meter information window. The battery compartment cover simply pulls off in the direction of the marked arrow. The batteries load side by side with their plus sides facing each other. To attach the Coupler to the camera, push the locking lever at the side outward and downward, slide the Coupler forward over the rewind knob and push the locking lever back into place.

(2) Slide off the battery compartment cover on the top of the Speedlite 133D in the direction of the arrow and insert four 1.5 volt pen cells as indicated in the diagrams inside the compartment. Replace the cover by sliding it into the grooves while holding the batteries down on their spring contacts. Attach the Speedlite 133D to the camera accessory shoe with the sliding switch on the back at OFF.

(3) Attach the appropriate Flash Auto Ring to the lens (see page 296). With the A and B rings, first set the selector switch on the front to the appropriate marking for the lens in use. Line up the attachment hook on the rear ring with the white dot on the outside rim of the front ring. Set the focusing ring of a 50 mm. lens to 1.2 m. or of a 35 mm. lens to between 0.5 and 0.6 m. Place the attachment hook of the Flash Auto Ring over the small stud on the focusing ring now at the bottom of the lens and

push the ring over the lens front with the red spot at the top lining up with the red spot on the camera body used for lens attachment. Turn the Flash Auto Ring clockwise and it will lock into position.

Attachment of A2 and B2 rings is similarly achieved, except that the lens focusing needs merely to be set anywhere between 1 m. and infinity. The ring is placed straight over the lens (lining up the red dots) and turned clockwise to lock it. The claw device engaging the focusing ring pin is brought into alignment simply by turning the rear part of the Flash Auto ring to left or right.

(4) With the Flash Auto Ring attached to the lens, insert the two pin plug of its connecting cord into the sockets at the side of the Speedlite foot. The plug cannot be inserted the wrong way round, but ensure that it is pushed fully home.

The Canon Auto Tuning system is now connected ready for use. To operate it with the F-1 or FTb set the camera meter switch to OFF and the shutter speed to 1/60 second. At any other shutter speed, apart from possible lack of synchronisation, the meter needle gives a false indication for flash use because it is linked to the shutter speed dial. If you have not already done so, set the film speed on the shutter speed dial. The film speed also affects the meter needle position. With the Canon F-1, you can illuminate the meter panel in the viewfinder if necessary by operating the switch on the back of the Flash Coupler L.

When you are ready to take your photograph, slide the switch on the back of the Speedlite upward to switch the power on. Sight your subject in the viewfinder and wait for the meter needle to swing upward, indicating that the flash is ready to fire. Focus the subject and the meter needle will move up or down to take the flash-to-subject distance into account. After focusing, turn the lens aperture ring to bring the circular pointer into alignment with the meter needle. The aperture is then set to give correct exposure according to film speed and the charge on the capacitor. You can fire the flash immediately on lining up the needles or wait a few more seconds and

## CAT FLASH SYSTEM

Featres of the Canon Automatic Tuning system for flash exposures are:

1. Plug.
2. Distance pin socket.
3. White index.
4. Battery compartment cover.
5. Batteries.
6. Speedlite 133D.
7. Lens type indicator.
8. Fastening ring.
9. Adjusting ring.
10. Lock release button.
11. Distance pin holder.
12. Neon indicator.
13. Auto ring connecting socket.
14. Direct contact (hot shoe).
15. CAT system contacts.
16. Main switch.
17. Plug.
18. Lens type indicator.
19. Lock release button.
20. Fastening ring.

To use the CAT system with the Canon F-1, you need the Flash Coupler L, because the camera has no accessory shoe. The coupler carries two batteries, one for the CAT system signals and one to power illumination for the F-1 exposure meter scale. This feature makes the Coupler useful for any work in dim-light conditions.

realign the needles—finding that you can set about one stop smaller on the lens.

Operation of the CAT system on the Canon EF is even more automatic. The attachment procedure is the same but the shutter speed must be set to 1/125 sec., the flash switch behind the rewind knob set to the flash symbol and the lens aperture ring set to the green circle as for AE operation. The main meter switch must be on. The CAT circuitry then operates automatically because the focused distance and the state of charge of the flash unit capacitor are transmitted to the AE circuit to control the aperture setting. When you release the shutter the diaphragm is adjusted automatically to the value shown in the view-finder.

To detach the Flash Auto Rings, take the plug out of the Speedlite, press the button or catch near the cable on the ring and turn the ring anticlockwise. You can pull it off when the red dots coincide.

## Features of Speedlite 133D

The Speedlite 133D is a "hot shoe" type electronic flash unit with no cable connection facility. It can be used in the normal manner on cameras with suitable contacts. In such cases, the guide number to use for exposure assessment is 60 (feet) or 18 (metres) with 100 ASA film. The angle of its beam is 55°, both vertical and horizontal and it provides light of a colour temperature of 6000K and a duration of about 1/1000 second. Using four pen-light manganese batteries it will give about eighty flashes with a recycling time of about 7 seconds. With alkaline batteries, up to 300 flashes are possible, recycling in about 5 seconds. It has a neon lamp and high-pitched whistle indicator for completion of charge.

Measuring $90 \times 74 \times 35$ mm. ($3\frac{1}{2} \times 3 \times 1\frac{3}{8}$ inches), it weighs 170 g. (6 oz.).

On some models of the 133D, separate switches are provided for manual and automatic operation because, when the unit is used manually, the guide number applies only when the capacitor reaches a higher voltage than the minimum necessary to fire the tube. The neon, therefore, strikes at a higher voltage when the switch is set to manual than when it is on automatic.

## Speedlite 155A

A different type of automatic flash operation became possible with the electronic circuitry embodied in the Canon A range of cameras. Contacts were accordingly built in to the hot shoe to set both shutter speed and aperture automatically. Naturally, special flash units are necessary and the first model, the Speedlite 155A, was introduced with the Canon AE-1.

The Speedlite 155A is a cordless electronic unit (a synchronising cord is available as an extra) of the automatic exposure type with built-in sensor. It offers a choice of two apertures for each film speed (2.8 and 5.6 for 100 ASA) plus manual control. It has a guide number of about 50 (ft.) at 100 ASA and an angle of coverage equal to that of a 35 mm. lens. Its maximum automatic working range with a 100 ASA film is from 0.5 to 6 m. It is powered by four AA size batteries giving about seven-second recycling (alkaline) or five seconds (ni-cads). These times are considerably reduced when working automatically at close range. Alkaline batteries give about 300 full-power flashes, ni-cads about 90. The Speedlite 155A measures $70 \times 51 \times 105$ mm. ($2\frac{3}{4} \times 2 \times 4$ inches) and weighs 300 g. ($10\frac{1}{2}$ oz.).

With the lens aperture ring and the flash unit set for auto operation, and the camera shutter speed ring set to any position except B, flash operation on the AE-1 and A-1 is completely automatic. As soon as the flash unit capacitors are charged, after switching on or recycling, the ready light glows and the camera shutter speed is set automatically to 1/60 second. (You cannot use slower speeds, not even on manual operation.) At the same time the lens aperture is set to the value dictated by the selector switch and film speed dial settings of the Speedlite. It sets the minimum aperture if the selector switch is on manual and the lens set to auto. The Speedlite can be used with the AT-1 but then only the shutter speed is set automatically.

While the Speedlite is recharging after a shot, or is still connected to the camera but is switched off, the camera reverts to normal AE operation. The flash unit fires and controls the camera only when the ready light is glowing. Thus, if you think you might be shooting more rapidly than the unit recycles, set the camera controls to an

aperture or shutter speed feasible for AE operation in the prevailing circumstances.

The procedure for using the Speedlite 155A automatically is as follows:

(1) Set the film speed dial of the Speedlite to the figure appropriate to the film in the camera. This is not just a reminder: it controls the automatic aperture setting.

(2) Slide the Speedlite into the camera accessory shoe and tighten with the milled wheel.

(3) Set the Speedlite selector switch to give the aperture required—as indicated by the coloured lines on the dial.

(4) Set the camera lens to auto operation and make sure that the shutter speed is not set to B. The A-1 dial can be on Av or Tv.

(5) Switch on the Speedlite.

(6) Focus and compose the picture and release the shutter when the ready light glows on the back of the Speedlite.

## Speedlite 199A

The Speedlite 199A is a more advanced version of the 155A. It is the same type of cordless electronic unit for automatic operation but has additional features and more power. The most noticeable additional feature is the tilting head, allowing the flash to be directed at a reflecting surface for bounced flash without affecting the automatic operation. The sensor remains pointing at the subject.

You have a choice of three apertures with each film speed on the 199A (2.8, 5.6 and 11 at 100 ASA), reflecting the greater power available: the guide number is about 90 for a 100 ASA film with maximum automatic working range from 1.5 to 10.6 m. The angle of coverage is that of a 35 mm. lens but an adapter is available to spread the output over the area covered by a 24 mm. lens. That entails considerable power loss, however, the guide number being reduced to about 55 for 100 ASA.

The pilot light acts as an open flash or test button in the usual manner but can also be used to check that the subject is within the automatic working range. After the flash fires, a green light to the left of the pilot lamp glows when the range is correct, gradually fading out as the

# SPEEDLITE ELECTRONIC FLASH UNITS

The main features of the Speedlite 155A are:
1. Sensor.
2. Socket for cable connection.
3. Battery compartment.
4. Film speed setting.
5. Exposure calculator.
6. Ready light/open flash button.
7. Main switch.
8. Aperture selection switch.

The main features of the Speedlite 199A are:
1. Sensor.
2. Socket for cable connection.
3. Lock lever.
4. Film speed setting.
5. Exposure calculator.
6. Main switch.
7. Auto/manual switch.
8. Check light.
9. Ready light.

unit recycles. This confirmation lamp also has a dual function. When you press it, the dial settings are illuminated.

The Speedlite 199A has two manual operation switches. The normal one, combined with the aperture selection switch, allows you to control the lens aperture setting yourself. The other is under the tilting head of the unit and provides a 1/60 second to 30 seconds setting. At this setting, the camera shutter speed is automatically set to 1/60 second if a higher speed is set on its dial but is maintained at the camera setting if that is slower than 1/60 second.

The control dial on the back of the 199A is similar to that on the 155A, with film speed settings, aperture and distance scales. The film speed setting is obligatory for automatic operation because it sets the flash unit circuit to control the lens aperture.

The Speedlite 199A is powered by four AA size batteries giving about 10 second recycling (alkaline) or six seconds (ni-cads). These times can be reduced to about one-fifth of a second when working automatically at close range, allowing the unit to keep pace with the five frames a second capability of the Motor Drive MA—for a few frames at least. Alkaline batteries give about 100 full-power flashes, ni-cads about 50.

The procedure for automatic operation with the Speedlite 199A is as follows:

(1) Set the film speed dial of the Speedlite to the figure appropriate to the film in the camera. If you are in the dark, you can illuminate the dial by pressing the confirmation light button.

(2) Slide the Speedlite into the camera accessory shoe and push the lever beside the foot forward to lock it.

(3) Set the selector switch to provide the aperture of your choice, as indicated by the coloured panels and the lines showing the appropriate settings on the dial.

(4) Set the camera lens to the auto position and make sure that the shutter speed dial is not set to B. The A-1 dial can be set to Tv or Av.

(5) Switch on the Speedlite. You can then test the operation and the suitability of the subject range

A fine profile outlined by careful backlighting. Photo: *David Waterman.*

*Above.* Semi-silvered spectacles provide brilliant reflections. Photo: *George Konig.*

*Opposite.* A characteristic shot that almost guarantees an inquisitive stare if taken quickly. Photo: *David Waterman.*

Humour and the really wide-angle lens. Not the extensive depth of field. Photo: *Canon Inc.*

You need patience to capture the right expression. A low viewpoint is often the best for children. Photo: *David Waterman.*

(*Top*). A Japanese temple shot in soft lighting to preserve detail under the eaves. Photo: *Canon Inc.*

(*Bottom*). Fast panning for a really fast moving subject. Photo: *David Waterman.*

(*Top*). Spring crocuses in close-up with the 50mm *f*1.4 and a 2X tele-extender. Photo: *George Konig.*

(*Bottom*). Carefully angled lighting shows the woodcarver's art. Photo: *Canon Inc.*

Parting shot at the end of a photo session. Photo: *Canon Inc.*

if you wish. Press the ready light button when it glows. If all is in order the green confirmation light glows after the flash fires.

(6) Compose and focus the picture and release the shutter when the ready light glows. Watch for the confirmation light.

As with the 155A, the camera reverts to normal AE operation while the Speedlite is recharging.

## Other Speedlite operations

A special synchronisation cord is available to allow the Speedlites 155A and 199A to be used off the camera with full automatic operation. The normal cord, available as an extra, is for non-auto operation only.

If you wish to use either the 155A or 199A with an FL or other non-AE lens, you still have automatic flash control but have to set the lens aperture manually in accordance with the auto setting you have selected on the Speedlite. The A-1 readout indicates the aperture to which the lens must be set. The Speedlites can be used on other Canon cameras but only in the manual mode. There is no automatic shutter speed setting (except on the AT-1) or aperture setting.

Although you must not set the camera shutter speed to B for normal automatic flash exposures, you can use the B setting with the Speedlites. The flash synchronises with the full opening of the first shutter blind. An FD lens can remain on auto operation and the aperture chosen on the Speedlite will be set on the camera. With an FL lens (or an FD lens on tubes or bellows), the aperture must be set manually as usual.

## A-1 viewfinder readout with flash

When using the Speedlites 155A or 199A for automatic operation on the Canon A-1, the digital readout in the viewfinder is also activated. The F signal for flash appears in the centre of the readout flanked by the automatic 1/60 second shutter speed setting on the left and the aperture selected by the flash unit on the right. All rather pointless really, but the F appears only when the Speedlite capacitors are charged and the unit is switched on and ready to fire. While the unit is recycling or switched off,

the camera reverts to ordinary AE operation, as confirmed by the readout.

The readout is similar when you use a lens other than the FD type (i.e. without the automatic setting) or when you wish to control the aperture manually and thus turn the FD ring away from the A setting. The letter M appears to the right of the aperture figure, which is that selected on the Speedlite. The M indicates that you have to set the aperture manually on the lens.

Warnings are given in the readout if you make an incorrect setting. If, for example you choose $f2.8$ as your aperture setting on the flash unit but the lens on the camera has a maximum aperture setting of $f4$, then an aperture reading of 4 will flash on and off in the viewfinder. If you select a smaller aperture than $f16$, the selected setting flashes in the viewfinder to indicate that you should check your lens to make sure that such an aperture is available.

The Speedlite 199A allows you to use shutter speeds slower than 1/60 second. In that case set the required speed on the camera and it is displayed in the readout.

If you decide to use either Speedlite on the manual setting, calculating your required aperture according to flash distance and film speed, the shutter speed is still set to 1/60 second automatically and that speed is displayed in the viewfinder. The F and M indications are also shown but no aperture figure appears.

When you use the B setting with flash, the viewfinder shows "bu" in the shutter speed position and the shutter remains open as long as the release is held depressed. The other indicators in the readout appear normally, as for automatic or manual operation.

## Flash Coupler D

The Canon F-1 has a coaxial flash socket in the side wall of the top plate at the rewind end but it has no accessory shoe fitting, because its pentaprism is removable. To use a direct-contact (hot-shoe) flashgun other than the Speedlite 133D, you have to attach the Flash Coupler D to the rewind knob. This connects a central flash contact to the F-1 contacts behind the rewind knob.

## Locking device for Flash Coupler L

When the Flash Coupler L is used for the CAT system, the plug on the lead from the Flash Auto Ring also serves as a lock to ensure that the Speedlite 133D remains firmly attached to the accessory shoe and cannot slip out. If the 133D is used without the Flash Auto Ring (as with a lens other than the four with coupling pins on the focusing ring), a substitute plug is available to serve the same locking purpose.

## Using flash on the camera

Flash is not an easy form of light to use. Mechanically, it is simple enough. Any flash unit can be connected to any of the Canon reflex cameras via a coaxial cable and plug or, in most later models, via a contact in the accessory shoe. Once the unit is connected, you set the shutter speed to 1/30 second for bulbs and 1/60 second or X for electronic flash and the flash will synchronise perfectly with the shutter opening. On the EF, however, the recommended shutter speeds are 1/15 second for bulbs and 1/125 second for electronic flash. The guide number system allows you to set the aperture for correct exposure. On the A-1 and AE-1 you do not even have to set shutter speed or aperture when you use the special Speedlites. On the AT-1, you have to set the aperture but not the shutter speed.

The easiest way to use flash equipment is to attach it to the camera accessory shoe or to a flash bracket fixed to the camera via the tripod socket. If you use the automatic Speedlites on a bracket, you need the special auto sync cord. When you think of it, you would arrange no other light source on the camera. You would rarely shoot with a very low sun at your back shining directly over or just past your shoulder. You would not normally arrange photofloods or studio lamps as your main lights right next to the camera. You would be well aware that such lighting destroys all modelling in the subject, making it look flat and uninteresting, and throws harsh shadows on the background close to the subject.

The practical value, therefore, of a flash unit mounted on the camera is generally rather limited. You use it that way when you have no choice—like the newsman in a

crowd—although, if he can, even he will raise his flashgun at arm's length and move it sideways from the lens axis.

Even a slight sideways movement of the light source causes prominent features to cast shadows to one side and thus give the subject some form and substance. It also eliminates the disfiguring "red-eye" effect in colour pictures caused by the subject staring into the flash reflector and so sending a reflection from the back of the eye straight back into the camera lens.

There is, in fact, very little to be said at all for using a flash unit mounted on the camera, except when photographing a flat subject or when using the flash as a fill-in light. This is an unfortunate fact that severely limits the value of some ingenious flash systems.

## Using flash off the camera

The preferred position for a flash light source, in nearly all circumstances, is at an angle of at least 30-40° from the lens axis. It is also usually preferable for it to be at a similar angle at least in the upward direction because we are generally used to seeing our light coming from above. The difficulty about that is that no flashgun manufacturer attaches a cable to his unit of any reasonable length. Many are so short that they have difficulty in reaching the camera socket if the flashgun is mounted on a bracket. Whenever you buy a flash unit, therefore, you really should buy an extension lead at the same time. They are sold in a variety of lengths.

Even with an extension lead, you are faced with the further problem of supporting your flash unit in its remote position. You can use a tripod, a clamp, a handy shelf or bookcase or improvise any other method. And you must be careful where you drape the extension lead.

It is such considerations as these that prompted us to write that flash is not an easy form of lighting to use. The extreme portability of many modern units encourages the belief that it is, but portability tends to lose its value when there are so few opportunities for using the flash in a simple on-camera arrangement.

A single flash unit of reasonable power can provide satisfactory illumination of most subjects if used together with reflecting surfaces to redirect some of its light into the areas that are inevitably cast into shadow by the

angled, strong illumination. The flash portrait, for example, is vastly improved if a large white reflector is placed to catch some of the light from a flash placed to provide modelling and direct it back into the shadows the modelling light casts.

When strong modelling is not required, as in many colour shots, the flash can be used indirectly. Frontal light is commonly used in such situations. The flash unit faces the camera but is directed at a reflecting surface. A white umbrella is often used but a flat surface is perfectly adequate. The small, rather harsh light source is then transformed into a broad flood that reduces shadows to a minimum while not destroying them completely. An improvisation that can overcome the disadvantages of direct, on-camera flash is to direct the flash on to your chest or thereabouts. A white shirt or light clothing makes a useful reflector, but the colour of any such clothing must be neutral if colour film is used.

One of the advantages of this type of "bounced flash" is that the subject is generally illuminated fairly evenly from top to bottom. The practice of bouncing the flash off the ceiling may lead to a noticeable fall-off in illumination on, for example, the lower legs and feet of a standing subject. The ceiling is by no means a point light source and the fall-off may not obey the inverse square law but it is there.

Using the flash indirectly in this manner negates the guide number, of course. The guide number is based on the total amount of light received directly from the source and from reflectors. When you confine the light on the subject to reflected light, you can still use the guide number as a starting point but you divide into it the distance from flash to subject via the reflecting surface. Additionally, you give at least one stop more exposure to allow for the lack of direct light. It is best to standardise such arrangements, if possible, and to make tests to arrive at a suitable exposure factor for your usual set-up.

## Fill-in flash

The basic unsuitability of the focal plane shutter to the use of flash as a light source leads to the practice of using flash mostly as the sole source. The opportunities for using flash to reinforce existing light are somewhat restricted.

In particular, it is virtually impossible to use fill-in flash with a fast-moving subject because the flash cannot be synchronised with a sufficiently high shutter speed unless you use bulb equipment with focal plane bulbs.

If the subject is static—an outdoor portrait, an against-the-light shot needing frontal fill-in, etc.—flash can be used but there are still problems. In bright sunshine, for example, with a 100 ASA film in the camera, the basic exposure for the general scene may be 1/125 second at $f$11 or $f$16. You have to use a shutter speed of 1/60 second for electronic flash or 1/30 second for bulbs, which means that you have to stop down to the maximum. For the portrait, in particular, that is not likely to be desirable.

There are two ways out of such a situation—you use a slower film and/or add neutral density filters, if shooting in colour, and perhaps a coloured filter when shooting in black-and-white. In some circumstances, you might even use a polarising filter.

If you can use fill-in flash—and there are occasions when it is desirable to reduce the subject contrast for colour work—you have to balance the flash and daylight exposures rather carefully. It is far better to err on the side of too little flash than too much. If the flash is stronger than the daylight, shadows are obliterated or changed and the effect is noticeable and disturbing. If the shadows are insufficiently illuminated, the picture is rarely comppletey ruined.

There are various formulae for the calculation of the flash exposure but, as in most such problems, the best guide is practical experience with your own equipment. You can start from the basic premise that the strength of the flash should be about one quarter of a full flash exposure. This will actually provide rather less than one-quarter-strength illumination on the subject, owing to the lack of nearby reflecting surfaces. The aperture is fixed by the obligatory shutter speed and the prevailing light and should be the setting that exposes the general scene correctly. The "general scene" in this context is often the background and, as the lighting is probably from the back or thereabouts, you cannot take a direct meter reading pointing toward the subject. The ideal reading is from a mid-tone with your back to the subject, provided your body does not shade the reading area.

## USING FLASH

Direct on-camera flash should be avoided if possible. It gives no modelling and throws harsh shadows.

Bouncing the light from the ceiling gives a softer light, less harsh shadows and better modelling.

The small unit is often not powerful enough for bounced lighting. Whenever possible, however, it should be removed from the camera so that shadows can be thrown clear of the subject and a degree of modelling provided.

Cross-lighting is not usually recommended but it is often very effective with colour portraits where the single flash from one side can throw unattractive deep shadows that might also cause colour distortion.

The small electronic unit is particularly useful as a front fill-in in daylight. Its guide number should be reduced by at least one-half.

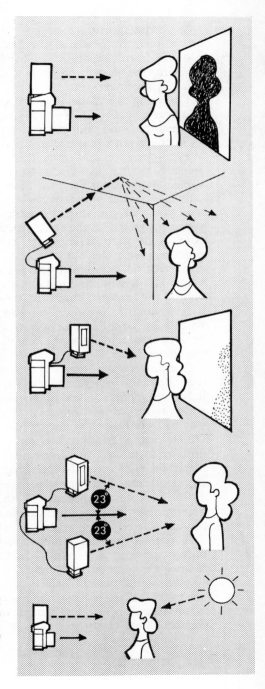

With the aperture fixed by these considerations, you can control the power of the flash only by changing its distance from the subject or by direct methods such as covering the flash head with a diffuser—handkerchief, gauze, your fingers, etc.

Changing the distance is not very satisfactory unless you have an assistant. If you are shooting at about 10 feet, for example, and your flash unit has a guide number of 55 in the given circumstances, and you are able to shoot at $f11$—then you are lucky. The guide number of 55 and aperture of $f11$ give you 5 feet as the correct flash-to-subject distance for a normal flash exposure. As you want only one quarter of that exposure, the inverse square law tells you that you should double the flash distance. So you can shoot with the flash on the camera at 10 feet. If your guide number were 70, however, and you were shooting, with the aid of filters, perhaps, at $f8$, your required flash-to-subject distance would be $17\frac{1}{2}$ feet and you would have to find some way of supporting it $7\frac{1}{2}$ feet behind the camera. That is by no means impossible, but it is frequently inconvenient and, as the use of fill-in flash is one of the rare occasions when the flash unit can be used satisfactorily on the camera, it is a pity to sacrifice the convenience.

A more practical method and one that can by experiment be made very reliable is to reduce the power of the light at the source. Some photographers have an uncanny ability to spread their fingers in front of the flash in such a way as to reduce the light by just the required amount. Others use a handkerchief or a specially-constructed diffuser to fit over the front of the flash head. Various materials, such as opal-type plastic, white linen, cotton, etc, can be attached to a simple wire frame to form such a diffuser. A few experimental shots can be made to determine the amount or thickness of material required to produce the required result.

A method that sometimes proves effective with flash-bulb equipment is to remove or fold up the reflector to remove the component of light, by no means inconsiderable, thrown forward by the reflector. It is worth noting, however, that such a method presupposes that the flash is not placed below the camera in front of the photographer's light clothing.

On the other hand, many a photographer habitually wears a white shirt for this very purpose, bouncing his fill-in light from it to provide a quite drastic reduction in subject illumination.

## Multiple-flash techniques

For many categories of work using flash as the sole light source, you cannot work with just a single flash unit. A lot of very fine work is, indeed, produced with a single light source (not including daylight, which invariably uses a lot of reflecting surfaces), but interiors of buildings, formal portraits, banquets, etc. need more traditional lighting methods.

In the well-equipped studio, there are no problems. Professional equipment is available to supply all the photographer's needs, with virtually unlimited numbers of electronic flash tubes fired from large free-standing power units, attachments for spot, flood, patterned, shaded and any other effect required.

Owners of more modest equipment have to compromise. Those who use the really small electronic flash units are severely limited, because they never provide facilities for attaching extra flash heads, and the practice of using two or more units connected to the camera contacts is not to be recommended as a general practice. Manufacturers' opinions vary but there is a distinct possibility of overloading the none-too-robust flash contacts in the camera and there is always a risk of misfiring or premature firing when the characteristics of the units (polarity, resistance of tube, etc.) are not absolutely identical.

It is quite feasible in some circumstances to fire a single flash source repeatedly at various parts of a large subject, such as the outside of a building or the inside of a hall, church, etc. You have to leave the shutter open on the B setting with a locking cable release, however, and that can complicate matters if there is more than a glimmer of existing light in the scene.

The more logical way of going about things is to obtain a flash unit with provision for attaching extension heads. Such additional units usually contain their own capacitors and triggering circuits and do not affect the output of the main tube. In some cases, however, they have only half

the power of the main tube. Extension heads are commonly fitted with quite long leads and can be used to cover a large area or to light subject and background from any desired angle.

An alternative to the trailing lead to each flash head is the slave unit which contains a light-sensitive element connected to a flash tube so that light from the main flash can be used to trigger the slave flash. The best of these units are very effective, provided their cells are accurately lined up, and they can even be used, with some ingenuity, to trigger one another in sequence to give a kind of strobe effect. The procedure is detailed in *The Focalguide to Flash*, by Gunter Spitzing.

The use of multiple flash always seems to raise doubts about exposure but, in most cases, no special calculations are necessary. The main light is the only one that really affects the level of exposure. The others are used to lighten shadows, illuminate the background or other part of the subject or add an effect light, such as a spot on the hair or rim-lighting. Such additional light as they may possibly cast on the subject cannot significantly affect its level of illumination.

# FILTERS AND FILTER PRACTICE

A filter is so called because it extracts unwanted components of light. It is usually placed over the camera lens but the effect would be the same if it were placed over the light source. In the one case it extracts the unwanted colour reflected by the subject. In the other, it extracts the unwanted colour from the mixture of colours emitted by the light source. Most light sources are composed of light of various colours and it is possible to extract one or more colours and thus alter the colour of the light. Daylight, for example, contains all the colours of the spectrum. So, generally, does artificial light, but in different proportions. A filter can adjust the proportions of different coloured light in one to make them approximately the same as those in the other. The spectral quality of daylight varies. Average daylight, consisting of both direct sunlight and reflected light from a fairly clear sky, is taken to be the normal "white" light, but light from a deep blue sky with no direct sunlight is a very different proposition. Although we still consider it white light, it has a considerably stronger blue content that affects colour film and demands the use of a filter.

## Colour quality and colour temperature

The colour quality of a light source is generally expressed in kelvins for photographic purposes. The kelvin is the unit of colour temperature.

Average daylight, as there defined, has a colour temperature of about 6500K, while blue sky light can be anything from 12 000K upward. The average tunsten lamp has a colour temperature of 2800K, a photoflood 3400K and a photographic studio lamp 3200K. Electronic flash and blue flashbulbs are generally made to emit light of a colour temperature of about 6000K.

The colour temperature of a light source does not significantly affect black-and-white photography but it

is important in colour photography. Colour temperature figures can, however, be rather misleading because we rarely bother with filters when shooting in normal daylight although the colour temperature of the light may vary from 6000 to 8000K or so. Yet we find that there is a noticeable difference in colour reproduction when we use a film designed for photolamp (3400K) illumination in tungsten lighting of about 2800K—only a 600K difference.

The reason is that the colour temperature scale does not provide intervals that correspond to variations in colour. The higher the colour temperature the greater the difference between kelvin ratings necessary to indicate the same amount of change in colour quality.

## Using mired values

Colour temperatures can, however, be easily converted to micro reciprocal degrees, commonly known as mireds. The mired value of any colour temperature is simply one million divided by the kelvin figure. Differences in colour quality are then roughly equal when the difference between the mired figures is equal—throughout the scale. Thus 3400K = 294 mireds, while 2800K = 357 mireds, a difference of 63 mireds. But 6000K = 166 mireds and 8000K = 125 mireds, a difference of only 41 mireds. The advantage of the mired scale is that it allows filters for use with colour film to be allotted mired shift values, i.e. a figure indicating the change the filter will effect in the mired value of the light source. Thus, to convert a 2800K light source to 3400K a filter with a mired shift value of +63 is required, while to effect the reverse change a filter with a mired shift value of −63 is necessary. The negative mired shift filter is bluish. The positive filter is reddish or amber.

Few filter manufacturers quote actual mired shift values but a custom has sprung up with some manufacturers to designate their colour correction filters as R1, R2, R3, B1, B2, B3, etc. You will notice that the six filters that Canon supply are given the reference CCA4, CCA8, CCA12, CCB4, CCB8 and CCB12. In their case the A indicates amber and the B indicates blue and the figures do, in fact, give the mired shift value in that they represent decamireds (10 mireds). Thus, the CCA12

provides a 120 mired positive shift, which is the shift required to make average daylight suitable for artificial light film balanced for 3400K.

Unfortunately, the position is still confused because two of the largest suppliers—Kodak and Agfa—use designations that do not follow the decamired values. Agfa get closest with their CTO (or orange) and the CTB series but the figures are slightly different, so that a CTB8, for example, is about a B10, giving a 100 mired negative shift. The Kodak Wratten filters, however, use a code number bearing no relation to mireds or decamireds. Their nearest to a CTB8, for example, is two 82C filters, which is equivalent to about B9.

The differences in these two cases are due to the particular qualities of the films and filters made by the two companies concerned and the combinations that they consider give the best results.

FILTERS AND MIRED SHIFT VALUES

| Mired shift | Kodak Wratten filter | Agfa-Gevaert | Canon |
|---|---|---|---|
| +10 | 81 | CTO 1 | |
| +18 | 81 A | CTO 2 | |
| +27 | 81 B | CTO 3 | |
| +35 | 81 C | CTO 3 | |
| +42 | 81 D | CTO 4 | CCA 4 |
| +53 | 81 EF | CTO 5 | |
| +81 | 85 C | CTO 8 | CCA 8 |
| +112 | 85 | CTO 10 | |
| +131 | 85 B | | CCA 12 |
| −10 | 82 | CTB 1 | |
| −18 | 82 A | CTB 2 | |
| −32 | 82 B | CTB 3 | |
| −45 | 82 C | CTB 4 | CCB 4 |
| −56 | 80 D | CTB 6 | |
| −81 | 80 C | CTB 8 | CCB 8 |
| −112 | 80 B | CTB 10 | |
| −131 | 80 A | CTB 12 | CCB 12 |

## CANON FILTERS FOR BLACK AND WHITE FILM

| Type | Factor | Use and effect |
|---|---|---|
| UV | 1× | Recommended especially for high mountain areas and seaside where ultraviolet rays are strong. |
| Y1 | 1·5× | For landscapes and portraits with low sun; gives correction of tonal values, darkening the blue of the sea and brings out the whiteness of the clouds by darkening the sky. |
| Y3 | 2× | For landscapes and still life. This filter is similar to Y1 but the effects are stronger. |
| G1 | 2× | For portraits against the sky; natural reproduction of foliage; gives correction of tonal values. |
| O1 | 3× | For haze penetration, contrast in marine scenes, distant landscapes, aerial photography and sky-cloud contrast. |
| R1 | 6× | For distant landscapes. Exaggerated sky-cloud contrast with a very dark sky; gives dramatic and interesting effects. |
| ND-4 | 4× | Neutral density filters are used only to control exposure and have no effect on colours. |
| ND-8 | 8× | Especially used with high speed black and white film in bright daylight. |

## CANON FILTERS FOR COLOUR FILM

| Type | Factor | Use and effect |
|---|---|---|
| Skylight | 1× | For distant snow or mountain scenes on an overcast day; for open shade photos under a clear sky to reduce the excessive bluish results. |
| CCA4 (Amber) | 1·5× | Used with daylight type film for shooting under cloudy or rainy weather conditions or in the shade under fair weather conditions. Eliminates bluish tinge. |
| CCA8 (Amber) | 2× | Used with universal type film for shooting under cloudy or rainy weather or in the shade. Used with tungsten type film for shooting in morning or evening light. |
| CCA12 (equiv.) (Amber) | 2× | Used with tungsten type film for shooting under sunlight (under colour temperature of daylight source) to obtain normal colour tones. |
| CCB4 (Blue) | 1·5× | Used with daylight type film for shooting in morning or evening light to eliminate reddish tinge. |
| CCB8 (Blue) | 2× | Used with daylight type film for shooting at night or indoors with clear flashbulbs. |
| CCB12 (equiv.) | 3× | Used with daylight type film for shooting under artificial lighting to obtain normal colour tones. |

## COLOUR TEMPERATURES AND MIRED VALUES

| Source | Colour temperature (K) | Mired value |
|---|---|---|
| Daylight (sun plus sky) | 5500 | 182 |
| Photolamps (photofloods) | 3400 | 294 |
| Tungsten studio lamps | 3200 | 312 |
| Electronic flash | 6000 | 167 |
| Blue flashbulbs | 5500 | 182 |
| Tungsten halogen lamps | 3200 | 312 |
| Household lamps, 100-watt | 2900 | 345 |

## Other Canon filters for colour film

Apart from the CCA and CCB filters for colour film, Canon supply three other types of filter that can be used with colour film. These are the skylight, UV and neutral density filters.

The skylight filter is a very pale amber type for use when there may be an excess of visible blue in the ambient light. Such conditions occur most commonly when shooting in the shade under a very blue sky, so that only the skylight reaches the subject, with no yellowish light from the sun. The skylight filter gives just enough "warmth" to the lighting to compensate for the missing sunlight and to prevent the picture being overlaid by a faint blue cast that may show up on pale colours.

Excess blue in the picture can also be caused by invisible radiations—those beyond the visible blue end of the spectrum usually known as ultra violet. The human eye cannot see ultra-violet radiation, which is why we do not call it "light", but all films are sensitive to part of the ultra-violet band and reproduce it as an addition to the visible blue.

In normal conditions, very little ultra violet radiation of the wavelength to which films are sensitive reaches the earth, because it is scattered by the atmosphere. When the atmosphere is relatively free from scattering particles, however, the ultra-violet gets through. These conditions most commonly apply at high altitudes and near large stretches of water, and in those conditions the UV filter (more correctly a UV-absorbing filter) can be useful. It absorbs the ultra-violet radiation and prevents it from reaching the film.

The UV filter is virtually clear glass and calls for no extra exposure as other filters do. Nor does it affect the colour rendering when no UV is present. These facts have led to the practice of permanently mounting a UV filter on the lens as a protective device. This is not a particularly sensible practice. No matter how good the quality of a filter, it is inferior to that of the camera lens. It *can* take the critical edge off the definition. It *can* upset the colour correction of the lens. And these faults can become pronounced if the filter is constantly handled and cleaned, no matter how carefully.

Naturally, such a filter can provide some protection if

you must shoot in very dusty conditions or in flying spray but even then, it would be advisable to have your camera professionally cleaned immediately afterwards, because dust, sand and spray are deadly enemies of the camera body and mechanism as well as the lens.

The third additional type of Canon filter for use with colour films is the neutral density filter. The term is self explanatory. The filter has density and therefore absorbs light, but it is neutral and does not affect colour rendering. It is for use when the light is too strong and Canon supply two types—the ND4 which reduces the light to one quarter of its intensity and the ND8, which cuts it to one eighth.

If you put a fast film in your camera to shoot indoors and then have to go outside to shoot in brilliant daylight, you should, in fact, change the film for a slower one. If, for some reason, that is not practicable, you can use an ND filter to bring the light down to a more suitable strength. With a 400 ASA film, for example, you may find that, for correct exposure, you have to stop down to at least $f8$ and perhaps, with the 1/500 second top speed of the TLb, to $f11$ or $f16$. If you happen to want a shot that calls for a slow shutter speed or a large aperture, you are in trouble. The ND4 filter, however, would allow you to open up two stops. The ND8 filter would allow you to open up three stops. And if you want more drastic treatment you can use both together, reduce the strength of the light to 1/32nd and open up five stops—to $f2.8$ instead of $f16$, for example.

Very dense ND filters, or combinations of filters, are occasionally used to prolong exposures to minutes or even hours so that objects passing through a scene fail to register on the film, giving the impression of deserted streets, buildings, etc. Such a device is necessary when there are frequent incursions by such moving objects and it would be impracticable to cover the lens on every occasion.

Both UV and ND filters can also be used on black-and-white film. The uses for the ND filter are the same as for colour film. The UV filter is used to prevent the UV radiation from making the sky appear too light and to subdue the excess haze over distant parts of the scene, particularly in mountain shots. It does not cut out all the haze, because some of it is caused by the scattering of

visible blue light but it prevents the haze from appearing as a heavy mist.

## Polarising filters

A further type of filter suitable for use with both black-and-white and colour film is the polarising filter or screen. This, again, is a filter of neutral colour that has no effect on the normal colours in the scene. It is constructed, however, in a manner different from that of other filters in that it is made from a special crystalline material that has the effect of passing light as if through slots so that it travels in apparently flat slices instead of as a solid beam with rays radiating in all directions at right angles to the direction of travel. Only those rays vibrating in the planes of the slots can pass through the polarising filter. Such rays are then said to be polarised.

Light can also be polarised as a natural phenomenon by certain highly reflective surfaces such as water, glass, polished surfaces, etc., and by minute dust particles and moisture droplets in the atmosphere. Thus reflections from such surfaces are at least partly polarised. The degree of polarisation varies with the type of surface and the angle at which the light strikes it. Light rays striking glass at an angle of about $57°$ from the normal (perpendicular) are almost completely polarised. With water the angle is about $53°$.

Reflections from such surfaces are troublesome for photographers. On shop windows, for instance, they can obscure the objects behind the window by glare or reflection of buildings, vehicles, etc. Paintings behind glass can be difficult to photograph because of reflections from windows, lamps, etc.

The polarising filter offers a solution, because if it is placed over the lens in such a way that its "slots" are at rightangles to the plane of polarisation of the reflections, the reflected light cannot pass through to reach the film. Only those elements of the random light reflected by the actual subject that radiate in the direction of the filter "slots" can get through to form an image. The unwanted reflections or glare are therefore prevented from interfering with the clear reproduction of the subject.

The value of the polarising filter in these circumstances should not be overrated. Almost complete polarisation

occurs only when the viewpoint is fairly acute to the reflecting surface—about 33° (57° from the normal, or the lens axis for a head-on view). Only at that angle, therefore, can reflections be almost totally eliminated. At other angles polarisation is only partial and reflections can be only partially eliminated. When the camera is square to the surface, as in copying, reflections are hardly polarised at all and cannot be eliminated.

Similar limitations apply to the often-cited application of the polarising filter to deepening the sky tone or colour. Light from a clear sky is also partly polarised and elimination of the polarised light darkens the sky tone in black-and-white pictures and deepens the blue in colour reproductions. Again, however, the polarising effect is strongest when the sun is shining at right angles to the axis of the camera lens. When the sun is behind you, very little of the skylight is polarised.

## Using filters with black-and-white film

Most 35 mm. black-and-white films are now panchromatic, i.e. they react to coloured light in much the same way as the human eye as far as intensity is concerned. Thus, the black-and-white film reproduces colours as grey tones varying with the brightness of the coloured original. For most photography, this is perfectly satisfactory. Colours put together by nature and/or man tend to differ sufficiently in brightness to separate them even when translated into greys.

Occasions do arise, however, when the film reproduces the relative brightness reasonably accurately but the result is not quite what the photographer wants. Black-and-white films still remain a little over-sensitive to blue, for example, so that clouds do not show up too well against a pale blue sky, particularly if the exposure is on the heavy side. Or there may be times, especially in copying or photomicrography when adjoining colours are so similar in brightness that the required detail does not show up with sufficient contrast. Yet again, the photographer may wish to falsify tonal values for a special reason—as when he is photographing a stained original and wishes to eliminate or emphasise the stain. These are the occasions when coloured filters are useful.

Generally speaking, the coloured filter passes freely all

## FILTERS

Panchromatic film "sees" colours in much the same way as the human eye. This relationship can be considerably altered, however, by placing filters over the camera lens. The chart gives an approximation of the darkening or lightening effect on various colours of the most commonly used filters.

light of its own colour characteristics and absorbs light of the complementary colours. If we regard white light as a mixture of equal proportions of red, green and blue (the general principle of colour photography, in fact), the principle is relatively simple. A red filter passes red and absorbs green and blue and all mixtures of those colours. A green filter passes green and absorbs red and blue, and so on. In practice, of course, this would apply only if the filters were of pure colour and the colours reflected by the subject were pure—and if the filters had a sharp cut-off at the border between the component colours. Practical filters as used in general photography, however, pass a certain amount of light of other colours, too.

Thus, although in theory we can filter a subject containing reds and greens of equal brightness in order to reproduce them as different intensities of grey, the effect on the subject may not be exactly as expected, as it depends on the actual quality of the reds and greens involved and on the properties of the filter used. Similarly, other colours in a scene are affected by the filter and, again, the effect cannot be accurately predicted.

The Canon filters for black-and-white photography are available in two strengths of yellow and one each of orange, red and green. The yellow is perhaps the most popular filter because of its widespread use to darken the blue of the sky to enable white clouds to stand out strongly. It should be used, however, only when it is reasonably certain that it will not radically alter other tonal values. A yellow filter darkens blue because yellow is a mixture of red and green. Depending on the strength of the red content, blue is darkened to a greater or lesser degree, but reds and yellow are made somewhat lighter and greens can be affected either way. Some of those effects may not be acceptable. The effect of a yellow filter is, in fact, often a flattening of contrast in the whole scene.

The orange filter has a similar effect to that of the yellow filter but, as it has a greater red content it has a stronger darkening effect on blue and will also darken most greens. It makes most reds and yellows very light. The effect with red brick buildings, against a blue sky is to increase contrast dramatically but, again, if the scene is composed largely of greens and blues, the effect can be to reduce contrast.

The red filter gives the most dramatic effects, reducing the blue sky to almost nil intensity on the negative and enabling it to print virtually black. Nearly all greens are also considerably darkened.

The effect that both red and orange filters have on blue light is particularly helpful when you wish to penetrate the haze in distant scenes. This haze is caused by the light scattering action of tiny solid particles, water droplets, etc., in the atmosphere. The strongest scattering is suffered by the components of white light that are nearest in wavelength to the physical size of the light scattering elements, i.e. the short-wave blue components. By strongly absorbing blue light, the orange and red filters eliminate a great deal of the haze effect. That is not always an advantage, of course. Most landscape shots depend on the separation of planes provided by the gradually increasing haze. If the haze is eliminated, the sense of distance from foreground to background is lost.

On the other hand, when you shoot a distant subject through a long-focus lens, both contrast and definition may suffer because of light scatter. Then a moderately deeply coloured filter can help.

The green filter has its strongest effect on red and is therefore useful for some portraits on fast film, which tends to be a little over sensitive to red. It can prevent lips from looking too pale. It can also make a moderately ruddy complexion look healthily sunburned and, less fortunately, make a nose with a tendency to red look as if the wearer were over fond of the bottle. It may darken freckles and emphasise red veining or any skin blemishes with a red content. Its effect on greens is generally to lighten them but the extent of the effect is not easily predictable. Blues are darkened somewhat but not to quite the same extent as with a yellow filter, which has, of course, a greater red content. A popular filter for outdoor portraits is, in fact, a green filter with a little red content, i.e. a yellow-green.

## Exposure and filter factors

All filters with the exception of the clear glass UV filter absorb a certain amount of visible light and therefore reduce the amount of light reaching the film. Thus, the exposure required for a given density of image tone is

greater when the filter is used than when it is not. It is customary to indicate the extra exposure required by allotting to each filter an exposure factor, such as 1.4 ×, 2 ×, 2.5 ×, 3 ×, etc. The factor indicates the figure by which the normally-metered exposure should be multiplied. A factor of 2 ×, for example, indicates that when the filter is used the normal exposure has to be doubled—by opening up the lens one stop or by lengthening the shutter speed from say, 1/60 to 1/30 second.

Filter factors are adequate for most photography but they are necessarily approximate. Assuming, for example, that a red filter passes all the red light from a given source, and absorbs all light of other colours, it can be readily seen that it transmits a greater proportion of the total light from a tungsten source than it does from daylight—because the tungsten source contains proportionately more red light. A red filter with a 4 × factor for daylight may, in fact, have a factor of only 1.5 × in tungsten lighting.

The through-the-lens meters of the later Canon cameras take account of this fact but the separate clip-on meters can only do so if the filter is placed over the meter window while the reading is taken.

There remain the facts, however, that spectral sensitivity varies from film to film and from meter to meter and that, with the deeper coloured filters in particular, there may be an appreciable difference between the sensitivity of the meter and the film. Again, the most reliable course is to follow the recommendations of the film manufacturer. Failing that, it might be advisable to make test exposures through each filter in your collection and check them against unfiltered exposures of the same subject under the same conditions. The true filter factor for the film in use is indicated by the relationship between the filtered and unfiltered exposures that produce more or less the same density in the areas not unduly subject to the influence of the particular filter.

Exposures with the paler coloured filters are quite critical because over-exposure can so easily nullify the effect of the filter.

It is rarely advisable to use two filters simultaneously over the camera lens because of the degradation of image quality that may arise. If you do use two filters at once,

334

however, the factors are multiplied to find the combined factor. For a $2 \times$ and a $1.5 \times$ filter, for example, the combined factor is $3 \times$. In practice, it is liable to be rather greater, owing to additional light losses by reflection. The normal filter factor allows for reflection effects but it cannot take account of internal reflections between two filters.

## Soft focus effects

Canon's Softomat lenses are not strictly filters but they are produced in a similar form for attachment to lenses with 48, 55 and 58 mm. screw-in filter threads.

They are soft-focus attachments, designed to take the edge off the extremely abrupt delineation between tones of which modern lenses are capable. This was at one time thought necessary for portraits of women and young children—to romanticise them, cover up blemishes and reduce the need for subsequent retouching. This application is now comparatively rare and the use of the soft-focus attachment is confined to the production of special effects.

The Softomats are available in two "strengths"—Nos. 1 and 2. The No. 2 version gives a stronger softening effect than the No. 1.

The principle of the soft-focus lens is that its finely-etched surface causes additional refraction of some of the rays emanating from the subject, so that they fail to come to a focus in the film plane and form discs instead of points of light on the film, surrounding the sharper points produced by the unaffected rays. The effect is to spread the greater image densities on the film into the areas of lesser or no density. In the positive image, therefore, the lighter tones tend to spread into the shadows and give an attractive luminous quality to the print.

Softomats or similar devices can also be used on enlargers or projectors but the result is usually far less attractive because it is the greater image densities of the positive image that are then spread into the lower density areas. In other words, the shadows encroach on the highlights and the effect tends toward gloominess.

# CANON AT CLOSE RANGE

Many of the lenses for the Canon reflex cameras can be focused on objects quite close to them without any additional equipment. Wide angle lenses can frequently focus down to about 12 inches (30 cm.) and even the standard 50 cm. lenses focus to 2 feet (60 cm.) or less.

## Supplementary lenses

The easiest way to enable a camera lens to focus closer than its normal focusing movement allows is to attach a supplementary close-up lens to the front of it. The close-up lens is generally a relatively simple lens of comparatively long focal length such as the Canon 1800, 450 and 240 close-up lenses which have focal lengths of 180, 45 and 24 cm. respectively.

The principle of such a lens is that when placed at a distance from the subject equal to its focal length, the rays emitted from the rear of the lens are parallel. As this is virtually the condition of rays emanating from a subject at a very great distance, the camera lens focused at infinity accepts the parallel rays as coming from an infinitely distant object and brings them to a focus in the film plane. If the object is rather closer than the focal length of the supplementary lens, the camera lens accepts the rays as coming from a semi-distant image and the focusing movement of the camera lens can thus be used to provide a limited range of focused distances for each supplementary lens.

Exposure is not affected by a close-up lens, which gives rise to no change in the separation between camera lens and film plane. This can often be an advantage because close-up work generally requires a small aperture to ensure adequate depth of field.

Naturally, the reflex viewfinder shows the effect obtainable with any lens attachment and supplementary lenses are thus very simple to use. The Canon designations

indicate the focal length (in millimetres) of the supplementary lens, which is the distance it focuses at (measured from the front of the supplementary lens) with the camera lens set to infinity. In general, however, these lenses are described by their "power" in dioptres, as in the case of spectacle lenses. The focal length is obtained by dividing the dioptre number into 1 m. Thus, a 3-dioptre lens has a focal length of 33.3 cm., while the 450 Canon lens (45 cm.) has a dioptre strength of about 2.2.

The 450 lens serves little purpose on the FD 50 mm. $f$1.4 lens which can focus unaided at 45 cm. (from film plane to object). It can however, increase the range of lenses focusing only to 2 feet (60 cm.) so that they can focus down to about $13\frac{1}{2}$ inches (34 cm.). The field size at that distance is about 165 × 110 mm. ($6\frac{1}{2}$ × $4\frac{1}{4}$ inches).

## Extension tubes

Although good quality supplementary lenses can provide excellent images at moderate magnifications, real close-up work would require powerful supplementary lenses that would need to be very expensive to give the quality expected of Canon equipment.

There is, however, a simple method of providing close-focusing facilities for the camera lenses. To enable any lens to focus on closer objects, the distance between the lens and the film plane is increased. This is how the ordinary focusing mechanism works but there are practical limits to the amount of focusing travel that can be built into a lens. So, when extra close focusing is required, the lens-film plane separation is increased by interposing a unit or units—extension tubes or bellows—between the camera body and the lens.

The term "extension tube" is self explanatory. It is simply a tube that is placed between camera and lens to provide a fixed amount of extra lens-film plane separation. The Canon extension tubes include three M-type, without automatic diaphragm connection, in lengths of 5, 10 and 20 mm. and two FL-type, with automatic diaphragm connection, in 15 and 25 mm. lengths. The M set of tubes consists of one each of the 5 and 10 mm. sizes and two 20 mm. The FL tubes are supplied separately. They can be used in conjunction with the auto-

matic diaphragm mechanisms of all the Canon reflexes (except EX EE) back to the model FP. The Canonflex models used a different mechanism. The tubes can also be used to couple with other equipment with automatic diaphragm mechanisms, such as the Bellows FL and Auto Bellows or the Life Size Adaptor supplied with the Macro Lens FL 50 mm. Canon recommend, however, that if more than three such items are connected to an FL extension tube, the diaphragm should be operated manually to avoid overstraining the mechanism.

The tubes are fitted to the camera in exactly the same way as all the interchangeable lenses. They have the same bayonet tightening ring arrangement. At the other end, they have the same bayonet and locking recess as the camera body so that lenses are attached just as if they were being put on the camera body.

Even greater extension can be obtained by using the Canon macrophoto extension tubes available in lengths of 25, 50, 75, 100, 150 and 200 mm. These tubes have a screw thread and are attached to the reflex cameras via adaptor rings or Lens Mount Converters. There are two types of Converter: Type A with bayonet attachment to fit the camera body and screw to accept extension tubes or screw-mount lenses, and Type B with screw to fit extension tubes and bayonet to accept bayonet-mount lenses. A typical arrangement for macrophotography would therefore be camera body plus Converter A, screw-mount tube, Converter B and bayonet-mount lens. In most cases, however, it is advisable to reverse the lens by interposing between the lens and Converter B a macrophoto coupler.

There is, theoretically at least, no limit to the number of tubes that can be used together on the Canon cameras to provide extension for photography with greatly magnified images. Physical limitations, however, such as clumsiness in operation, difficulties in focusing and composition owing to extremely low illumination of the image plane, and lighting problems when the subject is within millimetres of the lens surface, make extensions much above 3-400 mm. impracticable. With extra extension of 400 mm. and a 50 mm. lens, the reproduction ratio is 8:1 and it would normally be preferable to use a microscope for that type of work.

## CLOSE-UP PHOTOGRAPHY

Canon equipment for close-up photography includes:
1. Extension tube M20.
2. Extension tube M10.
3. Extension tube M5.
4. Bellows M.
5. Bellows FL.
6. Macrophoto Coupler FL.
7. Lens (reversed).
8. Macro lens.
9. Lens.
10. Close-up lens 240.
11. Close-up lens 450.
12. Attachment ring.
13. Slide Duplicator FL.

The low illumination of the image plane, caused by the lengthening of the light path when extension tubes are used, gives rise to exposure problems, while the very close shooting distance reduces depth of field considerably. These and similar features of close range photography apply also to the use of extension bellows and are therefore considered later, after the details on the Canon bellows units.

## Canon extension bellows

A slight drawback to the use of extension tubes is that they are of a fixed length and alterations to the length of the extension have to be made by adding extra tubes or detaching those already fitted. A more versatile arrangement is the extension bellows which allows continuous alteration of the extension between the limits imposed by its construction. There have been four such units for the Canon Reflexes—Bellows R and Bellows FL (both discontinued) and the current Bellows M and Auto Bellows.

The *Bellows FL*, for all models from the FP onward is a precision-made mechanism with three movement adjustments—of the lens, of the camera body and of the whole unit by means of the integral focusing slide. It couples with the automatic diaphragm mechanisms of lens and camera body, but the diaphragm does not reopen automatically. There is also a Slide Duplicator that attaches to the front of the bellows unit. A detachable scale attaches to the top of the bellows to indicate length of extension and image scale with a 50 mm. lens used both normally and in reverse on the Macrophoto Coupler FL. The bellows extension is from 35 to 145 mm.

The *Canon Auto Bellows* is an improved version of the Bellows FL. It has all the movement of the earlier unit plus fully automatic iris operation by double cable release. It has its own slide duplicator and other versions for 16 mm. and 8 mm. frames. Scales on the runner replace the detachable scale of the Bellows FL. The front panel is detachable and can be reversed. The bellows extension is from 39 to 175 mm.

The *Bellows R* is a sturdily made, relatively simple unit but it has unique features. It is designed not only for close-up photography but also as the focusing unit of the longer

focal length lenses before the FD series. For this reason the rear attachment ring rotates so that the camera can assume either upright or horizontal positions and the lens mounting ring is removable to allow Canon screw lens heads to be fitted to a Lens Head Adaptor and then screwed into the bellows unit. The bellows extension is from 35 to 160 mm. There is no automatic diaphragm facility.

The *Bellows M* is a simple, lightweight construction, much smaller than the other two units although still with an extension range from 35 to 142 mm.

## Attaching and using the Bellows FL

Attaching the Bellows FL to the camera body is basically the same operation as attaching a lens, but the securing ring has a protruding lever for easier handling. To attach the bellows, turn the lever upward and bring the red dot on the securing ring to the top. Align the dot with that on the camera body or with the slot in the lens mount, push the bellows unit on to the bayonet mount and turn the lever downward to secure the bellows in position.

Before attaching the lens to the front of the bellows, push downward on the diaphragm charge lever on the right of the bellows at the front. If you do not do this, the lens will not close down to the pre-set aperture when you press the shutter release. Attach the lens as if to the camera body by lining up the dots or the key slot and turning the securing ring. Attach the scale to the top of the bellows by inserting the pin at the back of the bellows into the hole in the scale and dropping the other end between the prongs at the front. The line on the top of the front standard forms the index mark. The bellows is now ready for use and can be attached to a tripod by means of the appropriate tripod bush in the sliding base.

The bellows extension governs the reproduction ratio or magnification. To calculate the approximate extension, multiply the focal length of the lens by the magnification required, i.e. for a 1.5 magnification with a 50 mm. lens, you need 75 mm. bellows extension with the camera lens set to infinity. You can therefore set up that extension with the bellows more or less centred on the runner and the runner centred on the focusing slide. Then move the whole unit or the subject until the image on the screen is

at its sharpest. Final adjustments can be made with the right-hand knob on the focusing slide.

The control knobs on the Bellows FL allow a variety of movements. You can increase or decrease film plane to subject distance by turning the left-hand knob at the back of the bellows (as you face the subject). The corresponding right-hand knob locks or releases this movement. With this movement, you simultaneously increase the bellows extension but leave the lens to subject distance unaltered.

Close-up photography is frequently carried out on a basis of obtaining as large an image as possible. You set up the camera close to the subject with maximum bellows extension, if that seems feasible, and slowly move either camera or subject back until rough focus is achieved. With a 50 mm. lens on the Bellows FL, this will give you about a 3 × life-size image. If this is obviously impossible or it becomes apparent from the screen image that you are not including a sufficient area of the subject, you can reduce the bellows extension and the film plane to subject distance (and thus the degree of magnification) simultaneously by turning the left-hand knob at the rear of the bellows. Final focusing can then be achieved by minute adjustment of the shooting distance with the right-hand knob on the focusing slide. Be sure, however, to release the locking knobs before making these adjustments and to return them to the locked position afterwards.

If you wish to increase or decrease the film plane to subject distance without altering the bellows extension (as when focusing the image at a fixed reproduction ratio) you turn the right-hand knob in the block below the runner. This moves the whole set-up of camera, bellows and lens back and forth to bring the image into focus. The corresponding left-hand knob is the lock for this movement.

If you intend to shoot at very close range, move the focusing slide well forward on the runner or you will find that the runner prevents the camera from approaching the subject closely.

It is frequently convenient when the camera is shooting downward to use the strut built in to the runner as an additional camera support. This is especially useful when the camera is attached to a copying stand. To adjust the strut, loosen the screw fixing below the front of the runner

## BELLOWS FL

The main features of the Canon Bellows FL are:

1. Bellows extension control.
2. Focusing slide control.
3. Bellows extension lock.
4. Lens mount.
5. Scale plate holder.
6. Index mark.
7. Scale plate pin.
8. Body attachment lever.
9. Bellows extension control.
10. Tripod bushes.
11. Groove for copying stand attachment.
12. Bellows extension lock.
13. Diaphragm charge lever.
14. Focusing slide lock.
15. Strut lock.
16. Supporting strut.
17. Diaphragm release rod.
18. Copying stand base-board.

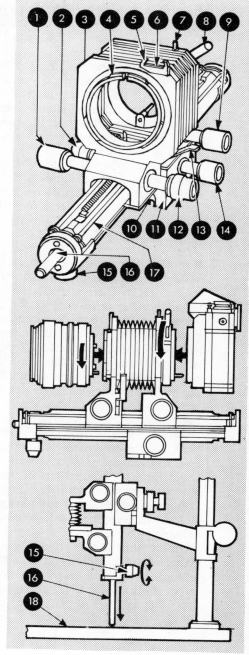

To attach the camera to the Bellows FL, turn the body attachment lever of the bellows upward. Align the red dots of camera and bellows bayonet and push the camera on to the bellows so that the bellows key enters the camera groove. Push the body attachment lever down to lock camera to bellows.

To attach a lens to the bellows, push down the diaphragm charge lever and then attach the lens as if to the camera body.

When using the Bellows FL with a copying stand, the supporting strut provides additional stability. Unscrew the strut lock and allow the strut to fall to the baseboard. Tighten the lock with the strut in close contact with the baseboard.

and allow the strut to slide out. When it rests on the shooting surface tighten the fixing screw and the strut will help to hold the whole apparatus firmly in position. Adjustments to the bellows can still be made with the strut extended.

Any lens can be used on the bellows unit, including those of shorter and longer focal length. The shorter the focal length the greater the magnification possible with the given maximum bellows extension. Conversely, of course, no very great magnification can be obtained with a lens of too great focal length unless extension tubes are added to the bellows.

Most commonly the standard 50 mm. lens is used, but better results are obtained if it is reversed when the reproduction ratio approaches 1:1. This is because the lens is designed to converge the light rays more sharply at the back than at the front.

## Uses of the Macrophoto Coupler

Reversing the lens on the camera or on extension tubes or bellows is accomplished with the FL Macrophoto Coupler, of which there are three models to fit lenses with filter diameter threads of 48, 55 and 58 mm. They have screw threads of those diameters at one end and the usual bayonet and tightening ring at the other.

The FL Macrophoto Coupler is, however, more than just a coupling ring. It has a helicoid focusing movement that can add 13 mm. to its normal 26 mm. length. Depending on how far the lens is recessed in its barrel, it therefore adds considerably to the length of extension tubes or bellows with which it is used.

When a lens is used reversed on the FL Macrophoto Coupler, the automatic diaphragm mechanism is put out of operation and you must therefore remember to close the diaphragm manually after carrying out the necessary exposure calculations. This is no hardship because it is comparatively rare for straight exposure meter readings of such subjects (even through the lens) to be completely reliable.

Apart from its uses on bellows and extension tubes, the Macrophoto Coupler can also be used directly on the camera, where it serves the function of a variable extension tube. This makes the FL Macrophoto Coupler a par-

# SLIDE DUPLICATOR

Features of the Canon Slide Duplicator FL are:
1. Holder for film strip.
2. Diffusing glass.
3. Guide pin.
4. Slot for mounted slides.
5. Lens tightening screw.
6. Bellows clip.
7. Lens attachment.
8. Film holder release pin.
9. Fixing screw.
10. Locating pin.
11. Bellows rack guide.
12. Lens attachment ring.

To attach the Slide Duplicator.

A. Screw the appropriate lens attachment into the front of the lens.

B. Attach the Slide Duplicator to the Bellows FL by sliding the bellows rack guide over the rack and aligning the fixing screw and locating pins on the duplicator and bellows front. Release strut lock and tighten duplicator fixing screw.

C. Loosen the lens tightening screw, unfasten the bellows clip and draw the bellows forward until the lens attachment enters the ring on the duplicator. Tighten the screw.

To use the Slide Duplicator with mounted slides, simply insert the slide in the slot with emulsion side toward the diffusing glass. Focus and shoot in the normal manner. With unmounted film, pull the diffusing glass holder outward with the film holder release pin. Attach film, emulsion side out, to the four guide pins and close the holder.

Illumination for slides or negatives can be tungsten lamps for black-and-white work but daylight or electronic flash must be used for daylight colour film.

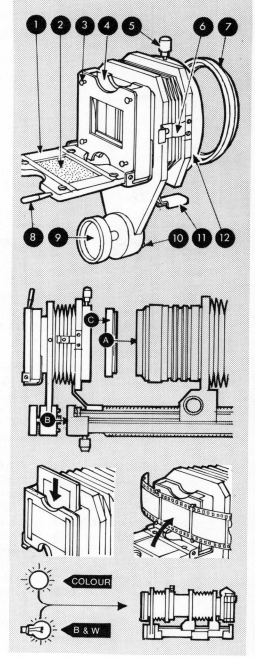

ticularly useful unit to use in the field (literally) for wild flowers and insect photography from a table tripod or other such easily portable support.

photo Coupler a particularly useful unit to use in the field (literally) for wild flowers and insect photography from a table tripod or other such easily portable support.

## Slide duplicator for Bellows FL

The runner of the Bellows FL has a threaded recess from which the supporting strut emerges. If the strut is pushed inward, the Canon Slide Duplicator can be attached to the bellows by screwing the large knob below the frosted glass of the duplicator. The footpiece at the front of the duplicator slides over the track of the Bellows FL when the bellows of the duplicator is extended.

With Slide Duplicator, camera body and standard lens attached to the bellows, the procedure is as follows:

(1) Loosen the screw at the top of the lens attachment ring at the front of the Slide Duplicator.

(2) Unfasten the clips at the side of the duplicator bellows and draw the bellows forward so that the foot slides over the Bellows FL rack and the lens attachment ring fits over the front of the camera lens, bringing the camera and bellows forward on the runner, if necessary. Alternative attachment rings are available for various lenses.

(3) Tighten the screw on the lens attachment ring so that it clamps firmly on the front edge of the lens or the supplementary attachment ring, as the case may be. You can now view the slide through the eyepiece and adjust the shooting distance and bellows extension in the normal way to obtain the required image size.

The slide to be copied is simply pushed into the slot behind the bellows, if it is mounted; if it is unmounted, push back on the pin above the frosted glass to hinge open the film holder, place the film over the opening to engage the four guide pins and close the film holder. In both cases, the slide is inserted correctly oriented for viewing in the hand, with the emulsion toward the frosted glass.

When you wish to reproduce only part of a mounted slide, a certain amount of latitude in positioning is possible by pushing downward or upward on the slide or by

gripping top and bottom edge between finger and thumb at the recesses provided and moving the slide a millimetre or two sideways.

Illumination should be provided preferably by photoflood if you use Type A colour film or by daylight or electronic flash if you make your duplicates on daylight colour film. Any source can be used for making black and white negatives from colour slides or positives from black and white negatives. You can also use various correction or effect filters when using colour film to correct minor imbalances in the original slide or to introduce effects for special purposes. Exposure calculations are carried out by the normal methods for close-up photography.

The reproduction ratios with the Bellows FL and the Slide Duplicator range from about 1:1 with the FL Bellows set to a 50 mm. extension to 1.74:1 with 90 mm. extension. For the best quality results at about 1:1 to 1.74:1 the Macro FL 50 mm. lens should be used but if you wish to enlarge sections of slides beyond that magnification, you can use the Macrophoto Coupler to reverse the standard lenses. The lens attachment ring of the Slide Duplicator fits comfortably over the rear of the lens. When using this method, remember once again, that the reversed lens does not couple with the automatic diaphragm mechanism in the camera and therefore has to be stopped down manually.

## Attaching and using the Auto Bellows

The Auto Bellows is similar in specification and use to the Bellows FL, which it replaces. After attaching the bellows to the camera, however, you do not have to operate a charge lever for the auto iris mechanism. The front panel is fitted with a socket to take one part of a double cable release supplied with the unit. This operates the lens diaphragm before the other part, screwed into the camera socket, releases the shutter.

Scales on the runner show the bellows extension in millimetres and the scales of reproduction for a 50 mm. lens set to infinity both normally and reverse mounted.

Reverse mounting is accomplished by first mounting the lens normally, then loosening the front panel fastening

screw, unscrewing and removing the stopper from the front of the rail and sliding the panel forward and off the rail. Turn the panel round and reverse the procedure to refasten it. The lens front is then toward the bellows, to which it is fastened by an attachment ring. Rings are available with 48, 55 and 58 mm. threads, so only lenses with those sizes of filter thread (or which can be adapted to one of these threads) can be reverse mounted.

As with the Bellows FL, the camera body can be rotated on the rear panel to provide horizontal or vertical shots. Click stops are positioned at 90° intervals for anti-clockwise rotation (viewed from the rear). This operation is also possible with the Motor Drive MA fitted to an A series camera, provided the rear panel is in its rearmost position on the track.

## Canon Duplicator 35

Slide copying with the Auto Bellows is carried out with the Duplicator 35, designed for use with the FD50 mm. $f3.5$ macro lens. With the lens normally mounted, this combination gives magnifications of 1 to 1.4X. With the lens reversed, magnifications of 1.4 to 3X are possible, thus allowing size 110 frames to be enlarged to 35 mm. size (2.1X magnification). When copying part of a frame, adjustments up to 8 mm. in height and 12 mm. in width can be made.

The Duplicator is attached to the Auto Bellows rail by removing the stopper, fitting the Duplicator in place with the aid of guide pins, and replacing the stopper. The front of the macro lens is then fitted to the mounting ring of the Duplicator and secured by screws. The lens can also be reverse mounted in the normal way. The Canon Double Cable Release allows automatic diaphragm operation in either mode.

The Duplicator can be attached only to the Auto Bellows and is recommended for use only with the FD50 mm. $f3.5$ macro lens. Even then, focusing should be carried out in the centre of the field and the lens well stopped down. Few mounted slides are completely flat.

The opal diffuser of the film holder stage helps to spread the light evenly but it is not recommended for use with illumination of low colour temperature, as when copying on to Type B film stock.

## AUTO BELLOWS AND ACCESSORIES

The main features of the Canon Auto Bellows are:
1. Stopper.
2. DCR socket.
3. Bellows release.
4. Lens mount.
5. Auto iris lever.
6. Front plate.
7. Rear plate.
8. Bellows.
9. Camera mount lever.
10. Camera mount.
11. Extension and magnification scales.
12. Locking knob.

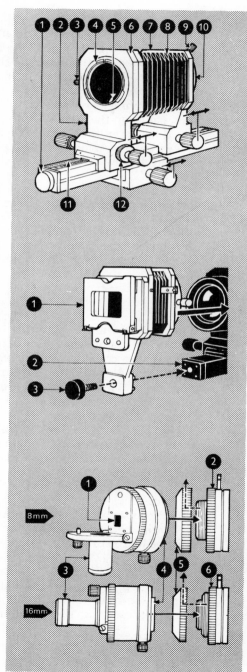

The Duplicator 35 is attached to the Auto Bellows by means of the stopper screw:
1. 35 mm frame.
2. Locating holes.
3. Stopper/fastening screw.

Duplicators 8 and 16 are basically similar:
1. Aperture.
2. 20 mm Macrophoto lens.
3. Illumination tube.
4. Connecting hood.
5. Removable front of Macrophoto lens.
6. 35 mm Macrophoto lens.

## Double Cable Release

The Double Cable Release is, in effect, two cable releases operated by a single plunger. One serves to stop down the lens and operates fractionally before the other releases the shutter. The difference in pressure required for the two operations is noticeable.

The diaphragm release screws into the Auto Bellows front panel or the Macro Auto Ring and is identified by red bands on the thread. It has an adjustable release stroke from 9 mm. for the Macro Auto Ring to 15 mm. for the Auto Bellows. The shutter release cable has a stroke of 11 mm.

The plunger has a ring lock. When the ring is screwed down the plunger operates normally. When it is unscrewed, the plunger locks when pressed and stays locked until the ring is pressed down. It is advisable to lock the plunger for any long exposure because the diaphragm reopens when pressure on the plunger is released. If you do not lock it, you must hold the plunger depressed throughout the exposure.

## Macro Auto Ring

When a lens with an automatic diaphragm mechanism (FD or FL) is attached to a bellows or extension tube without auto coupling or is mounted in reverse (except on the Auto Bellows), the auto-iris mechanism becomes inoperative. The Macro Auto Ring is designed to restore automatic working when used in conjunction with the Double Cable Release.

The ring is attached to the back of the lens and contains a cable release socket on the right (viewed from the front) which couples with the auto-iris operating lever in the back of the lens.

Some earlier lenses, such as the FL19 mm. *f*3.5, 35 mm. *f*2.5, 58 mm. *f*1.2 and 50 mm. *f*1.8 Type 1, cannot be used with the Macro Auto Ring.

As with the Auto Bellows, the cable release plunger must be locked or held down throughout the exposure.

## Macrophoto lenses

Canon supply two lenses specifically for macrophotography—20 mm. *f*3.5 and 35 mm. *f*2.8. These lenses must not be confused with the compromise "macro" lenses that

The true Macrophoto lenses *(top)* have no focusing mechanism and must be used on bellows units. The rear mounting is as used on microscope objectives and an adapter is required to fit the lenses to the normal Canon lens mount.

The 20 mm lens gives magnifications of 4–10× with the Auto Bellows and the 35 mm lens gives 2–5×.

Canon also produce the compromise macro lens type designed for direct attachment to the camera and to work both for normal photography and at extremely close range.

A 50 mm version focuses down to 9 in to give half-life-size reproduction and is supplied with an extension tube to give life-size images.

A 100 mm version gives half-life-size images at 18 in and also has a life-size adapter.

also serve for general photography. The Macrophoto lenses have no focusing mechanism and must be used on a bellows unit. They are designed for photography at life size and larger. With the Auto Bellows, magnifications of 4X to 10X are possible with the 20 mm. lens and 2X to 5X with the 35 mm. The Bellows M can also be used and allows only slightly less magnification.

The lens barrels are very small and are tapered at the front to make lighting the subject a little easier. The rear mounting is the same as that of microscope objectives and a Macrophoto Lens Adapter must be used to attach the lenses to the normal Canon mount.

The adapter gives only 2.6 mm. extra extension and has the normal Canon lens mount at the rear with screw mounting for microscope lenses or the special Canon Macrophoto lenses at the front.

## Movie frame duplication

The copying and enlargement of 16 mm. or 8 mm. frames to 35 mm. can be carried out with the Canon Macrophoto lenses and Canon Duplicator 16 or Duplicator 8, in conjunction with the Auto Bellows or Bellows M. aperture opening and closing as you move the aperture

The two Duplicators are similar in construction and are used with the 20 and 35 mm. macrophoto lenses mounted on a bellows unit.

Each consists of a tube containing two convex lenses, a fixed diaphragm, a glass diffuser plate and built-in Koehler-type illumination. A film gate and holder is attached to the rear of the tube and a detachable hood at the front allows connection to the appropriate Macrophoto lens.

To attach the Duplicator, unscrew the front ring of the Macrophoto lens and screw on the connecting hood. Fit the Duplicator to the hood and secure with the fixing screw.

The Duplicator 16 is used with the 35 mm. Macrophoto lens and photographs an area 7.21 by 9.65 mm. Magnification is adjustable up to 3.7X.

The Duplicator 8 is used with the 20 mm. lens and photographs an area 4.01 by 5.46 mm. Magnification is adjustable up to 6.6X.

## Attaching and using the Bellows R

Like the Bellows FL, the Bellows R has a lever on the camera attachment ring, but in this case the lever is turned downward to bring the red dot to the top. The bellows is then fitted to the camera by lining up the red dots or the pin and groove. The lever is then turned upward to secure the bellows to the camera body. Once attached to the bellows the camera body may be rotated to the left (viewed from the back) to bring it to the vertical format shooting position.

The lens is attached to the bellows in the normal manner by lining up the pin at the back of the lens (or the red dot) with the groove in the lens attachment ring on the front of the bellows, pushing the lens in and turning the securing ring of the lens clockwise (viewed from the front).

Extension of the bellows is controlled by turning the knobs on either side. The right-hand knob has a locking ring.

The Bellows R has a minimum extension of 35 mm. but the scale, on the left hand side of the base, indicates −2 mm. at the minimum extension. The bellows can be attached to any of the Canon reflex cameras but has no automatic diaphragm mechanism to connect with the automatic lenses. The aperture is always manually controlled.

A feature of the Bellows R is its removable lens attachment ring (Bellows Adaptor R). Beneath it is a thread that matches the screw fitting of the now discontinued Lens Head Adaptor for use with the separable heads of the following older Canon lenses:

  85 mm. *f*1.9 (up to No. 70932)
  100 mm. *f*2 and *f*3.5 III (up to No. 78311 and after No. 80001)
  135 mm. *f*3.5 I (up to No. 65300)
  135 mm. *f*3.5 III (after No. 80001)

These lenses can be separated by unscrewing the helicoid section, which is replaced by the Bellows R, allowing photography from infinity to 1:1.

There is also a Lens Mount Converter A which attaches to the Adaptor R while still on the Bellows to allow various Canon screw lenses to be used for close-up photography.

With the Canon reflex cameras, however, the Bellows R normally uses the R, FL or FD lenses, together if necessary with extension tubes, Macrophoto Coupler, etc. With an intermediate tube it also formed the focusing unit of the older long-focus FL and R lenses.

## Attaching and using the Bellows M

The Bellows M is the simplest of all the Canon Bellows units, designed purely for close-range work and, with a maximum extension of 142 mm., giving a reproduction ratio of nearly 3:1 with the standard 50 mm. lens.

The Bellows M is attached to the camera by pressing the spring-loaded button on the top of the attachment ring at the back of the bellows, lining up the red dot at about the 2 o'clock position on the ring with the camera body red dot or groove and turning the bellows clockwise until it clicks into the locked position. It is removed by depressing the button and turning the Bellows to the left.

The front of the Bellows has the standard lens attachment ring to take all lenses for Canon reflex cameras, extension tubes, Macrophoto Coupler, etc.

The bellows extension is controlled by turning the left-hand knob (viewed from the back). The right-hand knob is the locking knob.

## Principles of close-up and macrophotography

It is a prime requirement of most photographs that they be sharp in the most important areas. This has to be ensured by using a lens aperture that gives adequate depth of field, by focusing accurately and by holding the camera steady. Once you move into the close-up world, these requirements are paramount. The aperture does not generally raise insoluble problems, because you will almost certainly be shooting with the camera on a tripod or other rigid support and can therefore use slow shutter speeds to compensate for small apertures. Again, with the camera rigidly positioned, accurate focusing should not be too difficult.

Camera shake is another matter. When you are photographing at very close range, even the minutest movement of the camera can take the edge off the critical sharpness you require. You must always use a cable release and it is often advantageous to use the delayed action mech-

## BELLOWS R AND M

The features of the Canon Bellows R are:
1. Bellows adjustment knob.
2. Bellows extension lock.
3. Bellows Adaptor R.
4. Scale index mark.
5. Scale (bellows extension).
6. Bayonet ring lever.
7. Camera attaching bayonet ring.
8. Tripod socket.

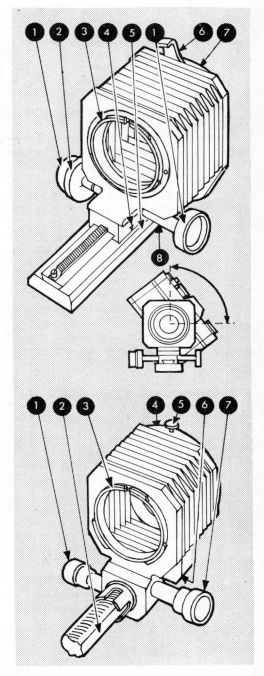

The Bellows R is specifically designed for use as a focusing unit with the earlier FL range of long focus lenses, as well as for normal close-up work. The camera attaching section rotates to allow the camera to be positioned for horizontal or vertical shots.

The features of the Bellows M are:
1. Bellows extension lock.
2. Runner.
3. Lens attaching ring.
4. Camera attaching ring.
5. Locking screw.
6. Tripod socket.
7. Bellows adjustment knob.

anism of the shutter. This allows any possible vibrations caused by handling the cameras to die down. With the most critical work, you might even be well advised, with those models that allow it, to lock the mirror up before releasing the shutter. The mirror action of the Canon cameras is such that it is unlikely to cause any significant vibration in normal photography but in macrophotography, particularly with long exposures, the possibility cannot be ignored.

Depth of field occasionally imposes absolute limits on close range work. No matter how small an aperture you set, depth of field at really close quarters is no more than a few millimetres, so you cannot render sharply in all planes a subject with any real depth to it. You have to focus critically on the plane of most importance and then study the screen image of the rest of the subject. If the depth of field is insufficient, you just cannot shoot at that reproduction ratio. You have to be content with a smaller image on the film and a greater degree of enlargement in the print.

At long bellows extensions, the screen image can be rather dim, even at maximum aperture. Where it is not possible to increase the light on the subject for actual shooting, you may at least be able to augment it for focusing purposes—if only with a pocket torch or flashlamp. If you can by such means throw more light on to the most important part of the subject, focusing is made much easier. The pocket lamp is also a useful accessory when using the TTL meters with viewfinder readout relying on illumination from the top as in the Canon F-1 and the Servo EE Finder.

If you are shooting in dim light conditions with only the subject illuminated, a separate means of providing light for the meter scale window is helpful. The Flash Coupler L (see page 297) is useful in this connection because it has a built-in light source.

With most close range work, even apart from depth of field considerations, the use of relatively small apertures is recommended, say $f$ 5.6 at least, because few lenses can give their best performance at the larger aperture settings. When you use supplementary lenses, even the highly-corrected Canon types, an aperture of about $f$ 8 or smaller is recommended because these single glass lenses just

cannot be fully corrected and much better results are obtained by excluding those rays emanating from the extreme edges of the supplementary lens.

## Exposure adjustments

A major problem with close-up photography is the calculation of the correct exposure. Even the TTL meter does not offer an automatic solution.

Generally, when no other close-up accessory than a supplementary lens is used, exposure is calculated in the normal manner. When extension bellows or tubes are used, however, the light path from the rear of the lens to the film plane is increased and, accordingly, the intensity of the light reaching any particular point on the film is reduced. This is true even of the normal focusing travel of the lens but the effect is negligible except with lenses that focus at very close range, such as macrophoto lenses.

The fall-off in light intensity follows the inverse square law (see page 292) and can therefore be easily calculated from the formula $(E/F)^2$ where E is the total lens extension (i.e. focal length plus length of tubes or bellows) and F is the lens focal length. Thus, where the reproduction ratio is 1:1 (say a 50 mm. lens used at 50 mm. bellows extension), the formula gives $(100/50)^2 = 4$. That is the exposure factor, indicating that the illumination of the film is reduced to one-quarter and that a fourfold increase in the normally-indicated exposure is required.

For macro work an alternative formula is often recommended, based on the reproduction ratio. This is $(M + 1)^2$, M being the ratio between image size and object size. Thus at a 2:1 (twice life size) ratio, the formula gives $(2 + 1)^2 = 9$. The result is the same with either formula (a 2:1 ratio calls for a 2x focal length extension from the infinity position) but the $(M + 1)^2$ formula presupposes a knowledge of or measurement of the magnification, whereas the Canon bellows units have scales from which the extension can be read directly.

TTL meters can adjust close-up readings automatically, providing that the reading is taken correctly. Like any meter reading, the close-up reading must be taken from a mid-tone. If, in copying a document, you take a reading from a white paper with comparatively little black lettered or drawn matter, the meter recommends

an exposure that will reproduce the document as if its tones averaged out to a mid-tone. The result is under-exposure and insufficient contrast to print the document base as a clear white. In such circumstances you generally have to give one or two stops more exposure than the meter recommends, depending on the nature of the original.

There are, however, other matters affecting close-up exposures. The construction of the lens is one of the most significant of these. Most wide angle and long focus lenses for reflex cameras are now of a special retrofocus or telephoto construction respectively and some standard lenses are also retrofocus types. This means that the light path from the back of the lens to the film is longer or shorter than in the normal lens. Accordingly, when you add, say, 35 mm. of extra extension to a 35 mm. retrofocus lens for 1:1 reproduction, you are not doubling the light path as in the normal lens but are rather less than doubling it according to the actual length of the light path when the lens is set to infinity. Similarly, if you add 100 mm. of extra extension to a 100 mm. telephoto lens, you might actually be trebling the light path. The result is that the retrofocus lens used for 1:1 photography might need only a 2-3 × extra exposure, instead of the 4 × normally expected, while the telephoto lens in similar circumstances might need 9 × or more. The TTL-meter Canons take care of these adjustments automatically, but if a separate meter is used, they have to be calculated.

Even more difficult problems arise when lenses of these types are used in reverse. Owing to the prevalent misconception that these variations in exposure requirements are caused by the so-called pupil magnification effect, it is often said that they work in reverse when the lens is used in reverse. This would mean that the telephoto lens used in reverse leads to less than the normally calculated exposure while the retrofocus lens demands that more exposure be given. This is not so for the very practical reason that when the telephoto lens is used in reverse, just like the normal long-focus lens, it needs additional extension to take the place of the empty barrel of the normal long-focus lens. In fact, the telephoto lens needs rather more additional extension. The retrofocus lens, on the other hand, needs less extension when

reversed to retain the image size provided when it is used right way round and, in practice, such reduced extension is not always possible because these lenses are frequently deeply recessed in their mounts.

These considerations would in fact, cancel out the effect of pupil magnification if it had any significance but they have the far more practical effect of making it unlikely that you will attempt to use such lenses in reverse.

The pupil magnification referred to is the phenomenon easily observed by holding a telephoto or retrofocus lens at arm's length so that you can see through it. As you look first through the back and then through the front you will notice a change in the apparent size of the diaphragm opening. This is caused by the fact that the telephoto lens consists of positive (magnifying) elements at the front and negative (reducing) elements at the back. The reverse is true of the retrofocus lens, which is also known as an inverted telephoto. The effect on the exit pupil of the lens has some significance in the design of through-the-lens meters but is only a partial explanation of close-up exposure problems.

Nevertheless, there are problems. In addition to those already mentioned, there is always the possibility that the exposure time will become so long that failure of the reciprocity law (see page 36) will have some effect. That effect varies from film to film. The result is that the best exposure (there is rarely one correct exposure) is not easy to predict and it is usually best to fall back on the method of bracketing exposures, i.e. to take several shots, one at the estimated correct exposure and others at half a stop and one stop or one stop and two stops either side of that exposure. It may be unscientific but it is practical and the cost of the film is generally a great deal less than that of setting up the shot all over again, when the original single exposure proves to have been miscalculated.

# PHOTOMICROGRAPHY WITH CANON EQUIPMENT

Close-up equipment allows us to present considerably enlarged views of minute objects. Although the enlargement it can provide is theoretically almost limitless, practical considerations of light losses at very great lens extension impose limits of their own. To get into the realms of serious study of genuine minutiae, we have to call in the aid of the microscope.

## Microscope data

Any microscope can be used for photomicrography but it is axiomatic that the quality of the final photomicrograph depends entirely on the efficiency of the microscope optical system. The objectives must be the best possible in terms of flatness of field and colour correction. For that reason, apochromats are advisable, although a good achromat will generally give quite acceptable results for black-and-white work. If you use the eyepiece, a compensating type is preferable, owing to its superiority in terms of flatness of field. The highest grade sub-stage condenser lenses should also be used.

Modern microscopes are generally quite suitable for photomicrography because of the widespread use of such techniques in recent years. Older models may use poorer quality condensers and eyepieces because the human eye is tolerant of a degree of curvature of field that the camera registers as very poor definition on the perimeter of the field. If you do use an older instrument it is likely that you will need at least to change the eyepiece. The commonly used Huyghenian eyepieces are not suitable for photomicrography.

The magnification obtainable in photomicrography depends on three factors:
    (1)   The magnification provided by the objective.
    (2)   The magnification provided by the eyepiece.
    (3)   The distance of the film from the eyepiece.

## PHOTOMICROGRAPHY

Features of Canon photomicrographic equipment are:

1. Photomicro Unit F, outer tube.
2. Inner tube.
3. Light shielding tube.
4. Clamp ring.
5. Microphoto Hood, for use with bellows and copy stand.
6. Camera with Speed Finder.
7. Bellows FL.
8. Copy Stand 4.
9. Photomicro Unit F.
10. Microscope.

The third factor depends on the fact that the apparent microscope magnification is actually projected at a distance of 25 cm. from the eyepiece. When the film plane of the camera is at that distance from the eyepiece, the size of the subject on the film is as it appears visually through the microscope. If the camera is raised or lowered, the magnification is increased or decreased respectively in direct proportion to the camera distance. Thus, when the eyepiece is used, total magnification is calculated:

objective magnification × eyepiece magnification × camera extension (cm.) ÷ 25.

When the eyepiece is not used and photography is effected directly through the microscope objective total magnification is derived from:

objective magnification × camera extension ÷ 25.

Naturally, in order to carry out photography through the microscope, the whole set-up of microscope plus camera has to be rigidly supported so that there is no possibility of movement between the two components. This is effected by securing the camera to the microscope by special connecting units. Canon supply two such units: the Photomicro Unit F for a single, fixed camera extension and the Microphoto Hood, which, in conjunction with the Bellows FL and Copy Stand F, allows the camera extension to be varied.

## Canon Photomicro Unit F

This is a four-piece unit that can be used with any type of microscope having a sleeve of 24 mm. outside diameter. The parts are outer and inner hood tubes, a light-shielding tube for the microscope eyepiece sleeve and a clamp mounting ring. It provides a fixed camera extension of 10.84 cm. ($4\frac{5}{16}$ inches), giving a magnification of rather less than half of the visual microscope magnification. The overall size of the unit is 107.5 × 59 mm. ($4\frac{1}{4} × 2\frac{5}{16}$ inches) and it weighs about 320 g. (11 oz.).

The unit can be used on any Canon reflex camera but it is naturally preferable that a through-the-lens metering type be used. The mounting procedure is as follows:

(1) Loosen the screw on the outer tube and remove the inner tube.

## MACROPHOTOGRAPHY AND PHOTOMICROGRAPHY

Canon equipment for macrophotography and photomicrography includes:

1. Magnifier R.
2. Angle Finder.
3. Camera.
4. Booster T Finder (for Canon F-1).
5. Extension Tube M5.
6. FD 50 mm *f*1.4 lens.
7. Handy Stand attachment.
8. Handy Stand F.
9. Photomicro Unit F.
10. Bellows FL.
11. Lens Mount Converter A.
12. Microphoto Hood.
13. Extension tube.
14. Macrophoto strut.
15. Lens Mount Converter B.
16. Macrophoto Coupler FL55.
17. Microscope.
18. Copy Stand 4.

(2) Remove the eyepiece from the microscope, fit the inner tube to the microscope draw tube and tighten the fixing screw.

(3) Insert the eyepiece in the inner tube if it is to be used. If not, insert the light-shielding tube instead.

(4) Place the outer tube over the inner tube and tighten the fixing screw.

(5) Attach the camera to the outer tube in the normal manner, as if attaching a lens, extension tube, etc.

(6) If using a microscope with non-focusing stages, secure the outer section against the weight of the camera by attaching and tightening the clamp ring.

## Canon Micro Hood

Unlike the Photomicro Unit F, the Microphoto Hood allows a variable camera extension. It is attached to the camera via the Bellows FL or M and the Lens Mount Converter A. The whole set-up has to be supported on a copy stand. Camera extension limits are 115 mm. to about 260 mm, allowing magnification of the visual microscope image ranging from about 0.5 to 1.0.

## Focusing the microscope image

Focusing through the central rangefinder section of the camera screen is not easy and it is preferable to use the clear ground-glass area. When using the Canon F-1, the focusing screen could profitably be changed for the all-mat or section-mat type. As the Photomicro Unit F allows only a fixed camera extension, focusing has to be carried out by means of the microscope objective only. When the Microphoto Hood is used, the bellows provides an additional focusing range. The image is best viewed via the Angle Finder or, with the Canon F-1, via the Speed Finder.

## Lighting for photomicrography

There are various lighting systems for microscopy and similar systems can be used for photomicrography. Attention must be paid, however, to particularly even illumination of the field, ensuring that there is no "hot spot" in the centre.

The system devised by Professor Auguste Kohler is

generally recommended. The rules for applying Kohler illumination can be found in any text book of microscopy. You need to be careful, too, to avoid internal reflections. Odd light-catching burrs or shiny surfaces within the draw tube might not be noticeable in normal use but they tend to show up disastrously in photography.

With colour film, you have to watch the colour temperature of the light source and, if necessary, match it to the film by the use of filters. Colour temperature is not generally important with black and white films but filtering may be necessary to produce sufficient contrast to show up detail. A light blue staining, for example, can be considerably darkened by an orange or red filter.

The more sophisticated microscopes and lamps have provisions for the insertion of filters. When no such provision is made, improvised methods must be devised to hold the required filter in front of the light source.

A particularly interesting form of lighting, especially with colour film, is polarised light. This has become widely practicable since the advent of polarising sheet materials or foils. Before that, rather expensive Nicol prisms had to be used.

Suitable materials can be obtained from distributors of Polaroid products—such as Polarisers (UK) Ltd in the United Kingdom—or from microscope manufacturers. Carl Zeiss Jena supply a variety of polarisation sets for their microscopes and also publish fully informative literature on their use.

The materials used consist basically of a polariser placed in the substage filter tray and an analyser on top of the eyepiece. The two are contra-rotated until their planes of polarisation are at $90°$ to each other and the light, as viewed through the eyepiece appears to be extinguished. Visually, it may appear deep purple but colour film generally renders it as black. Suitable objects placed on the microscope stage and correctly focused show quite remarkable colours and patterns not visible in normal lighting. This has considerable scientific value in the study of specific properties of inorganic crystalline materials and of directional anisotropic arrangements of structural elements in various tissues, plastic materials, etc. It also produces images that make fascinating pictures in their own right. The additional use of compensators

(whole wave or quarter wave plates) at the eyepiece produces even more brilliantly coloured and patterned results.

Fuller information on photo-micrography is given in *Amateur Photomicrography*, by M. I. Walker (Focal Press).

## Films for photomicrography

Photography at high magnification raises the twin problems of speed and contrast of the film used. Unfortunately, the faster the film, the lower the contrast of the image it provides and a compromise is generally necessary.

Whenever possible, the magnification should be kept within reasonable limits so that the slower, fairly contrasty emulsion can be used. These days, that does not entail using really slow film. Medium speed (100-125 ASA) black-and-white film has adequate contrast for the average subject and is generally fast enough to allow reasonably short exposures. Super fine grain processing is unnecessary because even fast films have better resolution than the average microscope can achieve.

If the microscope lens is an achromat, only black-and-white work can be undertaken and, as these objectives are corrected for yellow-green and blue rays a narrow-pass filter should be used over the light source. The narrower the spectrum band passed, the sharper the image is likely to be.

Colour films give you less choice in speed and contrast and most of the available films will give satisfactory results. With daylight colour slide film, the best form of lighting is probably electronic flash and there are microscope lamps available that provide tungsten light for focusing and electronic flash for photography. A straw-coloured or pink haze filter may be necessary. If tungsten lighting is used for the photography, a blue filter is required or, preferably, artificial light colour film should be used. Colour negative film can generally be used with any type of lighting, but is not a popular material for photomicrography.

## Calculating the exposure

The Canons with through-the-lens exposure metering simplify exposure calculation, although at the higher

magnifications the Canon Booster or, for the F-1, the Booster T Finder may be necessary. As in all exposure metering, however, you must be careful to read an appropriate mid-tone, by moving the slide if necessary. If the slide has no mid-tone, the reading must be adjusted to take account of the excessive brightness or darkness of the image. It is advisable in such cases to bracket exposures, i.e. to make two or three exposures within a stop or so of the estimated correct settings.

Special exposure meter devices are available if you have no TTL metering facility but if photomicrography is regularly undertaken in standard conditions of magnification, illumination, etc., a few test exposures can rapidly establish a standard exposure time—for a given density of slide. Naturally, adjustments still have to be made for slides of greater or lesser density.

Shutter speeds may frequently be rather long when tungsten illumination is used and problems may arise owing to failure of the reciprocity law. This means that the theoretical equivalence of, say, $1/15$ second at $f1.4$ and 8 seconds at $f16$ may not be true in practice. The correct exposure may be considerably more. Different films react differently and you must either seek advice from the manufacturers or conduct experiments for yourself. With colour film, reciprocity law failure results in colour shifts as well as underexposure, owing to the differential reaction of the three emulsions.

# ACCESSORIES FOR THE
# CANON REFLEXES

Apart from the many major accessories described in other chapters, the Canon system includes a wide variety of items such as interchangeable viewfinders and screens for the F-1, carrying straps, lens hoods, rubber eyecup for viewfinder eyepiece, eyepiece adjustment lenses, copy stands, etc.

## Eyepiece adjustment lenses

The eyepiece of the Canon has a negative power of 1.2 dioptres, which suits most users with what is generally regarded as normal eyesight—and those with defective eyesight who keep their spectacles on when using the camera. Those who prefer to dispense with spectacles can obtain dioptric adjustment lenses to correct the eyepiece to the following powers

$$+3, \ +2, \ +1.5, \ +1, \ +0.5, \ 0, \ -0.5, \ -2, \ -3, \ -4$$

The user should select the adjustment lens corresponding to the prescription for the spectacle lens for the eye he uses for viewing and focusing. Wherever possible, however, practical tests are preferable to theoretical selection and it is better to use the correction lens that enables you to see the image most clearly.

The adjustment lenses screw into the eyepiece after removal of the black milled eyepiece ring or slot into grooves in the rectangular eyepieces. The circular types can be used in the same way as the eyepiece ring to secure the Magnifier S (see below) but cannot be used with the Angle Finders which have their own dioptric adjustment.

## Magnifier S

The Magnifier S fits over the eyepiece of the F-1 and is secured by the black milled eyepiece ring or by one of the dioptric adjustment lenses. Adaptors are supplied to fit the magnifier to the cameras with rectangular eyepieces.

Designed primarily for precision focusing in close-range work, it is also valuable as a focusing aid when using wide-angle lenses, which, owing to the great depth of field they provide can sometimes be difficult to focus accurately. It provides a 2.5 × magnification of the centre of the view-finder image. The attachment piece of the Magnifier S is hinged to allow the Magnifier to be swung upward off the eyepiece so that the whole screen image can be seen. The flat backs of the Servo EE Finder and Booster T Finder do not allow this upward movement so special clip-on attachments are available for use with these items.

## Angle finders

The angle finder attaches to the Canon F-1 eyepiece, after removal of the black milled eyepiece ring or any dioptric adjustment lens that may be in use. Rectangular attach-ments for other Canon reflexes are also available. Its function is to permit the viewfinder image to be viewed indirectly from the side or above whenever it is in-convenient or impossible to look directly through the eyepiece, as in low angle work, microscopy, copying, etc.

There are two types, the A2 which presents a laterally reversed image and the higher quality type B which presents the normal camera image. Both show the full viewfinder area, including the meter panel, and have eye-sight correction adjustments built in.

The Angle Finders can be attached to the Servo EE Finder and the Booster T Finder in the same way as they attach to the standard eye-level finder.

## Interchangeable viewfinders

The standard viewfinder of the Canon F-1 gives the con-ventional eye-level view of the single-lens reflex but such a versatile camera as the F-1 can be used in a variety of ways that demand various methods of viewing. These are provided for by two other types of viewfinder, apart from the specialised Booster T Finder and Servo EE Finder.

Removing the standard viewfinder is a very simple operation. As you grip the rear of the viewfinder between thumb and forefinger, you depress a small button on each side which release spring-loaded catches. Slide the hand

backward and the whole assembly is detached from the camera.

Any of the replacement viewfinders can be attached to the camera by lining up the rail with the grooves on the camera and sliding the viewfinder assembly forward until it clicks into the locked position.

The simplest of the alternative finders is the waist-level type, which is a folding frame with a flip-up 5 × magnifier. When you use this finder you look directly at the focusing screen and use the magnifier if necessary for critical focusing. Viewing is rather awkward because the image is laterally reversed or, if viewed for an upright format, upside down. The meter information is also lost because, in the F-1, the meter panel is viewed through the pentaprism and, although it is actually just visible below the guide rail on the left of the screen, the waist-level finder obscures even that. Consequently, metering has to be carried out before the finder is changed.

The more sophisticated alternative finder is the Speed Finder. This is an extremely versatile unit incorporating a pentaprism to present a correctly oriented image and also to preserve the presentation of the meter information. It has a swivelling rear portion which converts it from an eye-level to a waist-level type. Also the Speed Finder is designed so that you can see the entire screen image area with the eye 60 mm. (nearly $2\frac{1}{2}$ inches) behind the eyepiece. The image size is a little over half life-size with the 50 mm. lens set at infinity.

The Speed Finder has many uses, particularly in circumstances where any form of eye protection is used—goggles, wind visors, perhaps even space helmets. Certainly spectacle wearers will find it useful, especially if they are engaged in any form of sports or action photography. The simple swivel action that brings the eyepiece to the horizontal position allows the camera to be held above the head in crowd conditions without too much eyestrain and to be placed on the ground and viewed reasonably comfortably from above. It allows a comfortable stance when the camera is used at chest or waist level, and is extremely useful in either position for copying work.

Owing to its unorthodox shape, this finder has its lock release button on the underside at the rear.

## Interchangeable screens

The standard focusing screen of the latest Canon F-1 has a split-image centre with microprism collar, which is suitable for a wide range of photographic activities. This is focusing screen E: Eight other types are available:

A. Microprism centre
B. Split image centre
C. All mat
D. Section mat
E. Split image and microprism
F. Microprism for large apertures
G. Microprism for small apertures
H. Mat plus vertical and horizontal scales
I. Double cross hair

Screen A was the standard version on the early Canon F-1 but was replaced in 1976 by screen E.

The split-image type is the same as screen A but with a horizontal split image in place of the microprism centre. This is the version still preferred by some users because it is generally easier and quicker to use except with subjects having no clearly defined lines. The all-mat version enables the entire image area to be seen clearly and is often preferred for close-range work, microscopy, etc., and in conjunction with the Magnifier R. Screen D is also all mat but has a fine-line grid to facilitate precise placing of the image, lining up of copy, etc. This can be useful for double or multi-exposure work. Screen E combines the split-image and microprism systems by putting an annular microprism field around the split-image centre. This is for general use, allowing either type of rangefinder to be used as occasion demands. Screens F and G take account of the fact that a single microprism type cannot ideally suit all lenses. Screen F is for use with large-aperture lenses (f2.8 and larger). It darkens when used with smaller apertures. Screen G is for use with telephoto lenses and others with restricted maximum apertures (f3.5 to f5.6). At wider apertures this screen could lead to focusing inaccuracy. Screen H has an all-over mat field with a 6 mm. centre free from fresnel rings and vertical and horizontal millimetre scales to assist in sizing the subject. Screen I has an all-over mat field except in the centre circle which is clear with double crossed hair lines. This provides a form

of aerial-image focusing for critical work. The image is correctly focused if the hair lines do not move in respect to the image when you move your eye from side to side at the eyepiece.

Screen changing is a simple operation. First remove the pentaprism unit, to reveal the screen in its sunken well. Insert a finger nail into one of the notches at the rear of the screen and pull upward until you can grasp the sides of the metal frame and remove it from the well. To insert a screen, face the protruding lug on the front of the frame toward the lens and push it under the spring holder at the front of the well. Press down on the rear end of the screen until it locks. Avoid touching the surfaces of the screens or allowing them to attract dust or dirt.

Alternative screens are also available for the Canon A-1 but cannot be fitted by the user.

## Carrying strap

When you carry your Canon without its ever-ready case, it is advisable to attach the carrying strap supplied. The ends of the strap should pass through the triangular fittings in the lugs on the camera body and fold inward and back through the buckle. If the strap is folded outward it can slip and allow the camera to fall.

## Lens caps and hoods

The lens caps for the FD lenses have a quick action press fitting for the front thread of the lens. Simply press the two spring-loaded lugs and pull the cap off.

When replacing a lens cap, press the lugs, push the cap on and release the lugs. These lens caps can also be used on filters with front threads.

Lens hoods turn clockwise into the bayonet fitting on the front of the lens. They can be stored for carrying by placing them on the lens backward and turning clockwise until locked. The lens cap can be placed on an inverted lens hood.

## Rubber cup or ring for viewfinder eyepiece

Spectacle users find the wide, soft rubber eyecup useful both for protecting their spectacle lenses and to facilitate centering the eye on the eyepiece. The eyecup is held on the F-1 eyepiece by the eyepiece ring and can be detached

## FINDER SYSTEMS

The main features of the interchangeable viewfinder systems available for the Canon F-1 are:
1. Angle finder B.
2. Magnifier.
3. Dioptric adjustment lenses.
4. Eyecup.
5. Speed finder.
6. Servo EE finder.
7. Booster T finder.
8. Waist-level finder.
9. Eye-level finder.

The focusing screen of the Canon F-1 is removable and can be replaced by alternative types for specialised uses.

simply by pulling gently. A rectangular version is available for other models. As this is a fairly large eyecup that over-laps the camera back, be careful not to trap it when closing the camera. It was for this reason in fact that the eyecup for the F-1 was replaced in 1976 by the rubber cover around the eyepiece ring.

## Copy stands

The Canon Copy Stand 4 is a valuable accessory for a variety of close range work from copying at a reproduction ratio of about 1:12 and greater to macro and micro work. It consists of a baseboard measuring 45 × 42 cm. (about 18 × $16\frac{1}{2}$ inches), a stanchion or pillar of 62 cm. height (about 2 feet) and a carrying arm. The arm has a tripod screw fitting which can screw into the bush in the camera base, but for ordinary copying work with supplementary lenses or extension tubes it is advisable to use the Camera Holder F to support the camera body. For macro work and photomicrography, the arm can be fixed directly to the focusing slide of the Bellows FL.

With the camera fixed directly to the arm, the film plane to subject area can be varied from 64 cm. (2 feet $1\frac{1}{4}$ inches) to 8.3 cm. ($3\frac{1}{4}$ inches). The Copy Stand 4 weighs 3.5 kg. (7 lb. 11 oz.).

The Copy Stand 5 is an improved version with a 59.5 cm. ($23\frac{1}{2}$ in.) square baseboard and a 90 cm. ($35\frac{1}{2}$ in.) stanchion with internal counterbalance to facilitate arm movement. The balance is biased upward.

The arm is moved by two handgrips with a twist action. Turned toward the operator they release the lock and allow arm movement. When the grip is released they automatically return to the locked position. A lever at the base of the arm allows it to be locked completely.

The baseboard is 33.5 mm. thick and has an iron plate insert that not only prevents warping but also allows magnetic copy holders to be used. Four legs are fitted, three with anti-vibration rubber caps and the other adjustable for levelling.

A simpler camera support for copying work is supplied by the Handy Stand F, a four-legged arrangement with an open ring at the top to which the camera lens is attached via its filter thread and a suitable F ring. The unit is supplied complete with an M5 extension ring. Apart from

## ACCESSORIES FOR COPYING

Sturdy camera supports are essential for copying and other close-range work. Canon have several products in this field:

A. Camera Holder F, designed primarily for use on a copy stand. The camera fixing screw is movable to allow various models to be used. It has tripod sockets for vertical or horizontal mounting.

B. Copy Stand 4 can take a focusing rail, camera holder, bellows or the camera direct for a variety of tasks.

C. Handy Stand F is a simple form of copy stand, the legs bounding the image area.

D. Copy Stand 5 is an improved version with box form column, counterweighted arm and twist-grip controls.

E. Canon Focusing Rail for use on Copy Stands 4 and 5. The camera can be moved through 85 mm vertically without adjusting the copy stand arm.

ordinary copying work the Handy Stand F can be used for static indoor macrophotography with bellows or extension tubes.

## Canon Focusing Rail

Fine focusing on copy stands is facilitated by the use of a focusing rail. The Canon Focusing Rail can be used with Copy Stands 4 or 5 to allow the camera to be moved up or down without moving the copy stand arm. The rail is mounted on the arm via the usual tripod socket and is supplied with a tripod-type fixing screw to secure the camera. Movement is achieved by turning knobs on either side of the rail to operate a rack and pinion system with a total adjustment of 85 mm. Positive locking of the rail is provided.

Additionally, the rail can be attached to Copy Stand 5 in either the normal vertical or in a horizontal position.

## Data Back A

An imprinting device was developed for use with the Canon AE-1 and can also be used on the A-1. Marketed as the Data Back A, it replaces the camera back plate.

The device prints various characters in three groups into the bottom right hand corner of the picture. The printing is effected by a built-in flash tube that can be fired manually independently of the shutter release, or automatically in synchronisation with the shutter release via a cord connected to the camera flash socket. The power source is a 6-volt silver oxide battery (Mallory PX28 or similar) which, with single-frame shooting, should give about 5000 imprints. With continuous shooting, 2000 imprints are possible. The Data Back A measures 103 × 48.5 × 14 mm. and weighs 160 g.

To attach the Data Back, first make sure that there is no film in the camera. Then push down the protruding lug on the camera back hinge pin and lift the back off the bottom hinge. Insert the lower hinge pin of the Data Back into the hinge socket, press the lug of the upper hinge pin and ease the hinge into place, releasing the lug to secure it. Close the back in the normal manner and load the camera with film.

The battery compartment is at the left hand end. Pull out the sync cord and slide the battery compartment

376

## DATA BACK A

The main features of the Data Back A are:
1. Plug holder.
2. Manual button.
3. Indicator lamp.
4, 5, 6. Setting dials.
7. Synchronisation cord.
8. Battery compartment.
9. Main switch.
10. Light intensity selector.

The synchronisation cord is stowed away beside the battery compartment when not in use. For imprinting synchronised with exposure, pull the plug from its holder and insert it in the camera's flash socket.

Data is printed in the lower right hand corner of the picture as printed or projected. Proportions and spacing are shown in the diagram.

To bring the Data Back into use, set the main switch to ON and select the light intensity required.

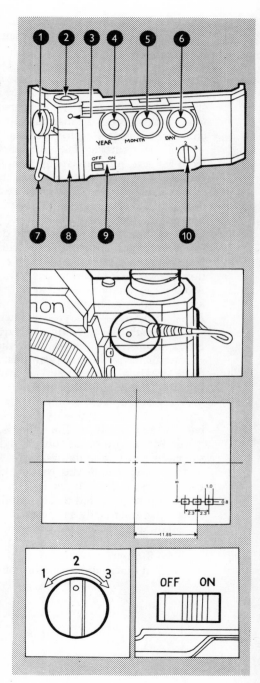

cover off while pushing down the ribbed latch. Insert a battery with polarity as indicated and slide the cover back along the rails.

To use the Data Back, plug the sync cord into the camera's flash socket. You can use a hot shoe flash unit at the same time but a cord flash obliges you to use a hot shoe adapter if you want synchronised printing. Other wise, you can press the manual button on top of the battery compartment after each exposure.

The Data setting dials are marked year, month, day from the left, but the data appears in reverse order on the picture. You can interchange day and month if that is your custom. Adhesive labels are provided to allow you to mark the dials in accordance with the data you intend to imprint. The characters provided on the dials allow for various forms of classification apart from dating.

The characters available on the dials are as follows:
*Year :* 39 characters—0 to 9, 77 to 88, I to X in Roman numerals, a to g in lower case letters—and one blank.
*Month :* 39 characters—0 to 31, A to G in upper case letters—and one blank.
*Day :* 32 figures—0 to 31—and two blanks.

Turn each dial to bring the required characters to the index line, remembering that the imprint appears in reverse order to the dial positions. Turn the main switch on and, when you release the shutter, the built-in flash fires and the data is imprinted.

A film-type table is supplied with the Data Back to indicate the light intensity needed to penetrate the film backing and emulsion. Each film is given a figure—1, 2 or 3—and that figure is set on the light-intensity dial below the right hand data dial.

The lamp above the battery compartment indicates that the unit is ready to fire. It glows when the main switch is on, provided there is sufficient battery power. It goes off momentarily as the data is imprinted.

In colour pictures, the data appears in orange, so it is important to avoid that colour in the bottom right-hand corner. Similarly, white or very light tones should be avoided in black-and-white or colour.

# FILMS FOR THE CANON REFLEXES

All the Canon reflex cameras use standard 35 mm. perforated film designed for still photography. The film is 35 mm. wide and is sold in various lengths and packings of bare film with no backing paper or other protective device. The standard packing for use in the camera is a metal or plastic cassette consisting of an inner spool, to which one end of the film is attached, and an outer shell with a light trapped slit through which the film passes. The shell has at least one removable end to allow the spool to be removed. The cassette is completely light-proof so that the camera can be loaded in daylight, but the film has to be wound back into the cassette before the camera can be unloaded. The most common loadings of the cassette provide either 36, 24 or 20 exposures of the standard 36 × 24 mm. frame size.

Black-and-white films are also freely available in 5, 17 and 30 m. lengths of unspooled film and other lengths can be obtained to special order. Colour films are generally supplied only in cassettes.

## Characteristics of black-and-white film

Virtually all 35 mm. black-and-white film in common use is fully panchromatic. This means that the film is sensitive to light of all colours and will reproduce those colours in a range of greys closely approximating their relative brightnesses. It is, in fact, also sensitive to parts of the invisible radiation band at each end of the spectrum—the infra red and the ultra violet—which can occasionally lead to unexpected results.

This sensitivity results from the light sensitivity of the silver halides incorporated in the emulsion of the film, assisted by special dyes and other additives. The silver halides are suspended in the emulsion in minute grains totally invisible to the human eye even at the maximum enlargement of the ordinary photographic enlarger.

Nevertheless, in certain circumstances, the granular nature of the photographic image can become apparent. This is because, despite the microscopically thin nature of the emulsion coating (on a sheet plastic base), the silver halide grains are located at various depths within the emulsion and can overlap. Because of this, after development, silver grains may be grouped in irregular bunches. Over-exposure and/or overdevelopment can encourage this tendency and make the granular structure visible even at relatively low degrees of enlargement.

The size of the light sensitive grains in the emulsion has an influence on the sensitivity of the film. Generally speaking, the greater the proportion of larger-sized grains, the greater the sensitivity, i.e. the less the exposure to light that is necessary to produce a given depth of tone. Thus, the least sensitive, or slowest films can produce extremely fine-grained images. The very fastest, or most sensitive films inevitably show an obvious granular pattern, even at moderate degrees of enlargement. An additional difference between the faster and slower films is that the faster film is generally less contrasty. It can produce a greater range of tones between its extremes of clear film and maximum blackening.

It naturally follows from these two facts that the slower film can, because of its finer grain structure, handle minute detail better than the fast film and, because of its more contrasty nature, increase the apparent sharpness of that detail. However, gain in one direction is often a loss in another and the slow film does, in fact, lose to some extent by being much less tolerant than the fast film of exposure and development errors. The normal fine-grain effect is very easily destroyed by over-exposure or over-development, while even slight underexposure results in loss of shadow details.

In both these cases we are talking about the extremes—say films of ASA 25 and 400 or more. There are films of 40-50 ASA which are still slow, reasonably contrasty and very fine-grained, which have just that little bit more tolerance. Similarly, there are films of about 250-320 ASA that can serve adequately for most normal purposes. The usual all-purpose film, however, is that which falls between these two—say 100-125 ASA. These films have adequate speed for most subjects, a grain structure fine enough to

## FILM CHARACTERISTICS

The graininess of film images is much less pronounced than it was some years ago but, broadly speaking, a faster film tends to produce a grainier image than a slow film. As a consequence, resolution and contrast tend also to be lower as film speed increases.

These characteristics become noticeable at the extremes, where a 16 ASA film, black and white or colour, can give extremely fine resolution but may be rather contrasty and with limited exposure latitude. Such films are useful for copying.

At the other extreme, very fast films, say faster than 400 ASA, may produce images that show considerable graininess when enlarged. Such films are generally used only when absolutely necessary.

allow very great enlargement and good tone-rendering characteristics.

## Film speed

The ASA figures we have been quoting are a convenient short-hand for expressing the relative sensitivities of various films. The ASA scale is that devised by the former American Standards Association and adopted by most countries outside Continental Europe and the Soviet bloc. Because the speed rating has been accepted by the British Standards Institute as its arithmetic scale, the information is sometimes printed as "ASA/BS". It is an arithmetic scale, which means that a doubling of the ASA figure indicates a doubling of film speed or sensitivity. The ratings are scientifically calculated from the degree of blackening of the silver halides achieved by a given exposure followed by film processing in strictly controlled conditions. Naturally, unless the user follows the standard procedure, the actual ratings laid down may not be accurate and may not therefore accord with the recommendations of exposure charts or meters. Provided he standardises *his* procedure, however, he can use a different ASA figure for exposure calculation and be assured that every film of similar rated speed will behave similarly.

No user should, in fact, accept the manufacturer's film speed rating as gospel. The figure itself has no meaning except for comparison purposes. It applies only in certain given circumstances. Change the circumstances and you must change the figure.

This does not mean that the speed or sensitivity of the film can change (except by ageing, fogging, contamination, etc.). The sensitivity is fixed at the time of manufacture but the symbol used to express the sensitivity (the ASA figure) is coupled with exposure recommendations on charts and exposure meters. The chart compilers assume, and the meters are calibrated to believe, that the light will be interpreted—by meter or eye—in a certain way and that the film will be processed in a certain fixed manner. If these conditions are not complied with, the figure is meaningless. So, whenever you use a film that you have not used before, it is always wise to use several exposures as a test of the film speed figure. Take a dozen or

so shots of your usual type of subject, using the manu-facturer's speed figure. Process the film in your usual manner and examine the negatives. If they are less or more dense than your usual results, you need to use a different speed figure and a few more shots will probably be necessary to determine what that figure should be.

Adjustments of this kind are necessary with different kinds of developers and many chemical manufacturers recommend different film speed settings for certain developers and even for different methods of using the same developer.

The film speed system used in Continental Europe is that devised by the German standards association and is indicated by the letters DIN—meaning German Indus-trial Standard. It is a logarithmic system that has the advantage of compactness. A doubling of film speed is indicated by an increase of 3 in the DIN figure, so that a film of 27 DIN is twice as fast as a film of 24 DIN.

The Soviet system is indicated by the letters GOST. The figures are very similar to those of the ASA system.

## Handling black-and-white film

The safest way to ensure trouble-free photography is to buy all your film in standard cassettes. When you extract these from their wrappings, you find a long tongue or leader of which the first inch or so protrudes from the felt-lined cassette lips. With most films this leader is only half the width of the film and is of a length designed for the original bottom-loading Leica cameras. You do not need it for the Canon reflexes but you are stuck with it, unless you care to trim most of it off so that you can more easily ensure, when loading the camera, that both sets of per-forations are engaged by the film transport roller sprocket wheels.

The objection to buying all your film in standard cassettes is that it is rather expensive. You can save a substantial amount by buying darkroom refills—lengths of ready-trimmed film (also with the long tongue) for loading into your own cassettes. You can save even more by buying bulk lengths to obtain three, ten or seventeen 36-exposure lengths. You can also load any length you require from these rolls although it is rather wasteful to

load very short lengths owing to the requirement for a leader on each length.

Loading a darkroom refill into a cassette is not a difficult procedure. You first prise one end off the cassette—or simply unscrew some plastic types—and extract the spool. Detach the end of the old film. It is now usually secured by a piece of adhesive tape passing round the spool and sticking to both sides of the film. Take the spool parts and the refill into a darkroom or other *totally* dark place and remove the wrapping from the refill. Fasten the end of the film to the spool so that, with the protruding knob of the spool facing you, the film winds anti-clockwise round the spool with the emulsion facing inward. It is only too easy to wind in the wrong direction, and then find the spool goes into the cassette upside down and the film is back to front when you try to load the camera.

If you have to use a new piece of adhesive tape to fasten the film to the spool, do not use the cellulose variety because the adhesive tends to ooze out. Masking or drafting tape is as good as any. Make sure that the tape is stuck firmly to both sides of the film. Holding the film between thumb at one edge and fingers at the other, so that the surface of the film is not touched at all, rotate the spool and feed the film on to it. Keep the film under reasonable tension but do not pull it tight as you turn because scratches can be caused by the one surface rubbing on the other. If you find that you have wound the film too losely, unwind it carefully and start all over again; do not pull on the free end to tighten the roll, as this may make parallel marks (cinch marks) on the film.

When all the film is on the spool, you can touch the outside to hold it firmly because the film is now surrounded by the piece which will be used as a leader. Slide the spool into the cassette so that the curl of the film follows the line of the cassette lips, allowing the beginning of the leader to slip down between the lips. Replace the end of the cassette. To replace the clip-on type, hold the cassette lips together against their tendency to spring slightly apart.

Loading cassettes from bulk lengths can be carried out in a similar manner but if you intend to do so regularly, you will simplify the process if you obtain a daylight loader. There are one or two models on the market, based on a light-tight chamber for the roll of film (different

384

## LOADING CASSETTES

The standard 35 mm cassette consists of a shell with a felt-lined slit containing a spool with one end protruding beyond the flange and the other containing a bar to engage the rewind knob.

The loaded cassette is supplied with the film leader protruding, ready to be attached to the camera take-up spool. The film is wound emulsion side in.

When loading from bulk film, the preferred method of attaching the end of the film to the spool is to fasten it with adhesive tape on both sides. Loading can be carried out by hand, but you must be careful to wind the film in the direction shown, emulsion side in. A short leader can be trimmed for the cameras without quick load facilities. Naturally, cassettes must be loaded in total darkness.

Daylight loaders are available. The features of the type shown are:
1. Film compartment.
2. Exposure counter.
3. Cassette.
4. Cassette chamber cover.
5. Safety lock.
6. Winding handle.

This type fogs the end of the film attached to the spool unless this operation is carried out in darkness. Any number of exposures up to the maximum thirty-six can be wound on by noting the number indicated by the exposure counter.

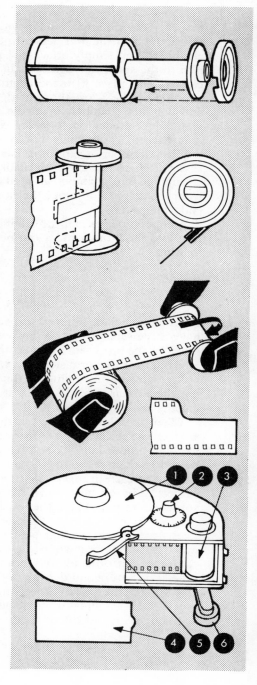

models take different loads) with a light-trapped slit through which the film passes to a cassette and winding chamber. You simply attach the protruding end of the film to the spool as when loading refills, reassemble the cassette and place it in the chamber to connect with a winding handle. Close the light-tight door on the cassette and winding chamber, open the film chamber slit and wind. Your model may have an exposure counter or you may have to count the turns of the handle. When the required number of exposures has been loaded, open the cassette chamber door (normally only possible after closing the film-chamber slit) and cut the film protruding from the cassette. Remove the cassette and trim the film end as required.

All operations except the original loading of the roll of film into the film chamber can be carried out in normal lighting.

## Characteristics of colour films

All modern colour films are tripacks. That is to say they have three separate emulsions coated one on top of the other on the one base. Various other layers are incorporated but the three emulsion layers, separately sensitised to red, green and blue light, are the important ones. These are the primary colours of light, from which all other colours can be produced.

When the film is exposed in the camera to a coloured subject, the various layers separate out the colours so that varying proportions of red, green and blue light are passed to their respective layers in accordance with the amount of each primary colour contained in the original subject. The chemistry of each emulsion layer and its subsequent processing is then such that coloured dyes are released in proximity to the normal silver image. The dyes used are the complementary yellow, magenta and cyan, sometimes known as the subtractive primaries, as compared with the additive primaries of red, green and blue. The nature and density of the dye produced varies according to the type of processing, because there are two types of colour film—negative and reversal, also known as colour print and colour slide.

## COLOUR FILMS

Both types of colour film can be used to produce various end results.

Colour negative film is primarily designed for colour prints (3) but can also be printed on to special film to provide transparencies (1). This service is available commercially. Black-and-white prints (2) can be made on ordinary bromide paper or on special panchromatic paper.

Colour reversal film is designed for the production of colour slides. Black-and-white prints can be made from the slides either on direct reversal material or via an internegative.

The relationship between colours is largely subjective but, generally speaking, colours opposite each other on the colour wheel contrast strongly and can be used together for lively effects. Colours close to each other on the wheel generally tend to harmonise but that depends a great deal on their strength and purity.

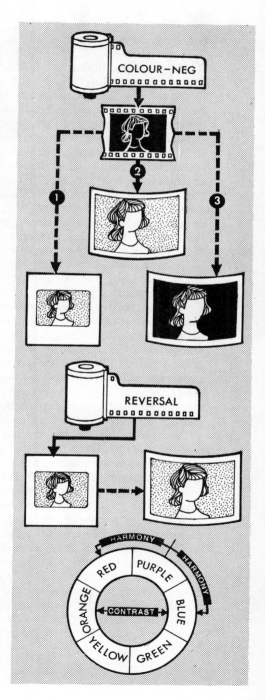

## Reversal colour film

Reversal colour film is so called because it is reversal processed to produce a positive image on the film exposed in the camera. The result is a full colour image that can be viewed directly in the hand (by transillumination), in a magnifying viewer or by projection.

Basically, the procedure consists of a first development to a black-and-white negative image, followed by a complete fogging of the film by white light or special chemicals to provide developable silver halides in the parts of the emulsion so far unaffected. Development in a colour developer affects only these fogged parts of the emulsion and releases coloured dyes at the same time. All the developed silver (i.e. first and reversal images) is then bleached out and only a clear dye positive image remains.

Exposure is rather critical because it must not be so slight as to leave too much silver halide to be affected by the subsequent fogging and colour development. That would produce dense, heavy colouring. On the other hand, overexposure leaves too little silver halide to produce a satisfactory positive image and the colours are pale and washed out. Consequently, although the film can handle quite a range of brightnesses, it cannot be guaranteed to provide accurate colours throughout the range of a contrasty subject. It is better to lessen the contrast wherever possible—by extra lighting, use of reflectors, change of viewpoint to exclude shadow areas, etc.

Processing, too, must be carried out with extreme care. Too long or too short a first development can have similar effects to over or underexposure, as can variations in solution temperatures. Contamination of one solution by another can have disastrous effects on the colour rendering. The fogging (reversal) exposure must be complete. If it is not, the colours are again too weak and may be distorted by an unequal fogging effect on the three layers.

The nature of the light to which colour reversal film is exposed is also critical. Ideally, film intended for daylight pictures should be exposed to light with the character of noonday sunlight, generally reckoned to be about 6000K. The Kelvin scale (K) is an expression of "colour temperature", which is defined as the temperature, on the absolute scale, of a theoretical perfect radiator heated to

produce light of the colour in question. This is a relatively low temperature when the radiator is heated sufficiently to turn red, and gradually rises as it passes through orange, yellow, etc. to a peak at the palest blue. The unit used is the kelvin (K), numerically equal to the actual temperature on the absolute scale and equal to the celsius (Centigrade) temperature plus 273, because the absolute zero is zero K or $-273\,°C$.

Thus, when reversal colour film is exposed to morning or evening light, which tends to be reddish, the colours are apt to be overlaid with a red cast to a greater or lesser degree. When the light comes from a heavily blue sky without direct sunlight (as in the shade of a building on a sunny day) a blue cast is produced. Where light is reflected on the subject from grass, walls, hat brims, etc., a partial colour cast is likely to be produced on the lighter colours in the parts of the subject affected. Partial casts will also be produced if a subject is lit by more than one type of lighting—e.g. daylight and tungsten light.

Overall colour casts can generally be eliminated to some extent by the use of filters. There is no remedy for partial colour casts except removal of the cause—by removing the hat, moving the subject away from the reflecting surface, etc.

It is not normally practicable with transparency films to extend the filtration of light sources down to the lower end of the spectrum—such as the light provided by studio lamps, photo floods and ordinary domestic lighting. For that reason, some manufacturers produce films specially designed for use in artificial light—generally known as Type A for photofloods (3400K) and Type B for studio lamps (3200K). Type A is now obsolete.

Flashbulbs are now generally blue-coated to approximate the quality of daylight. Electronic flash is manufactured to give light of a similar quality (by adjusting the mixture of gases used in the tubes).

## Colour negative film

As colour negative film is primarily designed to produce prints by a negative-positive procedure similar to that used for black-and-white films, the image produced on the camera film is negative—both in tone and colour. The film is basically the same as the colour reversal film but the

processing is different. There is only one development—colour development—and no fogging step. In most films, too, an overall yellow-orange masking dye is incorporated in the unexposed parts during processing to improve the quality of the colours in the final print. The negative nature of the colours plus the strong effect of the mask make the colour negative difficult to evaluate without electronic equipment.

As no reversal is involved, exposure is not quite so critical. Nevertheless, you have to be reasonably careful because you have the colours to think of. With a fairly contrasty subject, any departure from the calculated compromise exposure (which, after all, all exposures are) is a gross departure for either the highlights or the deep shadows. That can lead to highly inaccurate colour reproduction in those areas.

Colour negative film for general use is usually of a "universal" type, meaning that it can be exposed to daylight or artificial light because the overall cast that the "wrong" lighting would produce can be corrected by adjusting the filtration at the printing stage. Thus, filters rarely need to be used on the camera. Partial colour casts cannot be corrected in this way, so you still have to watch out for them.

## Handling colour film

Many colour films can be obtained only in standard cassettes. Refills and bulk lengths are the exception rather than the rule. Nevertheless a few films are obtainable in bulk and can be loaded into cassettes, or indeed into the 250-exposure magazines, in the same way as black-and-white film.

Most films, including all colour negative film, can be used processed. Kodachrome is still the one notable exception because the dye materials are contained in the colour developers instead of in the emulsion layers as in other types. Consequently, the developing process is extremely complicated and well beyond the capabilities of the vast majority of users.

# FILM PROCESSING

If you use your camera professionally, there is a lot to be said for leaving the processing and printing to somebody else who may be more expert at the job than you are. No technician, however expert, can produce a first-class print from a really bad negative but it is amazing how often he can rescue the photographer from the pitfalls of under or over exposure and allied faults to which all of us are prone. Some professionals even adopt the attitude that theirs is the creative task of seeing and capturing the picture and the rest is routine that they should not waste their time on. Some are just plain careless and are apt to make a mess of the job.

There is no excuse, however, for any photographer not knowing *how* to process his films or to print them. He should at least process and print some of his own films now and again to make sure that he understands what makes a good negative and a good print. Some may then even begin to appreciate the skills of the darkroom technician.

## Rules for film processing

Given ordinary discipline and carefulness, anybody can process black-and-white film satisfactorily. The technique has been reduced entirely to time and temperature methods that just cannot fail if the rules are strictly observed. The rules are few:
 (1)  Absolute cleanliness.
 (2)  Patience.
 (3)  Attention to instructions.
Cleanliness means that you must wash all measures, tanks, thermometer and other equipment thoroughly after use. If chemicals splash on the hands during processing, wash the hands immediately. Work in as dust-free an atmosphere as possible and handle film only by the edges at all times.

Patience means that you must wait until the film is completely processed, washed *and dried* before subjecting it to any close scrutiny. Extracting it from the spiral and reinserting it while it is still wet is a very good method of introducing marks and abrasions.

Attention to instructions means that you follow the advice of film, chemical and equipment manufacturers to the letter. After a while, you may tend to modify the instructions a little to suit your own convenience and desires. There is no reason why you should not, provided you realise that you are then on your own. You cannot fail if you follow the three rules exactly. Once you deviate, you can fail miserably. But, of course, you will deviate only when you are certain that your methods suit you best and have no untoward effect on the final result.

## Mechanics of black-and-white processing

Very little equipment or space is needed to process a black-and-white film. The developing tank is, however, a must. A 36-exposure cassette contains more than 5 feet of film and you just cannot handle that length satisfactorily except in the spiral reel of a developing tank.

There are slight variations from tank to tank but the basic components of all models are a tank body (circular and varying in depth according to the number and size of films it can take) a spiral or spirals consisting of a core with grooved flanges into which the film is fed so that it coils up into the smallest practicable space, and a lid for the tank to make it light-proof and watertight. The watertight feature is usually supplied by a small cap in the centre of the lid. When the cap is removed, solutions can be poured in and out but the tank remains light-proof.

Other essential items are two graduated measures—usually plastic these days—for measuring the required amounts of developing and fixing solutions, and a photographic thermometer. That is all. You may like to add film clips for hanging the film up to dry—they are safer than clothes pegs or other improvised hangers—and storage bottles if you do not follow the sensible practice of using concentrated liquid solutions that are simply diluted for use and thrown away afterwards. You require one storage bottle anyway for the fixer and it is not advisable to use beer or soft drink bottles.

# FILM PROCESSING

The equipment to process a 35 mm film need be no more than a developing tank, a supply of developer and fixer (and water) a measure, a thermometer and a simple timer.

In darkness, the film is loaded into the spiral, which is placed in the tank body. From then on, processing can be carried out in any light. The developer is made up and the timer set.

The developer is poured into the tank, which is inverted periodically during processing to prevent exhaustion of the solution near the film surface. At the end of the recommended time the developer is poured away or returned to its storage bottle, the film is rinsed, and the fixing solution is poured in. After fixing, the solution is returned to stock and the film is washed and hung in a reasonably dust-free atmosphere to dry.

All the actual processing is carried out in normal lighting. The only operation that needs total darkness is loading the exposed film into the tank, although there are one or two tanks that even allow this to be done in normal lighting. If you have no darkroom or other area from which light can be completely excluded, you might consider acquiring a changing bag—a capacious light-tight fabric bag with elasticated armholes. Loading the film on to the spiral is not difficult but it does need a little practice and you should not try it for the first time with a film that has unrepeatable shots on it.

Developing tanks are generally made from plastic materials or stainless steel. The latter are now hardly any more expensive than the former and have obvious advantages. They have, however, the not-always-recognised disadvantage that they can develop rust spots and corrosion, and frequently do if kept in damp surroundings.

When you have loaded the tank you can make up the required solutions. These are simply a developer and a fixer. Both are available in concentrated liquid form for dilution according to the instructions. Both are also available in powder form to be made up into working solutions that need to be kept in storage bottles. The concentrated solutions are the easiest to use and, in the case of the developer, have the added advantage that they are one-shot types that can be thrown away after use. That way, you ensure that you use fresh developer each time.

Stick to standard recommended brands at first. There are a lot of different types and you will learn about them soon enough, but their claims of superiority are generally rather insecurely based—except in the case of rapid fixer. Fixing solutions are based on sodium thiosulphate (needing about 10 minutes for its full effect) or ammonium thiosulphate, which fixes a film thoroughly in 1-3 minutes. The rapid fixer is becoming more popular and is completely reliable. It is generally more expensive than the slower variety.

Make up, in your graduated measures, the required quantity of the two solutions. You will find the amount marked on the developing tank or noted in the instructions supplied with it.

The normal required temperature of the developer is

20°C (68°F.). You can bring it up to this temperature by judicious admixture of hot water if you use concentrated solutions, or by standing the flask in hot water if you use developer from a stock working solution. If the ambient temperature is above 20°C., stand the flask in cold water or an ice-bucket. You may find it better to transfer the solution to a glass vessel for this purpose.

It is convenient to use the fixer at the same temperature, but it will work quite adequately at temperatures from 15°C. (60°F.) upward.

When the developer is at the required temperature, pour it into the tank as quickly as possible, place the cap on, and immediately turn the tank upside down and back again and carry on repeating that process for about half a minute. Thereafter, invert the tank twice at the end of each minute of the developing time stated in the manufacturer's instructions. If your tank is a model that does not allow this "inverse agitation" method, follow the instructions supplied with the tank. At the end of the developing time, pour the developer out quickly, fill the tank with water, preferably also at 20°C., and empty it again. Pour in the fixer, again agitating by inversion for the first 10-15 seconds and leave for the recommended time.

The end of the fixing time is the end of processing except for the final washing stage to remove the soluble chemicals remaining in the emulsion. If you take the lid off the tank, you will be able to see the images on the film but do not examine it closely yet. Place the tank under the cold water tap and allow the water to run into it with reasonable force for 30 minutes. If you prefer it, you can attach a narrow rubber hose to the tap to run the water to the bottom of the tank first—such a washing aid is available commercially—but it is by no means essential.

Similarly, if you have a mixer tap that works efficiently, you may prefer to run the washing water at 20°C. but that should not be necessary if you have left the film long enough in the fixer to enable the hardening agent to take full effect. Nearly all proprietary fixing solutions are now acid-hardener-fixers. The acid serves to arrest development immediately by neutralising the alkalinity the developer needs before it can work, and the hardener toughens the film emulsion to protect it against scratches and abrasions. The important point to watch in this

connection is that rapid fixers can, in fact, fix a film before it is adequately hardened. Hardening generally takes 3-4 minutes and it is not advisable to take the film out of the fixer before at least 3 minutes has elapsed.

The danger of washing an inadequately hardened film in very cold water is that the emulsion may contract rapidly and reticulate, i.e. break up into tiny parts that put a fine-line pattern all over the image.

After washing, extract the film carefully from the spiral, holding it by the edges and hang it up in a dust-free atmosphere to dry. Film clips facilitate this procedure and should be attached to both top and bottom to prevent the film curling up as it dries.

When the film is completely dry, cut it into strips of four, five or six according to preference and place each strip in a filing envelope obtainable from most photographic dealers. You can eventually obtain a filing system of bound envelopes, wallets, index drawers, etc. to suit your requirements.

## Colour film processing

There are two types of colour film—colour negative for prints and colour reversal for slides—and they have to be processed by different methods. Both are tripacks, which means that they have three superimposed emulsion layers separately sensitised to red, green and blue light. The requirement is that, for colour negative films, these three layers be developed to produce dyes matching more or less in density the black silver deposits that would be formed in a black-and-white negative of the same subject. In the colour reversal film, however, we need a positive image, so the dye densities have to match more or less the black silver deposits that would appear in a positive print of the same subject.

The colour negative process is the simplest. The required dyes are incorporated in the emulsion layers and they are produced in the required densities simply by using a developer that liberates the dyes in proportion to the normally developed negative image. Then all that remains is to bleach away the silver image and clear the film in a fixing solution. The process is quite simple and is readily undertaken with the same equipment as is used for black-and-white processing. The colour developer, how-

ever, has a limited shelf life once made up and is much more expensive than black-and-white types.

Developing a colour reversal film is rather more complicated. The requirement of a positive image has to be met by producing dyes in proportion to the silver halide *not* reduced to metallic silver by normal development. So the extra steps are introduced of a more or less normal first development followed by a fogging process to render the previously unexposed halides developable. Naturally, there has to be a thorough wash between these stages.

The fogged halides are then in densities that would produce a positive image, so colour development can be used to produce a positive colour image. Colour is produced only in the fogged areas. The originally exposed areas are not affected because they have already been developed and cannot be acted on by the colour developer.

At this stage you have a positive colour image plus developed silver halide, i.e. metallic silver throughout the image area. You then bleach away the silver image, fix the colour image and wash out or neutralise the unwanted chemicals.

Improvements are being made all the time but colour reversal processing is still a rather lengthy business and is not really worth the trouble unless results are required urgently or a great deal of experimental work is undertaken.

For the enthusiast, however, it raises no real problems and is simply a matter of care, discipline and attention to detail. Temperature control, particularly for the developers, is much more important than in black-and-white processing and some films have to be developed at inconveniently high temperatures.

Colour negative film is a much easier proposition, taking less time because it has fewer steps. The disadvantage is that the results are not easily evaluated because both colours and densities are in "negative" form and, with most films, an orange or yellow dye overlays the image and obscures some of the colours. This is a masking dye designed to improve the quality of the colours produced in the final printed image.

The precise steps in processing cannot be detailed because they vary from film to film and, generally speaking, each make of film has to be processed in its own

particular kit of chemicals. The chemicals are not cheap and, unless you have half a dozen or more films to process within a few weeks, it is not even economic to process your own. One type of film, indeed, cannot be processed by the user because there are no dye substances in the emulsion. This is Kodachrome, which undergoes three separate fogging processes and separate colour development of each emulsion.

# MAKING THE PRINT

Virtually all black-and-white photography is a negative-positive process, the final result being a print on paper. In 35 mm. work, this means making enlargements, which has the advantage over colour transparency work that you can frequently improve the framing of your shot and adjust the contrast and information content by techniques of selective exposure. You can "burn in" unavoidably over exposed highlights or "shade" dense shadows to restore detail.

Whether you make all your own prints or employ a skilled printer to undertake the work for you depends very much on the nature and organisation of your work and the type of result required. If you should take on a job that calls for a large number of identical prints of high quality, you may feel that you can spend your time more profitably in directions other than undertaking such repetitive work. A commercial printer can do this job for you at a price that still leaves room for profit. If your photographs are purely for your own pleasure or for exhibition, you may feel that only you can produce exactly the results you require.

For some people, the camera work is all. They have no interest in printing. For others, the greater pleasure is derived from long hours in the darkroom getting the best possible result from a given negative or using that negative simply as a basis for further creative work.

## Equipment and materials

The equipment required for black-and-white printing is not extensive. The basis, of course, is an enlarger, which is a device for projecting the negative image on to a flat surface where it can be composed and focused. Photographic paper suitably placed on that surface can then receive the projected image and be subsequently developed to provide the print. The enlarger is now almost invariably a vertical type consisting of a lamp-house,

negative carrier and lens built into a head that slides up and down a vertical column solidly mounted at the rear edge of a flat baseboard. The lamphouse contains a lamp, and a condenser to concentrate the light on the negative, or a diffuser to spread the light evenly over it. The lens is attached to a bellows or helical tube for focusing purposes and the movement up and down the column allows prints to be made at various degrees of enlargement.

The paper used for making prints is generally not panchromatic. Its sensitivity is largely in the blue-green end of the spectrum and it can therefore be handled in relatively bright yellow or orange light. Rectangular safelight filters in various colours are available commercially and are placed over a form of light-box to illuminate the darkroom. The instructions contained with the printing paper advise you which particular filter to use, but generally any filter recommended for one brand of bromide paper will suit other makes too.

The remainder of the equipment required is for processing the paper. The procedure is similar to that for processing film but, as you can work in reasonably well-lit conditions and as the size of print you make varies, processing is normally carried out in open dishes. You need three dishes of sufficient size to accommodate the largest prints that you are likely to make. If you expect to make both small and large prints it is advisable to obtain two sets of dishes, so that you do not have to use a wasteful amount of solutions when processing the smaller prints.

For handling the prints and transferring them from one solution to another, you need two pairs of print tongs. One pair is not enough because the print has to be transferred from the developer to a stop bath or intermediate rinse and then to the fixer. It is important that the tongs used to extract the print from the developer do not enter either of the other solutions because even the faintest contamination of the developer by fixing solution can considerably affect print quality.

The chemicals required, as in processing films, are a developer and a fixer. Various universal developers are available for processing both films and prints but in 35 mm. work it is generally advisable to use less energetic developers and you therefore need a separate bromide paper developer for your prints. This, like film developers,

## ENLARGING EQUIPMENT

Features of the average enlarger and its darkroom accessories are:

1. Timer.
2. Safelight.
3. Condensers.
4. Lamp.
5. Locking knob for lamp-house movement.
6. Fine focusing control.
7. Negative carrier.
8. Swing filter.
9. Lens.
10. Developer.
11. Water rinse or stop bath.
12. Fixer.
13. Printing paper.
14. Masking frame.
15. Printing exposure timer.

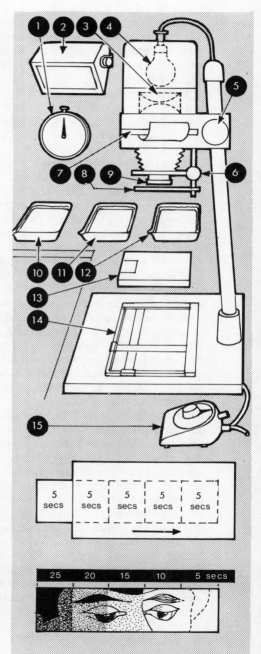

The best method of determining the printing exposure is to make a test strip. A reasonably sized piece of paper is given a series of exposures of different durations. After full processing, the strip is examined in white light to determine the exposure which provides the best result.

is supplied in powder or liquid form. The fixer can be the same product as is used for film processing but is generally used with greater dilution. Again, the rapid fixer is particularly useful to avoid a build-up of prints in the fixing solution.

Measuring flasks and a thermometer are also required but these can be the ones you use for film processing. You also require some means of measuring exposure times, which may simply be a timer calibrated in minutes and seconds.

An additional item which is not absolutely essential but which certainly makes life easier is a masking frame. This is simply a flat surface, generally heavy metal, with a hinged open frame carrying adjustable strips at right angles to each other moving along graduated scales. The paper is inserted under the frame and held down by the strips on two edges and the frame at the other two edges. Paper of any size up to the maximum provided by the frame can be used. As the edges of the paper are held, the frame also puts a white border around the prints and in some frames the width of this border is adjustable.

Further refinements can be added if you wish. It is, for example, useful to wire into the electrical lead to your enlarger lamp a timer switch which allows the exposure to be terminated automatically at the end of a set period. These switches are available in various forms, from a simple clockwork mechanism to elaborate electronic devices. Similarly, you can obtain exposure metering instruments designed to measure the light transmitted through the negative and advise you what exposure to give to the paper to produce a perfect print. These, too, vary in sophistication and can be most elaborate and time-consuming pieces of equipment. Their value for black-and-white printing is doubtful, because it is so much easier to make a test strip and check visually the actual result obtained.

If you are purchasing an enlarger, you might also look for the added refinement of automatic focusing, which means that once you have focused the image for a given scale of enlargement, you can alter the scale to make a bigger or smaller print without refocusing. This can be a useful feature if you are constantly altering the scale of your enlargements by printing from portions of negatives

only. It is as well, however, to make sure that the system works infallibly. If you cannot trust it implicitly, you will negate its value by constantly checking to make sure that your focus is correct.

Most enlargers are now fitted with a filter drawer to enable them to be used for colour printing. If you purchase an older enlarger on the used market, bear this feature in mind if you expect to go on to make colour prints in the future—unless, of course, you then intend to purchase a more elaborate colour head or colour enlarger to enable you to tackle this form of printing with greater confidence.

## Printing paper characteristics

The paper most commonly used for black-and-white photographic printing is known as bromide paper, because its light sensitive content is largely silver bromide, which provides a good neutral black image most suitable for pure record and reproduction work. There are alternative chlorobromide papers with emulsion containing both silver chloride and silver bromide, which give a brownish-black image varying in tone with the type of developer used and the time of development. These papers are frequently used for exhibition prints, and, for various personal reasons, by those who are not attracted to the stark black and white of the bromide print.

For similar reasons, printing papers are available on paper bases of various tints—from brilliant white through ivory to cream. Further, there are papers with various surfaces, such as the ordinary smooth glossy, designed to take a high glaze, lustre or stipple, with a regularly or irregularly patterned surface, dead matt and even one or two papers with a luxuriously velvety appearance. There is a tendency now to restrict the more exotic surfaces, but specialist manufacturers have taken the base tint to extreme limits and can supply heavily coloured types with a dye under the emulsion layer so that all portions of the print that would normally appear white are in brilliant red, blue, green, metallic silver and gold, etc. The image, however, prints black in the normal way. The surface is generally matt and different contrast grades (see below) are not normally available. Even more exceptional are the emulsions coated on a washable linen and metal.

Most manufacturers now produce printing papers in a sandwich construction—a paper base coated on both sides with a plastic film, the emulsion being on top of the film coating. Consequently, chemicals are not absorbed by the paper base and washing and drying times are considerably shortened. These resin-coated (RC) or polyethylene (PE) papers are generally supplied in a more restricted range of surfaces than conventional papers and on a white base only. Conventional papers are supplied in various thicknesses or weights but RC papers are generally of one weight only. They were originally produced for colour work where the lack of chemical absorption has obvious advantages but are now gradually taking over the black-and-white market. A persistent question hangs over the possible impermanence of the plastic coating. If that can be dispelled, the advantages of RC papers are indisputable.

Apart from variations in emulsion. type, base colour, surface texture, etc., photographic papers differ in the image contrast they provide. This variation is designated by the paper grade and most popular papers are available in grades from 0-5 or 1-6 or a similar range. There is no universally agreed standard for paper grade and whereas the norm in one manufacturer's range may be grade 3, in another it may be grade 2. Papers with a lower grade number than the normal provide images of lower contrast and are generally known as soft papers. Those of a higher number provide images of greater contrast and are known as hard papers.

This characteristic of printing papers is provided to allow for variations in contrast in the negative from which the print is to be made. If, for example, your negative turns out to be a little more contrasty than you intended to make it, you can print it on a softer grade of paper to provide what might be considered a normal print. Similarly, a rather soft negative can give a brighter print if it is printed on harder paper. The use of different grades of paper in this way is generally quite acceptable with the more contrasty papers. There are even some workers who prefer to use a paper giving greater contrast than the generally accepted normal because of the extra brilliance and "bite" it appears to give to the print.

## Factors affecting print quality

The mechanics of making a print are perfectly straight-forward and, as you work all the time in sufficient light to be able to see what you are doing, it is quite literally child's play to produce a print of sorts from a given negative. On the other hand, whereas processing a film is almost an automatic process, insofar as it is simply a matter of time and temperature and each exposure on the roll has to receive the same treatment, print making is a much more skilful operation with opportunities for individual handling of each print. First class prints are produced only by skilled workers. The skill is analogous to that of the cameraman in that the real work goes into the exposure and into the framing and composition of the image. In printing, however, there are more methods of control available than there are when exposing the original negative. The print can be of any shape to suit the subject, so that composition within the frame can be precise. Extra detail that was unavoidable when shooting can be cropped away and mistakes such as sideways tilts and even converging verticals caused by upward tilts can be corrected to some extent.

The cameraman is often unable to do anything about extreme contrast in the subject but the printer can give different exposures to different parts of the image so that blocked up highlights or shadows can be made to show detail or he can use a different grade of paper. He can under- or over-print an obtrusive background to obliterate fussy detail. He can print in detail from another negative, such as clouds in a bald sky or even a figure in an empty landscape. He can make a variety of improvements in these ways but the one thing he cannot do is to make a first class print from a bad negative. Even that, however, is a matter of degree. The skilled printer can often make a perfectly usable print from a negative that the less knowledgeable would reject as a total failure.

Apart from such skilled operations, however, the printer can ensure that printing and processing conditions are absolutely perfect. The paper he uses, for example, must itself be in perfect condition and must be properly exposed and processed. This entails storing the paper correctly, using it while it is still fresh, ensuring that it is

exposed to no light other than image forming light (or, at least, to no unsafe light), keeping his developer at the correct temperature, not processing too many prints in the same solution, and fixing and washing the print adequately.

Printing paper needs to be kept in reasonably cool, dry conditions and well protected from chemical fumes or dust. Dampness can cause deterioration of image tone and, in serious cases, variations in density across the print. Paper that has been kept for too long (the safe life is indeterminate and depends very much on the storage conditions) becomes "stale" and gives poor image quality, with veiling of highlights and print margins. This is an insidious deterioration that is not always immediately apparent. Only when the print is compared with a first class print on fresh paper does the unsatisfactory nature of the print on slightly stale paper become apparent. This condition can be alleviated to some extent by adding developer improver, or anti-fog solution, to the paper developer. The results are not comparable however, with those obtained from fresh paper.

Image quality is also seriously affected by over use of the developer, by using the developer at too low a temperature (60° or 15.6°C. is generally the lower limit), by allowing the developer to become contaminated with fixing solution and by the many ways in which paper can be inadvertently exposed to unsafe light. The correct safelight must be used at the recommended distance from the paper surface and all possible sources of unsafe light, such as leaky dark-room blinds, reflections of light emitted from the lamp-house, reflections of image light from the lens when big enlargements are made from a portion of the negative, etc., must be blocked off. During the printing session, paper must be kept in perfectly light-tight drawers or packets and neither development nor fixing must be unduly prolonged.

All these factors affect the image quality in terms of image tone and brightness and even sharpness to the extent that contrast affects the visual sharpness of the image. Sharpness can obviously, however, be affected in other ways. First, the image must be correctly focused on the paper. Focusing is, in fact, normally carried out on the surface of the masking frame and this is perfectly

satisfactory in all normal conditions. There is no point whatever in placing a sheet of paper of the same thickness as the printing paper on the masking frame to ensure that focusing is effected in the correct plane. The latitude of paper position in these circumstances is analogous to that of the film plane in close-up photography, when depth of focus is considerably greater than the thickness of any photographic paper. The lens must, however, be critically focused, because the analogy then is the depth of field in close-up photography and the most fractional alteration of lens-to-subject (the negative) distance can radically affect image sharpness.

Critical focusing is not always easy, particularly for those whose close-range eyesight is less than perfect. If your negative is at all dense, and you are making a large print, the baseboard illumination can be quite low—even though you always focus at full aperture. It is for such purposes that focusing aids are manufactured. These can be quite simple box-like arrangements containing a mirror angled in such a way as to catch part of the image projected from the lens and direct it to a ground glass screen easily visible to the viewer. As in the reflex camera, the distance from the mirror to the ground glass screen is the same as the distance from the mirror to the surface on which the focuser stands, so that when the image on the ground glass screen is sharp so too is that projected on the baseboard or masking frame. Such a focusing aid does not, however, have to be made with anything like the precision of the reflex camera, owing to the relatively large depth of focus in the image plane.

The object of such an aid is to provide a brighter (because transilluminated) and sometimes magnified version of part of the image that can be more easily focused than the image on the baseboard. More elaborate devices have a magnifying eyepiece focused on the image provided by a small mirror and enable you to focus on greatly-magnified, brilliant images of very small features —sometimes as small as the actual granular structure of the image.

How sharply the image can, in fact, be focused depends on the quality of the enlarger lens. A good quality enlarger lens need not be very expensive. It is computed for a certain limited range of usage and is usually of relatively

modest maximum aperture. It can therefore more easily be made of high quality than a camera lens which commonly has to provide sharp images of objects at distances from a foot or two to infinity. Most enlarger lenses now sold specifically as such give good quality images at two stops or so below their maximum aperture. The difference with the high quality enlarger lens is that it gives excellent definition and brilliance at full aperture, and at all apertures it provides an image with just that little extra "bite" or contrast than that given by the lower quality lens. Additionally, the high quality lens enables you to make first class enlargements at almost any degree of magnification, whereas the lens of lower quality may begin to show defects when the degree of enlargement exceeds 5 or 6 × .

Sharpness of the image can also be affected by the steadiness or otherwise of the enlarger and the alignment of its various parts. For example, if the vertical column is loosely mounted on the baseboard, and tends to lean, even fractionally, edge to edge sharpness cannot be obtained. Similarly, the optical axis of the lens must form a perfect right angle with the negative carrier. Rigidity between baseboard and enlarger column is extremely important because it is very difficult in some circumstances to avoid at least a minor degree of vibration from floor or walls, caused by movement of people, passing road traffic, etc. If the mounting of the column and the attachment of the head to the column is really rigid some vibration can be tolerated because all parts vibrate in sympathy but the slightest slackness between any two parts can cause counter-vibrations that affect the sharpness of the image.

A factor that can affect sharpness or contrast in camera work is the state of the atmosphere between the lens and the subject. In enlarging, the atmosphere is between the lens and the sensitive surface of the paper. As this distance is so comparatively short, no trouble need generally arise, but there is the obvious fact that smoking in the darkroom is not to be recommended.

## Printing procedure

When setting up for a printing session, you have first to make sure that your blackout is complete. Those with a permanently blacked-out darkroom or access to darkroom facilities are fortunate in this respect. Your safelight must

be of the type recommended for the material you intend to use or, if of a different type, must be tested to ensure that it is safe. The darkroom temperature should, where possible, be held at 65-70°F (18-21°C.) so that the processing solutions do not become too cool for efficient use. If you are unable to heat your darkroom, you must devise some method of keeping the developer, at least, up to working temperature. This can be done with a thermostatically controlled dish heater or small immersion heater, or by the water-jacket method of placing the developer dish in a larger dish containing water maintained at a degree or two above the working temperature by adding hot water from time to time.

If you do not wish to spend more time in the darkroom than is strictly necessary, you will find it a useful practice to make contact prints from every negative. You can then select negatives suitable for printing at your leisure and mark the contacts (with a grease pencil easily visible by darkroom light) with the most likely cropping.

## Making contact prints

Contact prints are most conveniently made from 35 mm. negatives on 10 × 8 inch bromide paper, because each sheet of that size will accommodate a full 35 mm. film cut into six six-exposure strips.

The procedure is simplicity itself. You place the sheet of bromide paper emulsion up on a flat surface in safelight conditions, position the strips of film on it emulsion side down and flatten them into perfect contact with the paper with a sheet of thick, clean glass. Make the exposure by shining a light through the glass and develop the paper in the normal way. The correct exposure is found by trial and error, using a smaller piece of paper to expose a few negatives only as a test strip.

There are various ways of simplifying this procedure. There are, for example, commercially produced proof printers with a flat surface to hold the paper and a flat glass or plastic cover with slots into which the negative strips can be fitted. For illumination, you can place the proof printer or your glass-covered paper on the enlarger baseboard, raise the enlarger head sufficiently to fully illuminate the 10 × 8 inch paper area with the negative carrier in place, and use the enlarger lamp as the exposing light.

The exposure sometimes has to be a compromise where some shots are over- or under-exposed. This is relatively unimportant, however, because the object of the proof print is merely to select those negatives that you think worth printing.

After selecting the negatives for printing, some workers like to clip out one of the perforations below the appropriate frames on the film strip to enable them to be found easily in the darkroom.

## Making a test strip

To make your first print, you place the strip of film in the negative carrier and switch on the enlarger lamp to project an image on to the baseboard or masking frame. Set the masking frame to the required size of print and raise the enlarger head until the selected part of the image roughly fills the area required. Adjust the setting of the lens to focus the image sharply, readjust the height of the head as necessary and refocus. When you finally have the image correctly framed and focused, you are ready to make the exposure.

You do not have to make many prints before you acquire a reasonable skill in judging the exposure required. Nevertheless, most workers prefer to make a test strip at the beginning of each printing session. When you are using large sheets of paper, it is even advisable to make a test strip for each print.

The test strip is made on a piece of paper at least $1\frac{1}{2}$ inches (38 mm.) in width and of sufficient length to cover most of the tones in the picture. You first study the projected image to choose the position in which to place the test strip most effectively. It should, for example, cover both sky and land areas in landscapes, flesh tones and clothing in portraits and so on. With the enlarger lamp switched off, place the strip on the masking frame in the memorised position and set the enlarger timer (if fitted) to the longest time that you think may be necessary. Assuming that this is 20 seconds, switch on the enlarger lamp and, after 5 seconds, hold a black card or other light shield in the enlarger beam so that it prevents light from reaching about one third of the strip. After 10 seconds, move the card further to obscure two thirds of the strip. After 20 seconds, switch off the enlarger lamp if no timer

is fitted. Your strip of paper has then received exposures of 5, 10 and 20 seconds. The card must, of course, be held so that each strip contains as many tones as possible, which generally means that each strip runs the full length of the paper. Process the test strip exactly as you intend to process the final print. You need not, however, worry too much about complete fixing or washing. The image is usually adequately fixed in 20 seconds or so in a rapid fixer or in a minute or so in the standard sodium thio-sulphate fixer. Examine the strip in bright light to determine which test exposure produced the result that you want to see in the final print. In normal cases, this is the print showing full details in all tones. The deepest shadows should be dense black, while the brightest highlights remain clear.

Early attempts may show none of these results. You may have misjudged the maximum exposure so that each strip is under- or over-exposed. If all strips are too light, you must make a further test with longer exposures. If all are too dark, a new test must be made with shorter ex-posures. If you feel that the correct exposure falls between two of those on the strip, you will generally be able to interpolate the required exposure accurately. When large sheets of paper are used, however, and the intervals between test exposures are long, a further test with nar-rower intervals may be advisable.

You may also be able to see from the test strip that it is impossible to get an acceptable result with one basic exposure. This can arise with a contrasty subject, when an exposure sufficient to give detail in the highlights is too long for the shaded portions and causes all shadow detail to merge into total black. You may find, for example, that your 20-second exposure strip shows the sky with clouds while the 10 and 5 second strips show a plain white sky. On the other hand, the foreground may print too dark in the 20 and 10 second strips and too light in the 5 second strip. The indication then is that sky area needs an exposure of about 20 seconds but the foreground needs, perhaps, 7 or 8 seconds. Similarly, you may notice that the clothing or hair in a portrait needs a shorter exposure or that a notice-board, piece of printed paper, etc., needs a longer ex-posure to reproduce the detail on it. You make a note of

these facts to enable you to exercise control when you make the final print.

## Exposing the print

Once you have made your test strip, exposing the print is simply a matter of placing a piece of bromide paper of the required size in the masking frame and switching on the enlarger lamp for the time determined. If you have a perfect negative, nothing more is needed. Perfect negatives are rare, however, and the skilled printer can improve on almost any straight print because he knows that the printing paper has a much more restricted tonal range than the film. He cannot reproduce all the tones of a long-scale negative on any grade of printing paper. He can, however, differentially adjust the exposure to various parts so as to use the full range of tones that the paper is capable of producing.

The simplest adjustment of this kind is to hold back the light from a large portion of the image area extending to the edges of the paper. To do this you hold your hand or a piece of black card in the light beam as you do when making the test strip to restrict the exposure of the given area. In this case, however, you must keep the black card or your hand constantly moving slightly to avoid a hard edge of tonal change on the print.

The more difficult adjustment arises when the area or areas requiring differential exposure treatment are wholly within the borders of the print. Again, the skilled printer can give more exposure to such areas by so positioning his hand in the light beam that only a small ray of light passes through. The less skilled may find it easier to cut a smallish hole in a large piece of black card and direct the light through the hole to the area requiring extra exposure. Where it is necessary to hold light back from areas within the print borders, small pieces of black card cut into various shapes and fixed to lengths of thin wire can act as "dodgers". In both cases, the card has to be kept moving to avoid the formation of a hard edge and to prevent the wire "handle" from throwing a shadow.

It needs a great deal of practice to carry out these adjustments satisfactorily but the time is well spent because it is a rare negative indeed that cannot be improved by some manipulation at the exposure stage.

## Checking light spill

We have previously mentioned the factors that can affect print quality. You will ensure, for example, that throughout your session in the darkroom, you never switch on the white light until you have made sure that all unexposed photographic paper is safely packed away in light-tight packets, boxes, cupboards, etc. You can keep paper in its original wrappings, in a specially-made light-tight drawer or in commercially produced "paper safes". You will ensure, too, that your safelight is at the recommended distance from your working area—usually about 4 feet (1.3 m.). Darkroom illumination can be quite bright provided the light is all indirect or comes from the recommended distance.

If you make a print from a portion of a negative, it is as well to mask off the unwanted portion so that no light is projected through it. Some enlargers provide facilities for such masking within the negative carrier. If you do not have such facilities, you must either make suitable masks from black paper or at least ensure that the unwanted image light is not striking surrounding objects or surfaces that might reflect it back on to the paper surface. Such reflections can have a subtly degrading effect on the final print.

Most enlarger heads tend to spill a little light and, although this is not usually sufficient to have any effect on the paper, it is as well to darken any wall or ceiling surfaces close to the enlarger head to prevent reflections.

## Developing the print

When the paper has been exposed to your satisfaction, it shows no apparent change, but it does, in fact, bear a latent image that you can now develop. You should have your solutions prepared in dishes according to the manufacturer's instructions. You should have three dishes, one containing the developer, one with plain water or an acid stop bath (which can be a 1 per cent solution of acetic acid or one of the various proprietary solutions available) and the third containing the fixing solution. Each dish should contain sufficient solution to enable the print to be totally submerged without difficulty. It is false economy to skimp on solutions and risk a part of the print receiving inadequate treatment.

As conventional printing paper tends to curl inward toward the emulsion, it is generally most convenient to place it in the developer solution emulsion side down while tilting the dish slightly away from you. Then you can hold the paper down with your tongs while allowing the dish to return to the horizontal so that the developer floods over it and submerges it completely. Turn the paper face upward again immediately, however, and press it gently down with the tongs until it is sufficiently saturated to remain submerged in the solution without attention. It is not generally advisable to leave the paper emulsion side downward in the developer because bubbles may form under the paper where you cannot see them and prevent the developer from taking effect, giving rise to undeveloped spots or patches on the print. This danger is most common in the first half-minute or so of developing and when it does occur, the process has to be prolonged to allow the undeveloped areas to catch up. This is not always desirable, especially with chloro-bromide papers (see below).

RC papers have the opposite tendency. Such curl as they have is outward (away from the emulsion side) and the danger of leaving them floating in the developer is that the middle remains uncovered and develops more slowly. This is not disastrous if you develop to finality but it is unsatisfactory and should be avoided if possible. It *can* be avoided by rolling the paper gently against the curl before placing it in the developer. It will then generally lie quite flat on the bottom of the dish.

You can observe the progress of development by the light of the safelight but this should have little or no effect on the time when you take the paper out of the developer. The recommended time for the development of bromide paper is generally 2 minutes and you should never take a print out of the developer in less than the recommended time. It is preferable, in fact, to so adjust the exposure that your print can remain in the developer for at least 50 per cent longer than the recommended development time without any further noticeable change in density. This ensures that the emulsion is developed to finality and that any really dark tone is reproduced as the fullest black that the paper and developer combination can provide.

The exception to this practice is in the use of chloro-

bromide papers, which are designed to provide a brown-ish-black tone at the end of the recommended develop-ment time—generally about $1\frac{1}{2}$ minutes. As you extend the development time, the image tone tends more toward a neutral black similar to that provided by bromide paper. Chlorobromide papers can provide a range of tones from a reddish brown to a full black according to the type of developer used and the development time.

RC papers generally have a shorter development time, too, especially when you use the developers made specifically for them. In this case, however, the longer time does no harm.

## Fixing the print

When you remove the print from the developer solu-tion, you do so with the tongs reserved for that purpose. Hold the print above the solution for a few seconds to allow excess liquid to drain off and then drop it into the intermediate rinse or stop bath. You must not allow the developer tongs to enter this bath. You then take your other pair of tongs and push your print under the stop bath solution and leave it there for the recommended time (generally about 1 minute). In the case of a water rinse, a brief 10 or 20 second immersion and agitation is sufficient. You use the same pair of tongs to transfer the print to the fixing solution, again ensuring that it is fully submerged, rocking the dish a few times to mix the solu-tion thoroughly. It is because the second pair of tongs enter both the fixer and the intermediate rinse that the developer tongs must be confined to their own bath. If they are allowed to enter the intermediate rinse they become contaminated with fixer, which they then transfer to the developer.

Do not leave the prints in the fixing solution for much more than the recommended time. If the fixing time is unduly prolonged, a certain amount of bleaching can take place, reducing the clarity of fine detail in highlights and some of the delicate differentiation between mid-tones. This is a minimal risk, however, and it is far more important to ensure that the print is adequately fixed.

After fixing, the prints must be thoroughly washed to remove the fixing solution and other chemicals that can cause discoloration. If you have no running water in the

darkroom, the fixed prints can be transferred to a large dish or bucket of plain water until you are ready to carry out the final washing.

## Washing and drying the print

Washing of prints under a running tap needs $\frac{1}{2}$ hour or more for single-weight papers and 1 hour or more for double-weight papers. RC papers need much less time—say 10-15 minutes in ideal conditions. The efficiency of the washing depends to some extent on the temperature of the washing water, on the manner in which it drains from the washing dish or bath and on the separation of the prints during washing. Where many prints are washed together, they must be constantly separated to ensure that clean water can reach both sides of each print.

After washing, paper prints may be dried naturally on towels, clean blotting paper, etc., or they may be heat dried on a drying and glazing press. Electrically heated flat-bed driers are not too expensive and undoubtedly speed up the drying process considerably as well as ensuring that the prints dry relatively flat. The drier consists essentially of a heated metal box with a gently curved top over which a canvas blanket can be stretched to hold the prints in contact with the warm metal surface. When the prints are to be glazed, they are squeezed, while wet, on to special highly polished metal sheets of stainless steel or chromium plated brass. The glazing sheets are then placed on the drying press and the blanket stretched across in the normal way. Glazing and drying is complete within a few minutes and the prints peel off the glazing surface, provided it has been thoroughly washed in a mild detergent before use.

The flat-bed glazer is reasonably efficient and can give a good glaze if correctly handled. It is, however, rather slow in use, particularly for large prints. For the more professional worker, who needs reliability and speed of operation, rotary glazers are available at a considerably higher price.

RC papers must not be heat-treated in any way, except in equipment especially designed for them and operating at relatively low temperatures. The glossy version dries to a good glaze naturally and no artificial glazing is necessary. RC papers also dry quickly and flat.

## Finer points of printing

Apart from the manipulative processes already mentioned, by which extra exposure may be given to certain areas of the print, there are many other processes by which the printer can improve, modify or completely change the nature of a photographic print. These are more the province of specialist publications, such as Professor Croy's *Complete Art of Printing and Enlarging*, but it is worth pointing the way to a few of these processes.

The simplest and most-often-quoted method of improving a landscape picture, for example, is to print in clouds on a bald sky. To do this effectively is not so simple as it might at first seem. Sometimes, indeed, the sky area of a negative is so dense that virtually no light gets through to the printing paper when you expose for the remaining areas. If such a negative also happens to have a relatively uncluttered sky line without medium or light toned shapes protruding into the sky area, it is a relatively simple matter to make a normal print of the foreground and then replace the negative by one containing specially photographed cloud formations. You can print the clouds into the sky area, while shading off the lower portion of the print to a little above the skyline with your hand or a suitable piece of black card. Nevertheless, you still have to be careful not to chop clouds in half, to see that they are lit from the same direction as foreground objects, to check that they do not conflict with the apparent weather conditions, and so on.

You may have to remove the printing paper from the masking frame in order to compose the cloudscape, as described below, but this raises no particular problems with straightforward printing-in. The difficulty arises when the sky area on the negative is not, in fact, as dense as you thought it was and, when you come to print the clouds, you find that sufficient light did, in fact, pass through the sky area of the original negative to produce a density that makes the clouds look distinctly grey when the extra exposure is given through the cloud negative.

In such cases you have to use masks to prevent light reaching any area that is to be subsequently printed-in. Such masks are also necessary when the skyline has a variety of intricately shaped light areas projecting above

it. Dark shapes need not cause any problems because you cannot print lighter tones over them.

To make the masks, you place a sheet of white paper on glass raised an inch or so above the masking frame with wooden blocks, books, etc. With the image normally focused on the baseboard, you have an image on the paper which, although rather fuzzy, is sufficiently clear to allow you to trace its outline fairly accurately. This outline provides your guide or template for cutting masks from black card. If you place the masks carefully on the glass to coincide with the projected image, you can attach them by bottom and top edges with adhesive tape to allow each to be folded back in turn to make the appropriate exposure. The height of the masks above the baseboard softens the outline edge and allows the tones to blend together.

Except with simple outlines, this process can rarely be undertaken completely satisfactorily without some after-work on the print but it can be quite satisfactory for reproduction purposes. Snags arise when the features to be printed in are enlarged to a greater or lesser degree than the original negative. This alters the angle of the beam of the enlarger and, if the masks are made in one step as described, overlapping or unexposed areas can arise. The remedy is to make each mask separately with the enlarger head at the correct height for each negative. The outline of the printed in area to be traced on the paper is then that corresponding with the part actually appearing on the masking frame surface. This can sometimes entail rather a lot of guesswork and consequent afterwork on the print.

The original composition for the inserted matter, which can be a figure or other object totally within the picture area as well as clouds in the sky, has first to be made by placing a piece of unsensitised paper or card in the masking frame and tracing outlines very accurately to indicate where the inserted material is to appear. This piece of paper is left in the masking frame throughout the subsequent processes. The first negative is then recomposed in accordance with the drawn outlines, the appropriate mask is placed in position and the exposure is made. The sensitised paper is removed from the masking frame and marked on the back to indicate its orientation when it is replaced. The negatives are changed and the

second negative recomposed. With the enlarger light switched off and the masks changed, the second exposure is made.

In all such cases of double printing, you must pay particular attention to the lighting of the inserted material to ensure that it corresponds with that of the original picture. With figures, matters such as size and perspective must also be considered and, for completely satisfactory results, the inserted figure frequently has to be specially photographed against a suitable background and/or standing on a suitable surface. It is rarely satisfactory to attempt to cut a mask to the exact outline of a complicated figure and it is usually better to make an irregular outline to blend with the surroundings of the original scene.

## Image modification processes

While the principle idea of printing from a negative is to reproduce the original scene in a more or less natural form, there are various methods available whereby the characteristics of the image can be altered to provide particular effects. Of these, two related processes are frequently confused. These are tone separation and posterisation.

*Tone separation.* The tone separation process is now rarely used. The object is chiefly to provide detail in both highlight and shadow areas while effecting an almost unnoticeable compression of the mid-tones. The result is what appears to be a finely graded print with a long tonal range. The principle used is to make two negatives from the original negative, one to provide highlight detail and the other to provide the shadow detail. The mid-tones are ignored. They are not recorded on the highlight negative and are compressed virtually into a monotone on the shadow negative.

The first step therefore is to prepare a transparency from the original negative. To prepare this transparency, you can contact print the original negative on to a strip of 35 mm. film or enlarge it on to a piece of sheet film for subsequent contact or projection printing. The film used for the transparency should be a medium-speed stock to provide a full range of tones. Exposure and development are adjusted by trial and error to this end.

The highlight and shadow negatives are made from this transparency and, as they subsequently have to be

printed in register, the transparency must be marked in some way to provide identical registration marks on both negatives. If you make the transparency by enlarging on to sheet film, it is a simple matter to put a border around the whole image area to make registration perfectly straightforward. If you are contact printing at each step and using the whole image area, you are in some difficulty because you have no place in which to put registration marks. You may have to devise a modified negative carrier so that the edges of the image area can be made visible on projection to the final print. If you enlarge part of the original negative image on to 35 mm. film, you can mask off the unwanted portion and print the positive image slightly within the normal 35 mm. frame. Whatever system you use, make sure that the registration marks are as large and positive as possible. The frequently recommended scratched crosses are rarely satisfactory.

The separation negatives are made from the intermediate positive by adjusting the exposure of one to provide the required detail in the highlight area only. The exposure should be short enough to leave the rest of the film virtually clear. The shadow negative has a much longer exposure so that the highlights become completely blocked up while full details appears in the shadows. The overall appearance of this negative is extremely dense and, in fact, there may be occasions when the original negative can be used as the shadow negative.

The final tone-separated print is produced by printing these two negatives separately on to the same sheet of bromide paper. This is not a simple matter. If the highlight negative has not been very carefully prepared, it will be impossible to print it without considerably fogging the rest of the image area. It has to be a very thin negative indeed so that it can be given the very minimum of exposure to produce sufficient detail in the highlights without putting more than a trace of tone across the rest of the image area.

The shadow negative is, in fact, printed first. As in the manipulative processes previously described, it is first projected on to a piece of paper in the masking frame and its registration marks or frame are very carefully and accurately traced on to the paper with a sharp, hard pencil. The bromide paper is then placed on top of the

tracing and the exposure made normally. The correct exposure has to be found by trial and error or by the test strip method to ensure that it provides exactly the detail required in the shadow areas. No detail at all should appear in the highlight areas. After exposure to the shadow negative the bromide paper is removed, taking great care not to move the tracing beneath it (which is preferably taped to the masking frame), marked to indicate its orientation and placed in a light-tight packet, drawer, etc. The shadow negative is then replaced by the highlight negative, which is positioned so that its registration marks coincide exactly with those traced on the paper. The bromide paper is then replaced and predetermined exposure for the highlight negative is made. The paper is then processed in the normal way, fixed, washed and dried.

This particular process is most suitable for subjects which contain important highlight and shadow areas but in which the middle tones are of no great importance. The compression of these middle tones is not immediately obvious in the well-executed tone-separated print. The untrained observer might not even be aware that the print had been subjected to any unusual treatment.

*Posterisation.* A more popular form of tone separation frequently used in advertising and publicity work is known as posterisation because of the similarity of the final image to the flat tones and masses of some types of poster. This process extends the separation of tones to the limit, so that there is no blending of tones in any area of the print. There are simply two, three, four or more, flat, well-differentiated tones.

The process is virtually the same as in tone separation but the material used for the intermediate positive and for the highlight and shadow negatives is a high-contrast type such as line or lith film. Each of these negatives should consist of areas of nothing but black and clear film. The highlight negative should be completely clear film except for the completely opaque highlights that are to reproduce as plain white. The shadow negative should extend these opaque areas into the mid tones, including the lighter shadows. The shadow areas themselves should be completely clear film.

Thus, when you print the highlight negative on to bromide paper, you can adjust the exposure to give any tone from the very lightest of greys to full black over the whole image area except the extreme highlights. In fact, you aim to give sufficient exposure to produce an even mid-grey tone in these areas. You then print the shadow negative so that its exposure, added to that already given to the shadow areas by the highlight negative, produces a dense black in those areas. Thus, the final posterised print contains completely clear highlights, mid-grey tones and dense black shadows.

The posterisation process can be extended further by making three or four intermediate negatives to provide four or five separate tones. Generally, however, the simple three-tone posterisation is most effective.

*Line methods.* An even more extreme method of tone compression than posterisation or tone separation is the use of line or lith material to reduce the image to two tones only —black and white. One of the most effective methods of using this process is to make the original negative deliberately grainy. This can be achieved by shooting on very fast film and developing in bromide paper developer or by over-exposure or over-development techniques. Alternatively, you can copy an existing negative by similar methods to produce a grainy image.

The aim is to break the image up into a granular structure that can be printed in pure black and white and can be reproduced without the aid of a half-tone screen. Sometimes a sufficiently hard negative can be produced by these methods to give a suitable straight print on the hardest grade of bromide paper. Generally, however, it is preferable to print the original negative (almost any negative is suitable) on to lith or line material to produce a positive and then to print the positive again on to lith or line material to produce a very contrasty negative. The process can be repeated as often as necessary to produce the contrast required.

The result can be to turn almost any tone into a jet black, provided there is a lighter tone to remain white. Thus, even a fair-haired person can be portrayed with jet-black hair if the flesh tones have greater density on the original negative than the hair. They then become completely opaque in the final negative and the features

## POSTERISATION AND PRINTING-IN

A simple printing-in example is that of adding a cloud-filled sky to an otherwise "bald" print. The image is projected on to white paper or card held an inch or two above the baseboard. Focus is on the baseboard. The skyline is pencilled in on the paper, which is then used as a template to cut masks in black paper or card.

*Right:* With printing paper on the baseboard, the sky mask is placed in position and the landscape exposed. The landscape is then masked while the sky negative is printed in.

If the sky area in the original negative is sufficiently dense, the sky mask may not be needed.

The essential steps in the posterisation process are, first, to convert an ordinary negative into a contrast transparency.

The second step is to make identically-sized highlight and shadow negatives of the highest possible contrast.

The third step is to print the highlight negative with a short exposure to put an even grey tone in mid-tone and shadow areas and then to print in exact register the shadow negative to reproduce the shadow areas as a full black.

are represented only by small clear parts of film representing highlights, eyes, eyebrows, etc.

Lith material should preferably be processed in its own developer but for most experimental purposes it is quite satisfactory to use ordinary or contrast bromide paper developer. Moreover, if you use blue-sensitive (non-panchromatic) materials you can treat them just like bromide paper, developing in a dish by visual inspection.

The advantage of this method of processing is that it makes the "solarisation" of lith film comparatively easy. You can eliminate virtually all the tones of the image and leave only an outline representation of the subject. This is achieved again by printing your original negative on to lith material to produce a positive which is further printed on lith material. This final print, which would normally be processed to a negative, is placed in the developer in the usual way. After sufficient time in the developer, however, to show a fairly strong image in all areas, it is exposed, while still in the developer, emulsion side up, to white light until you can just see the clear areas begin to darken. Switch off the light and continue developing for about 1 minute. Your negative will then look completely black from the front but reasonably strongly detailed from the back. When you fix this negative, you will find that it is completely black except for an outline image of your subject.

The process will work with almost any negative but the outline is simpler and the result more striking if the original subject has little internal detail, such as full face portraits, single blooms, uncomplicated statues and buildings, etc.

You can vary this effect by making the fogging exposure somewhat earlier in the process and/or by shortening or lengthening its duration. You then obtain reversed tones in some areas accompanied by some outlining. This effect is not so predictable as total solarisation and you may find that the reversal of tones appears in different areas in different versions.

## Stabilisation processing

Undoubtedly for those whose time or space is restricted, the setting up of large trays of processing solutions and the making up of the necessary chemicals is rather a disad-

vantage in making their own prints. Fortunately, there is an alternative technique. Various makes of paper are available in which the developing agent is incorporated in the emulsion. After exposure, this type of paper needs only to pass through a strong alkali solution to effect complete development in a few seconds. These papers are known as stabilisation papers and various roller processors are made to enable them to be handled quickly.

Stabilisation paper is exposed in the normal way. After exposure, however, it is fed into a slot leading to a system of rubber rollers in a machine resembling the wet-process copying machines used in offices. The rollers draw the printing paper into the machine and at the same time pick up the activator solution from a trough into which the lower roller dips. As the solution is rolled on to the paper, the image develops almost instantaneously. Further rollers then carry the paper through to the stabilising solution which prevents the emulsion from being further affected by light.

The enormous advantage of these machines is that they can handle quite large sheets of paper (the length is unlimited) and that the final print emerges damp-dry and stabilised in the relatively short time that it takes the paper to pass through the machine. The machines are not small and take up more room than, say, three half plate dishes but they occupy considerably less space than three 15 × 12 inch dishes. Moreover, in a properly-designed machine, the solutions are extremely long-lasting and can be left in the machine almost indefinitely.

The snag at present perhaps for many users is that these machines are rather expensive. It is, however, quite possible to adapt copying machines to this use. They do not usually contain as many rollers as the genuine machine and may have no emptying device or storage reservoirs, but they can produce perfectly satisfactory prints.

The quality of a good print on stabilisation paper is virtually indistinguishable from that of a normal bromide print. The stabilisation itself is effective for long periods but if much exposure to light is expected, prints can be fixed and washed in the normal way. They cannot, in any case, be glazed unless they are first fixed and washed because soaking in water eliminates the effect of the stabilisation process. The papers can also be processed in

the normal chemicals, although there is generally little point in that because they are more expensive than normal bromide papers.

## Colour printing

We cannot attempt to give a full run-down on colour printing methods in such a book as this but every camera user should be made aware of the fact that colour printing is by no means beyond his ability. It is becoming easier almost every year and there are no doubt tremendous advantages to be gained from printing your own colour pictures if your business or hobby cannot bear the heavy expense of individual treatment of colour prints.

The paper on which colour prints are made has three light-sensitive emulsions, coated one on top of the other, each sensitive to a different part of the spectrum. They are fully panchromatic and must be handled in total darkness. As with colour films, there are two types—one for the production of colour prints from colour negatives and the other for the production of colour prints from colour transparencies. The latter is the more recent product and is much easier to handle, in that, like colour transparency film, it can be handled in normal light after the first development and fogging stages. That is colour reversal paper, in which dyes in the emulsion are activated by the colour developer. A still later product is the dye-destruction type in which the dyes are already active in the emulsion, which therefore appears almost black, but are destroyed selectively by the colour developer. No fogging exposure is required.

The equipment required for colour printing is basically the same as that for black-and-white printing. The main difference is that, because colour negative film is of "universal" character, i.e. it can be exposed to either daylight or artificial light, and because there are slight variations in sensitivity of colour paper from batch to batch, delicate filtration of the exposing light is necessary at the printing stage. The enlarger used for colour printing should therefore provide facilities for the use of filters, although for additive printing, it is possible to hold the filters below the lens.

Additionally, for the negative positive process, some form of developing drum or enclosed tray with light

trapped filling and draining facilities is advisable to avoid the necessity for transferring the prints from dish to dish in total darkness. Many such comparatively inexpensive devices are available commercially and, for the advanced worker, there are more elaborate machines for the rapid, mechanical processing of colour prints.

Temperature control of the solutions is more important in colour printing than when handling black-and-white materials. This is not too difficult to arrange when a developing drum is used because the storage bottles can be kept in a deep tray of water at the correct temperature until immediately before use.

For the critical work, the colour temperature of the light source used for printing must also be rigidly controlled and this implies the use of methods of voltage control because fluctuations in the voltage of the electrical supply to the enlarger lamp can cause signficant changes in its colour temperature.

Matters of temperature and voltage control, however, are of overriding importance only when the highest quality of work and the certainty of being able to repeat a particular result are themselves matters of extreme importance. This is not generally so with the amateur or with those who are making prints for one particular purpose. They generally have the time to experiment afresh with each print and to produce the exact result they require. Slight variations of temperature and voltage do not make it impossible to produce a good colour print. They can make it difficult to repeat a given result without the expenditure of extra time in achieving the correct filtration. With the latest dye-destruction process, however, the printing material is much more tolerant of exposure and temperature variations.

The filters used depend on the colour printing method. Colour prints can be made by an additive process or by a subtractive process. The additive process uses three filters only (narrow-cut red, green and blue) and requires that separate exposures are made through each filter to expose each of the emulsion layers in turn. The obvious difficulty arises that every care must be taken not to disturb the setting of lens, negative carrier, masking frame, etc., between the separate exposures.

The more poular subtractive method uses a single

427

exposure to white light filtered by the interposition of filters of the complementary colours, yellow, magenta and cyan. These filters are supplied in sets of about twenty-two in various densities of each colour. They are most conveniently placed in a filter drawer above the negative carrier where they cannot interfere with the image-forming quality of the lens and therefore need not be of optical quality. For those who have no filter drawer but can easily remove the top of the lamphouse, the filters can equally successfully be laid on top of the condenser. Although it is possible to use filters in a holder below the lens, they must be of especially high optical quality, and must be restricted to a maximum of three for any exposure.

Filtration of a colour print is a tricky procedure and is frequently a stumbling block for beginners. It involves a great deal of trial and error and subjective judgement but various aids to the process are published by manufacturers of colour printing materials and in specialist books on the subject, such as Jack H. Coote's *Focalguide to Colour Printing*.

The processing of colour prints is comparatively straightforward but is time consuming in that the process has to be taken to completion, often to washing and drying before the results can be accurately assessed. With the most recent material, it tends to be made a little inconvenient by the necessity for high temperatures (around $37°C$.) that can be difficult to maintain. The negative-positive process consists basically of a colour development in a special solution that liberates the colour dyes in the emulsion alongside the developed silver halide. The silver image then has to be bleached away and the dyes stabilised or fixed. Other solutions such as clearing and stop baths may also be employed, depending on the type of material used, and there is generally a rinse or wash stage between each step. The tendency now, however, is toward simple two-solution (develop and bleach-fix) processes which, apart from the high temperatures involved, have made colour-paper processing almost as straight-forward as black and white.

Processing of colour reversal paper follows similar lines to that of colour reversal films in that the first development is in a black-and-white developer to produce

a normal monochrome image. After rinsing, the paper is then fogged either chemically or by white light to allow the undeveloped emulsion to be developed in another developer, which liberates the dyes in that part of the emulsion to form a positive image. The remaining steps are then similar to those for the colour negative process but can be carried out in normal lighting.

Processing of dye-destruction material is a simple, three-solution—develop, bleach and fix—operation at comparatively low temperatures (around 24°C.).

# MATTERS OF EXPOSURE

The essence of photography is the action of light on a light-sensitive emulsion. When such an emulsion is exposed to light, it undergoes a change that is generally invisible. When, however, the exposed emulsion is treated with certain chemicals, the silver halides that form the light-sensitive part of the emulsion are reduced to metallic silver in proportion to the extent to which they have been acted upon by light. The metallic silver is black and, when the developed emulsion is subsequently cleared of the undeveloped halides and rendered insensitive to further action of light, it appears black in the areas exposed to light and more or less clear film in the areas that were not so exposed. Thus, an emulsion of this nature differentially exposed to light by projecting an image on to it, as in a camera, presents, on subsequent development, a tonally reversed image of the original subject. Parts of the subject that are light-toned appear dark-toned on the film and vice versa. Depending on the characteristics of the emulsion, mid-tones are also represented by varying densities of silver deposit. This is the photographic negative. This negative may then be used to produce a positive print, or on colour film, either a colour negative, or a positive image within the emulsion.

## Effects of over and under exposure

The problem that arises for the photographer is to assess the amount of light that he should allow to act on the film. The result of light action on the film is cumulative, i.e. a very weak light acting for a very long time has more or less the same effect as a great deal of light acting for a very short time. Thus, even the deepest shadow in the subject, provided it reflects some light, can be represented by a degree of blackening of the emulsion that increases as the exposure time increases. Such lengthy exposure of lighter tones in the subject, however, might blacken them to the

full capability of the emulsion and so obliterate any differentiation between them. Thus, for any given subject, there is a certain degree of exposure that produces a range of densities on the film that is reasonably representative of the tones of the original subject. Less exposure may fail to reproduce some of the darker tones at all; more exposure may raise all the densities to such an extent that the negative becomes difficult or even impossible to print satisfactorily. The first condition is underexposure and the second is overexposure. In the black-and-white photograph, underexposure leads to lack of detail in shaded areas and a veiling or loss of brilliance in the highlights. Overexposure leads to blocked-up highlights with little detail and shadow areas that are lighter and more detailed than they should be.

In colour transparencies, overexposure additionally leads to an image of light tone and diluted colour, because there is no printing stage during which the overall density can be adjusted. Underexposure leads to a dark image with degraded colours, or colours much deeper than in the original subject. In both cases, there is also likely to be some inaccuracy in the colour rendering of highlight and shadow areas.

## Exposure latitude

In black and white and, to some extent, in colour negative photography, the exposure level is not generally highly critical. In other words, the exposure has some tolerance of over or underexposure—a characteristic sometimes called exposure latitude. The latitude is greater when the tonal range of the subject is shorter. Obviously, for example, a subject consisting of one tone only can be given any of a wide range of exposure times that would produce a single density on the negative that could be printed as any desired tone. As most emulsions have a reasonably linear response to additional increments of exposure within a certain range, a subject with only a few tones—all well within the capability of the emulsion—can similarly be adequately reproduced with several different exposures. Only as the range of tones in the subject approaches the full capability of the emulsion does the exposure become more critical, so that a long scale subject, with a full range of tones from deep shadow to bright high-

light, has to be exposed rather carefully to avoid loss of detail at one or other end of the scale.

In colour reversal work, the tolerance of exposure errors is less, for two reasons. First, the reversal process itself requires that a certain amount of emulsion remain unexposed to form the image and, as it is that part of the emulsion that also releases the dyes to form the coloured image, its actual density is quite critical. Secondly, there is no opportunity for adjusting the tonal range at the printing stage, as there is in the negative-positive process.

Colour reversal material, therefore, generally has to be accurately exposed to within one-half or at most one whole aperture setting of the lens. Colour negative material may be able to tolerate $1$-$1\frac{1}{2}$ stops of exposure error and black-and-white film can often be satisfactorily printed even if the exposure error runs to 2 or 3 stops. The tolerance is usually greater in the overexposure region because underexposure can fail to produce any density at all in some shadow areas and no amount of printing adjustment can put that right.

Overexposure of both black-and-white and colour materials has, however, an important drawback. It has the effect of spreading the action of the light into adjacent grains of the emulsion, rather like the outward spread of inked lettering on absorbent paper. This can soften the edges between adjacent tones, thicken fine lines and generally obscure minute detail. It also has the effect of causing the granular structure of the image to become more apparent.

Exposure error can also affect the contrast of the image. If the exposure is so low that the negative image obtained has little density even in the brightest highlights, it is difficult, even on the most contrasty paper, to give a printing exposure long enough to produce a full black in the shadows without the light penetrating the highlight areas to such an extent as to render them as nearer a midtone. If the film is overexposed, printing to obtain adequate detail in the highlight areas may call for an exposure so long as to totally blacken all the lower mid-tones.

## Functions of exposure meters

Despite all these considerations, exposure assessment is not difficult for at least 90 per cent of normal photography.

Most subjects selected for photography are not excessively contrasty and contain a range of tones that can easily be accommodated in the photographic negative. Moreover, the differences in tone are usually reasonably equally distributed through the range so that their average density approximates to the generally accepted mid-tone of a surface that reflects about 18 per cent of the light falling upon it. It is this "integration to grey" principle on which most exposure calculations are based. It makes it possible, for example, for automatic exposure mechanisms to produce accurate exposures in most circumstances. All such mechanisms rely on an exposure meter— in the traditional form an instrument consisting basically of a galvanometer linked to a pointer moving across a scale. In the cadmium sulphide type meters, the galvanometer is driven by current from a battery, modulated by the resistance of a CdS photo-resistor that varies according to the amount of light falling upon it. In the selenium type of meter of the earlier Canon reflexes, the current is generated by the selenium light-sensitive element itself, again depending on the amount of light falling upon it. The later silicon type generates a minute voltage that has to be amplified by a battery-powered circuit. The meter needle can, therefore, register the average strength of the various intensities of light reflected by different parts of the subject. If the meter is so calibrated as to accept this reading as identical to that it would make from a surface of 18 per cent reflectance, the scale across which the pointer moves can be so designed that it recommends an exposure that will render such a mid-tone correctly on the film.

The response of the film is generally such that other tones are then automatically reproduced with the correct densities.

This is the principle on which all exposure meters work. Naturally, there are variations in detail. In most Canon cameras, there is, in effect, no scale and the meter needle is linked to film speed and shutter speed settings and is lined up with a fixed index mark or a movable pointer linked to the aperture setting. As electronics play a greater part in camera design, galvanometers and needles are dispensed with in favour of flashing LEDs (light-emitting diodes) and digital readouts, as in the Canon

A-1. In these systems, the camera settings themselves act as the scale.

The angle of acceptance of the meter can also vary. The separate hand-held meter, for example, generally has an angle of acceptance between 40 and 50° to approximate to that of a standard camera lens. The through-the-lens meter may measure the whole subject area, in which case its angle varies with the focal length of the lens fitted, or, as in some Canon models, it may have its angle restricted to cover only a small portion of the subject area.

No matter what the variations in construction, however, the principle is the same. The meter is instructed to accept that every subject integrates to grey and it therefore treats every reading it makes as a mid-grey tone and makes its exposure recommendations accordingly. Difficulties arise when the subject does not, in fact, integrate to grey. If, for example, to take an extreme case, the whole subject is quite light in tone, as in a snow scene with relatively few shadows, the meter is misinformed. Its instruction to translate its reading as a mid-tone is incorrect. The meter cannot appreciate the fact and consequently gives an incorrect reading. It treats the predominantly light tone as if it were a mid-tone and recommends an exposure to produce a mid-tone, i.e. it recommends underexposure. Conversely, if the meter reads a collection of tones that are predominantly dark, it recommends overexposure to reproduce lighter tones.

This is a feature that needs to be watched carefully in such meters as that of the normal pentaprism on the Canon F-1, which reads only a part of the subject area, because although the whole subject may integrate to grey, unthinking use of the meter could cause a reading to be taken from an unrepresentative part of the subject. This type of meter must always be aimed, therefore, so that the metering area covers a mid-tone, even if that means recomposing the picture after the metering has been effected. Where there is no mid-tone in the subject, or no such tone that can be easily metered, a substitute reading must be made. The back of the hand of the average light-skinned person is a reasonably good substitute. For more accurate results 18 per cent reflectance grey cards are commercially available or a quite close approximation is obtained by taking a reading from a pure white surface

## USING AN EXPOSURE METER

There are various methods of using an exposure meter—some right, some wrong, some rather pointless. It is often said that you should tilt the meter downward to avoid too much influence from the sky. This applies only if the sky is very bright and occupies a major part of the picture.

Taking the mean of two separate readings—one from light areas, one from shadows—may work in practice but is unnecessarily complicated. A reading from a mid-tone makes more sense.

For backlit subjects in which full detail is required in the shadow parts, a close-up reading from those parts will generally prove adequate.

For almost all subjects, the most accurate reading is that taken from a mid-tone, because that is what the meter is calibrated to. A good approximation to a mid-tone is often the hand but official "grey cards" can be purchased which reflect 18 per cent of light falling on them. This is, in fact, the average reflection of most photographic subjects.

The metering method that solves most problems is the incident-light method not generally available with built-in meters. It measures the light falling on the subject. The meter has a diffuser fitted over its cell and is pointed from the subject position toward the camera. Thus, the reading is in no way affected by the nature of the subject.

and dividing the recommended exposure by 5, on the principle that the average such surface reflects 90 per cent of the light falling upon it. In black-and-white photography, 2 or $2\frac{1}{2}$ stops more exposure than is recommended by such a reading is generally adequate.

## Setting the film speed

The mechanics of exposure calculation with an exposure meter are, therefore, relatively simple. There is always, however, the problem of calibrating the exposure meter scale to give the correct exposure in the first place. This calibration is provided on all exposure meters by an adjustment for the speed of the film in use. Methods of defining film speed were discussed earlier, where it was stated that the film speed figure is not sacred. It varies according to the efficiencies of the lens diaphragm and the camera shutter and the particular processing methods of the user. In black-and-white processing, it can also vary slightly according to the personal preferences of the photographer. Some prefer their negatives to be a little denser than others and this preference can lead to a doubling or halving of the recommended film speed from one photographer to another. It is quite possible for one photographer to rate the same film four times faster than another and yet by his own particular working methods, each can obtain results of equal quality. In such cases, however, it is likely that one of these photographers at least is working near the limits of the film's exposure latitude. He must, therefore, be careful in his exposure calculations.

## Against-the-light exposures

Your exposure meter takes care of all normal subjects perfectly. It is when you come up against the non-average subject that you have to add a little more calculation to the procedure. One of the most common of these non-average subjects is that encountered in strong side or back lighting. If you use a meter that reads the whole subject area in such cases, the meter cell is affected by light from the source as well as that reflected by the subject.

The semi-spot-reading meters enable you to overcome this difficulty quite simply by directing the metering area at an appropriate part of the subject, such as the model's face in a backlit portrait. You can move in closer for the

same purpose if your meter has a wide acceptance angle, or you can take a reading from the back of your hand if you position it to receive light from the same direction as the model's face.

That is the straightforward way of dealing with the problem but it is not always completely satisfactory. It assumes that you want the subject's face to be reproduced as if it were not in shade and that the background and perhaps the halo around the subject's hair caused by light passing through the looser strands around the perimeter are not features of particular interest. This is in fact rarely so, for side-back lighting of this nature can be very attractive and it is generally preferable to retain some detail in the haloed hair. Similarly, if the background is overlit, you may not wish it to be overexposed to the point of losing detail. In such circumstances, your exposure becomes something of a compromise. In black-and-white photography in particular it may be acceptable to allow your subject's face to be reproduced rather darker than it is in reality and you can therefore give at least one stop less exposure than the local reading recommends. You may give even less exposure to retain the fullest possible detail in background and hair if you allow for subsequent manipulative printing.

In colour, you have to contend with the more restricted exposure latitude of the emulsion. If you similarly underexpose the subject, you may introduce colour distortion. If you expose for the subject, background colours may be washed out completely. Against-the-light photography in colour calls, in fact, for a little more thought to ensure that a suitable background is used. Alternatively, it might be advisable to use fill-in lighting from reflectors or flash from the front so that exposures for subject and background can be more easily equated.

Different types of against-the-light photography, such as the sun's light through trees, sunsets and sunrises, large buildings, monuments, sailing boats, etc. with the sun behind them, often make a feature of the partially-obscured sun itself. The subject of such pictures may be allowed to reproduce as a silhouette or semi-silhouette and, indeed, with sunsets or sunrises at least, it is preferable that it should do so. Exposures in these cases are quite short and are not easily assessed by exposure meter

readings. In colour, particularly, you usually want the warm effect of the sun's rays to show reasonably strongly. To obtain such a rendering you must not overexpose. On the other hand, a direct reading against the light is likely to be suitable only for the most vivid rendering of sunsets and sunrises.

For effective rendering of the sun's rays past buildings or through trees, a shortish exposure is also required but as some detail is generally required in the foliage and tree trunks, the exposure is likely to be rather longer than a direct reading indicates.

In all such non-average subjects, however, bracketing exposures is recommended. This simply means that you assess the exposures that you think will be correct and then make other exposures at 1 or $\frac{1}{2}$ stop intervals below and above the estimated level. The number of such bracketed exposures depends on the confidence you have in the accuracy of your original assessment. It is by no means unknown for one of these extra exposures to produce a satisfying result that the photographer had not foreseen at the time of shooting.

## Exposure in low light levels

The owner of one of the Canon exposure meter boosters, either the original Booster or the Booster T Finder for the Canon F-1, has no very great problems in assessing the exposures required in low light levels—provided he is shooting in conditions in which the length of time these meters need to take a reading is not prohibitive. The Canon EF or A-1 owner does not even have that problem. In other circumstances, low ambient light raises exposure problems, if only for the fact that there are many ways in which a subject so lit can be recorded. At the extremes, for example, the low light may be a nuisance and you may wish to record the subject as if it were more brightly lit or the low light may be a feature of the subject itself and should be evident in the final picture.

The first problem is largely one of time only. No matter how low the lighting on a particular subject, it can be photographed as though adequately lit if the exposure can be sufficiently prolonged. Where the exposure has to be, say, longer than 1/30 second, there can be no movement of the prime subject. When the exposure becomes very

438

long, however, movement through the picture area (of traffic, pedestrians, etc.) is sometimes possible, because you can cover the lens until the moving object has passed out of the picture area. Indeed, a dark-clothed pedestrian might be able to pass fairly rapidly through the area without leaving a trace on the film. Sometimes, it may be advisable to extend the exposure by the use of neutral density filters to allow such techniques to be used.

Generally, however, low light photography is a compromise between reproducing the subject as it actually appears and as the photographic emulsion can best present it. An obvious example is a floodlit or decoratively lit building or scene. In such subjects the lights or the floodlit features may be so much brighter than the surrounding areas that it is impossible to retain detail at both extremes. Such scenes therefore call for a little forethought. At dusk, for example, the sky loses much of its brightness and features of the subject not illuminated by the lights would need a relatively long exposure to reproduce as the eye sees them. The lights or the illuminated features, on the other hand, call for a relatively short exposure in order to retain detail. Thus, if you shoot at this time and expose for the highlights, surrounding features appear much darker on the film than they actually are and, with a careful adjustment of time of shooting and exposure given, a simulation of full nighttime lighting can be obtained. This is particularly effective with colour materials when a relatively light blue sky can be so underexposed by this means as to reproduce as a deep blue black tone.

Low-light level photography also includes work carried out in interiors or outdoors when the light is failing in conditions when slow shutter speeds are not possible owing to movement within the subject or the impracticability of using a camera support. In such circumstances, the $f$1.4 and $f$1.8 Canon standard lenses are particularly useful. Shooting at full aperture with these lenses does, however, raise problems of depth of field. If the most important parts of your subject are at some distance from the camera, depth of field may still be adequate but if you are shooting at relatively close range you have to choose your viewpoint carefully, focus very accurately and/or arrange the subject if possible so that the main features are

encompassed in a relatively flat plane. Where this is not possible, you must resort to using the fastest film available and/or underexposing for subsequent forced development. There are one or two developers available that quite genuinely enable you to rate the film at twice its normal speed, while it is also possible in certain conditions to increase developing time to squeeze out a little more speed at the expense, perhaps, of an extra grainy image or of excessive contrast.

Such speed-increasing methods are generally used only as a last resort because they can never provide the best image quality of which the film is capable. In such conditions, however, a picture of less than perfect quality is often better than no picture at all and there is no point in not making the exposure because theory says that it is impossible. You lose nothing by shooting regardless of theory and hoping that an expert printer might get you out of trouble.

A special type of low-light condition is caused by mist and fog. In weather conditions of this nature the subject cannot contain a full black. It must inevitably be rather lacking in contrast and is therefore a type of subject that provides reasonable exposure latitude. Your exposure must depend on the type of result you are seeking. An effective type of photograph in heavy mist or fog conditions particularly in colour, is that which includes a relatively small area of one prominent tone or colour, such as a street lamp, traffic light, motor vehicle brake or indicator lights, etc. In such cases, the exposure should be calculated for the predominant feature. A semi-spot reading of the feature is likely to be reasonably accurate but a range of bracketed exposures is advisable. In general misty conditions, a straightforward full area reading should be about right.

When you are not deliberately making the mist or fog a part of the picture and, in fact, are trying to "see" through it—as at a sporting event perhaps—your only solution is to get as close as possible to the action and give as generous an exposure as possible to increase contrast. If the conditions are foreseen, it is not necessarily wise to change to a fast film because the medium-speed general-purpose film has better contrast characteristics and stands up better to overexposure.

## Exposing the moving subject

Correct exposure is obtained by suitable adjustment of the shutter speed and aperture controls. As far as adequate exposure of the emulsion is concenred, therefore, it matters little whether you set these controls at, for example, 1/500 second and *f*2.8 or 1/15 second and *f*16. The same amount of light passes through the lens at either pair of settings, but if the subject is moving you probably need to use a shutter speed of 1/125 second or more. The actual shutter speed required is a matter of experience and common sense. The important point is the displacement of the image on the film within the time that the shutter is open. It is evident that the displacement is greater if the subject moves directly across in front of you, i.e. at right-angles to the lens axis, than if it moves directly toward or away from you or diagonally across the lens axis. Generally speaking, if the action is fast, such as that of a motor vehicle, aeroplane, racehorse, etc. you will use the fastest practicable shutter speed in order to ensure the sharpest possible image. Sometimes, you have to take into account the fact that there is faster movement within the subject than in its actual speed of travel, as in the wings of a bird, the legs of animals and people, etc. It is not always desirable that this movement should be "frozen". Slight blur in these parts gives a better impression of speed and movement.

## Panning techniques

There are occasions when even your fastest shutter speed cannot produce a sharp image or when the prevailing light or depth of field considerations do not allow you to use your fastest shutter speed. In such circumstances, the accepted method of shooting the moving subject is to pan the camera. Panning entails picking the subject up in the viewfinder a moment or two before you intend to shoot, then swinging the camera steadily to hold the subject in the viewfinder until it reaches the required position. You then release the shutter while continuing the panning movement and the image should be perfectly sharp even at quite slow shutter speeds. It is best to effect the panning movement by swinging the whole upper part of the body from the hips and resisting the temptation to stop swinging as you release the shutter. When you use

this technique the image of the background is blurred according to the speed of the panning movement. This is a fortunate effect rather than a drawback in that it gives an effective impression of speed. Nevertheless, if the panning movement is relatively slow, as, for example, when following an athlete, figures in the background can be grotesquely blurred in a distracting manner. You should therefore try to choose a plainer background so that all attention can be focused on the main subject.

The panning method is often used for ground to air photography when shooting low flying aircraft at air shows or pageants. Another exposure difficulty arises in these cases because the subject is very heavily backlit and a large part of your image area is likely to be the brilliantly illuminated sky. The exposure required is much heavier than you might think if you are shooting more or less directly upward to the underside of the aircraft—perhaps two or three times the reading from a mid-tone or standard grey card if you want detail in the aircraft. When you have a blue sky with clouds and wish to retain the detail you may have to compromise, because the exposure for the sky may be a great deal less than that required for the aircraft. You may have to sacrifice some detail in the aircraft or even let it go into more or less complete silhouette. With all such shots, an efficient lens hood is absolutely essential to minimise flare effects.

In the opposite case of air-to-ground photography, it is the camera that moves and the subject that remains more or less stationary. At any reasonable height, however, the relative movement between the two is barely noticeable and does not generally of itself call for a high shutter speed. In all aircraft, however, there is some vibration and the fastest practicable shutter speed is advisable. The aperture used is of little importance because at such a distance you will set your lens on infinity and, even at full aperture, you are not likely to run into depth of field troubles. In this case, however, the exposure is likely to be rather less than you might anticipate because the subject contrast is generally low and overexposure may destroy some of the mid-tone detail. As detail in the picture is often on a small scale, a medium speed film of 100-125 ASA is advisable both for its better resolution and better contrast characteristics.

## Special exposure techniques

*Photographing the television screen.* Various subjects have characteristics that call for special exposure treatment. One such is the shooting of picture from the television screen. In Britain, for example, where the electricity supply has a frequency of 50 Hz (cycles per second), the television screen takes 1/25 second to build up its full 625-line picture. In practice, a shutter speed of 1/30 second is adequate (as it is for the American 60 Hz supply) but the horizontally-moving shutter blinds of the Canon cameras do not synchronise with the movement of the television flying spot scanner and the result is generally dark diagonal bands across the picture area. You can usually overcome this by turning the camera to the upright position to provide a vertical movement of the shutter blinds. The movement should be from top to bottom (i.e. with the shutter release end at the top) to follow the picture build-up. By this method you sacrifice image size but you should get a perfectly clear picture.

You can use fast film for shooting from the television screen because the television image consists of lines that are considerably more prominent than the grain of the emulsion and, additionally, because the television image tends to be contrasty and the lower-contrast characteristics of the faster film provide a suitable counter-balance. If you do use slower film, you should adjust the brightness and contrast controls of the television receiver to provide a relatively flat image on the screen. Exposure varies according to the brilliance of the image on the tube face but, at a shutter speed of 1/30 second with a 400 ASA film, the aperture required for black-and-white television is in the region of $f5.6$. The image on the colour television screen is rather less brilliant and colour films are generally slower than black-and-white films. You may well find that with a 64 ASA colour film the aperture required is $f2$ or greater. You might do better to shoot on a faster film or arrange for your film to be "forced" in processing.

*Multiple exposures.* You can overcome the double exposure prevention device built in to all Canon reflexes except the Canon EF and Canon A-1 in order to make more than one exposure on the same film. To do this, you depress the rewind button after making the first exposure,

and rewind the film until the mark on the rewind button has made about seven-eighths of a full turn. You then operate the film transport lever while lightly holding the rewind crank. Stop when you feel a pull on the rewind crank. Operate the film transport once more and the frame is pulled back into place again. After the second exposure you can repeat the process to make any number of exposures on the same frame.

The Canon EF and Canon A-1 have multiple exposure facilities built in.

The exposure problem is to decide what effect each exposure will have on the others. If, for example, you wish to produce a ghost effect by exposing, say, a staircase and then taking a further picture of the same staircase with a figure on it, you must give only half the metered exposure for each shot, so that the background is not overexposed. On the other hand, if you wish to print a fully exposed image into the shadow area of another, both exposures need to be full. A different kind of ghost image is the shot occasionally used in industrial or advertising photography whereby a product in a case, under a cover, etc. is shown as if the cover or case were transparent. A motor car engine, for example, can be shown with the bonnet closed but with the engine visible through it. This would need some engineer co-operation because the bonnet would have to be removed for the shot of the engine and replaced for a second exposure of rather less than full duration so that it appears only in a rather shadowy form. The bonnet must, of course, be relatively dark in colour. If it were white, for example, it would simply burn out all detail in the first exposure. It can, however, and preferably should, have small light features, such as mascot, name, trim and so on. The exposure for the engine must be very full and may even be necessary to lighten some features with removable paint to make them more prominent.

For this type of picture, registration of the two images needs to be accurate and a different method might be advisable. The first exposure can be made long enough by the use of a small aperture and neutral density filters, if necessary, so that you can open the shutter on B with a locking cable release and then cap the lens at the end of the exposure time. The second exposure is then similarly controlled by the lens cap.

## Creative exposure techniques

There are various methods of using exposure time, over-exposure and underexposure to produce images of a distinctive nature to put across various ideas. You can enhance the grain effect, induce blur, produce shadow images, disguise the existing light conditions and so on.

*Blur*. Simple blur techniques are based on the use of a relatively slow shutter speed when shooting a moving subject. A colourful, blurred image of a whirling dancer, for example, may give a better impression of the movement and atmosphere of the dance than a static, flashlit figure "frozen" in action. Blur of only part of the subject, such as the ball leaving the footballer's foot, or the swiftly moving racket of a tennis player, etc., can be quite effective. At the other extreme, you may have just one sharp part of the subject with the rest of the picture blurred. This can be produced by panning or by using a slow exposure to photograph a static figure on a railway station forecourt while hurrying commuters pass by. An exposure of 1/2 second or more can blur the moving figures while leaving the static figure pin sharp.

Even more decisive blur can be induced by heavily over-exposing a moving figure against a light background. The moving figure should be fairly dark-toned and the background as light as possible. The movement must be relatively slow and the overexposure effected by aperture rather than shutter speed. The effect required is that the background eats through the outer parts of the figure, leaving it thinner and indeterminate in shape. If the figure moves too fast, it can disappear altogether.

*Grain effects*. The photographic image is granular in structure because it is composed of microscopic specks or grains of black metallic silver in the emulsion. These grains are irregularly scattered throughout the emulsion. The aim is normally to expose and process the film in such a way that the granular structure is kept as fine as possible. For such a result it is vital to avoid overexposure or over-development, either of which can extend the blackening effect so that an overlapping or clumping effect is produced in grains at different depths in the emulsion. In serious cases, this even makes the granular structure visible in the negative. In others, the structure may become noticeable only in the enlarged print. The effect of

noticeable graininess is to obscure fine detail, soften edges between adjacent tones and destroy any smoothness, as of skin, polished materials, etc.

In general photography, graininess is regarded as undesirable but there are occasions when it can add atmosphere to a picture or simply provide an effect in itself. When it is enhanced in this way, graininess should be prominent, relatively fine, even and sharp. The simplest way to emphasise the granular structure is to enlarge a very small portion of a normal negative, but this is rarely a very satisfactory method, because the graininess is rather uneven in structure and not particularly sharp-edged.

A more satisfactory method is to make an exposure especially for the grain and then to overdevelop up to 50 or 100 per cent. The exposure can be normal, short or long, according to the density and contrast you require. Generally, the shorter the exposure, the greater the contrast, given considerable overdevelopment. With very short exposures, even overdevelopment can bring up only the highlights and the granular effect is slight. With more exposure, you add medium tones and shadows until, with both overexposure and overdevelopment you have full detail throughout the image area and a heavy grain structure in all areas but the deepest shadows and the brightest highlights. The grain should be sharp and fairly even in size and distribution. The slower the film, the sharper and smaller the grains.

Even greater emphasis can be given to the granular structure by using a more vigorous developer, such as a bromide paper developer. Contrast then increases, the pattern becomes finer and stronger. For even more emphasis, you can copy the grainy negative on to line or lith film via a positive. These very contrasty treatments are particularly suitable for scenes shot in fog, mist, smoky interior lighting, etc.

*Underexposure techniques.* The first effect of underexposure is to lose detail in shadow areas. As you decrease the exposure further, so more and more tones are lost. Thus, if you have a figure standing against a light-toned background, you can give a short exposure to reduce the figure to little more than a shadow while still producing a reasonable density on the film to represent the back-

ground. There are many ways in which you can use this treatment, ranging from an underlit foreground on a sunset backdrop to a full black silhouette on a stark white ground. The nature of the result depends on the subject lighting and the film material used. With a figure against a bright sky, for example, you are not likely to be able to produce a full silhouette effect unless the figure is in very dark clothing. An exposure short enough to produce nil density for the figure is likely to provide insufficient density in the sky area to enable it to print pure white. In such circumstances, you would do better to allow some detail to appear in the figure so that density can build up in the sky area. If you must have the silhouette effect, you can copy the negative on to more contrasty material.

The true silhouette, however, is more usually obtained by artificial heavily overlit backgrounds, with special precautions to prevent light falling on the subject. Alternatively, the subject is placed behind a translucent screen and backlit to throw its shadow on to the screen. The light must be relatively small and directional and reasonably close to the subject to produce a hard-edged shadow.

Underexposure can be used deliberately with colour materials (particularly colour slide film) to increase the intensity of some colours. A blue sky, for example, can become more intensely blue if underexposed. It can even tend to blue-black—an effect that is often usefully employed in photographing floodlit buildings or decorative lighting set-ups just before dusk. The underexposure of buildings and sky gives a night-time effect to the surroundings while maintaining full detail in the lighted areas. Similarly, underexposure of a strongly sunlit scene can simulate moonlight, especially if a blue filter is added to subdue the warmer colours. You have to be careful with this "day-for-night" technique, however, not to include street lights, vehicles, etc. which should be lit up in the apparent conditions.

# SHOOTING FOR EFFECT

The Canon reflex cameras are essentially system cameras, in that a very wide range of accessories can be used with every one of them, except the EX models, which are designed for special applications.

Naturally, this applies with even greater force to the Canon F-1, with its interchangeable finders and exposure meters, motor drive, 250-exposure back, remote control facilities, etc. The motor drive is, in fact, the basis for a wide range of specialist applications.

## Specialised uses of the Motor Drive Unit

Once you motorise the film transport mechanism of your camera, you leave yourself free to concentrate on picture making and taking, capturing the decisive moment, concentrating fully on your finder image, etc. without the distraction of operating the film transport lever or fear of the possibility that you may not have done so. Where the action is fast and the actual moment of exposure is critical, the time spent in winding on can decide whether you get the picture or not. Nevertheless, you should not rely on automatic continuous firing for such subjects. In motor racing, football, athletics, etc., the experienced photographer can judge the exact moment to press the button to stop the action for 1/500 second or less. At the fastest speed of the normal motor drive (three frames a second), he relies on luck and can quite easily miss the decisive moment. On the other hand, he might in some cases decide to set the motor drive to C (for continuous shooting) so that after the first anticipated shot he may capture any fast-moving unexpected sequence that may follow.

It is in sequence shooting—to demonstrate the separate movements in a relatively slow process, such as the take-off or landing of an aircraft, for example, that the continuous shooting facility excels. For the more rapid action, such as a golfer's swing or a tennis service, you need either

a faster sequence or a single shot at the moment of impact.

The faster sequence can be provided by using several motorised cameras sequentially. The moment of impact is more reliably caught by experience of exactly when to press the button.

An aspect of motor drive usage that has already received considerable attention is that of security work—in banks, stores, post offices, etc. Concealed cameras can be set off by intruders to provide a series of photographs of their activities. Electrical or electronic circuitry can be linked with the cameras and with light sources to provide fool-proof methods and Canon engineers are always ready to devise special systems to suit particular cases.

The remote control capability of the F-1 allows pictures to be taken of pre-focused areas at the touch of a button so that suspicious characters can be photographed without their knowledge. Cameras can be linked with CCTV security systems in this way to provide permanent records of doubtful events—perhaps from a different viewpoint.

Similar methods can be used by machine or special process work by mounting a camera above the machine or workbench with the remote control button within easy reach of the operative's hand. If necessary, special circuits can again be set up so that the machine itself triggers off a firing sequence.

Where any of these operations requires large numbers of photographs, the Film Chamber 250 can be fitted to the F-1. If the light varies, the Servo EE Finder can be added to set the aperture automatically.

The combination of remote-controlled motor drive and Servo EE Finder, with or without the Film Chamber 250, is particularly useful for the naturalist's work. The camera can be operated from a comfortable distance while the subject is observed through a telescope if necessary. The timer of the motor drive can be pre-set for any sequence work that may be required while single-shot firing is used for other actions.

This combination can take care of simple time lapse work for the study of cloud movements, opening and closing of blooms, etc. More elaborate sequences can be undertaken with the aid of an interval timer.

The motor drive and remote control can also facilitate the taking of observation pictures from aircraft or moving

449

vehicles. Road behaviour can be effectively studied in this way with sequences shot through the windscreen of a following car or from a helicopter.

## Zoom lens applications

The zoom lenses available for the Canon cameras are naturally of particular value for their prime function of providing several lenses in one. The focal length—and therefore the image scale—can be varied to suit the framing required without changing the viewpoint or perspective.

They can also be used to provide special effects, the most obvious of which is the explosive effect obtained by operating the zoom control during the exposure. If, for example, you increase the focal length in the course of a relatively long exposure, the image is progressively magnified and drawn out to the corners of the frame. The subject of such a picture is normally stationary and largely centred in the frame. There is then a relatively sharp central image with blur progressively increasing toward the frame edges. More interesting effects are obtainable in colour than in black-and-white owing to the blending of colours that frequently accompanies the blur.

The zooming movement should be reasonably slow so that the image can register adequately as it moves across the emulsion. The exposure must, therefore, be of half a second or more and the lens must be well-stopped down or a slow film used to avoid too heavy an overexposure of the central portion.

Multiple exposures with a zoom lens can also provide interesting effects. As the image magnification increases or decreases so the subject can be given a convoluted appearance or, if the camera is moved slightly between exposures, can seem to disappear into the distance. Decreasing the exposure with each shot can produce a fade-out effect at the same time. Naturally, such exposures must be made against a black background.

Further variations include zooming from a given magnification to two or three others, pausing at each stage to provide a sharp image. Or you can change the subject between shots—providing a sharp image of the main subject and a zoomed, blurred framework of the orna-

mental variety. You can zoom from a central position in both directions—to greater and lesser magnification.

When zooming in close-up it is generally preferable to use supplementary lenses rather than extension tubes or bellows because the zoom ratio is greater and correct focus is maintained.

Multiple exposures with zoom lenses can be made by the usual methods or you can cap the lens between exposures. You can take advantage of the pauses to re-arrange the components of the picture and/or to change the lighting. In colour, you can vary the character or colour of the lighting. In black and white you can change tonal values by adding filters.

## Image modification techniques

Distortion of the image with the zoom lens is a sort of image modification technique and there are many such techniques that can be used with the Canon reflex cameras. All models except the EF have horizontally-moving focal plane shutters and it is a well-known fact that such a shutter can distort the image of a moving object because it exposes it piecemeal as it moves across the emulsion surface. Thus, a motor car moving in the same direction as the shutter could appear longer than the same car moving in the opposite direction. Fortunately or un-fortunately, according to your requirements, this well-known fact can be more accurately described as a well-worn theory. The effect is very rarely noticeable in prac-tice. It can, however, be encouraged by suitable movement of the camera.

To compress the subject, for example, you can pan the camera against the direction of shutter blind movement. The subject should be stationary or slow moving and you will need the highest possible shutter speed to obtain a reasonably sharp picture. You cannot expect perfect sharpness. To elongate the subject you pan in the direc-tion of the shutter blind movement. You can try diagonal or vertical movements of the camera for other types of distortion. The results are not entirely predictable and depend very much on the speed of the shutter and of the camera movement. Slow speeds can have no effect because there is then no piecemeal exposure. The back-ground can also have an effect because it will be blurred to

a greater or lesser extent. If possible, shoot against relatively plain, dark backgrounds to avoid distracting elements—particularly in colour.

Movement of the camera during exposure induces blur, of course. The amount and nature of the blur depends on the type of movement and the speed with which it is carried out. When you are striving for something new and think that blur might help, try various movements, such as twisting the camera or even rotating it on a turntable. Again, double or multiple exposures combining various types of movement can be effective, together, perhaps, with changes of lighting colours or set-ups.

If movement of the camera cannot provide the result you are seeking, try moving the subject or part of it. Blur is easily induced in the naturally moving subject by shooting at a relatively slow shutter speed. You may feel, for example, that a stageful of whirling dancers is better represented for a particular purpose when shot at a shutter speed of about half a second. If one figure is static, the effect can be greater.

If the subject does not move naturally, you may be able to call the turntable into service again, perhaps with black paper or velvet covering it to provide a suitable background for the blurred images. Colours placed around the perimeter can be blended together in this way. Or objects can be suspended on cords to provide patterns. Two-point suspension can give eccentric movement. A flash exposure at a given point in the movement can provide a sharp reference point.

Reflecting images provide another source of distortion and/or multiple imaging. An image reflected in water or other liquid for example, is easily distorted by disturbing the liquid surface. The reflected image can be combined with objects under the liquid, the images of which are not so easily distorted by the liquid movement.

Two mirrors placed edge to edge stood up in a V formation provide multiple images of an object placed within the V. Differences in density between the various images are minimised by front surfaced mirrors. This is the principle of the kaleidoscope, and a toy kaleidoscope can in fact provide interesting pattern pictures, too. It is better, however, to make your own kaleidoscope from

three mirrors and either shoot through it or place it over translucent objects on a light box.

A sheet of good quality glass can be substituted for a semi-reflecting mirror (which is rather expensive) if you place it at an angle in front of the camera lens so that it picks up a reflection of a well lit object to one side of, above, or below the camera. You can then combine the reflection with the scene in front of the camera (shot through the glass). Combination of such a subject with a normal scene provides a ghost image, because the background shows through. If the subject in front of the camera is set against a black background, however, or has a black portion within it, you can place the reflected image within the black area to provide any particular effect required.

## Image-softening effects

All-over soft focus of the type once considered mandatory for portraits of women is provided by the Canon Softomats. This effect is now rarely used but it is not uncommon to use a form of selective soft-focus for some advertising and similar work. The simplest such effect is provided by smearing petroleum jelly around the edges of a sheet of clean glass placed a few inches in front of the lens. The jelly is smeared by observation through the viewfinder to obscure to a greater or lesser degree the background around the subject, leaving the central portion of the image unaffected. The jelly can be coloured for greater effect if required.

The principle can be extended to providing a suitably fuzzy foreground—imitation waves perhaps—or to placing defocused coloured shapes within the picture area as if floating in space. Coloured paper shapes stuck to the glass can provide this effect. With a suitable wide-angle lens and a small shooting aperture you may even combine a sharp image of a picture stuck on the glass with the background scene.

To return to soft-focus effects—or something akin to them—a similar background vignetting method is to shoot through a tube of crumpled kitchen foil of such dimensions that it vignettes the image area with out-of-focus images of the foil and may also impart some flare to

the image as a whole, giving a softening, ethereal impression.

## Effective shooting

Imaginative picture making includes ignoring one or more of the generally accepted principles of camera work. Move the camera during exposure, use unsuitable lighting or the "wrong" type of film or filter, shoot through gauzes, nets, etc., place prisms or various types of faceted glass (even the commercial types) in front of the lens and study the effect. The possibilities are limited only by your own powers of inventiveness. Do not be afraid to copy somebody else's efforts and try to improve on them. You may fail more often than you succeed. Even if you succeed in producing an original and striking effect, you may wonder why you bothered. There may seem to be no immediate application for your achievement. It doesn't matter. You will have learned something—even if only that you should stick to orthodox photography.

# LIGHT SOURCES FOR PHOTOGRAPHY

The functions of photographic lighting fall into two basic categories:

(1) To illuminate the subject sufficiently to allow it to be photographed with the available equipment and materials.

(2) To show form, shape, texture, etc.

These categories virtually resolve themselves into matters of light intensity and the direction or angle of the light respectively. In general, they can also be regarded as basically indirect or diffused, and direct lighting respectively.

The light sources used fall into three main groups:

(1) Natural light, meaning sun, moon, sky, etc.

(2) Artificial light, which can be anything from a high-powered studio lamp to a candle.

(3) Flash, in the two categories of bulb and electronic. As flash is adequately covered in its own chapter, we shall have little to say about it here.

## Daylight outdoors

Daylight is still the most suitable light for most forms of photography, but it is an immensely variable form of light. From early morning to late evening it varies between quite wide limits in colour temperature and intensity. Its character depends on the proportion of direct sunlight to reflected skylight, on the thickness of cloud cover, on the state of the atmosphere and on any artificial modifications, such as reflectors, filters, diffusing screens, etc., used by the photographer.

The most suitable form of daylight for most photography, and particularly colour photography, is that provided by the sun with a light veiling of cloud to provide reflected skylight from a very wide area that is not too strongly affected by the blue sky. The greater the cloud cover, the more diffused the light and the lighter the

shadows cast. When the sun is totally obscured by cloud, shadows are virtually non-existent and it is very difficult to show the true shape and form of your subject. Sometimes shape is only evident by the perspective effects of converging lines and size differences, helped by knowledge of the identity of the subject. If you want to conceal the shape or form of a subject to present a puzzle picture or mislead an observer, this is the form of lighting to choose. Similarly, it is obviously ideal for flat subjects, as in copying, to avoid uneven lighting or shadows from tiny protrusions or elements of texture.

At the opposite extreme, direct sunlight, with no clouds to exert a softening effect, is a very hard light source, small by virtue of its distance and therefore casting deep shadows. When the sun is high in the sky, the shadows are small and can be disfiguring in portraits, showing as deep black patches in eyesockets, under the nose, beneath a hat brim and so on. Where subject contrast is great, as in a shot of a bridal couple, for example, the harsh light can make it almost impossible to produce a properly graded negative. Colours are brilliantly rendered in such lighting but the extremes of a contrasty subject may lose all semblance of colour.

Naturally, this form of lighting has its uses too. Direct sunlight on frost, snow, icicles, rain-spattered windows, tiled roofs, hedgerowed or ploughed fields and innumerable other subjects can show up texture or form patterns. Direct sunlight behind the subject can give interesting rim lighting, semi-silhouettes, translucent effects through hair, foliage, sails and so on.

Generally, however, your outdoor photography requires sufficient direct sunlight to provide modelling in the subject, with a reasonable amount of cloud cover to allow some detail to be shown in the shadowed areas. If you have to shoot when the lighting does not approach the ideal, modify your exposure and processing technique accordingly or introduce reflecting surfaces or auxiliary light sources, such as flash.

## Daylight indoors

Daylight is not only used outdoors. It can be used indoors, too, where adequate windows are available. Window light varies in character much more than outdoor light because

the source is effectively much smaller—in the case of diffused light, that is. Direct sunlight through windows has much the same effect that it has outdoors—only more so, because there is even less skylight to offset the harshness of the effectively small source.

Large windows make indoor portraiture without artificial light quite feasible. The light is more directional than diffused light outdoors because, however large the window, it still lights the subject more strongly on the side nearer the window. There is no skylight to relieve the shadows on the opposite side. There, all the light has to come from the walls and ceiling and therefore varies in intensity with the tone of those reflecting surfaces and their distance from the subject.

If the light on the shadow side is insufficient it can be supplemented by the use of large or small reflecting surfaces, such as sheets of white background paper, projection screens, metal foil, mirrors, etc. For black-and-white photography, you can fill in with tungsten lighting if you wish but the difference in colour temperature calls for electronic flash or blue flashbulbs with daylight or negative colour films.

The nature of the lighting can be varied by changing the position of the subject. The closer the subject is to the window, the greater the contrast between the directly lit and the shadow side. The nearer the subject is to a reflecting wall or other surface, the lower the contrast.

Camera position affects the presentation, too. You can shoot toward the window for backlighting or away from it for relatively flat frontal lighting. You can shoot across the window for side, side-front or side-back lighting. In each case you can add reflectors for shadow relief and small mirrors for effect or make deliberate use of the relatively high contrast.

Window lighting is much more versatile than you might think. Slight changes of camera position and/or stance of the model can introduce almost limitless variations. Nor is its use confined to portraiture. Small objects placed fairly close to the window can be evenly and softly lit (with the help of reflectors if necessary), but still with enough directional effect to provide modelling. Windows reflected into silverware, glazed pottery, etc., can provide lively highlights. Tall, narrow windows or windows

457

partially blanked off are particularly useful for this effect. It is generally better to throw the reflections slightly out of focus if possible.

## Moonlight

With sufficient exposure, any low-level light can provide a picture, and moonlight is certainly no exception. A long exposure of a moonlit scene is not easy to distinguish from a daylight shot, unless lighted windows, street lamps, or star tracks give the game away. Photography by moonlight is, however, generally intended to look authentic. There is not much point in faking daylight in this way.

It is difficult to assess the actual exposure required because the eye adjusts to the low light level and because increased exposure gives the appearance of brighter lighting. Do you want a moonlight scene to appear natural to most people or to show rather more detail or less in the shadows? What would appear natural to most people? The result must be compromise.

You can produce a picture with very little detail at all, but with revealing highlights on wet roofs, pavements, etc., and perhaps a few reflections in windows, to set the scene sufficiently. The surroundings may be adequately implied by vague shapes and outlines against a slightly less dense sky. Or, at the full moon, you may have bright surfaces lit almost as strongly as in sunlight but with deeper shadows and a relatively dark sky. It is generally necessary to bracket your exposures so that you can choose the most effective result after processing.

Including the moon in the picture is rather difficult because its apparent movement is surprisingly fast and exposures of more than a few seconds are likely to show some evidence of that movement. If the prime subject is the moon, however, and other parts of the subject can be silhouetted against it or can merge into the general gloom, exposures can be quite short, even on medium speed film. A direct reading with the through-the-lens meter and a longer focus lens is about right if the moon occupies about one-third to one-half the metering area.

The size of the moon in your picture depends, naturally enough, on the focal length of the lens. At about 1000 mm. it begins to overlap the frame, but is also very difficult to keep within the frame because its relative movement is

then surprisingly fast. What is not so often realised is that the perspective effect of long-range shooting with a long-focus lens can also present a moon that looks unbelievably large in relation to a very distant earthbound object. If, for example, you can place a church steeple half a mile or more away against a moon low in the sky, the moon looks truly gigantic because the steeple is in the foreground and looks as if it were photographed from a much closer viewpoint than it actually was. It is, in fact, the small image of the steeple in view of the apparent shooting distance that makes the moon look so large.

Moonlight shots in colour can be effective only with relatively short exposures. Long exposures, whether on black-and-white or colour film bring about failure of the reciprocity law. That is to say, the exposure required when the light level is very low does not follow a linear progression. An indicated exposure of 15 seconds, for example, might actually need an exposure of 20-30 seconds, depending on the characteristics of the film, to provide the expected image density. With most films, this reciprocity failure begins to become significant at about 5 seconds exposure. The difficulty with colour film is that it has three differently sensitised emulsions and each is likely to react differently to the long exposure, with resulting unpredictable colour distortions.

## Artificial light

The artificial light sources (other than flash) used for photography are virtually all incandescent tungsten sources, i.e. the light is provided by a glowing filament of very high resistance tungsten wire in an evacuated or gas-filled glass envelope. It is a rather inefficient form of lighting, in that most of its energy is dissipated in heat—but it is the best we have for general purposes and it can be made to provide powerful, if hot, light sources. There are four main forms:

(1) Studio lamps of high power, generally with screw fittings and a colour temperature of 3200 K.

(2) Photolamps, such as photofloods, sometimes regarded as the amateur's studio lamp. These are lamps designed for deliberate overrunning. That is, their filaments would last much longer if used at a lower voltage. Used at full mains voltage they

give a brilliant light for a short period. The No. 1 photoflood gives the equivalent of about 7-800 watts but lasts for only about 2 hours. The No. 2 gives nearly twice the light output and has a life of 7-10 hours. The No. 1 actually consumes only 275 watts and the No. 2, 500. The colour temperature of photofloods is 3400 K.

(3)  Tungsten halogen lamps. One of the drawbacks of ordinary tungsten lamps is that as the filament burns particles become detached and are deposited on the glass envelope, causing blackening, loss of light output and, in theory at least, a change in colour temperature. The effect of the change in colour temperature is open to doubt. The tungsten halogen lamp is designed to avoid these problems by including a gas or vapour in the envelope (generally iodine) which has the effect of causing a recycling action by which the particles are attracted back to the filament and the envelope remains clear. The colour temperature may be 3200 K. or 3400 K. according to make. The filaments are not generally heavily overrun but the heat generated is quite considerable and replacement lamps are very expensive in comparison with the other types. The life runs from 15 hours upward according to type.

(4)  Domestic lamps. These are the ordinary household lamps with an alleged life of 1000 hours for the tungsten filament. They are easily obtainable in wattages from 15-200 and generate considerably less heat than any of the other types. The colour temperature is about 2400-2600 K. and is theoretically quite unsuitable for any form of colour film, even with filtering.

Other forms of artificial light from candles to bicycle lamps, car headlights, sodium streetlights and fluorescents are all usable for black-and-white photography but none of them can give "correct" colour rendering on colour film. Sodium streetlighting, for example, is virtually monochromatic and almost obliterates all colours. Fluorescents have what is picturesquely called a discontinuous spectrum, which means that, unlike daylight and tungsten lamps, which emit light of all wavelengths, they emit light of some wavelengths but not others. The emission varies

according to the phosphors used to provide the fluorescence.

The great advantage of any form of artificial light is that it is infinitely controllable. Its power can be controlled by changing the lamp, varying the distance from the subject, increasing or decreasing numbers and using dimming resistors. Its character can be altered by using reflectors of different shapes, sizes and surface finish. Lamps can be placed in housings with lenses to provide spotlights. They can be placed in troughs or arranged in banks to provide a powerful spread of light as large as or larger than the subject. They can be covered with diffusing screens, coloured gels or polarising material. They can be fitted with various attachments to direct the light on to particular parts of the subject and to prevent it from reaching other parts. Above all, perhaps, they can be used in sufficient numbers from various directions to light each part of the subject, its surroundings and background to exactly the level required.

## Lighting arrangements

You can photograph an object or scene under almost any lighting conditions. Your aim, however, is not generally just to provide a record. You probably want the subject to be reproduced to show shape, texture or mood. Shape or form cannot easily be shown if the light comes from a large source, such as skylight with no direct sun, because shape is delineated by shadow. A building, for example, photographed in overcast daylight can be shown to have some shape by the perspective effect of converging horizontal lines. Protruding window sills, ledges, buttresses, porches, etc., are not so obvious because they cast no well defined shadows. With direct sunlight, these features are obvious because they cast hard shadows. If there is a veil of cloud over the sun, the shadows are softer but the features are still evident.

The same applies to the portrait. A large bank of floods directed from the front gives flat lighting that leaves the features rather indeterminate. Add an undiffused light, relatively small, such as a single flood, from one side and the shape of the head, size of the nose, depth of the eye sockets, etc., become more evident.

Take a plank of rough wood. Light it directly from the

front, whether with diffused light or a concentrated beam and it appears to have a fairly even surface. Place a light to one side of it so that its beam skims the surface and the texture becomes evident. Remove the frontal light, leaving only the extreme sidelight and the texture is exaggerated.

Thus, the nature and direction of the light can affect form and texture.

Mood can be controlled by the general lighting level. Flood a light-toned subject with light and you have an airy, perhaps ethereal mood. If the lighting is frontal or all-enveloping, shadows are practically non-existent. Reduce the level of the lighting (exposing normally) and the light tones are darkened. Move the low lighting round to one side and you introduce shadows to lower the whole lighting "key".

This type of lighting is sometimes called "low key" as opposed to the "high key" of the well-lit subject. Strictly, high key and low key treatment start with the subject. You cannot have a low key picture of a blonde in a white gown or a high-key picture of a heavily-tanned brunette in black. The high-key picture consists essentially of a flatly lit light-toned subject. The low-key picture is of a dark subject lit at a low level. Both are of overall low contrast, but the high key shot should preferably have a small area of full black and the low-key shot can have a relatively small highlight.

Obviously, mood can be suited to subject. Glamour is rarely effective in sombre lighting. A nightclub scene looks unnatural if overlit. Stark tree shapes are more striking against threatening skies. Snow can look sparkling and healthy or lifeless and dirty, according to the lighting conditions.

Daylight is not easily controlled to produce these different effects. If you want a particular mood, light from a certain direction, etc., you generally have to wait for it. You may be able to move round the subject or move the subject itself to alter lighting direction in certain circumstances. You may be able to supplement the lighting with flash, reflectors, etc., but you are far more restricted than you are with artificial light set-ups.

There are many books to instruct you in the use of light to obtain the particular results you require, such as *Light on People*, by Paul Petzold and *Lighting for Photography*,

by Walter Nurnberg. It is no part of this manual to go into details of general lighting techniques. For certain types of industrial, commercial, publicity, etc., photography, formalised lighting set-ups are essential and Walter Nurnberg's book explains these fully. In general photography, there has been a tendency for some years to break away from the formal approach and to use light more adventurously. *Light on People* pays more attention to this approach. These two books demonstrate, in fact, the wide-ranging effects that various lighting arrangements can have on your photography and illustrate, too, that hard and fast rules can be laid down only for certain treatments. The fast lenses now available for Canon cameras make photography possible in almost any lighting conditions and it is worth experimenting with the various effects obtainable.

# INDEX